CARMICHAEL
HARRIS
JACKSON
JOHNSTON
LISMER
MACDONALD
VARLEY

THE GROUP OF SEVEN

Peter Mellen

THE GROUP

McCLELLAND AND STEWART LIMITED / 1970 / TORONTO

OF SEVEN

Fourth Printing 1973

ISBN 0-7710-5815-2

The Canadian Publishers
McClelland and Stewart Limited
25 Hollinger Road, Toronto 374

For permission to reprint the following copyright material, grateful acknowledgement is made to the copyright holders and publishers.

Excerpts from the MacCallum Correspondence, by permission of The National Gallery, Ottawa.

Excerpts from *The Globe*, March 27, 1916, by courtesy of The Globe and Mail, Toronto.

Excerpts *Canadian Art*, by permission of artscanada, Toronto.

Excerpts from the *Star*, by permission of the Toronto Star Syndicate.

Excerpts from *The Far North, A Book of Drawings by A.Y. Jackson* by F.G. Banting, by permission of Rous and Mann Press Limited, Toronto.

Excerpts from *Saturday Night*, by permission of Saturday Night.

Excerpts from *Canadian Magazine*, by permission of The Ontario Publishing Company Limited.

"O Canada" Copyright by Gordon V. Thompson Limited, Toronto – used by permission.

Excerpts from *Lawren Harris* by Bess Harris and R.G.P. Colgrove, by permission of The Macmillan Company of Canada Limited.

Excerpts from *A Painter's Country*, by A.Y. Jackson, © 1958 by Clarke, Irwin and Company. Used by permission.

Excerpts from *Hundred and Thousands, The Journals of Emily Carr*, © 1966 by Clarke, Irwin and Company Limited.

Excerpts from Lawren Harris's "Group of Seven" (1948) and "Group of Seven" (June 16-19, 1948), *Canadian Historical Association Report*, by permission of the author.

Excerpts from Barker Fairley's articles in *The Rebel* and *Canadian Forum* by permission of the author.

Excerpts from Arthur Lismer's "Tom Thomson (1877-1917), Canadian Painters," *Education Record of the Province of Quebec*, courtesy of Mrs. Arthur Lismer.

Excerpts from J.E.H. MacDonald's "ACR 10557," *The Lamps*, courtesy of Mr. Thoreau MacDonald.

Excerpts from "Far North is pictured by Two Artists," Regina Saskatchewan *Leader-Post*, courtesy of the *Leader-Post*.

Contents

PART TWO

Acknowledgements

It would take more than a lifetime to see all the works painted by the Group of Seven and to speak to everyone with some personal knowledge of the Group. I am extremely grateful to the many people who helped in the preparation of this book, and I only regret I could not do and see more.

My sincere thanks to all those private collectors who kindly permitted me to see their collections, especially Mrs. Charles S. Band, Miss Helen Band, Mr. Alan Manford, and Mr. Max Merkur. I would also like to thank the many public galleries who willingly provided information on the works under their care.

My thanks also to Dorothy Farr and Susan Crean for their work as research assistants; to Jill McMillan for the typing of the manuscript; to Hugh Thomson, John Glover, John Evans, and Ron Vickers for help with photography; and to Geoff Matthews for his map.

Thanks are also due to Miss Sybille Pantazzi and Mrs. Mary Balke, librarians at the Art Gallery of Ontario and the National Gallery of Canada, for their assistance; to Nancy Robertson Dillow and Margaret Davidson for having allowed me to read their theses; and to my students for their stimulating ideas and exciting discoveries.

And I would like to thank all those at McClelland and Stewart for their untiring efforts in bringing this book to press.

Among those more familiar with the Group, I am grateful to Mrs. Mary Mastin, Peter Varley and Paul Rodrik for details concerning their fathers. And for information of a more general nature, I am grateful to Professors G. S. Vickers, J. Russell Harper, Ian McNairn, and Dr. R. H. Hubbard.

There are now only a few of the Group and their intimate friends still living, and they all display remarkable longevity, energy, and alertness. A. J. Casson patiently answered a multitude of questions and went out of his way to find the answer to ones he didn't know; A. Y. Jackson, with his remarkable memory, provided answers that no one else could possibly give; Thoreau MacDonald kindly showed me letters, photographs, and mementos belonging to his father; Barker Fairley gave a vivid account of the personalities of the Group; and Chuck Matthews generously offered films, tapes, and photographs of the Group, as well as his own personal reminiscences.

I am especially indebted to Robert and Signe McMichael, who provided continual help and encouragement through the duration of the project. They welcomed me to their collection at Kleinburg innumerable times, and allowed me complete freedom to examine the paintings and archival material. They helped search out many important details, arranged for access to private collections, and helped in countless other ways.

To Dennis Reid, Assistant Curator at the National Gallery, I owe thanks of a special kind. Possessing a vast knowledge of the Group of Seven, he unselfishly provided me with ideas, information, and, above all, much needed moral support.

Having run out of different ways to indicate my gratitude, it becomes easier to thank the one individual most directly involved in the book. Words cannot adequately express the contribution made by my wife, both tangible and intangible, in the writing of this book.

To my father

1 Tom Thomson *Black Spruce in Autumn* oil on panel 8¹/₂″ x 10¹/₂″ 1916 McMichael Conservation Collection

Introduction

CANADA AND
ITS LANDSCAPE

Most Canadians feel that the Group of Seven were the first to paint Canada as it really is, and that they were the first to paint the Canadian North. Indeed, the image of Canada as a northern country is a recurrent theme in Canadian history and literature. Writers have compared Canada with other northern lands and its people with the hardy Vikings. Some have suggested that the cold northern air made one strong, healthy, and virile. Others felt that it was an insulation against lax morality.[1]

But Canada has not always been seen as a wild and rugged country. The artists who painted Canada have perceived different things at different times. The early topographers were mainly interested in it as a picturesque curiosity, and they painted "picture post-cards," depicting such scenes as quaint country picnics at Niagara Falls. The late nine-teenth century artists interpreted it as a tame and civilized landscape of fields and woods, which approximated that of England. Since no one lived in the North, or really cared about it, the artists saw no reason to paint it.

However, in the first decades of this century, Canadians were swept along by the idea of North American progress. As they looked about them, they saw the great undeveloped resources of the Canadian Shield. Here, they said, lies Canada's wealth and future — here lies its identity. And the Group looked, too, and painted what they saw. As a result, they, and the rugged North, became the "true" representatives of Canada.

But soon the focus shifted again — this time to the rapidly expanding cities. And later artists, following the trend, reacted against the landscape and turned to the city and into themselves for their sources of inspiration.

EARLY CANADIAN LANDSCAPES

There was little landscape painting of interest in Canada before 1850. In the eighteenth century, the topographical artists produced many views of Canada, but nearly all were uninspired, except for those of Thomas Davies (c. 1737-1812), who painted bright, sparkling watercolours with great sensitivity. Apart from a few exceptional works by anonymous artists, there was no major figure until Cornelius Krieghoff (1815-1872) appeared on the scene in the middle of the nineteenth century. His works have been criticized for

2 Lucius R. O'Brien *Sunrise on the Saguenay*
oil on canvas 34¹/₂'' x 49¹/₂'' 1880
National Gallery of Canada

their European skies and Germanic colours, but the better ones successfully capture the spirit of the Quebec countryside. Paintings such as the *Habitant Farm* of 1854 (in the National Gallery of Canada) appear to be nothing more than an amusing comment on the life of the *habitant*. It is necessary to move beyond the anecdotal details, to the landscape of the far distant hills and snow-covered trees, to see how successfully Krieghoff conveys a romantic and lyrical mood. Works by other contemporaries, such as Paul Kane (1810-1871), are dull and stiff by comparison.

After Confederation in 1867, and the establishment of the Royal Canadian Academy and numerous art societies, landscape painting in Canada became even more closely tied to European prototypes.[2] Artists wanted desperately to study in Europe and to emulate European standards. The pressure to produce good academic work was as strong as it is in the other direction today. There was no question of trying to break away and form a radical new style. Artists also turned to the United States, and it was not long before there were many scenes of Canada in the style of Albert Bierstadt or the Hudson River School artists. The resultant style – a kind of "romantic realism" – stressed detailed observation of nature, atmospheric qualities, dramatic lighting, and an overall romantic mood. Lucius O'Brien, who was president of the Royal Canadian Academy, and editor of *Picturesque Canada*, typified the successful academician. All the correct formulas were applied to produce works such as *Sunrise on the Saguenay* (1880), which was O'Brien's diploma work for admission to the Royal Canadian Academy.

The importation of European movements to Canada continued with the inevitable time lag. Canadian artists were to discover Constable and the Barbizon style, Impressionism, Post-Impressionism, and all the other "isms" in their own good time and apply them to what they saw in Canada.

Horatio Walker (1858-1938) was one of the first to bring the Barbizon style to Canada. Like many other artists of the period, he learned about art while working for the Notman Photographic Studios in Toronto. He then spent considerable time in the United States and Europe, where he discovered his affinity for the Barbizon school.

3 William Brymner *Early Moonrise in September*
oil on canvas 28½" x 39½" 1899
National Gallery of Canada

«*I have passed the greatest part of my life in trying to paint the poetry, the easy joys, the hard daily work of rural life, the sylvan beauty in which is spent the peaceable life of the habitant, the gesture of the wood-cutter and the ploughman, the bright colours of sunrise and sunset, the song of the cock, the daily tasks of the farmyard, all the activity which goes on from morning to evening, in the neighbourhood of the barn.*»[3]

Walker was soon praised for having "out-Barbizoned Barbizon," and during the 1880's he became one of America's most fashionable artists, receiving enormous sums for his paintings. Works such as *Oxen Drinking* were greatly admired for their richness of colour and poetic flavour, although they are now seen as sentimental and romantic. In later years he set himself up on the Ile d'Orléans near Quebec, with his own exclusive sketching reserve, and painted innumerable scenes of pigs, people, and country life.

Homer Watson (1855-1936), Walker's contemporary, painted many sensitive landscapes around his home in Doon, Ontario. Thanks to Oscar Wilde, he became known as the "Canadian Constable," a title which he could never quite live down. In his later works, his main concern was to capture atmosphere and mood, and he succeeded admirably in doing so. He knew most of the Group of Seven, and in 1931 wrote to Arthur Lismer saying, "I never thought of colour, my love preferred to take the form of structure and design, a mood of nature to be lived on canvas, in fact some story of the elements."[4] The Group dismissed Watson because he did not portray the rugged North, yet Watson rightly pointed out that he was also "painting Canada," and that each area had its native accent.

Fighting against the strong academic influences in Montreal was another of Walker's contemporaries, William Brymner (1855-1925). Brymner exerted a major influence as an art teacher and defender of the modern movement. He was one of the first to praise Monet, Renoir, and Cézanne, and to appreciate the innovations of other Montrealers, such as Cullen and Morrice. A transitional figure himself, he nevertheless belonged to the older generation, and his works never fully made the jump from the academic to the modern. But his importance as a teacher was well stated by A. Y. Jackson: "Of all the artists I knew as a student, there was no one I admired more. . . . He was not a very good painter, but he was a great individual."[5]

4 Horatio Walker *Oxen Drinking*
oil on canvas 47½" x 35½" 1899
National Gallery of Canada

5 Homer Watson *On the Grand River at Doon*
oil on canvas 23⅞" x 36" c. 1880
National Gallery of Canada

Despite the advances made by Walker and Watson in landscape painting, most collectors before the turn of the century had no interest whatsoever in scenes representing Canada. It was not yet fashionable to support Canadian artists, and the Canadian countryside was considered by many to be unpaintable. They felt that the harsh lighting, the crude colours, and the rugged landscape were not worthy of an artist's attention. Winter scenes were not depicted on Canadian publicity posters because they might discourage immigration. "It's bad enough to have to live in this country," an old lady once told A. Y. Jackson, "without having pictures of it in your home." [6] What the cultured collectors wanted to see were pleasant views of the civilized European landscape by famous European artists. So they purchased works by then famous people, such as Israels and Weissenbruch, who painted scenes of cows and trees in the best academic tradition, with lots of detail and dark brown colouring.

« *It was boasted in Montreal that more Dutch art was sold there than in any other city on this continent. Dutch pictures became a symbol of social position and wealth. It was also whispered that they were a sound investment. They collected them like cigaret cards. You had to complete your set. One would say to another, 'Oh, I see you have not a De Bock yet.' 'No—have you your Blommers?' The houses bulged with cows, old women peeling potatoes, and windmills. . . . If you were poor and had only half a million, there were Dutchmen to cater to your humbler circumstances. Art in Canada meant a cow or a windmill. They were grey, mild, inoffensive things, and when surrounded by heavy gold frames covered with plate glass and a spotlight placed over them, they looked expensive.* »[7]

6 Jan Hedrick Weissenbruch *Pasture Land*
watercolour on paper 18$^{1}/_{2}$" x 27" 1894
National Gallery of Canada

Precedents for the Group of Seven — Montreal

IMPRESSIONISM COMES TO CANADA

«At a time when Canadian landscape painting had the sweet timidity of the Victorian pastoral, Cullen rushed out of the carpeted studio, and, with a metaphorical whoop, took us all into the open air with him.»

CULLEN

This was the situation in the Montreal art world when Maurice Cullen (1866-1934) returned to Canada in 1895 after spending seven years studying art in Europe. During the cold winter months he sketched along the St. Lawrence River below Quebec City, tramping over the unspoiled countryside on snowshoes. He painted the clear atmosphere and brilliant colours of the snow-covered landscape, using the Impressionist techniques he had learned in Europe. By the use of these new techniques, the works broke with the stuffy academic traditions then popular in Canada. As a result, Cullen was ignored by the critics and collectors, and went through tremendous hardships. However, because of his rebellious stance, he became a hero for the younger artists.

When Cullen first went to study in Paris in 1888, Impressionism had already achieved a certain respectability, and the *avant garde* works of Van Gogh, Gauguin, and Seurat were being eagerly discussed in Paris art circles. The older Impressionists, such as Monet and Pissarro, were still active, even though the last Impressionist exhibition had been held in 1886.

By 1894, Cullen was beginning to make a name for himself in Paris, with several works exhibited in the Salon, a painting purchased by the French government, and an invitation to join the prestigious Société Nationale des Beaux Arts. Then, when many doors were being opened to him, Cullen unexpectedly decided to return to Canada, and arrived in Montreal in 1895.[2]

The reasons why Cullen returned are not known. But it is more than likely that he felt a new appreciation for his country after seven years abroad. His subsequent devotion to the Canadian landscape, and his determination to remain in Canada despite numerous hardships, indicate a growing awareness of national feeling — a feeling shared by many other artists and writers of that time.

The sensitivity with which Cullen grasped the character of the Canadian landscape is apparent from the earliest works he executed in Canada. *Logging in Winter, Ste. Anne de Beaupré* is one of his first large canvases, painted in 1896. It presents a striking contrast to the earlier winter scenes of Krieghoff, where snow and shadows are seen in varying tones of grey. In Cullen's work, the snow reflects the vivid blue of the sky, according to his view that "snow borrows the colours of the sky and sun. It is blue, it is mauve, it is grey, even black, but never entirely white."[3]

There is a sparkling luminosity to *Logging in Winter* not found before in Canadian art, and seldom seen later, even with the Group of Seven. Cullen conveys the brilliantly clear atmosphere of a winter's day, with the trees and hills sharply structured and outlined. The three-dimensional quality of deep space is emphasized by the sled trails leading into the picture and

away to the left, where the oxen struggle up a hill. The foreground is in shade, set off against a sunlit hill in the middle distance, with the blue sky beyond. This technique of recession with horizontal bands of colour moving from dark to light to dark, is used often by Cullen. The bright dabs of red, yellow and green used for the trees form a lively contrast with the cool, blue tonality.

Many of Cullen's best works were produced in the first decade of this century. One of his major canvases is the winter view of *Cape Diamond* (in the Art Gallery of Hamilton), which contains almost twenty different snow tones. Cullen acquired an extensive knowledge of the effects of light and snow from literally thousands of sketches before nature. In his city scenes, such as *Old Houses, Montreal* and *Old Ferry, Louise Basin*, greater attention is paid to atmospheric effects, but there is still a concern for the compositional structure.

In Cullen's adaptation of Impressionism to the Canadian landscape, what he rejected from the Impressionists is equally as interesting as what he borrowed. While introducing their brighter pallette and broken strokes of colour, he rejected the two-dimensional treatment of space found in most Impressionist works.[4] His pure landscapes have a strong emphasis on structure and form, as well as light and colour. Cullen was aware that the quality of light, colour, and space in Canada was different from that found in France. He saw that a typical winter's day was characterized by the cool, crisp atmosphere, the vivid colours, and the feeling of clearly defined space. None of the other Canadian or American Impressionists maintained such clarity of form; they remained closer to the European prototypes.[5]

7 Detail of Maurice Cullen *Logging in Winter (Beaupré)*
oil on canvas 25¼″ x 31½″ 1896
Art Gallery of Hamilton

The works by Cullen's friend and contemporary, Suzor-Coté (1869-1937), typify the approach of other Canadian Impressionists.[6] In *Settlement on a Hill-side,* the sunlit snow in the foreground is rendered by a brilliant splash of white next to a cool blue for the shadows. The roughly textured surface is saturated with a light so strong that it blurs the forms, producing a hazy, atmospheric effect. Although the sweeping curve that moves upwards from the lower right foreground to the road in the distance provides some recession into the depth of the painting, the final impression is essentially flat and two-dimensional.

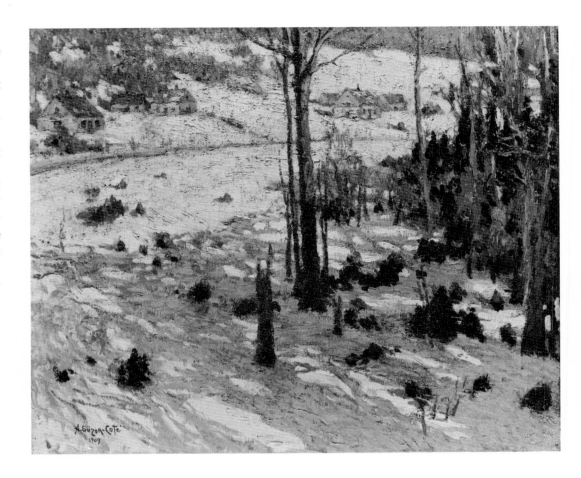

8 M. A. de Foy Suzor-Coté
Settlement on a Hill-side
oil on canvas 23'' x 28³/₄'' 1909
National Gallery of Canada

9 Maurice Cullen *The Old Ferry, Louise Basin, Quebec*
oil on canvas 23³/₄'' x 28³/₄'' c. 1907
National Gallery of Canada

10 Maurice Cullen *Old Houses, Montreal*
oil on canvas 24'' x 34'' c. 1908
Montreal Museum of Fine Arts

Another artist of this period to adapt Impressionist techniques to the Canadian landscape was James Wilson Morrice (1865-1924). Cullen and Morrice knew each other well and travelled around Europe together. Morrice made regular winter visits to Canada until 1914 and would often go sketching with Cullen on his trips down the St. Lawrence. The amusing anecdotes surrounding these excursions sound very much like the later ones of Jackson and Robinson in the 1920's. Once Morrice played a joke on his friends by stepping out into a freezing winter's night, and then rubbing white pastel on his face. When he came back, to his delight, everyone thought his face had frozen.[7] Both artists painted views of Quebec City from Lévis and Lévis from Quebec City, as well as scenes of the surrounding countryside. In Montreal, they painted old houses with horses and sleighs making their way through the snow, depicting a commonplace subject matter that was then considered tasteless. Their techniques and subject matter brought them the same type of criticism the Group was to receive a few years later.

In his most characteristic works, Morrice's approach to the Canadian landscape is different from Cullen's. Whereas Cullen sketched directly before nature, Morrice painted almost entirely in his studio. His colours are more dull and muted, with an emphasis on tonal harmony. Forms are stylized and contained within well-defined shapes, providing a two-dimensional effect closer to Impressionism. By comparison, Cullen uses more vivid colours and is more successful in capturing the clear winter atmosphere. However, Morrice is a much more individualistic artist, and his personal style is easily recognizable. His Canadian works still give an accurate impression of the landscape, even if they sometimes lack the freshness of the outdoor sketch.

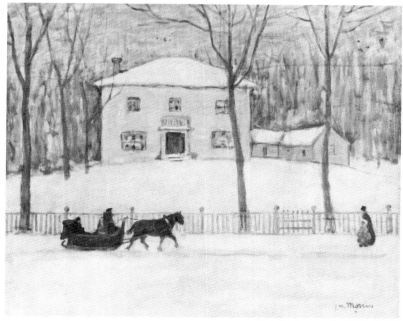

11 James Wilson Morrice *The Ferry, Quebec*
oil on canvas 24'' x 32'' 1909
National Gallery of Canada

12 James Wilson Morrice *The Old Holton House*
oil on canvas 24'' x 29'' c. 1909
Montreal Museum of Fine Arts

«It was through Cullen and Morrice that we in Montreal first became aware of the fresh and invigorating movements going on in the art circle of France; and it was their influence that weakened the respect of the younger generation of painters for the stuffy traditions that prevailed in that city.» [8]
(A. Y. JACKSON)

CULLEN

Cullen's influential role in Montreal was due as much to his personality and teaching as to his work. The younger artists admired his honesty and integrity, and respected his courage in facing public disapproval. He was known as a generous and sensitive person, always willing to be of help. His friend Albert Robinson recalled that he visited Cullen's studio when discouraged and came away "cheered and inspired." [9] As a teacher, Cullen took his students on field trips in the summer and taught in his Beaver Hall Square studio during the winter. Evenings were spent discussing Monet, Renoir, Cézanne, and the newest trends in art. There was a lively spirit of debate at these meetings, and the group was often joined by artists such as Morrice, Brymner, Gagnon, and Robinson. Among the visitors to Cullen's studio was A. Y. Jackson, who later established the main link with the Toronto artists.

Cullen won respect as an artist as well as a teacher. In 1910, Morrice wrote to Newton MacTavish describing Cullen as the one "man in Canada who gets at the guts of things." [10] Two years later MacTavish wrote an article for the *Canadian Magazine* entitled "Maurice Cullen, A Painter of the Snow," in which he pointed out that Canada was "frequently reviled as a country naturally unsuitable for the development of the art of painting." [11] Cullen, he felt, was the one artist who exposed the fallacy of this opinion and showed how paintable Canada really was. He suggested that other artists follow Cullen's example by painting their surroundings in a "style that will be, if not Canadian, at least distinctive." [12] The strongest statement of the importance of Cullen's contribution was made by Jackson:

To us he was a hero. His paintings of Quebec City, from Lévis and along the river, are among the most distinguished works produced in Canada. [13]

MORRICE

Morrice's influence was a much more direct one. He remained very much an outsider, and aside from his short visits to Canada he was an expatriate who considered Paris his home. His wealth, his internationalism, and his enigmatic personality set him apart from most of his Canadian contemporaries. In Paris, he moved in a colourful circle of artists and writers, including Somerset Maugham and Arnold Bennett, who gave a delightful picture of his eccentric character in their books. [14] His attitude towards the Canadian art community seems to have been slightly bitter, especially after the Montreal critics castigated his works. In reply to their indifference he said, "I have not the slightest desire to improve the taste of the Canadian public." [15]

Opinions vary on how influential an artist he was in his own country. A. Y. Jackson has said that "to all the young artists in Montreal when I was a student, Morrice was an inspiration." [16] On the other hand, Clarence Gagnon, another Quebec artist who greatly admired Morrice, once stated: "The fact that he came to Canada every year and painted scenes while here is not sufficient to admit him into the ranks of Canadian artists." [17] Unlike Cullen or Brymner, Morrice was not a teacher and had no pupils.

Cullen and Morrice can be credited with establishing the directions of the Montreal School. However, the powerful influence they exerted had an inhibiting effect on many of the younger artists, who continued to paint just like them for decades. Artists such as Gagnon and Robinson, who exhibited with the Group, did develop individual styles, but even they did not move far beyond the discoveries Cullen and Morrice had already made. [18]

13 Maurice Cullen *Hoar Frost and Snow*
oil on canvas 40″ x 30″ c. 1914
Mrs. O. B. Thornton Collection, Montreal

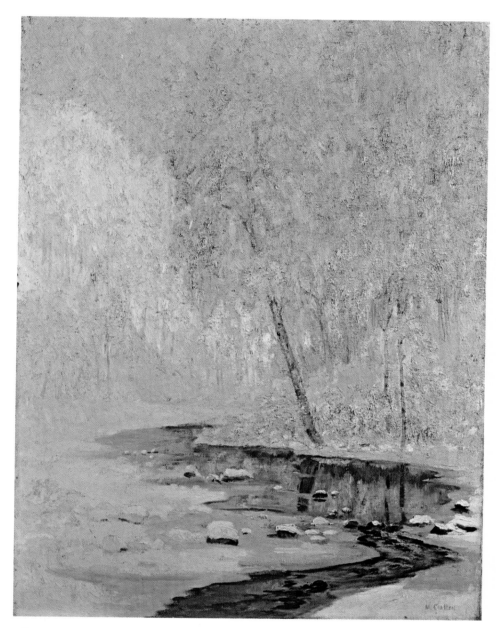

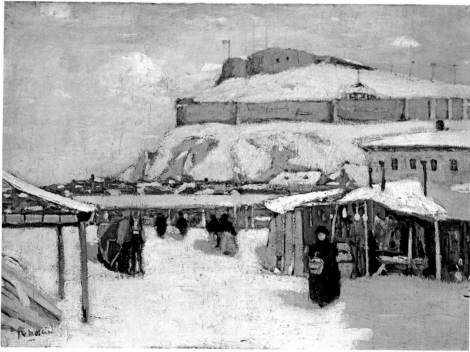

14 James Wilson Morrice *The Citadel, Quebec*
oil on canvas 18½″ x 24¼″ c. 1900
Mr. David R. Morrice Collection, Montreal

Following the trend set by Cullen and Morrice, the Montreal artists of the 1920's began eagerly painting and exploring the Quebec countryside. Their enthusiasm led Jackson to describe the Quebec village of Baie St. Paul in 1924 as the "liveliest art centre in Canada."[19] These artists were a generation younger than Cullen and Morrice, and were exact contemporaries of the Group. They all knew the Group and often exhibited with them. Considering the innovations of Cullen and Morrice earlier in the century and the activity of the Montreal artists in the twenties, the question arises – why was there no Group of Seven in Montreal?

The answer to this question sheds light not only on the Montreal school, but on the Group as well. The Group of Seven developed out of a complex interplay of events, but there are two issues which stand out more clearly than any others.

One was the Toronto artists' desire to present a united front against the criticism that was being levelled at them. In order to achieve this, they formed "a friendly alliance for defence," which was called the Group of Seven. In Montreal, artists were criticized too, and just as harshly. However, they never asserted themselves as a group against a critical press and were not concerned with winning public approval. The Beaver Hall Group was formed in the 1920's, but it never achieved the unity of expression and aims that the Group of Seven did.[20]

More important was the difference between the attitudes of Montreal and Toronto

GAGNON

Clarence Gagnon (1881-1942) was one of the Montreal contemporaries of the Group. He had studied under Brymner in Montreal and was a great admirer of Cullen and Morrice. Gagnon was in Paris at the same time as Jackson, and the two artists often visited art galleries together.[23] When he returned to Canada in 1909, he settled in the Baie St. Paul area and began painting scenes of *habitant* life in the rural villages. He was later joined by a hoard of artists, including Jackson and Robinson, who spent every spring together sketching in lower Quebec.

Scenes such as the *Village in the Laurentian Mountains*, which was painted at Baie St. Paul, capture the charm and gaiety of the province. Gagnon came close to over-romanticizing his subject by the emphasis on quaintness and the use of bright decorative colours. The warm oranges and yellows contrast with the cool blues of the shadows on the snow, making cheerful patterns of colour, similar to the quilts woven by the *habitants*. Like Cullen, Gagnon maintains complete clarity of form and space which becomes even more pronounced in his later works. During the late 1920's, he turned to the use of brighter local colours and concentrated more on pure design. The best examples of this can be found in his illustrations for *Le Grand Silence Blanc* in 1929 and *Maria Chapdelaine* in 1933.

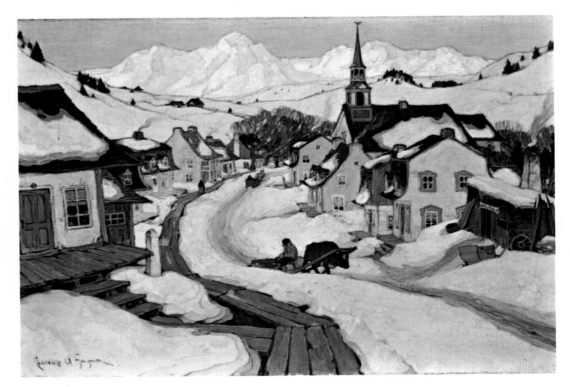

15 Clarence A. Gagnon *Village in the Laurentian Mountains*
oil on canvas 34½" x 51" c. 1924
National Gallery of Canada

artists toward the landscape. The Toronto group searched out the untamed northland, and painted it in a vigorous way. They consciously expressed a nationalistic philosophy in their paintings and in the many articles they wrote. In contrast, the Montreal artists seemed content to paint the peaceful Quebec countryside in a gay and decorative manner. Although they travelled and painted together, they made no claim to be painting all of Canada. Unlike the Toronto artists, they never moved beyond a basically Impressionist technique to a more "modern" style. The Group became so controversial because they applied the stylized design features of *Art Nouveau* to the landscape, breaking the more representational approach of Impressionism.

The Montreal public itself had something to do with its rather unadventurous artistic community, through its continuous suppression of any new developments. Jackson enraged the Montreal art world in 1927 when he told the press, "There is no more bigoted place than Montreal. . . . About the only freedom they have in Montreal is for booze."[21] After suggesting that the Group would starve to death in Montreal, Jackson went on to criticize Montreal artists. "What they do, they do remarkably well. They've got dignity and poise. But they have no great Canadianism. They do what other people do. They go to the Riviera and Paris, but they don't lead expeditions of discovery in their own land."[22] Provocative statements such as this show most clearly why Toronto had a Group of Seven and Montreal did not.

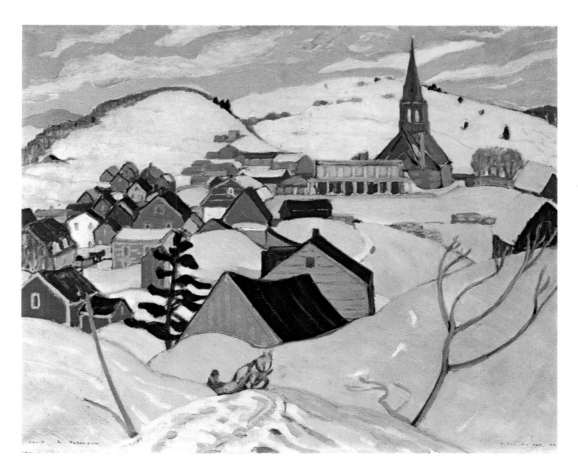

16 Albert H. Robinson *Saint Tite des Caps*
oil on canvas 28″ x 34″ 1928
Art Gallery of Ontario

ROBINSON

Of all the artists working in Montreal at this time, Albert H. Robinson had the closest connection with the Group. Born in Hamilton, Robinson studied in Paris from 1903 to 1906, and later moved to Montreal in 1908. There he met Cullen and Brymner and occupied a studio next to Suzor-Coté. He soon met Jackson, and in 1911 the two artists made a short trip to France together. They remained close friends, and often made sketching trips together along the St. Lawrence below Quebec. Robinson was an invited contributor in the first exhibition of the Group of Seven and was included in three subsequent shows as well. Considering how intimate he was with the Group, it is surprising he never became a member.

Robinson's *St. Tite des Caps* conveys much the same spirit as Gagnon's *Village in the Laurentian Mountains* and Jackson's *Winter Road, Quebec*. There is the same strong feeling for the countryside and emphasis on design; but Robinson displays more subtlety and refinement than Gagnon, more colour and pattern than Jackson. Robinson always manages to control his strong decorative tendencies with an almost classical sense of restraint. A concise summary of his style was once given by Lismer:

In Robinson's pictures we expect no great dramatic subject treatment, nor dynamic lines and sombre tones. His art is the colourful expression of daily life, full of charm, devoid of sentimentality.[24]

13

The main link between Montreal and Toronto was provided by A. Y. Jackson, who arrived in Toronto in May, 1913. The story of his life up to this point has been vividly told in his autobiography, *A Painter's Country*. Born in Montreal, Jackson was forced to earn his living from an early age. His father had run off to Chicago after several business failures, leaving his mother to look after a family of six children. He began as an office boy in a lithography company, and after six years was earning six dollars a week. In 1905, at the age of twenty-three, he worked his way to Europe on a cattle boat. After a short stay in Europe, Jackson went to Chicago, where he worked for a commercial art firm. By 1907 he had saved up enough money to allow him to spend two years in France learning the rudiments of Impressionism. This was just at the time that Picasso was venturing into Cubism, after painting his *Demoiselles d'Avignon* in 1907. It was during this period that Jackson decided to give up commercial art work and become a professional artist.

Jackson returned to Canada in 1909 and painted his first canvases at Sweetsburg, Quebec.

It was good country to paint, with its snake fences and weathered barns, the pasture fields that had never been under the plough, the boulders too big to remove, the ground all bumps and hollows. It was here, while the sap pails were still on the trees, that I painted Edge of the Maple Wood *and a couple of other canvases.*[25]

Two years after the painting was exhibited in Toronto, MacDonald wrote Jackson, asking if he still owned the work. In the interim, Jackson had once again gone to France, this time with A. H. Robinson. On his return in the spring of 1913, he held an exhibition at the Art Association of Montreal with Randolph Hewton. The show was a total failure, and the two artists retreated to Emileville near Montreal. Discouraged by the art situation in Canada, Jackson was considering a move to the United States when he received MacDonald's letter from Toronto.

In his letter MacDonald asked if Jackson still had the canvas; if so, another Toronto artist named Lawren Harris would like to buy it. The work was sold, and an enthusiastic exchange of letters followed, through which Jackson became aware of all that was going on in Toronto.[26]

The reaction of the Toronto artists to this painting is all the more astonishing when the painting itself is considered. Even though it is a competent work, very little about it is original or exceptional. Cullen and Morrice had already done far more exciting paintings, and almost every issue of *Studio* magazine contained reproductions of similar works by American artists.[27] But this painting, although heavily dependent on the Impressionist techniques which Jackson had learned in Europe, conveys a feeling for the Canadian landscape that sets it apart from the other paintings of dogs, flowers, and sleeping children in the *OSA* show of 1911.

The Toronto artists were completely isolated from new artistic movements except by what they read in magazines. Jackson has written that they "were woefully lacking in information about trends in art in other parts of the world. A few good paintings by Monet, Sisley and Pissarro would have been an inspiration to them. They saw nothing at all to give them direction."[28] *Edge of the Maple Wood* provided both the inspiration and the direction for the Toronto artists. Their discovery of Impressionism through Jackson and the Montreal artists was to be a major factor contributing to the early development of the Group of Seven.

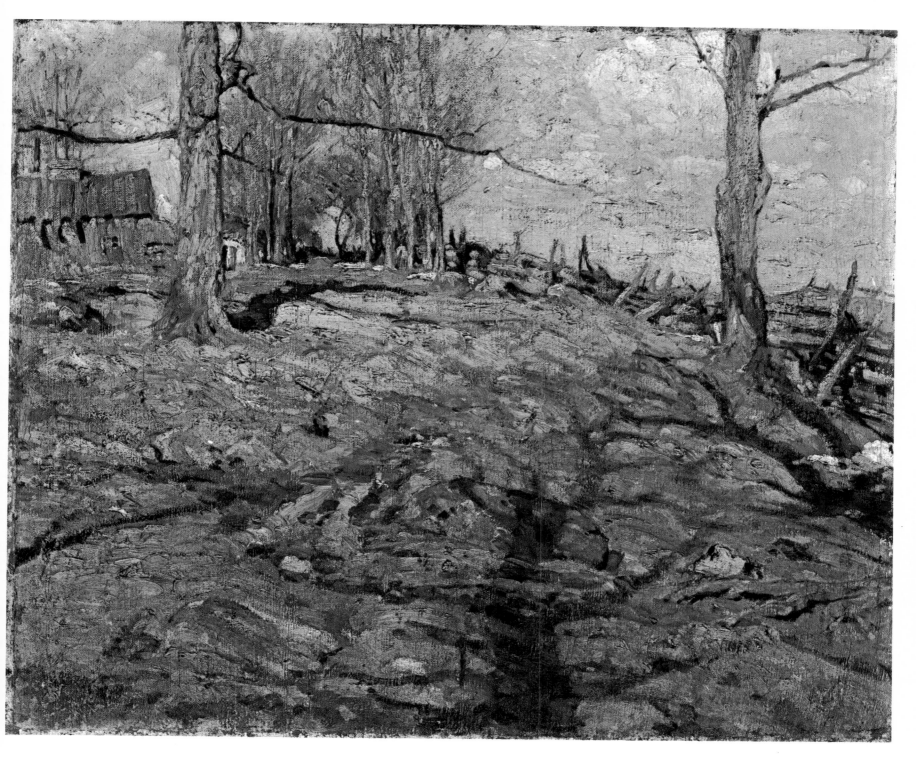

17 A. Y. Jackson *The Edge of the Maple Wood* oil on canvas 22½" x 26" 1910 National Gallery of Canada

It was *The Edge of the Maple Wood* that brought Jackson to Toronto through an unusual sequence of events. He exhibited it in the 1911 Ontario Society of Artists show in Toronto, where it made a vivid impression on Lismer, MacDonald, Thomson, and Harris. In later years, Lismer remembered how it stood out from the other works like a "glowing flame packed with potential energy, and loveliness."[29] MacDonald was impressed by its "native flavour," and Harris felt that it was the "freshest, brightest, most vital Canadian note in the exhibition!"[30] Tom Thomson, who was then painting in dark, muddy colours, claimed that it was the first painting to open his eyes to the possibilities of the Canadian landscape.[31]

3 Early Years in Toronto and the Cult of the North

ART CLUBS AND CLUBMEN

At the turn of the century, Toronto's art community was firmly entrenched in tradition, and the new art movement was slow to develop. The main creative forces were found in the many short-lived art clubs.[1] These clubs were usually sketch clubs, where artists of similar interests could meet. They represented a trend away from the official art circles and towards a more spontaneous interest in art for art's sake.

The first such club, the Toronto Art Students' League, established in 1886, was designed to provide further art training for laymen and commercial artists.[2] It conducted the first life-classes held in Canada, and organized weekend sketching trips in the Toronto area. This was the first time artists had gone out as a group to sketch the countryside.

The interest in Canadian subject matter was further advanced by the production of the Art Students' League Calendars, which came out yearly between 1893 and 1904. Themes such as "Canadian Waterways" or "Canadian Village Life" were chosen, and various members contributed works in pen and ink for each calendar. Many of the drawings managed to convey a vivid impression of the landscape through good design and clever handling of light and shade.

David Thomson's *The New North*, from the 1904 calendar, shows a new awareness of the Canadian environment. Thomson made numerous canoe trips to northern Ontario, thus becoming a precursor of the Group. In a letter tracing the Group's origins, MacDonald later recalled:

Dave Thomson's name also comes to me as one of the local heroes. His pen drawings in the Art League Calendars, and his water-colours of Algonquin Park and Scarboro Bluffs, were landmarks to us. Dave was a real Canadian, but he got switched off the tracks in a Boston lithographing house.[3]

18. David F. Thomson *The New North*
block print 7" x 8½" 1903
Toronto Art League Calendar,
Library of the Art Gallery of Ontario

19 William Cruickshank *Breaking a Road*
oil on canvas 35" x 68" 1894
National Gallery of Canada

One of the many clubs which came and went was the Mahlstick Club, which survived between 1899 and 1903. Its membership was similar to that of the other clubs and included well-known figures such as Fred Brigden, C. W. Jefferys, Bill Beatty and J. E. H. MacDonald. Its activities, like those of the Art Students' League, included life drawing and outdoor sketching. But the club had a friendly spirit of camaraderie as well; in addition to the art classes there were singsongs, boxing matches, and fencing.

A similar atmosphere pervaded the Graphic Arts Club, an organization which is still in existence today, and at one time included many of the Group of Seven as members. MacDonald remembers the "Canadian evenings," with the members all singing while seated one behind the other on benches.[4] There were also "visiting evenings" at different artists' studios, where each artist made half-hour compositions on Canadian subjects and other members criticized them. As MacDonald put it, "there was a real stirring of Canadian ideals."[5]

«*Men like Reid, Jefferys, Fred Brigden, Arthur Goode, Conacher, Plaskett and others had their places as pioneers and encouragers. The Art League and its annual publications, the Graphic Arts Club with its Canadian evenings . . . the visiting evenings we used to have at different artists' studios, to make half-hour compositions on Canadian subjects, with one chosen as critic for the evening. There was a great stirring of the Canadian ideal. Old Cruickshank, for instance, with his* Breaking a Road, *was a more direct Canadian influence among us than any Krieghoff.*»[6]

LETTER BY MacDONALD

20 Frederick Brigden *A Muskoka Highway*
oil on canvas 39¼" x 44½" 1909
National Gallery of Canada

21 C. W. Jefferys *Winter Afternoon*
oil on canvas 20" x 24" 1914
National Gallery of Canada

Another club that consciously tried to promote a national art was the Canadian Art Club. Founded in 1907, it restricted its membership to eight artists and a few invited contributors. Unlike the other clubs, it was not a social club and was not restricted to Toronto artists. Primarily formed for exhibition purposes, it had a cosmopolitan membership; Horatio Walker was listed as living in New York, Morrice and Gagnon in Paris, and Watson in Doon, Ontario.

The common aim of the club was "to produce something that shall be Canadian in spirit, something that shall be strong and vital and big, like our Northwest land."[7] These words could have been taken directly from a Group of Seven manifesto, except that they were written twelve years before the Group was formed. But they are an indication that the search for a Canadian identity was not an exclusive Group phenomenon, and that there were artists in Canada interested in developing a national art form.

ARTS AND LETTERS CLUB

For the young artists who were later to form the Group, the most important club was the Arts and Letters Club. Essentially a social club for those involved in the arts, this organization was a sanctuary for the artistically talented few and the interested rich. In today's world of bohemian artists and anti-establishment feeling, it is hard to believe that a private men's club could have played such a vital role in the formation of a radical art movement.

The members prided themselves on the inaccessibility of the club, which was located in the old Assize Court room behind Toronto's No.1 Police Station. The official entrance was along a dingy wall in Court Lane, between a manure pile and a stalk of firewood.[9] At the top of the long spiral staircase was a large hall with a huge fireplace at one end. It was here that the main activities of the club took place.

This everyday mélange *of all the arts came to a head in that grim, unconventional suite of rooms and the big hall, at the top of the spiral staircase. A weird, delightful rendezvous! Absolute escape from all that otherwise made Toronto.*[10]

A mood of high spirit and infectious creativity displayed itself in many of the club's activities, including the memorable Christmas dinners, with pageants staged by brilliant personalities such as Roy Mitchell and Robert Flaherty, and with original decorations by the artists. In the evenings, there were often concerts led by Ernest MacMillan, another club member, with guests such as Pablo Casals and Sergei Rachmaninoff. From these early efforts grew the Toronto Symphony, the Mendelssohn Choir, and the Hart House theatre. The club provided a healthy and creative atmosphere for the interaction of artists, musicians, actors, and patrons, in an otherwise sterile Toronto.

GRIP LIMITED – AND THE ARTISTS AT GRIP

Grip Limited was a commercial art firm which at one time or another employed five of the Group of Seven, as well as Tom Thomson. The only two who did not work for Grip were Jackson and Harris.

The firm had received its unusual name from a Toronto cartoonist named Bengough, who used "Grip" as his pseudonym.[13] It specialized in general art work and in design layouts for large stores like T. Eaton and Company. Most of the design work practised by the artists at Grip was a late form of European *Art Nouveau*.[14] This style was primarily a decorative one, with an emphasis on undulating rhythmic lines, usually with flat areas of colour in between. It helped the artists to perceive abstract patterns in nature and provided them with an artistic vocabulary completely different from that used by the academically trained artists. They saw numerous examples of *Art Nouveau* works in *Studio* magazine and *Jugend*, which they all read avidly, but only later did they discover how these techniques could be applied to their own work.

At a time when it was difficult for any-

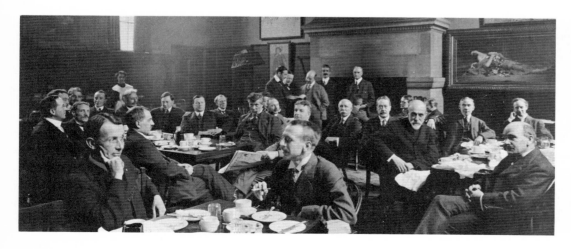

Another concern of the club was to raise the quality of Canadian art so as to overcome the low standards of the Royal Canadian Academy and other large institutions that were willing to hang almost anything in their annual shows. The Canadian Art Club held exhibitions in Toronto and Montreal, which enabled the young artists to see works by Cullen, Morrice, and other "moderns." By 1909, the club had made such an impact that a reviewer made this comment: "It would perhaps be too much or too premature to say that the coming of this group means the coming of a distinctively Canadian school, yet schools have been formed precisely in this way."[8] Unfortunately his statement was premature, for the club disappeared when it merged into the Art Gallery of Toronto in 1915. It had shown, however, that high standards in art could be maintained outside the official institutions, and that Canadians were interested in art that was representative of their country.

Almost every day at noon, a group of commercial artists from Grip Limited met at the club for lunch. Among them were MacDonald, Varley, Lismer, Carmichael and Frank Johnston. They usually sat at the "Artists' Table" with Harris and Jackson. Across from them was the "Knockers' Table," where the more traditional members, such as Hector Charlesworth and Wyly Grier, sat. A friendly exchange of insults often flew between the tables, but it was all in jest. At the club the artists from Grip came into contact with both artists and patrons from outside the firm. The friendly atmosphere of the club also provided them with an unusual opportunity to meet Toronto's wealthy élite, who were to become their first patrons. With Harris to bridge the gap, they met Dr. MacCallum, Vincent Massey, and Sir Edmund Walker.

Lawren Harris had been a member of the club since its foundation in 1908.[11] His background was vastly different from that of the other artists at Grip. Born in Brantford, Ontario in 1885, he was an heir to the Massey-Harris fortunes, which supplied him with an independent income throughout his painting career. Raised in a conservative, religious Toronto environment, he attended St. Andrew's College and the University of Toronto before going to Europe at the age of nineteen to study art. He spent the next three winters in Germany, receiving a thorough Germanic training in art techniques. In January, 1908, he went to the Near East with Norman Duncan, travelling from Beersheba to Damascus and making illustrations for Duncan's "Going Down from Jerusalem," which were later published in *Harper's Magazine*, along with drawings of a Minnesota lumbering camp Harris had visited.[12] Back in Toronto, he became friendly with the artists at Grip Limited, with whom he shared an enthusiasm for a distinctively Canadian art.

one to make a living as a full-time painter, Grip provided employment for many young artists. Most of them went to art school in the evenings and sketched on the weekends. Some began going further north to Algonquin Park and beyond in search of new material. This enthusiasm for the North was so infectious that soon Tom Thomson, another Grip employee, joined these canoe trips. When the artists returned to work, they spent their time eagerly talking about painting and the North. As Lismer said, there was "a force inside that Grip shop."[15]

The manager of Grip was Albert Robson, who maintained a friendly but demanding working atmosphere. He had a sincere interest in his employees and encouraged them in their endeavours.[16] However, when they began sketching in the office, he was quick to inform them that he wasn't running an art school.[17]

In 1912, Robson went to work for Rous and Mann printing house, taking Carmichael, Johnston, Lismer, Varley, and Thomson with him. As MacDonald had already left to devote himself fully to painting, Grip ceased to be of importance for the Group.

22 Interior of the Arts and Letters Club c. 1920

23 Lawren Harris c. 1930

24 Interior of Grip Limited c.1912
Left to right: Albert Robson (?), J. E. H. MacDonald, Harold James (?), Unknown, Tom Thomson

Jim MacDonald had joined Grip Limited back in 1895, shortly after it became a commercial art firm. Born in Durham, England in 1873 he arrived in Canada at the age of thirteen with his parents, and settled in Hamilton, Ontario, where he attended the Hamilton Art School.[18] In 1889 his family moved to Toronto, and a few years later he began working as an engraver with the Toronto Lithographing Company. MacDonald went from this firm to Grip and remained there until 1911, except for two years he spent in England working as a book designer for the Carlton Studio in London. The exciting art scene in Europe at this time left MacDonald untouched; he was still more attracted to the Barbizon School. In 1906 he wrote to his wife describing his reaction to a recent exhibition.

I was especially interested in a little picture (by Diaz – one of the Barbizon men) being inclined to look on myself as a forest specialist. Standing back, contemplating these little pictures I seem to get a feeling though faint and far off, that someday, I too would be an artist and produce similar things.[19]

25 J. E. H. MacDonald c. 1921

On his return from England, MacDonald was made head designer at Grip. At the office he was respected by the younger artists as a gentle and saintly father figure. To those who did not know him well, he appeared to be a quiet and shy redhead of frail stature, with the dreamy air of a poet. But underneath was a practical man of great strength of character. At this time he was just beginning to grapple seriously with his creative talents. For the first time he was working up large paintings from the postcard-size sketches he made in Toronto's High Park. They were stiff and sombre and gave little indication of what was to come.

Tom Thomson (1877-1917) joined the Grip staff in about 1907 as a specialist in lettering and Ben Day tints.[20] He was born in Claremont, Ontario, but his family moved to Leith, near Owen Sound, when he was still a child. He grew up in the country, spending much of his time hunting and fishing. In 1901, after trying several jobs without success, Thomson went to Seattle and spent a short time studying at the business school his brothers had set up. But he soon left the school to join a photo-engraving firm. Although the work there was not particularly creative, it enabled Thomson to train his hand and to develop as a designer. It also exposed him, for the first time, to the intricacies of *Art Nouveau* designs.

By 1905 he was back in Toronto, working as a photo-engraver, and about two years later he joined Grip. A former employee of Grip described Thomson this way:

26 Tom Thomson c. 1911

Tom, as I knew him, was also a quiet, retiring, fellow. Tall, like MacDonald, they had much in common. Indeed, they exercised a steadying influence on some of the too vivacious, lively spirits who worked in the same room. Tom was generous almost to a fault and possessed a quiet sense of humour.
He was generally liked by all the fellows and it was impossible not to get along with him because of his unselfish and kindly disposition.[21]

In his spare time, Thomson joined other Grip employees in sketching excursions around Toronto, and in 1912 he made his first extended canoe trip in the North.

LISMER

In February of 1911, Arthur Lismer, fresh off the boat from England, joined Grip Limited. He came from the industrial city of Sheffield, where he was born in 1885. At the early age of thirteen he won an entrance scholarship to the Sheffield School of Art and began what was normally a seven-year apprenticeship towards becoming a silver craftsman. Unhappy with the outdated teaching methods at the school, he spent much of his time absorbing Ruskin and developing a taste for Turner and Constable. Feeling the Sheffield environment too confining for his interest, Lismer went to Antwerp for a year and a half to study at the Académie royale des Beaux-Arts. He was then twenty-one, and the experience of living on the continent did much to expand his vision.

Early in 1908 he returned to Sheffield and set himself up in business as a "specialist in pictorial publicity."[22] This brought him only a meagre income, but he managed to visit London, where he saw Roger Fry's exhibition of Post-Impressionists at the Grafton Gallery in 1909. He was deeply impressed by Van Gogh, whose letters he read again and again after seeing the exhibition. Back in Sheffield he struggled to make a living, but with little success. He then heard about the opportunities in Canada from William Broadhead and Fred Brigden, who had both gone to Toronto and done extremely well in the commercial art field. Convinced that the only hope for a bright future lay in a new country, Lismer set sail on January 20, 1911.

27 Arthur Lismer c. 1921

A month later he was working for Grip Limited, where he soon became known as "the bronc...the damdest bronc you ever saw."[23] He was a gregarious, outgoing individual, always ready with a witty or caustic remark. Nothing delighted him more than taking a crack at the stuffy establishment or anything that hinted at pretension.

When Thomson and Broadhead returned from their canoe trip down the Mississagi in the fall of 1911, Lismer was very exci-

ted by what he heard about the Canadian countryside. On the other hand, he found Toronto a dismal cultural backwater, except for the Arts and Letters Club. "If the country's half as stirring as Tom's sketches seem to indicate, in Heaven's name why are so many Canadians always talking about their stomachs, their money, etc? Where's the romantic spirit, the philosophic spirit?"[24]

VARLEY

In 1912 Lismer returned briefly to Sheffield to marry, and while there he met his former schoolmate, Fred Varley. He found Varley depressed and in serious financial difficulties, with a wife and two children to support. After hearing about Canada from Lismer, Varley decided to try his luck in the new world. He borrowed some money

28 Frederick Varley c. 1920

from Lismer's brother-in-law and set off alone in 1912, eventually arriving in Toronto with thirty shillings in his pocket. When that was gone, he began work at Grip, but only stayed for three weeks before moving to the firm of Rous and Mann, where he remained for the next five years.

Varley's bohemian life began long before he came to Toronto. Born in 1881, he was four years older than Lismer. He had also gone to the Sheffield School of Art on a scholarship, but soon gave it up to go to the Antwerp academy. Lismer later recalled that when he followed Varley to Antwerp his reputation for living it up was so great that "he was spoken of at the academy in hushed tones."[25] Lismer also added, "But how he could paint! He won two gold medals for life drawings and paintings from the figure."[26] From Antwerp, Varley went to London where he almost starved trying to support himself as commercial artist. Four years later, he then returned to York-

shire where he married and had two children. He was scraping out his existence there when Lismer met him in 1912.

I can even remember my first impression of him. A man with a ruddy mop of hair – and it was red – which burned like a smouldering torch on the top of a head that seemed to have been hacked out with a blunt hatchet. That colour was the symbol of a fire in his soul.[27]

In Toronto, Varley soon became friendly with the other artists at Grip. He was often a difficult person to get along with because of his bohemian ways and temperamental moods, but he found a close friend in Tom Thomson, who was like him in spirit. The two artists often went on weekend excursions and talked about painting, but they seldom sketched together. Varley was not overly enthusiastic about the countryside; he preferred people to trees.

JOHNSTON

Toronto-born Frank Johnston was another of the artists who worked briefly for Grip Limited during this period.[28] After an early start earning his living as a designer and studying art at night, Johnston joined Grip around 1908. Robson remembered him as "a capable, brilliant designer and commercial artist."[29] However, Johnston did not stay long; in 1910 he went to the United States, where he first studied art in Philadelphia, and then did commercial work in New York. Except for a few brief visits in Canada, Johnston was away from Toronto during the critical years when the Group were working together. However, he did keep in touch with Toronto and exhibited regularly in the *OSA* shows.

29 Frank Johnston c. 1930

Johnston had a strong and exuberant personality, and was a man of amazing energy. One Grip employee remembered him as "a stockily built, extremely vivacious, supremely confident young fellow. Nothing could be quiet long when Frank was around, and he was responsible for many of the lively escapades which happened at the Grip. He was just as adroit in getting himself out of a difficult situation as his mischief-loving disposition got him into the scrapes."[30]

CARMICHAEL

The youngest member of the Group to be employed at Grip was Frank Carmichael, who became an apprentice in 1911, earning $2.50 per week. Carmichael had learned the carriage-making trade from his father in Orillia before coming to Toronto. While working at Grip, he was included in the weekend sketching trips and began to show rapid progress. He also began classes at the Ontario College of Art, under Reid and Cruikshank. Feeling the need for more advanced training in technique, he went to the Académie royale des Beaux-Arts in Antwerp in 1913 following the footsteps of Lismer and Varley.

30 Franklin Carmichael c. 1912

With the outbreak of the war and a shortage of funds, he returned to Toronto in late 1914, and moved into the Studio Building with Tom Thomson. A short time later he married, and soon had to devote much of his energy to supporting his family. His close friend A. J. Casson, who worked as his assistant from 1919 to 1926, remembers him as a "peppery little man, with great determination and drive."[31] Carmichael above all prided himself on his abilities as a craftsman, and worked hard at perfecting his technique.

In January, 1913, an exhibition of contemporary Scandinavian art was held in Buffalo, consisting of 163 works by artists from the Scandinavian countries.[32] MacDonald and Harris heard about it and immediately went to see it. Judging from the annotations MacDonald made in his catalogue, they were particularly impressed by Fjaestad's *Ripples*, Sohlberg's *Mountains* and the other landscapes.[33] The show made so great an impression on them that Harris later spoke of it as "one of the most stimulating and rewarding experiences either of us had had."[34]

There are several reasons why the exhibition had such an impact on Harris and MacDonald. The most obvious was the affinity they felt for the Scandinavian landscape. They saw the strong similarity in topography between the two northern countries and were impressed by the way the Scandinavians painted their rugged landscape of snow and mountains. MacDonald wrote that "except in minor points, the pictures might all have been Canadian, and we felt 'This is what we want to do with Canada.'"[35]

They were also sensitive to what MacDonald called the "rustic simplicity" of the show; they felt that it was "an art of the soil and woods and waters and rocks and sky."[3] Despite their familiarity with the commercial form of *Art Nouveau*, they did not appear to recognize the stylistic origins of the Scandinavian works, which were based on *Jugenstil*, the Germanic form of *Art Nouveau*. MacDonald noted that "it was not at all Parisian or fashionable." He was convinced that the Scandinavians were responding directly to their environment and were concerned only with painting nature as they saw it.[37] Later, both artists failed to see the same relationship between their own art and the European influences.

The main question that arises concerning the Scandinavian show is whether or not the Group artists were ultimately dependent on European influences. One major claim of the Group was that they were the first artists in Canada to break away from European art. Lismer stated that "what other countries did or movements did, interested us little."[38] Unfortunately, this carefully preserved image of complete independence from Europe does not stand up; it can be shown that they did rely on European techniques. Their works pass through all the familiar phases of Impressionism, Post-Impressionism, and *Art Nouveau*, with the inevitable time lag in the transference of techniques from Europe to Canada. But the artists themselves were not conscious of this continuing connection with Europe, and would have violently objected to having it pointed out. Jackson, who arrived in Toronto only three months after the show, claimed that it had no effect on their work.[39]

However, considering the enthusiasm of Harris and MacDonald, and the events that took place in Toronto during 1931, there can be no doubt that all the Toronto artists knew about the show. Those who did not see it undoubtedly studied the articles on Scandinavian art in *Studio* magazine.[40] Critics have even tried to show that Harris had Sohlberg's *Mountains* in mind when he painted *Bylot Island* over seventeen years later.[41]

The most important influence of the Scandinavian show was that it provided the Group with a new method for painting the landscape in which they could effectively apply their commercial art training. There was a considerable time lag before this change appeared in their art, but when it did there was a distinct move from Impressionism to a technique based on *Art Nouveau* motifs.

31 Gustaf A. Fjaestad *Below the Falls*
The Studio (LVIII, No. 240 (March, 1913))

32 Otto Hesselbom *My Country*
Cat. 25, Buffalo, Albright Art Gallery
Exhibition of Contemporary Scandinavian Art

«MacDonald and I discussed the possibility of an art expression which should embody the varied moods, character and spirit of this country. We heard there was an exhibition of modern Scandinavian paintings at the Albright Gallery in Buffalo – and took the train over to Buffalo to see it. This turned out to be one of the most exciting and rewarding experiences either of us had. Here was a large number of paintings which corroborated our ideas. Here were paintings of northern lands created in the spirit of those lands and through the hearts and minds of those who knew and loved them. Here was an art bold, vigorous and uncompromising, embodying direct, first-hand experience of the great North. As a result of that experience our enthusiasm increased, and our conviction was reinforced.»[42]

MacDONALD ON THE SCANDINAVIAN ART SHOW

«We were full of associated ideas. Not that we had ever been to Scandinavia, but we had feelings of height and breadth and depth and color and sunshine and solemnity and new wonder about our own country, and we were pretty pleased to find a correspondence with these feelings of ours, not only in the general attitude of the Scandinavian artists, but also in the natural aspects of their countries. Except in minor points, the pictures might all have been Canadian, and we felt 'This is what we want to do with Canada.'»

«I trust it is no reflection on Canada to say that there was a sort of rustic simplicity about the show which pleased us. It seemed an art of the soil and woods and waters and rocks and sky, and the interiors of simple houses, not exactly a peasant art, but certainly one with its foundations broadly planted on the good red earth. It was not at all Parisian or fashionable. These artists seemed to be a lot of men not trying to express themselves so much as trying to express something that took hold of themselves. The painters began with nature rather than with art. They could be understood and enjoyed without metaphysics, or the frosty condescensions of super critics on volumes or dimensions, and other art paraphernalia.»[43]

33 Gustaf A. Fjaestad *Hoarfrost*
Cat. 12, Buffalo, Albright Art Gallery
Exhibition of Contemporary Scandinavian Art

34 Henrik Krogh *Spruce Coppice*
The Studio (LVIII, No. 240 (March, 1913))

35 Harald Sohlberg *Mountains, Winter Landscape*
Cat. 156, Buffalo, Albright Art Gallery
Exhibition of Contemporary Scandinavian Art

One of the immediate effects of the show was a strengthened resolve to explore the North. As Harris stated, "from that time on we knew that we were at the beginning of an all-engrossing adventure. That adventure, as it turned out, was to include the exploration of the whole country for its expressive and creative possibilities in painting."[44] For many years artists had been sketching the area around Toronto, yet there had been little work done further afield. Most of the Group knew the North well, but had made no attempt to sketch it until 1912 or 1913. Thomson was brought up in the country near Owen Sound; Harris had passed many summers in the Muskoka district as a boy, and Carmichael had grown up in Orillia. Other artists at Grip, such as Tom McLean and William Broadhead, had made extensive trips north, and one promising artist named Neil McKechnie had drowned in the rapids of a northern river.

In May of 1912, Tom Thomson made his first trip to Algonquin Park with some friends from Grip. There he met Mark Robinson, the forest ranger who was to become one of his closest friends. A few months later, William Broadhead took him on a long trip down the Mississagi, reputed to be one of the finest canoe trips in the world. Thomson did a little sketching, but seemed far more interested in taking pictures of game. Shortly before the end of the trip, the canoe capsized in the rapids, and he lost almost all his film, which upset him terribly.[45]

When the two artists returned in late October, they spoke excitedly to their friends at Grip about their adventure. Dr. MacCallum heard about it and asked MacDonald to bring over some of the sketches so that he could see what the country was like:

This was done, and as I looked them over I realized their truthfulness, their feeling and their sympathy with the grim, fascinating northland. Dark they were, muddy in colour, tight, and not wanting in technical defects, but they made me feel that the North had gripped Thomson . . .[46]

During the next few years, the Doctor became Thomson's chief supporter, giving him encouragement, purchasing his works, and finally convincing him to devote all his time painting. He also played a crucial role in the careers of the other artists who were to form the Group. He introduced newcomers like Lismer and Varley to the north country, after they arrived from England. And, when Jackson was wandering around Georgian Bay in the fall of 1913, the Doctor persuaded him to stay. He also contributed to the financing of the Studio Building, and later he commissioned paintings for his cottage when the artists were unable to find work during the war.

Dr. MacCallum (1860-1941) was a great enthusiast for the Canadian North. He had been camping and canoeing around Georgian Bay long before many of the Group were born.[47] He loved the challenge of the North and was impressed by the young artists who were trying to paint it. His reaction to their work was a simple one – if their paintings conveyed a feeling for the landscape, he liked them. In other words, artistic taste was determined by his love of the North, rather than by any knowledge of art. The help he gave the artists was the best any patron could give, for he did not demand that they conform to any style. Nor did he ask anything in return for his generosity. As Carmichael once said, he took a "keen and sincere delight in painting and helping painters, not in a charitable way, but giving them a chance to help themselves – which is true help."[48]

Like the artists he supported, the Doctor was an unconventional figure. Something of an eccentric, he enjoyed switching from his role as a correct and sociably acceptable member of Toronto society to a semi-bohemian friend of artists and a rugged woodsman. He was known as a real "character" and liked to think of himself as a cynic.

In the years following the first trips to Algonquin Park and Georgian Bay the "Cult of the North" rapidly developed. The artists' immense enthusiasm became focused on the northern landscape, which they felt was not just any landscape, but Canada itself.

It was clear to them that "Canada" was not to be found in the cities, where the pursuit of materialism was the highest ideal. Behind the optimism associated with Toronto's tremendous commercial growth in the early twentieth century, the artists saw another side to city life – the coldness, the impersonality, and the materialism. The American

artists of the Ash Can School perceived the same elements in the city and focused on them as unique aspects of American life to be portrayed in a realistic way.[49] The more romantic Canadian Group reacted against the city altogether and turned instead to the pure, untamed North. Instead of facing the realities of city life and its people, for the most part they eliminated people from their work and sought landscapes where no humans had ever set foot.

When forced to stay in Toronto during the cold winter months, the artists isolated themselves as much as possible from city life. They worked together in the Studio Building and met at the Arts and Letters Club, which was "a weird, delightful rendezvous! Absolute escape from all that otherwise made Toronto."[50] In 1913, MacDonald moved to Thornhill, which was on the outskirts of Toronto and was virtually open countryside at the time. Jackson and Thomson spent all their time in the country, except when it was too cold to live outdoors. Even while in the city, Thomson continued to live as a woodsman in his shack behind the Studio Building. Harris led a very different type of life in a comfortable house on Queen's Park. He painted more city scenes than any of the Group, but romanticized them in the same way he did his landscapes.

With the first hint of spring thaw, the artists turned their backs on Toronto and headed north. Each of them responded to the call of the North in a different way. For MacDonald, there was a desire to return to nature in the manner of Whitman and Thoreau. Jackson indulged in a certain amount of chest-thumping and seemed to feel a romantic need to prove himself by undergoing great hardships. Harris felt a spiritual response to the North, where he could feel "a deeply moving experience of oneness with the spirit of the whole land."[51] Thomson was inspired by an uncomplicated love of the landscape and reacted mainly on gut instinct. Lismer, a non-Canadian, was much more aware of the reason all the others were so obsessed with the North; there is a note in his journal that expresses better than anything else the spirit behind the Group:

Harris once asked, "I don't know what moved us." He meant, I think, that he couldn't put his finger on the last indefinable something. I said, "Something in the air moved us. The artist just up and does something about it without knowing what it was exactly about. It was a genuinely Canadian thing. The Group of Seven caught and reflected the nationalism in the air." I said further to Harris, "It's a northern people with a northern country and we had to come to terms with it." Harris said, "I didn't see it that way." And I remarked, "No – you're a Canadian."[52]

36 A. Curtis Williamson
Portrait of Dr. J. M. MacCallum
oil on canvas 26½″ x 21½″ 1917
National Gallery of Canada

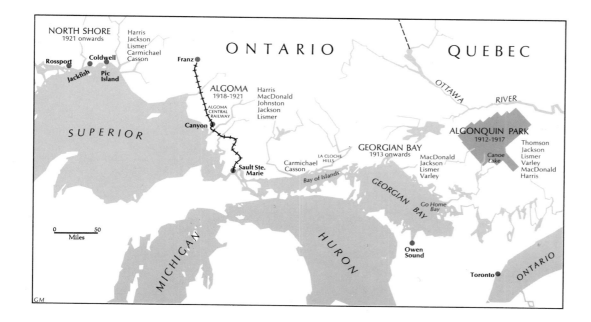

HARRIS

When Harris returned from Europe about 1908, his first subjects were the old houses in the Ward along lower University Avenue, which was then the poor section of Toronto. Harris had sketched the slums of Berlin while in Europe, but his interest in Toronto houses went back to his youth, when he made pictures of all the houses in the neighbourhood. The Toronto scenes were attacked by the critics, who could not understand why he didn't want to paint the nice houses in Rosedale. Harris continued to paint house portraits until the late 1920's, and their progression from year to year reveals the changes in his style.

Houses, Richmond Street, of 1911, is typical of the early scenes, with the houses and trees forming a flat plane across the canvas and blocking off the far view. Here, Harris is interested in the play of sunlight on the trees and the facades of the houses. He spreads on his colour in thick gobs, adding bright touches of red and green for the trim. He was obviously aware of Impressionist techniques at this time, but did not fully understand the ideas behind them.

The Drive, of 1912, one of his earliest landscapes in Canada, reflects the impressions he had upon returning from Europe. "He saw the landscape with fresh eyes and new insight. . . . The impact of returning to Canada was terrific. He had been immersed for four years in the old world. . . . But here he was transferred, transported too into a whole new experience. He became aware of the extravagant buoyancy and energy of this continent. The quality and clarity of the light excited him."[53] In *The Drive,* Harris shows the sunlight breaking through the dark clouds and melting the spring snow, so that the log drive can begin. It is boldly brushed, but still sombre in colour, apart from the sunlit areas and the bright red shirts of the loggers.

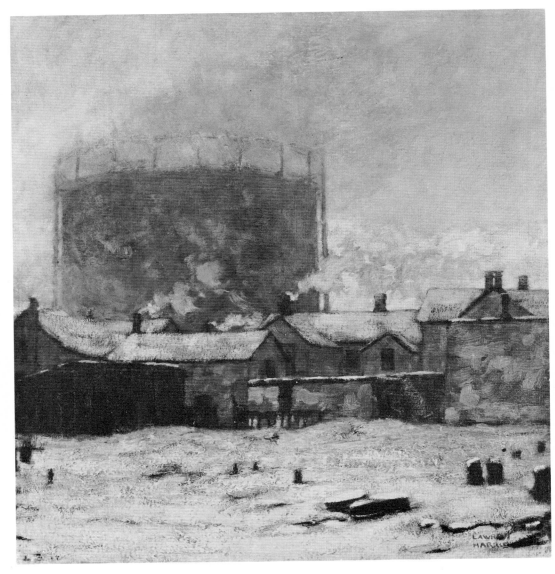

37 Lawren Harris *The Gas Works* oil on canvas 23 1/6" x 22 3/16" 1911-12 Art Gallery of Ontario

38 Lawren Harris *The Drive* oil on canvas 35 1/2" x 53 3/4" 1912 National Gallery of Canada

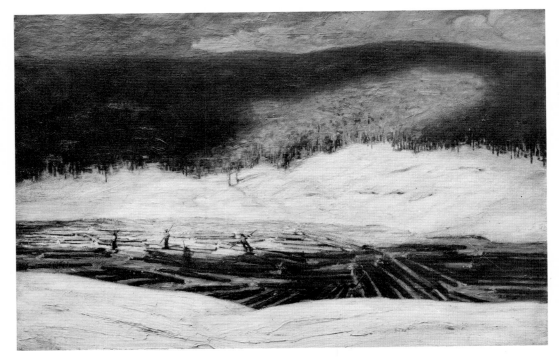

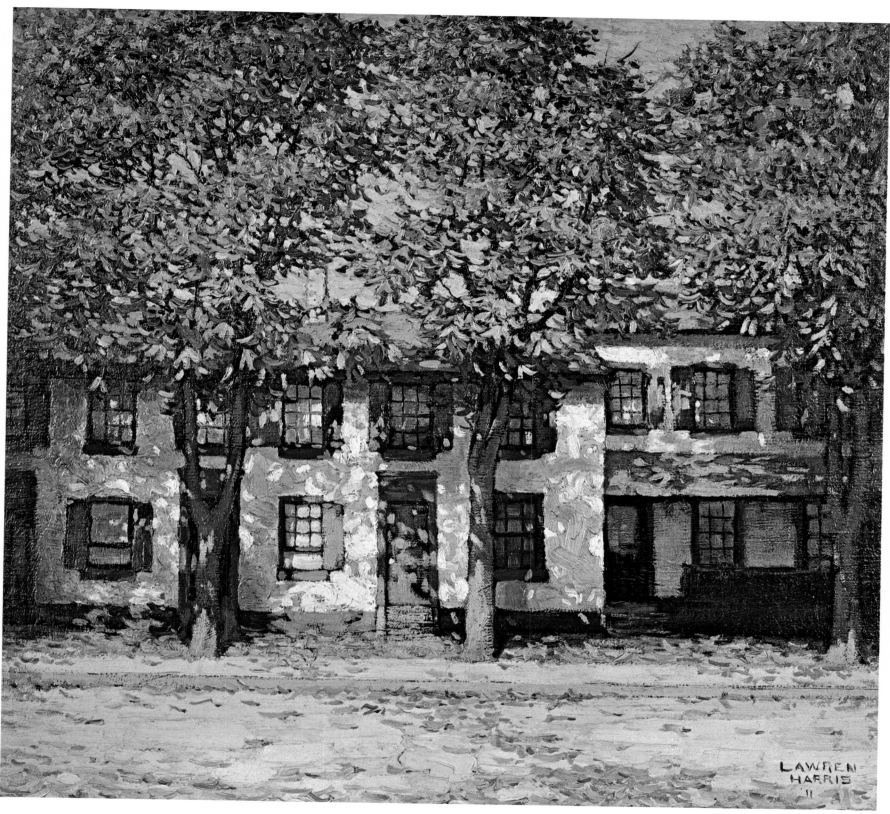

39 Lawren Harris *Houses, Richmond Street* oil on canvas 30'' x 32'' 1911 Arts & Letters Club, Toronto

MacDONALD

MacDonald left Grip in 1911, to devote himself entirely to painting. Although his works were Canadian in spirit, there was little to indicate his potential as an artist of any originality.[54] His paintings still leaned heavily on the Constable and the Barbizon traditions, and in the fashion of the day most of them were evening or moonlit scenes. Then he discovered Impressionism, probably through illustrations in the *Studio*

magazine. His first and most important Impressionist canvas was *Tracks and Traffic* of 1912, which was one of the only works by the Group dealing with an industrial theme. It was a view of the gas storage tanks and railroad tracks near the Toronto waterfront, at Bathurst and Front Streets. MacDonald and Harris had made sketches of the area in 1911 or 1912, probably at the instigation of Harris, who was fond of urban scenes. Harris painted his own version of the scene, entitled *Gas Works,* but later denied having painted it.

MacDonald's *Tracks and Traffic* was mainly concerned with the difficult problem of rendering light and atmosphere. He had to find an effective way to unite the steam from the locomotive, the smoke from the chimneys, and the snow on the ground. He solved the problem by using colour to provide an overall grey-blue tonality, relieved by areas of bright reds and yellows in the centre of the composition. The light focuses on this area also, and on the cloud of steam rising from the engine. The composition is carefully arranged and

40 J. E. H. MacDonald *Tracks and Traffic* oil on canvas 28″ x 40″ 1912 Art Gallery of Ontario

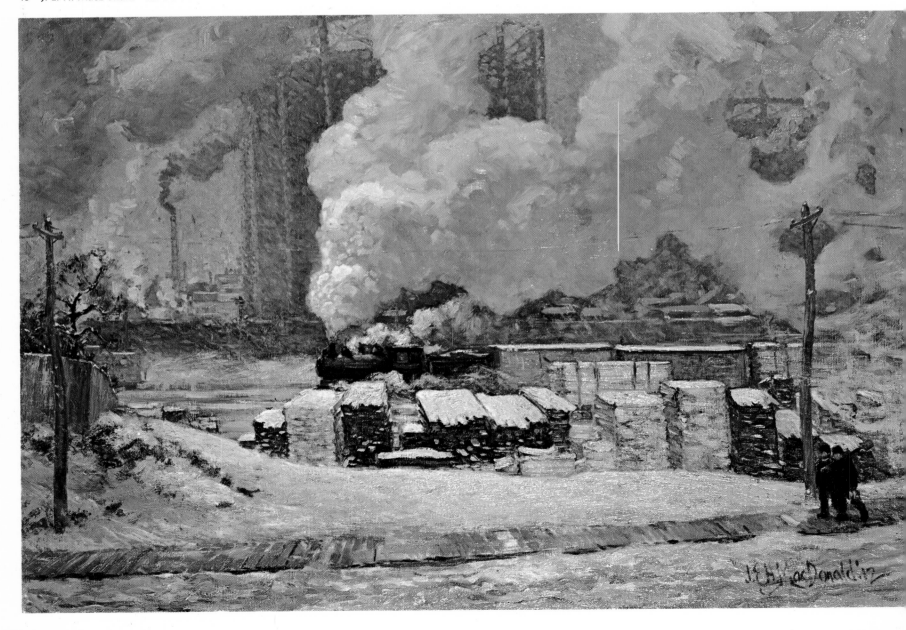

structured to provide well-defined horizontals and verticals. Even the lumber serves to lead the eye from the foreground into the depth, and to slow down the movement from the right to left. *Tracks and Traffic* is a complex work, in which MacDonald struggled with many of the problems that occurred in later paintings.

What were the precedents? MacDonald must have seen reproductions of works by the European Impressionists in magazines, but it is unlikely that he saw illustrations of obvious prototypes such as Monet's *Gare St. Lazare*.[55] He certainly knew of Cullen, who had painted *Old Ferry, Louise Basin* back in 1907, but there is no way of proving a direct influence, despite the strong similarities. Whatever the source, MacDonald's method of working was different from that used by the Impressionists. Instead of painting the scene before nature, MacDonald made numerous preparatory studies in oil and pencil, then painted the finished work in his studio.

The first landscape by MacDonald to successfully capture the dramatic power of nature was *The Lonely North*, painted at Go Home Bay in 1913. The sky dominates the painting, with its heavy, dark clouds sweeping upwards across the canvas. Contrast is provided by the sunlight on the bluffs of the far shore and the flecks of colour on the water. In many ways the work harks back to Beatty's *Evening Cloud of the Northland,* which MacDonald must have seen; but he far surpasses Beatty in force of expression. *The Lonely North* was a major step toward the monumental work of MacDonald's Algoma period.

41 J. E. H. MacDonald *The Lonely North* oil on canvas 30" x 40" 1913 Mrs. David Stratford Collection, Vancouver

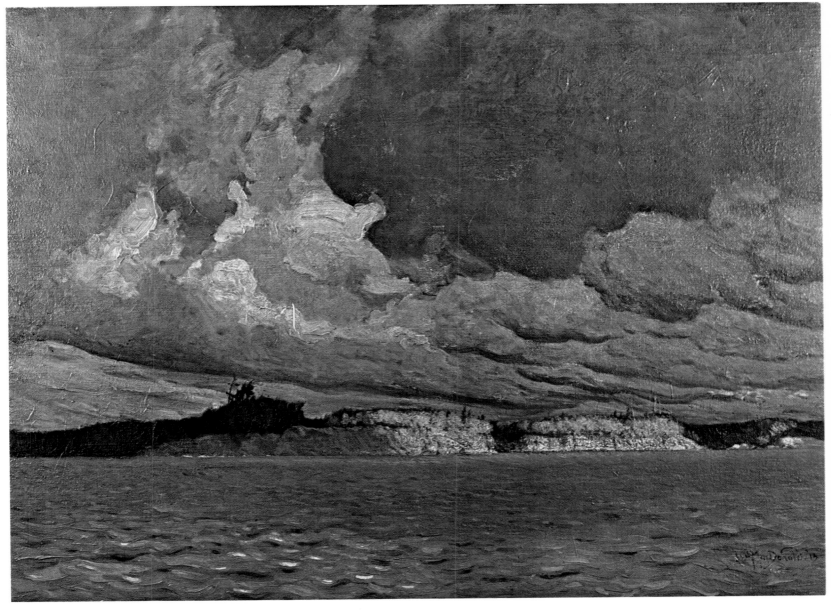

42　John W. Beatty　*The Evening Cloud of the Northland*
oil on canvas　38¹/₂″ x 55³/₄″　1910
National Gallery of Canada

43　Tom Thomson　*Lake Shore and Sky*
oil on canvas　7″ x 10″　1913
National Gallery of Canada

THOMSON

Thomson's beginnings as an artist were inauspicious. His early watercolour sketches, such as *Burn's Blessing* (in the McMichael Conservation Collection) are incredibly naive for an artist of twenty-eight. His early north country sketches are dark and sombre, and give no idea of his potential. One of them, called *Lake Shore and Sky*, he gave to Jackson as a gift. It was Jackson who later introduced Thomson to a brighter palette. At this stage, his work closely resembled that of Bill Beatty, who had returned from Europe in 1909.[56] Beatty was one of the first to paint Algonquin Park, and Thomson greatly admired his abilities as an artist. Thomson used many of the same devices found in Beatty's *Evening Cloud of the Northland* of 1910, such as the unobstructed foreground, the low horizon and the diagonal sweep of clouds. The colours are sombre greys and greens, except for pink-topped clouds and streaks of blue in the sky.

The turning point in Thomson's career came when he painted *A Northern Lake* in 1913. It was his first large canvas, and he only tackled it after considerable persuasion by his friends. He also had to be persuaded to exhibit it in the *OSA* show of 1913, but was thrilled when the Ontario government decided to purchase it for $250.[57] Lismer remembers visiting Thomson the day he received the cheque from this first sale. He had cashed it in dollar bills; when Lismer arrived he danced wildly around the room and threw the pile of money up into the air, then collapsed laughing on the floor, letting the money float down on top of him. Afterwards he pinned the bills around the wainscoting so that he could see them spread out around him.[58]

Tom Thomson's Northern Lake *is remarkable for its fidelity to the northern shore; boulders and undergrowth in the foreground, the brown water turned to the deep blue of the sky under the fresh gale that is putting white caps on the little lake.*[59]

This is how one reviewer described the work when writing about the *OSA* show. For his first large canvas, Thomson achieved a surprising degree of technical competence in the free brushwork and thickly applied colours. He also used a new

type of compositional arrangement, in which the foreground area and vertical trees set off, and at the same time unite, the water, mountains and sky beyond. This simple device became a trademark in later paintings by Thomson and the Group.

44　Tom Thomson　*A Northern Lake*　oil on canvas　30″ x 36″　1913　Prime Minister's Office, Queen's Park, Toronto

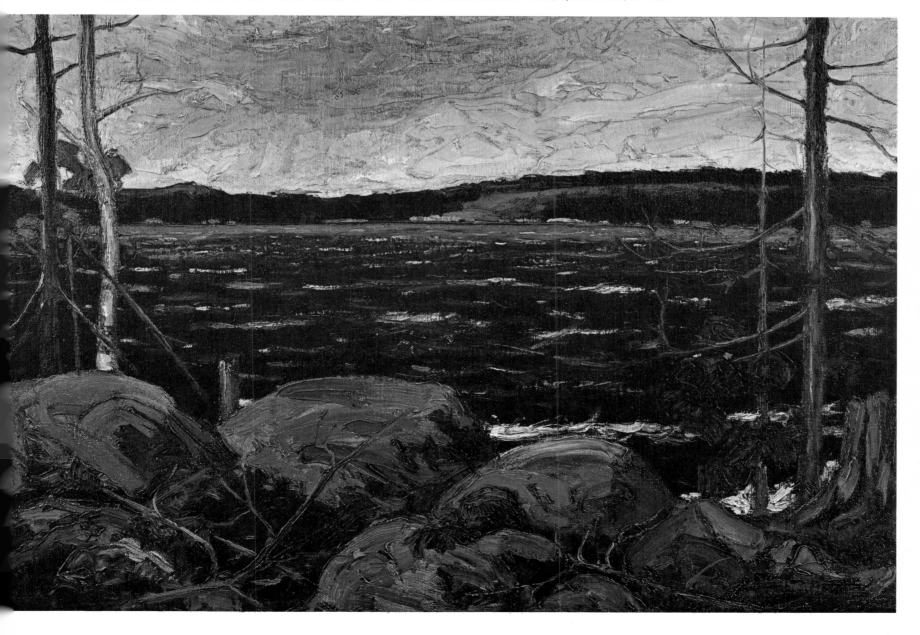

LISMER

Banks of the Don gives an indication of Lismer's style after his arrival in Canada. It reflects his admiration for Constable in the free brushwork and the balancing of open and closed spaces. Many of the elements of his later works can be seen here, particularly the strong foreground area with the trees uniting the middle distance and background.

In September of 1913, Lismer made his first trip to Georgian Bay, at the invitation of Dr. MacCallum. While making the boat voyage to Go Home Bay with his wife and child, the weather became so rough that they had to take shelter overnight on an island. This introduction to the North gave Lismer a deep respect and love for the area. It also gave him a feeling of identification with Canada which he had been unable to find in the city.

In John McLeish's biography on Lismer, he describes the artist's reaction to the North:

In the cool, clear September evenings, scented with the smoke of distant brush fires and lighted by the great moon of the Indian sagas, it came to Lismer that here, almost accidentally, he had found one way to the inner heart of the country – a way that many had missed altogether, and that others had found but had rarely consciously understood.[60]

The sketches from this trip begin a long series of works representing Georgian Bay, culminating in *September Gale* of 1921. *Georgian Bay* stands out from other works of this period because of its vigorous execution and fresh colour. Lismer is already experimenting with the effects of wind, waves, and water, but has not yet found a successful way to express his feelings. Most of his early sketches are crude in execution, muddy in colour, and lacking in form.

45 Arthur Lismer *The Banks of the Don*
oil on panel 5¹⁄₈″ x 8³⁄₄″ c. 1912
National Gallery of Canada

46 Arthur Lismer *Georgian Bay*
oil on board 9″ x 12″ 1913
Private Collection, Toronto

JACKSON

When Jackson arrived in Toronto in May, 1913, he met MacDonald, Varley, and Lismer at the Arts and Letters Club, and was told about the artistic awakening taking place in that city. Only three months earlier, MacDonald and Harris had seen the Scandinavian show, and everyone was eager to get out into the North. Jackson later recalled how he was received by the Toronto artists "as a kindred spirit. Like them, I had been a commercial artist for years. Now I had thrown up that job to devote myself exclusively to painting, and had, at the moment, no idea how I was going to live while I was doing it."[61]

After a short stay in Toronto, Jackson went to Berlin, Ontario, to visit his aunts. While he was there Harris made a special trip just to meet him. Jackson was still uncertain whether he wanted to remain in Canada or not, and Harris was probably influential in persuading him to stay. From Berlin he went to Georgian Bay to think things over and spent the summer "swimming, paddling, fishing, exploring, and looking for wild flowers."[62] In the fall, with everyone gone, he began to paint seriously, but was soon faced with the problem of keeping warm in his dilapidated bathing shack. One day he was busy trying to fill the cracks between the boards when Dr. MacCallum pulled up in a motorboat. The Doctor got out and introduced himself, saying that he wanted to see his works.

Then he inspected the shack, pronounced it rather draughty, asked how long I was staying, and when I told him till the end of October, he said he would send someone to take me to his place at Go Home Bay where I could live in a comfortable house. When he started back I went along with him part way towards Penetang with my boat in tow.

"Where are you going when you leave the Bay?" he asked. I said that I would probably go to the States. "If all you young fellows go off to the States," he growled, "art in Canada is never going to get anywhere."

Then he made a surprising proposition. If I would take a studio in the building he and Harris were having erected, he would guarantee my expenses for a year. Of course I accepted.[63]

47 A. Y. Jackson *Night, Georgian Bay*
oil on canvas 21″ x 25½″ 1913
National Gallery of Canada

48 A. Y. Jackson *Terre Sauvage* oil on canvas 50″ x 60″ 1913 National Gallery of Canada

TERRE SAUVAGE

When Jackson returned to Toronto in the late fall of 1913, he painted *Terre Sauvage* in Harris' studio over a bank on the corner of Bloor and Yonge Streets in Toronto. It was the first canvas he did in Toronto, and the other artists were markedly impressed by it. MacDonald nicknamed it Mount Ararat because "it looked like the first land that appeared after the Flood subsided."[64] While work on it was in progress, Thomson came over to see it and met Jackson for the first time, beginning their brief but intense friendship.

The painting might be termed a success-ful failure. The almost garish colours of bright oranges, blue and greens must have been startling to the other artists. There were boldly simplified shapes and bril-liant juxtapositions of complementary col-ours, such as the red maple shrub placed next to the green trees and royal blue sky. But the end result was stiff and overwork-ed. Even Jackson considered the painting to be an experiment, and he made no at-tempt to exhibit it. A few years later it was sent to the 1917 *OSA* show and was re-jected. Then, in 1918, it was accepted for the Academy show in Montreal, where "the critics tore it to pieces."[65] In 1920, Jackson placed it in the first Group of Seven show, where it was still one of the most radical paintings of the exhibition.

No single issue in the history of the Group of Seven has been more misunderstood or more distorted than the relationship between the artists and their critics. The artists themselves, and even the most recent writers on Canadian art, have long promoted the idea that the Group was slandered and abused by the press from its earliest years. The artists thrived on their reputation as the rebellious young men who defended their art and their country against a band of philistines. It was to their advantage to preserve this illusion, but it is now time to examine both sides of the issue.

There were good reviews and bad reviews; intelligent critics and unintelligent ones. The Group were criticized by their friends and praised by their foes, and much of the criticism and praise never appeared in the newspapers. Despite the appearance of some adverse reviews, they had a following, and the informed were generally sympathetic to their accomplishments. Not all public galleries and collectors appreciated their work, but a perceptive few, such as the National Gallery under Eric Brown, bought their paintings from the very beginning.

The attacks began in Montreal, where Cullen and Morrice had been receiving criticism ever since they brought the bright colours of Impressionism to Canada. In 1913, the Spring Exhibition opened at the newly completed gallery of the Art Association of Montreal. Commenting on the works by John Lyman, Randolph Hewton, and Jackson, the Montreal *Witness* began its review with the headline "Post-Impressionists Shock Local Art Lovers at the Spring Exhibition – Screaming Colours and Weird Drawing Cause Much Derisive Comment."[66] In another article, S. Morgan Powell undertook his crusade against the moderns by saying, "Post-Impressionism is a fad – an inartistic fetish for the amusement of bad draughtmanship, incompetent colourists, and others who find themselves unqualified to paint pictures."[67]

The first major attack on the Toronto group came in December of the same year, when H. F. Gadsby published his famous "Hot Mush School" article in the *Star*.[68] The article had apparently been provoked by an exhibition of Jackson's Georgian Bay sketches at the Arts and Letters Club, but Gadsby was taking a swing at all of the younger artists. In his colourful language he called them "the Advanced Atomizers who spray a tube of paint at a canvas and call it 'Sunshine on the Cowshed' or words to that effect." He went on to say, "All their pictures look pretty much alike, the net result being more like a gargle or gob of porridge than a work of art."[69] He then launched into a sarcastic dialogue in which he imagined himself looking at a painting with his friend Peter. This was the same method of attack used by the critics in Paris when they coined the term Impressionism many years before.

More devastating than Gadsby's "Hot Mush School" article is the reply to it written by MacDonald, published in the *Star* on December 20.[70] In the same facetious manner he

attacks the article "which has got my goat, my horse, my ass, and everything which is mine." Gadsby, he says, "should have been an artist. His broad-gauge, tramp-camp, black-thorn style, concerned only to get the big idea over, with no picayune regard for facts or cast-iron propriety, would have put him in the Giants as a Canvas-swatter. He would have been the star patron of a paint factory."[71] MacDonald's tongue-in-cheek rebuttal becomes so abstruse that it is difficult to follow. His real concern only becomes clear when he says, "Now I want to put it to Gadsby and Peter and the rest of us. Let us support our distinctly Native art, if only for the sake of experiment."[72]

In fighting Gadsby, he launched his first appeal for an art that was distinctively Canadian, and made a plea for an open-minded public to accept the experiments of the younger artists.

The Hot Mush School article became the rallying cry for the Group and was seen as indisputable proof that their works were attacked from the very beginning. However, they neglected to mention the many favourable reviews which appeared before and after Gadsby's article. In 1912, Augustus Bridle wrote about the works by the Toronto group in the spring *OSA* show saying, "There is an exhilaration, almost an abandon, that convinces any average beholder of the vitality of Canadian art which a few years ago showed signs of senility."[73] In a review of the next year's show, Jackson was praised for his daring colours, and Harris was described as one of the most original of the younger artists.

"Strength and Beauty in the New Pictures"
Toronto *Star*, March 14, 1914

"Power and Poetry in Art Galleries"
Mail & Empire, March 13, 1915

"Ontario Artists do Daring Work"
Mail & Empire, March 11, 1916

"Ontario Artists do Vigorous Work"
Mail & Empire, March 10, 1917

A glance at some of the review headlines in the years 1914-1917 reveals that the critics were generally favourable to the new school of Toronto artists. Even Hector Charlesworth spoke highly of them and praised them for breaking with the old conventions in favour of bright, glowing colours. He admired their vitality, their "pigmentary enthusiasm" and their desire to make pictures and not pot-boilers.[74] The Hot Mush School attack stands out as the only adverse criticism from this period.

«What is this picture, Peter?» he asks, pointing to a spasm in yellow and green.

«That,» says Peter, «is a Plesiosaurus in a fit as depicted by an industrious but misguided Japanese who scorns foreground or middle distance.»

«And this one?» says Big Bill, indicating another in sullen reds.

«A Hob-Nailed Liver,» says Peter quick as a flash, «painted from memory by the Elevator Man at the General Hospital.»[75]

50 Moyer *I Can't Get It School*
pencil Toronto, *Star*, December 12, 1913

By the end of 1913, the Toronto artists had consolidated themselves into a cohesive group, with the shared objective of painting Canada. They had made their first exploration of the North and had received their first initiation to harsh criticism. Now that they wanted to devote themselves full-time to painting, the need for a common working place became more apparent. The idea for the Studio Building probably originated with Harris, who believed that given favourable conditions, good artistic results would follow. The Studio was conceived of as a "workshop for artists doing distinctly Canadian work."[76] Here, artists could exchange ideas, and work, free of financial worries, with rents that were kept at a minimum. The plans called for an art gallery and theatre to be added at a later date, but unfortunately the war intervened.

Harris and MacCallum provided the financial backing, paying about three-quarters and one-quarter of the cost respectively. Eden Smith, another member of the Arts and Letters Club, designed the building, which was located in the Rosedale Ravine near Bloor and Yonge Streets. By the end of 1913, construction was nearly complete, and in January of 1914 Jackson and Thomson became the first tenants when they moved into Studio One. Their rent was a nominal twenty-two dollars per month. Harris and MacDonald soon joined them, taking over two more studios.

Several non-Group members also moved in, including Bill Beatty, Curtis Williamson, and Arthur Heming. At the time, these three artists showed promise as original creative artists, but none of them succeeded in breaking away from the academic tradition in which they had been trained. Jackson recalled that the only thing they had in common was a hearty dislike for each other.[77]

Of the remaining Group members, Lismer had his own house, and Varley preferred to be on his own. Johnston was in New York and Carmichael was in Europe. When he returned in late 1914, Carmichael moved in with Thomson, replacing Jackson, who had left for Montreal. A few months later he wrote to his fiancée, describing the studio as a congregating place for everyone, with people continually dropping in for a snack or to talk.[78] As Jackson said, "The building was a lively centre for new ideas, experiments, discussions, plans for the future and visions of an art inspired by the Canadian country-side. It was, of course, to be a northern movement."[79]

51 The Studio Building, Severn Street, Toronto

JACKSON ON THOMSON 1914

*«Tom is doing some exciting stuff.
He keeps one up to time. Very often I
have to figure out if I am leading or
following. He plasters on the paint and
gets fine quality, but there is a danger
of wandering too far down that road.»*[83]

52 Algonquin Park, October, 1914.
Left to right: Tom Thomson, Fred Varley, A. Y. Jackson,
Arthur Lismer, Marjerie Lismer, and Mrs. Lismer

THOMSON ON JACKSON 1914

*«Jackson and myself have been making
quite a few sketches lately and I will
send a bunch down with Lismer when
he goes back. He and Varley are greatly
taken with the look of things here just
now. The maples are about all stripped
of leaves now but the birches are very
rich in color. We are all working away
but the best I can do does not do the
place much justice in the way of beauty.»*[84]

53 Arthur Lismer and Tom Thomson, Algonquin Park, 1914

The year 1914 marked the culmination of all the excitement that had been building up for the past few years. The activities of the Toronto groups centred around Algonquin Park, which became their main sketching ground, earning them the title of the Algonquin Park School. Spurred by Thomson's enthusiasm, Jackson first visited the park in February of 1914, arriving when the temperature was forty-five degrees below zero.[80] He managed to survive the weather until March, when MacDonald and Beatty came to visit him. Shortly afterwards, Thomson introduced Lismer to his first canoe trip. That same month Jackson and Beatty left for the Rockies, where they spent most of the summer sketching.

During the fall of 1914, Thomson, Jackson, Lismer, and Varley went camping and sketching together to record the changing fall colours. Jackson had rejoined Thomson in the park by late September for their only sketching trip together. It lasted about six weeks, and part way through they were met by Lismer and Varley. Here for a brief interval all four artists were working and living together, exchanging ideas, and making great progress in their painting.

Algonquin was still unspoiled and relatively unknown when Thomson and his friends were sketching there. The park had originally been set up as a provincial reserve in 1853, and consisted of 1,466 square miles of wilderness, sprinkled with countless lakes and rivers.[81] It was situated on the southern edge of the Canadian Shield, between the Ottawa River and Georgian Bay. At first, it was used only by a few logging firms, but the completion of the railroad around 1900 brought more people to the park. It was still far from fashionable in 1912, when it was described as a place "chiefly enjoyed by American visitors and a few eccentric artists and nature lovers from Toronto."[82]

THE ALGONQUIN PARK SCHOOL

54 A. Y. Jackson A North Country Lake, Algonquin Park oil on panel 8¹/₂" x 10¹/₂" 1914 National Gallery of Canada

Dear Dr. MacCallum,

We have had a glorious week of colour. The glory of it has somewhat departed now after the heavy rain of yesterday and today which has left big windy skies and promise of cold clear weather, a pleasant change after the warm almost sultry weather we had had – The wind has stripped the trees however. The maples are bare but it is still wonderfully fine – I am finding it far from easy to express the riot of full colour and still keep the landscape in a high key – Thomson and Jackson are camped just opposite Fraser's and both are doing fine work and each having a decided influence on the others – Thomson has a lot of fine wood interiors rich in colour – he seems to be selecting his material carefully and using a finer sense of colour than his previous work. Jackson has some brilliant work, better than his "Rockies" studies. The material here is more intimate and suits his aggressive soul better I think.

Varley and I are struggling to create something to show as a result of our efforts,

With best wishes
Yours very sincerely
Arthur Lismer[85]

40

Dear Doctor,

Just a line to let you know what a great time we are having up here – The Country is a revelation to me – and completely bowled me over at first – We have been busy «slopping» paint about and Tom is rapidly developing into a new cubist but say, he has some great things up here.

I'd like to tell you that you have given me the opportunity to wake up. I had given painting the go-by but I'm going full tilt into it now and shall swing along steadily, determined that next year I'll bring the family up for a few months and paint the out-door figure – There's a glorious chance. With best wishes.

Yours very sincerely,
F. Horseman Varley[86]

55 Tom Thomson *Red Leaves* oil on panel 8½" x 10½" 1914 National Gallery of Canada

JACKSON ON *RED MAPLE* «*In Toronto I worked up the painting* Red Maple. *At the same time Lismer was painting* The Guide's Home. *Both were shown at the Academy exhibition, and were purchased for the National Gallery*»[87]

57 Arthur Lismer *The Guide's Home, Algonquin* oil on canvas 39¹/₂″ x 44¹/₂″ 1914 National Gallery of Canada

«The Guide's Home . . . *was probably a result of the animated discussions we used to have on the French Impressionists. We were all experimenting with broken colour at that time, but it was too involved a technique to express the movement and complex character of our northern wilds.»*[88]

JACKSON ON *GUIDE'S HOME*

MacDonald was also in Algonquin Park in the spring of 1914 with Bill Beatty. The two artists worked very closely together at this stage, and MacDonald learned a lot from Beatty. Beatty had spent many years studying in France and had a solid knowledge of the art techniques that MacDonald was then trying to master. *March Evening, Northland*, painted after their visit to the park, reflects the influence of Beatty's techniques in its roughly textured surface and its vigorous execution.

MacDonald's *Laurentian Hillside, October* was based on sketches made during his trip with Harris to the area of St. Jovite, Quebec in 1913. In this work he discovered the pure fresh colours of the Impressionists and delighted in the juxtaposition of bright oranges, greens, and yellows. The forms are freer and the paint is applied directly to the canvas without the laboured feeling of his earlier works. A step is taken in breaking away from the atmospheric rendering of space towards a more two-dimensional treatment. This new interest in design and colour may have been a result of the Scandinavian show and Jackson's arrival in Toronto.

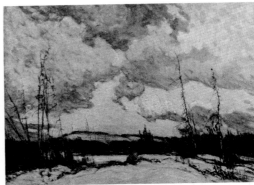

58 J. E. H. MacDonald *March Evening, Northland*
oil on canvas 29½″ x 39¾″ 1914
National Gallery of Canada

59 J. E. H. MacDonald *Laurentian Hillside, October* oil on canvas 30″ x 40″ 1914 Mr. W. Howard Wert Collection, Montreal

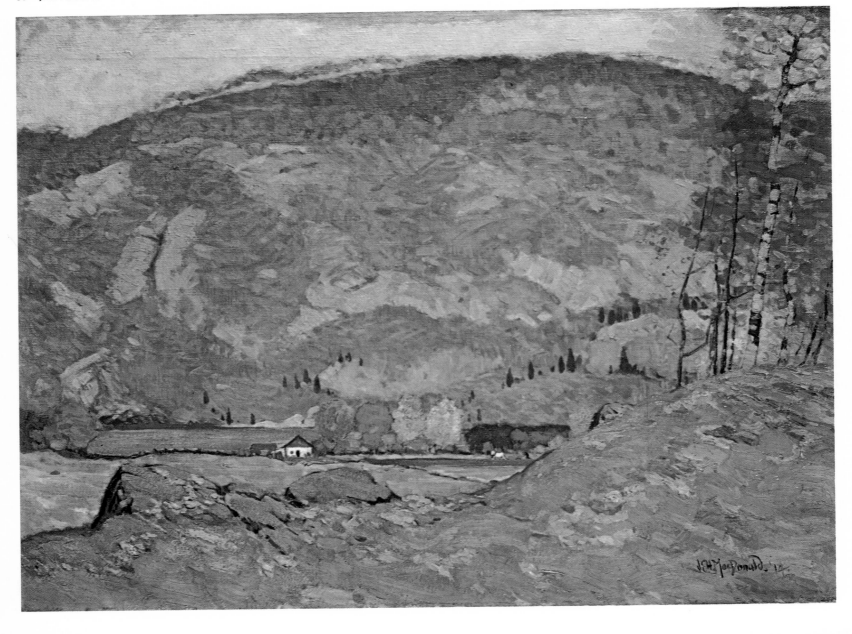

The War Years and Algoma

«*The maple, the birch and the poplar ran their gamut of colour and finally the tamarac tinted to shimmering gold; falling leaves and snow flurries made us aware that the sketching season was over. There was a war on too; in Algonquin we heard little about it and hoped it would soon be over. When we reached Toronto, however, we realized that we had been unduly optimistic, that the war was likely to be a long one, and that our relatively carefree days were over.*»[1]

As the artists returned to Toronto in the fall of 1914, the high spirits and tremendous enthusiasm of the past few months rapidly disintegrated. The war, which had become an inescapable fact, disrupted all their plans for the future. Aside from Jackson, who went to Montreal in December, the other artists continued to work relatively undisturbed throughout the winter. It was during this winter that the influence of *Art Nouveau* design first became apparent in their works. More than anything else, this feature established the mature style of the Group.

Jackson wrote that "we frankly abandoned any attempt after literal painting and treated our subjects with the freedom of the decorative designer, just as the Swedes had done, living in a land where the topography and climate are similar to our own."[2] The Group had at last found an application for their design training and a way of interpreting the Canadian landscape. The Impressionist technique, according to Jackson, "was too involved a technique to express the movement and complex character of our northern wilds."[3] The next stage was obviously to adapt the decorative design motifs of *Art Nouveau* to the landscape.

ART NOUVEAU INFLUENCES

The ideal subject matter for these first experiments was the snow scene, which allowed the artists to use bold simplification and design. Thomson's *Snow in October* is one of the earliest examples of this approach, with its use of a flat pattern of crisscross latticework for the upper branches. The dark tree trunks provide a stabilizing element and separate the upper area from the snow-covered ground. A comparison with Fjaestad's *Ski Tracks,* which appeared in the *Studio* magazine of 1913, reveals a likely precedent for this work.[4]

MacDonald's painting of *Snow-Bound* is less successful, but it shows a new concern for overall surface design, and a further attempt to break with Impressionism. By this time MacDonald had assimilated the essential characteristics of Scandinavian art and was making his own experiments in design treatment. He painted *Snow-Bound* at Thornhill, looking out from his window at snow-covered spruce trees. The heavy blanket of snow is rendered in blues, mauves, and greys, giving a gloomy overall effect which is relieved only by a few touches of colour in the upper left corner.

Harris painted many snow scenes during this period, and some of them were brilliant exercises in design. Harris, too, may have been applying the ideas of the Scandinavians, for there is an obvious *Art Nouveau* influence in the painting entitled *Snow* at the McMichael Collection. Unlike MacDonald, Harris adopted a more formal approach, with a tendency toward abstraction. This can be seen in the titles he used, such as *Snow I, Snow VI,* which avoid any reference to specific location.

The use of design motifs became even more apparent the next winter, when Thomson, MacDonald, and Lismer did the decorations for MacCallum's cottage at Go Home Bay.[5] The Doctor commissioned the works mainly to give the artists work during the lean period of the war. The unusual nature of the commission allowed them to experiment freely with pure decoration. The result was closer in style to their commercial art work, and revealed the extent to which they were aware of *Art Nouveau* techniques.

60 Tom Thomson *Snow in October*
oil on canvas 32¼″ x 34¼″ c. 1915-16
National Gallery of Canada

61 J. E. H. MacDonald *Snow-Bound*
oil on canvas 19½″ x 29½″ 1915
National Gallery of Canada

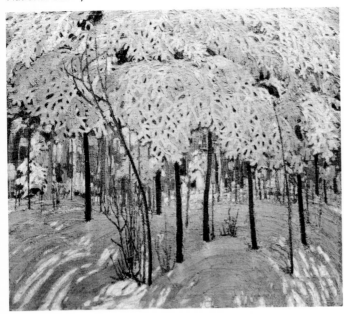

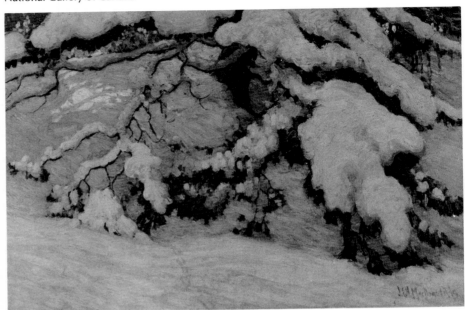

62 Lawren Harris *Snow* oil on canvas 27″ x 42″ c. 1915-16 McMichael Conservation Collection

63 Tom Thomson *Decorative Landscape*
(poem by Ella Wheeler Wilcox) 8½″ x 12½″ 1916
M. Merkur Collection

64 Tom Thomson *Decorative Panel (III)*
oil on panel 47½″ x 36½″ 1915-16
National Gallery of Canada

HARRIS
THE DECORATIVE PHASE

«*Living in and wandering the North, and
more or less literally copying a great
variety of her motives, led to a decorative
treatment of her great wealth of material
in designs and colour patterns conveying
her moods of seasons and places with
suggestions of her pervading spirit. It
seemed the only way to embody the charm
of so many of her motives and the in-
tricacies of her extraordinarily rich patterns.*

«*The artists saw decorative designs
everywhere in the North, and material for
every possible form of embellishment for
our daily life, and all of it waiting to be
used to create a home for the spirit of a
new-seeing people.*

«*This decorative phase touches the
whole glorious surface display of
nature, and creates patterns in the
flat, re-expressing her moods.*»[6]

MacDONALD
THE DECORATIVE ELEMENT IN ART

«*The Decorative Element is perhaps not so
much a component part, as the element
in which art lives and moves and has its
being. It is an element more in the
sense of the universal ether.*»[7]

65 Tom Thomson *The Pool* oil on canvas 30″ x 32¼″ c. 1915 National Gallery of Canada

While the outbreak of the First World War marked the end of the first phase of the "Algonquin School," it also marked the beginning of the last and most legendary phase of Thomson's career. He was then thirty-seven years old, and had less than three years remaining in his life before he drowned in Canoe Lake in July of 1917.

There has been considerable speculation over Thomson's reactions to the war. Many suggest that he did try to enlist, but for some reason was refused.[8] Others hinted that there may have been "some involvement with one or other of the young women whose shadows flit across his path."[9] Jackson's theory is that Dr. MacCallum wouldn't let him join up because he didn't want to risk losing Canada's greatest painter.[10]

There can be no doubt that Thomson detested the idea of war and hated to be in a position where any kind of authority was imposed on him. In July he wrote to MacDonald saying, "As with yourself, I can't get used to the idea of Jackson being in the machine and it is rotten that in this so-called civilized age that such things can exist."[11] However, since none of the other artists except Jackson really played an active part in the war before 1918, Thomson's non-involvement should not be overemphasized.

During the winter of 1914-15, Thomson shared Studio One with Frank Carmichael, painting several major canvases, including *Northern River*. With the first signs of spring, he headed for Algonquin Park, and stayed with the Frasers at Mowat Lodge. As the snow gradually disappeared, he did some sketching around Canoe Lake; and once summer came, he worked part time as a guide, although business was poor because of the war. It was generally a lonely summer for Thomson, and he went on several long canoe trips alone to the far corners of the park. In a letter to MacCallum he asked, "If Lismer or any of the boys can come get them to write me at South River. I should like awfully well to have some company."[12]

When he returned to Toronto in the late fall of 1915, he moved into the shack behind the Studio Building.[13] The shack, which had been there for many years, was probably once a cabinet-maker's workshop. Harris and MacCallum fixed it up and rented it to him for one dollar per month. Thomson made his own bunk shelves and table, and "moved in, hung his fishing tackle on the walls, stacked his sketches, set up his easel and settled down to his winter's work."[14] Thomson disliked staying in the city, but did not lead the solitary life that he was reputed to have. Lismer shared the studio with him during the day, and there were many friends who were "frequently dropping into the shack to share beans or mulligan and over a pipe, discuss the news."[15] He was almost completely oblivious to the city around him and lived as if he were in the woods. During the winter nights, he often roamed around the Rosedale Ravine on snowshoes.[16] Thoreau MacDonald recalled that "sometimes he invited me to stay for meals and I remember well the woodsman's flourish with which he threw a handful of tea into the pot and mashed the potatoes with an empty bottle, adding what looked like half a pound of butter."[17]

Following his usual pattern, he went north in the spring of 1916, this time to work the full season as a forest ranger in the northeastern section of the park. He later wrote to MacCallum saying, "Have done very little sketching this summer as I find the two jobs don't fit in."[18] Yet he did manage to make the sketches for his two most celebrated works, *Jack Pine* and *West Wind*, which he painted in Toronto the next winter.

Little is known about his other activities in Toronto that winter. But by April, he was back in the park again, working on a series of sketches that would record the changing seasons.[19] That summer he decided not to take on a permanent job so that he could devote more time to painting. But once the flies came out in May and June he did less sketching and spent his time fishing, canoeing, and doing some guide work. Then came early July, his last letter to MacCallum, and his death in Canoe Lake.

66 Arthur Lismer *Tom Thomson Priming a Canvas*
pencil 10" x 7-11/16" 1915
National Gallery of Canada

Thomson's *Northern River* of early 1915 was one of the first large canvases to show an awareness of *Art Nouveau* techniques. The dead spruce trees in the foreground form a delicate screen, through which the peaceful river and far shore can be seen in the distance. The arrangement appears to be perfectly natural, but a closer study reveals that Thomson has carefully placed the trees so that the heavy mass on the right is balanced by the single spruce on the left. Joining these two sides is the curving sweep of the foreground area and a fallen tree which lies almost at a precise forty-five degree angle. Another convention that he used is the contrast between the shaded foreground area and the brightly coloured river bank beyond.

A glance at the Swedish tapestry by Krogh called *Spruce Coppice*, which was illustrated in colour in the *Studio* magazine of 1913, reveals a very similar approach.[20] Krogh uses the common *Art Nouveau* motif of drooping foreground branches to set off the lake in the background and places emphasis on decorative pattern. Thomson, trained as a designer and using *Art Nouveau* design in his commercial work, must have felt an obvious affinity for the Scandinavian works, which were illustrated in many art magazines.[21] Whether he was conscious of it or not, he assimilated their approach, and it is highly unlikely that he could have painted *Northern River* without prior knowledge of them. For example, his use of colour, juxtaposing pure dabs of the complementaries, blue and orange, to give added brilliance, was a standard method of European artists and could not have been a self-taught device.

Many people felt that Thomson arrived at his mature style merely by painting nature as he saw it. Lismer clearly supported this view when he objected to those who said Thomson was "Impressionistic in technique" or "*Art Nouveau* in arrangement and pattern." He insisted that "if he absorbed them it was through his deep contemplation of the Canadian scene."[22] However, Thomson *did* know of European techniques and was, no doubt, influenced by them. They partly determined the way in which he perceived nature, and they gave him the technical means for recording his vision. Ultimately these techniques did no more than provide Thomson with a starting point, but their importance as such must be recognized.

Northern River was exhibited in the *OSA* show of 1915, and was praised as "one of the most striking pictures of its kind in the gallery."[23] Even Hector Charlesworth spoke of it as "fine, vigorous and colourful. The clever treatment of trees in the foreground gives a most effective composition."[24] The painting, which Thomson called his "Swamp Picture," was purchased by Eric Brown for the National Gallery of Canada in the same year.

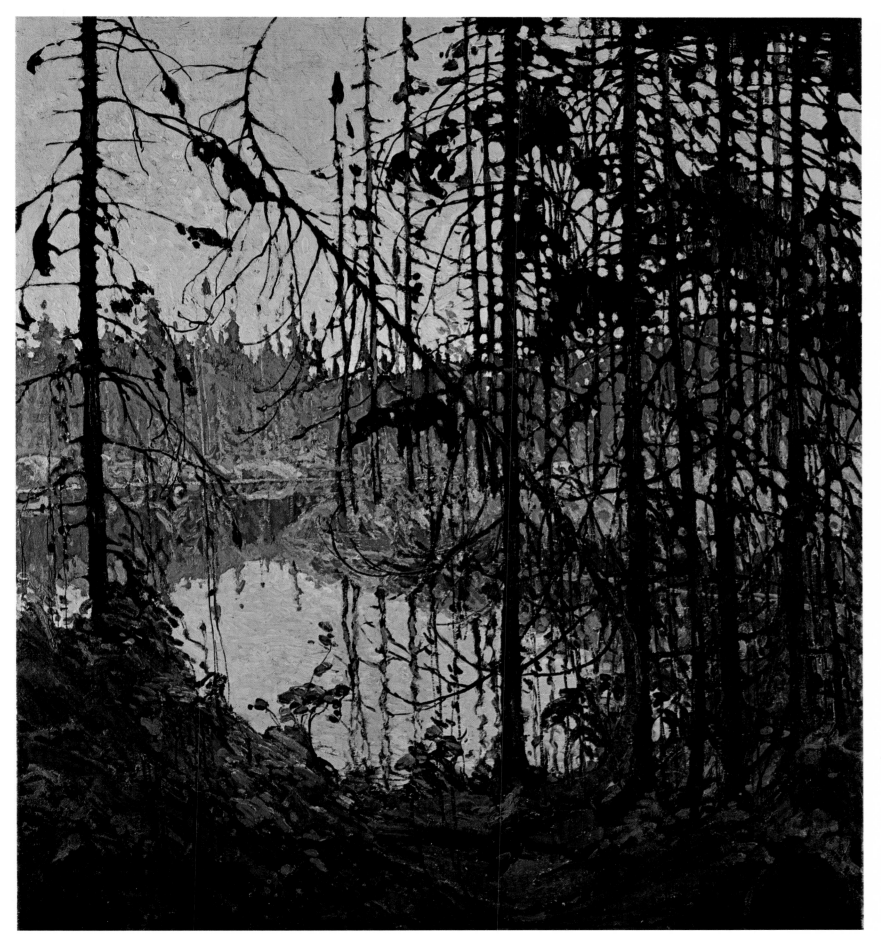

«*Thomson's small oil sketches of the last years palpitate and throb. They are as direct in attack as a punch in the nose, and the sense of movement in them has the sweep and pull of a paddle entering water. Paint is thrust and smashed onto the board with axe-like swings; it seems almost a substitute for the coarse fare of the bush, making of the final picture a banquet for Thomson's Spartan senses.*»[25]

69 Tom Thomson *Frost-Laden Cedars, Big Cauchon Lake* oil on canvas 12″ x 15″ 1914-15 National Gallery of Canada

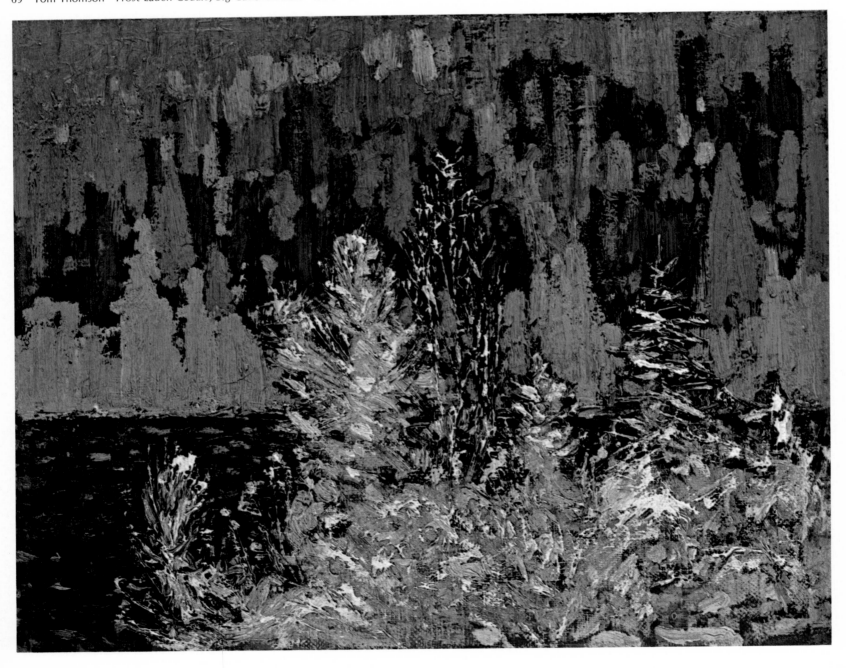

An intuitive artist, Thomson was at his best sketching before nature with the scene clearly before him. When faced with a large canvas he was less at ease, and as a result, his studio works are often stiff and devoid of feeling. In many of these paintings he fell back on more conventional methods, whereas in his sketches he was often far ahead of himself.

Thomson considered his sketches to be finished works in themselves, and not just preparatory studies for finished paintings. From 1914 onwards, he used standard 8¹/₂ x 10¹/₂-inch panels, a method borrowed from Jackson or Beatty, who had picked it up in Europe. The panels were all of a uniform size so that they could fit into a specially constructed sketching box. This made a small, portable outfit that could be easily transported over rough territory.

In many of the sketches he approached the bounds of pure abstraction by juxtaposing solid areas of pure colour. In *Autumn Foliage* and *Autumn Birches*, bright greens, reds, and yellows are set side by side in a dramatic way. There is a freedom of form and liveliness of brush, which comes close to a purely spontaneous gesture. In contrast to the singing colours of these two, *Frost Laden Cedars* has a cool, icy tonality to it. It consists of three simple elements – the foreground cedars, the flat blue-black lake, and the far hills. These areas are differentiated by colour and brush stroke alone.

Thomson was enough of an artist to carry off such difficult subjects as *Sunset, Moose at Night* or *Northern Lights*. He was also able to avoid the conventions that a more "intellectual" artist would use, and to approach each scene with directness and simplicity. There are many stories about Thomson trying to paint by moonlight or rushing out into a thunderstorm to try to get the scene down with immediacy and impact. He was deeply moved by what he saw, and in an almost "naive" way tried to capture these feelings in paint.

70 Tom Thomson *Autumn Foliage* oil on panel 8¹/₂″ x 10¹/₂″ Art Gallery of Ontario

71 Tom Thomson *Autumn Birches*
oil on panel 8¹/₂″ x 10¹/₂″ 1916 McMichael Conservation Collection

72

73

54

J. M. MacCALLUM ON TOM THOMSON

72 Tom Thomson *Northern Lights*
oil on panel 8¹/₂'' x 10¹/₂'' 1916
Alan A. Gibbons, Esq. Collection

73 Tom Thomson *Moose at Night*
oil on panel 8¹/₂'' x 10¹/₂'' 1916
National Gallery of Canada

74 Tom Thomson *Sunset*
oil on panel 8¹/₂'' x 10¹/₂'' 1915
National Gallery of Canada

«*Thomson painted not merely to paint, but because his nature compelled him to paint—because he had a message. The north country gradually enthralled him, body and soul. He began to paint that he might express the emotions the country inspired in him; all the moods and passions, all the sombreness and all the glory of colour, were so felt that they demanded from him pictorial expression. He never gave utterance in words to his feelings of the glories of nature. Words were not his instruments of expression—colour was the only medium open to him. Of all Canadian artists he was, I believe, the greatest colourist. But not from any desire to be unusual, or to make a sensation did he use colour. His aims were truthfulness and beauty—beauty of colour, of feeling, and of emotion. Yet to him, his most beautiful sketches were only paint. He placed no value on them. All he wanted was more paint, so that he could paint others. He enjoyed appreciation of his work; criticism of its methods he welcomed, but its truthfulness was unassailable, for he had seen it. He never painted anything that he had not seen.*»[27]

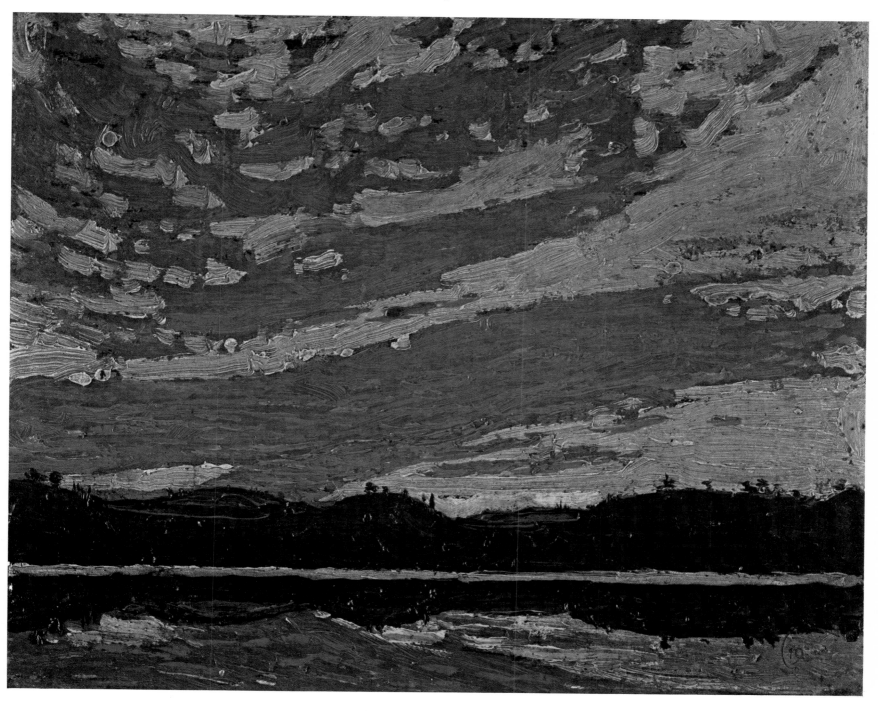

«*Not only did he paint trees and lakes and colours of fall or spring. These were subjects certainly—but they were only visually identifiable ones. It was the lyrical or dynamic sweep and character and colour that he seemed to integrate into a spacious and expressive whole; the mood and poetry as well as the personal character were there. In other words, here was a work of Art—a feeling for the rightness of things that comes from experience.*

«Whilst other painters, more experienced than he, were fighting the composition and the techniques of drawing, tone, colour and representation, sometimes succeeding, often failing to catch an appearance of actuality, Thomson seemed to drift with the mood, surrendering, waiting for the moment of vision. Then his expression moved into action, his colour and design fell into place, and another 8" x 10" panel became a unit of the whole creative plan, and was added to the stockpile. . . .

75 Tom Thomson *Tamaracks* oil on panel 8½" x 10½" 1916 McMichael Conservation Collection

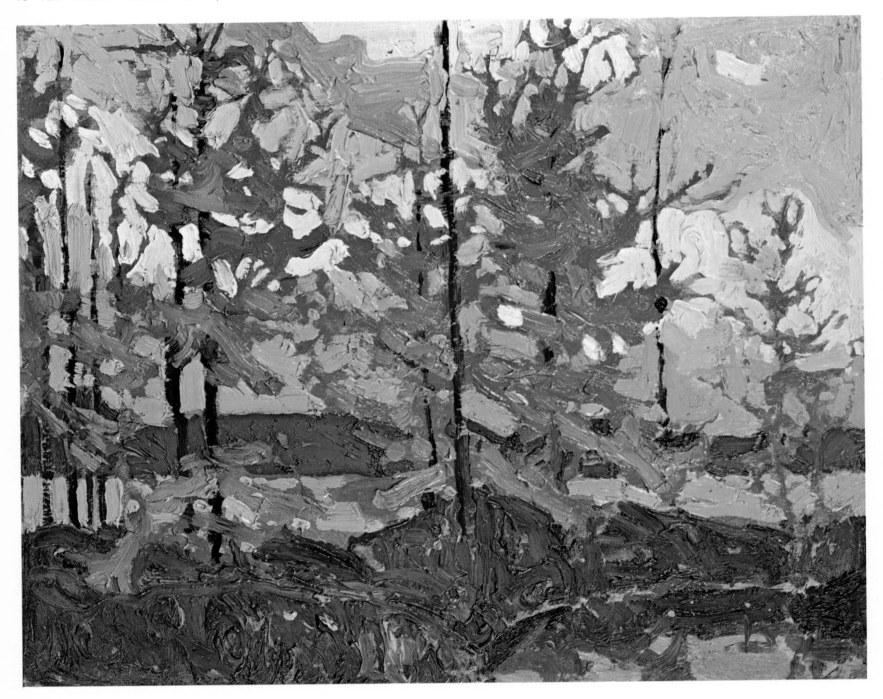

«*Thomson was a sort of Whitman: a more rugged Thoreau if you will, but he did the same things, sought the wilderness, never seeking to tame it but only to draw from it its magic of tangle and season, its changing skyline and its quiet or vigorous moods. He gave it a sense of order, revealing the golden thread of aesthetic symbolism — like music, symphonic. He revealed also the countenance and origins of all such untamed places that one day would be harnessed to industry, ravaged for its timber and metals, leaving scars on the face of the Pre-Cambrian shield, and leading the waters of its rapids into centres of power to light our city life and to turn the wheels of industry.*

«*Thomson in his canoe, with fishline and sketch box, paddling along a shore line looking for something to paint, somewhere to make camp for a night or a week, is a picture to remember of a pioneer who was an artist, and that is a rare combination in our national story.*» [26]

76 Tom Thomson *Tea Lake Dam* oil on panel 8¹/₂″ x 10¹/₂″ 1915 National Gallery of Canada

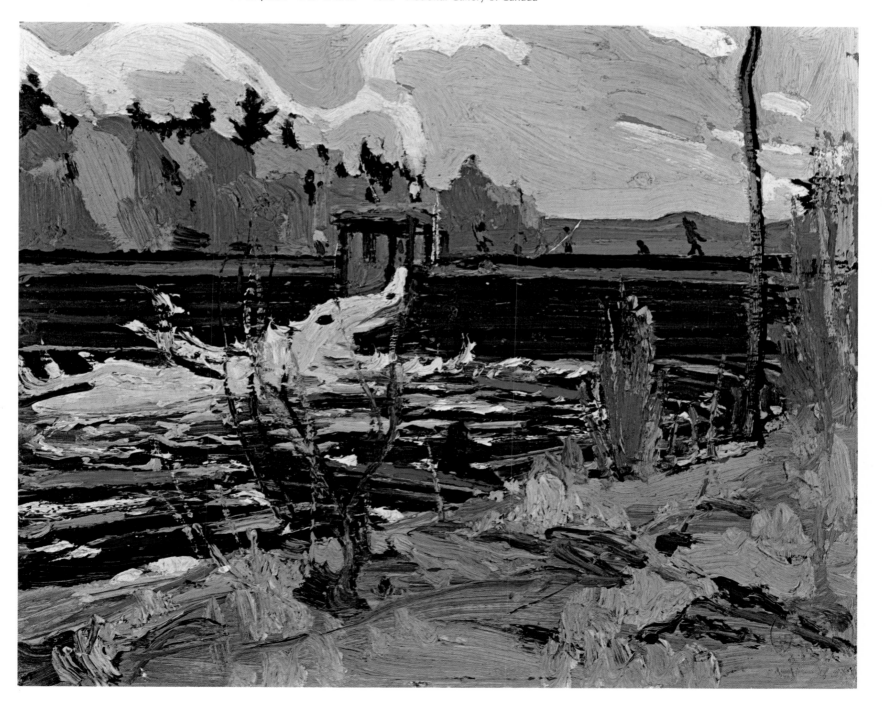

Thomson's deep understanding of nature can be seen in works like *Woodland Waterfall* of 1916-17. The impression is one of having entered into a secluded world which has been seen before only by wild animals as they drink in the pool below the falls. It is a landscape where the presence of man is never felt, yet nature is neither threatening nor awe-inspiring. With a few deft changes to the scene before him, Thomson is able to impose order on an intrinsically disorganized setting, while maintaining its complete naturalness.

Waterfall is a preview of the Group's work in years to come. The bold painting of the foreground rocks and the thick rich colours appear at about the same time in MacDonald's work and were probably due to an interchange between the two artists. The dabs of pure red which form an arc across the lower part of the painting reappear a few years later in Jackson's *First Snow Algoma,* and the stylized treatment of the waterfall can be found in Harris' *Waterfall Algoma* in 1918. The strong decorative quality, combined with a feeling for mood, became the trademark of the Group's work. This is not to say that Thomson was the originator of the Group's style, for he developed these qualities through a constant interchange with the other artists. In the years after his death, he was seen by many as the founder of the Group, and Jackson felt obliged to write Eric Brown, to set the record straight: "Thomson was quite enough of a miracle without making us into mere disciples and followers for the sake of contrast. . . . He owed just as much to MacDonald as later MacDonald owed to him and Thomson is none the less great for being less mythical."[28] However, Thomson was a remarkably intuitive artist, often well ahead of his friends, who were probably more hindered than helped by their academic training.

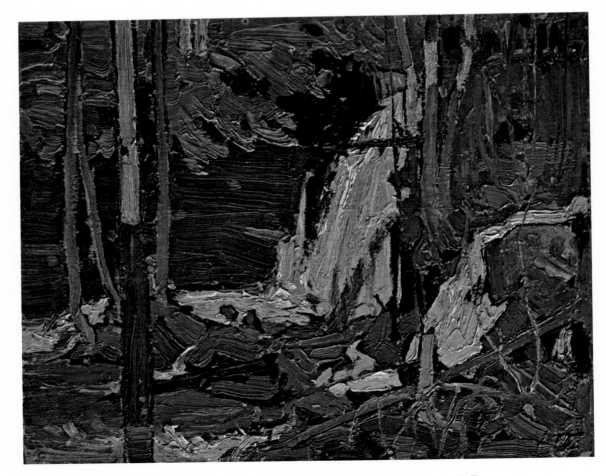

77 Tom Thomson *The Waterfall* oil on panel 8½″ x 10½″ 1916 Vancouver Art Gallery

78 Tom Thomson *Woodland Waterfall* oil on canvas 48″ x 52″ 1916 Private Collection, Toronto

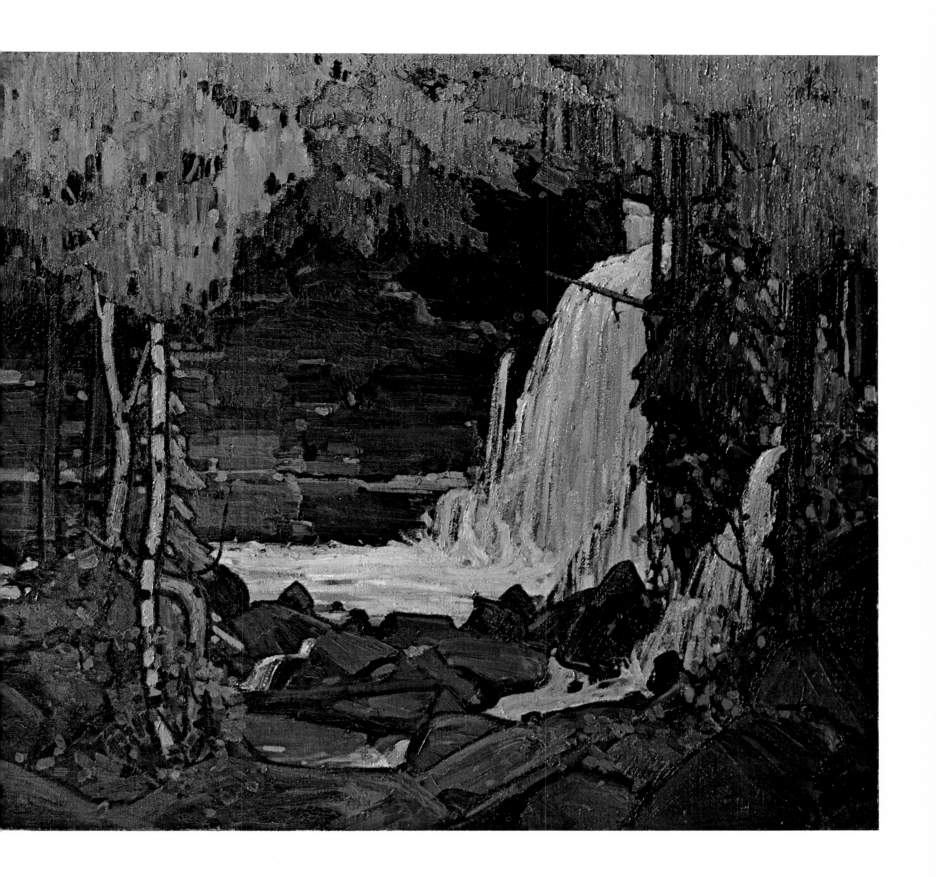

«He saw a thousand things – animals and birds, and signs along the trail that others missed. He knew where to find sub-jects – a stretch of muskeg, a fine stand of pine with possibilities for the kind of thing he wanted to paint. He could drop a line in places, and catch a fish where other experienced fishermen had failed. He identified a bird song, and noted changes in the weather. He could find his way over open water to a portage or a camp on a night as black as ink. It was this sense of awareness and significance of simple sights and sounds, his uncanny sensitivity carried over into his paint-ings and sketching that gave the authentic tang to his work.»[29]

West Wind and *Jack Pine* are familiar favourites, which stand for many as a symbols of Canadian art, if not for Canada itself. It is difficult to look at these works with fresh awareness, because they have been so widely exposed.

A comparison between the sketch and the finished painting of the *West Wind* shows Thomson's strengths and weaknesses. The canvas has none of the freshness of the sketch, but it is more successful in conveying mood. The colours are deeper and more sombre, but the majestic purples and blues are more suitable for a monumental and stormy scene. The abstract shapes of the green patches of fir create a sweeping movement, which curves down in a nearly full circle from the upper right to the centre foreground, and is stopped by the hump to the right of the tree. Tension is built up by the cyclonic swirl of the branches and the storm-bent tree. The turbulent sky and water produce a dynamic force moving from right to left across the canvas. If Thomson had not provided an effective means for stopping this powerful movement, the painting would be disturbing to look at. However, the curve of the tree goes full circle and creates a force in the other direction.

The lone pine, bending under the fierce wind, with the white caps on the water and storm clouds rushing overhead, cre-

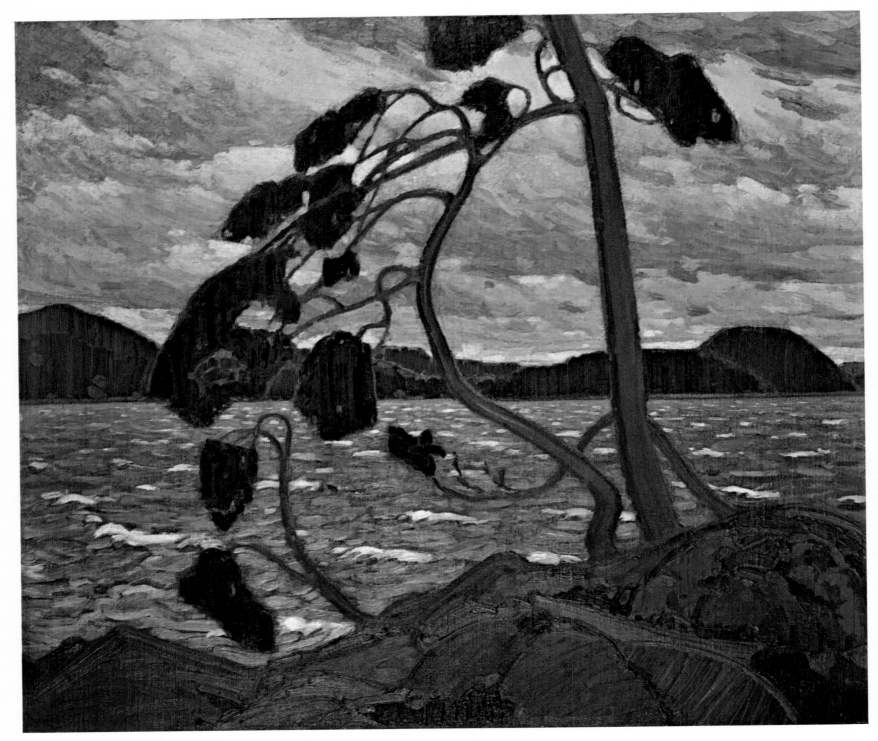

79 Tom Thomson *The West Wind* oil on canvas 47¹/₂″ x 54¹/₈″ 1917 Art Gallery of Ontario

ates a dramatic symbol for the North. Once again Thomson develops the theme of *Northern Lake* and previews the later Georgian Bay series by Varley and Lismer.

Jack Pine is one of Thomson's last and best-known canvas. Although it represents almost exactly the same scene as *West Wind*, it is completely different in character. Both works are a view toward the west end of Grand Lake, Algonquin Park, and were sketched while Thomson was working there as a park ranger in the summer of 1916.[30]

In contrast to *West Wind*, which is filled with restless movement, *Jack Pine* conveys perfect serenity. It is evening – the sky and lake are perfectly calm and are painted in broad, flat horizontal strokes. Even the soft mauves, pinks, and greens contribute to this effect. Countering the strong horizontals are the drooping red tendrils of the bare pine branches, the vertical lines of the trees, and the curves of the hills.

Once again it is the lone pine in the foreground which dominates the canvas and unites the elements of sky, land, and water. Thomson's development from *A Northern Lake* (1913) to this simple and effective statement took place in three short years. In this canvas he achieves pure poetry in painting, by combining an intuitive feeling for nature with an almost classical control of technique.

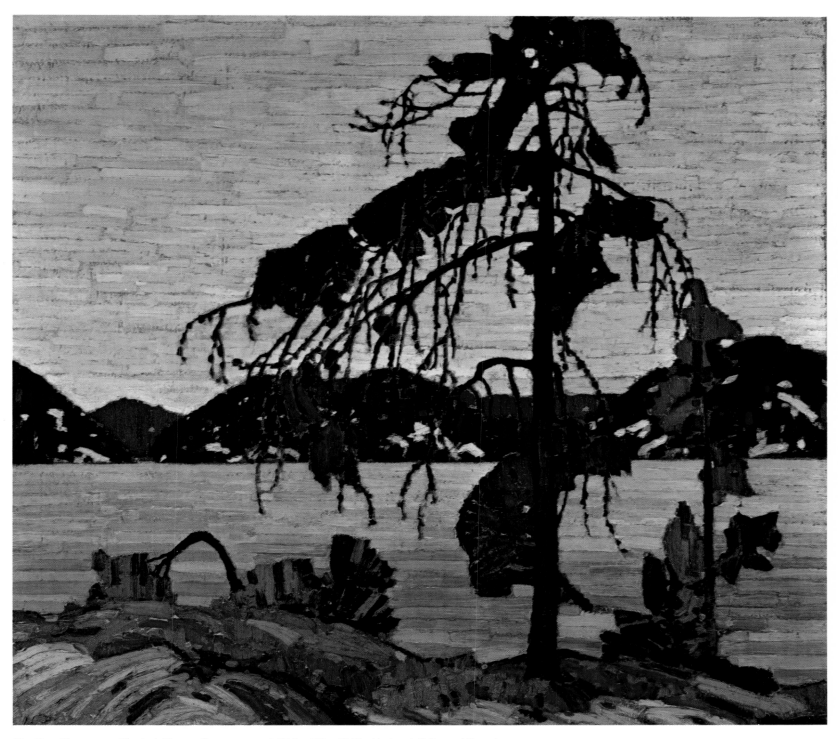

80 Tom Thomson *The Jack Pine* oil on canvas 50¼″ x 55″ 1917 National Gallery of Canada

TOM THOMSON'S LAST LETTER
TO DR. MacCALLUM – JULY 7

«*I am still around Frasers and have not done any sketching since the flies started. The weather has been wet and cold all spring and the flies and mosquitoes much worse than I have seen them any year and fly dope doesn't have any effect on them. This however is the second warm day we have had this year and another day or so like this will finish them. Will send my winter sketches down in a day or two and have every intention of making some more but it has been almost impossible lately. Have done a great deal of paddling this spring and the fishing has been fine. Have done some guiding for fishing parties and will have some other trips this month and next with probably sketching in between.*»[31]

This letter was written to Dr. MacCallum the day before Thomson died. A few days earlier he and Mark Robinson had discovered a wily old trout in the river below Joe Lake Dam. They had a friendly competition to catch the fish, but it continued to outsmart them. Finally, as a practical joke, Thomson decided to go to another lake, catch a big trout, and pretend that it was the one they had been looking for. He set off from Mowat Lodge dock in the early afternoon of July 8 and was last seen paddling around the bend. That evening he did not return, but no one was worried, because he had food and a groundsheet with him. The next day Thomson's upturned canoe was found, and a search party was formed. At worst, his friends thought that he might have broken a leg or had an accident. However, the search continued for a week, and there was still no sign of him. It was not until July 16 that his body was found.

Who met Tom Thomson on that stretch of grey lake, screened from all eyes, that July noon?
Who was it struck him a blow across the right temple—and was it done with the thin edge of a paddle blade?—that sent the blood spurting from his ear?
Who watched him crumple up and topple over the side of the canoe and sink slowly out of sight without a struggle?[32]

Was Tom Thomson murdered? Did he commit suicide? Was it an accident? The mysterious events surrounding his death, the inquest, and his burial have led to endless speculation on what actually happened. Recent films and books have carefully examined every gory detail, usually in an attempt to suggest that he was murdered.[33] The answer will probably never be found, and aside from morbid curiosity it is irrelevant to a discussion of Thomson's art. Murdered or not, his career as an artist was abruptly terminated, and what remains are the works he created during his lifetime.

With his death, Thomson became the great Canadian hero, both through his works and his personality. Viewed through his art he appeared to have devoted his life to painting his country in a new and virile way. Since he had never been to art school or to Europe, everyone admiringly concluded that he was a self-taught painter who went alone into the woods and painted what he saw. His death was all the more poignant because he was just beginning to find himself as an artist.

Adding to the romantic legend was the image of Thomson as a shy and lonely artist who lived a solitary existence, working in his shack during the winter and in the North during the summer. To those who didn't know him, he may have appeared reserved and moody, but to his friends he was a warm and generous person, with a quiet sense of humour. He craved friendship and acceptance, but at the same time he was a loner.

Thomson's enigmatic personality captured the imagination of all Canadians. He came the closest of any artist in Canada to what was generally considered to be the romantic artistic temperament. He was the brooding creative genius, who would go for weeks without being able to paint, or who would throw his sketches into the bushes in impotent rage when he wasn't satisfied with them.

Above all, Thomson represented the antithesis of the refined and sophisticated city artist who spends his time locked in his studio. Unlike these ivory tower aesthetes, Thomson was a man of the North; his abilities as a woodsman were legendary, even among the professional guides. He was reputed to have the reactions of an Indian in the wilderness and to know intimately the habits of wild animals and the songs of the rarest birds. He often told the story of how he once was picking raspberries on one side of a log while a big black bear was picking them on the other side. And many of his friends heard about the time a huge timber wolf came up to him in the bush, sniffed him over, then went on its way.[34]

The legend of Thomson as a mythical figure is an appealing one, and nearly all the writing on him continues to add to it.[35] Canada has few enough romantic heroes, and there is something to be said for preserving this image. However, Thomson was also a human being and a man of his times. To over-romanticize his accomplishments is to lessen the importance of his art and of his impact on those around him.

TO THE MEMORY OF
TOM THOMSON
ARTIST WOODSMAN
AND GUIDE
WHO WAS DROWNED IN CANOE LAKE
JULY 8TH 1917
HE LIVED HUMBLY BUT PASSIONATELY
WITH THE WILD IT MADE HIM BROTHER
TO ALL UNTAMED THINGS OF NATURE
IT DREW HIM APART AND REVEALED
ITSELF WONDERFULLY TO HIM
IT SENT HIM OUT FROM THE WOODS
ONLY TO SHOW THESE REVELATIONS
THROUGH HIS ART AND IT TOOK
HIM TO ITSELF AT LAST
HIS FELLOW ARTISTS AND OTHER FRIENDS AND ADMIRERS
JOIN GLADLY IN THIS TRIBUTE TO
HIS CHARACTER AND GENIUS
HIS BODY IS BURIED AT
OWEN SOUND ONTARIO NEAR
WHERE HE WAS BORN
AUGUST
1877

In 1916, the year before Thomson's death, MacDonald found himself defending the new art movement on his own. A major confrontation with the press occurred shortly after the *OSA* show opened in March of 1916. Many of the reviews were favourable, but Hector Charlesworth responded with his first attack on MacDonald and the Group in an article entitled "Pictures That Can Be Heard."[36] His main concern was whether an artist should be allowed to experiment freely and to break totally with convention. Although generally sympathetic to the new approach, he feared that unchecked individualism would result in chaos. It is difficult to appreciate this attitude in the present age of total permissiveness, but Canadians were considerably more cautious and conservative at that time than they are now.

A week later, MacDonald published his own reply to the critics, entitled "Bouquets From a Tangled Garden."[37] This set the pattern for future forays and firmly impressed MacDonald's work on the mind of the public. MacDonald, a shy and sensitive individual, was pushed into the limelight and called the most radical member of the Group, a title which he did not want (especially since it made it even more difficult for him to sell his works, at a time when he desperately needed money). As a result, MacDonald came to play the same role as Manet had with the Impressionists. Like Manet, he bore the brunt of the criticism and became a rebel in spite of himself. In his unwanted role as revolutionary, he was looked up to as a leader by the younger artists.

CHARLESWORTH –
«PICTURES THAT CAN BE HEARD»

«*The chief grudge that one has against these experimental pictures is that they almost destroy the effect of very meritous and sincere pictures which are hung on the same walls. The chief offender seems to be J.E.H. MacDonald who certainly does throw his paint pots in the face of the public. That Mr. MacDonald is a gifted man who can do something worthwhile when he sets his mind to it, is shown in his* Laurentian Village, October *which is well composed and rich and subdued in colour. Across the gallery from it, however, is his* Tangled Garden *which a discriminating spectator attempted to praise by saying it was not half so bad as it looked. In the first place the size of the canvas is much too large for the relative importance of the subject, and the crudity of the colours, rather than the delicate tracery of all vegetation seems to have appealed to the painter; but it is a masterpiece as compared with* The Elements *or* Rock and Maple *which for all they really convey might just as well have been called* Hungarian Goulash *and* Drunkard's Stomach. *Mr. MacDonald's impulse has also infected a number of other talented young artists, who seem to think that crudity in colour and brush work signify the qualities 'strength' and 'self-expression.'*»[38]

«*One makes no claim that* The Tangled Garden *and other pictures abusively condemned by the critics are genuine works of art merely because of their effect upon them, but they may be assured they were honestly and sincerely produced. Their makers know when 'vaudeville ideals' are in keeping. If they planned to 'hit' anyone anywhere it was in the heart and understanding. They expect Canadian critics to know the distinctive character of their own country and to approve, at least, any effort made by an artist to communicate his own knowledge of that character. One is also justified in retorting that there are apparently 'vaudeville ideals' in journalistic art criticism. The work of the critics is not without a suggestion of the slap-stick and the Charlie Chaplin kick. They affect to 'hear' pictures, to 'smell' them, and to taste them, but it must be granted that they do not claim to have seen the pictures they criticize adversely, their sensibilities apparently being too shocked for proper action. And have they not overlooked the ethical consideration? One would not plead for the exemption of pictures from adverse criticism, but it seems only right that such criticism should be kept within limits that are now frequently unobserved. A ribald and slashing condemnation without justifying analysis, of any picture approved and hung by a committee of artists is rarely, if ever, necessary in the public interest. The exhibiting of a picture does not force it on the critic. He is asked to share it. The artist is not paid to exhibit his picture. It is his stock in trade and certainly should not be flippantly lowered in the estimation of the public. Yet this is done regularly by critics. Men to whom a tangled garden is as foreign as an Indian jungle, who are better acquainted with the footlights than with the sunlight... of an October morning, who were perhaps "Dancing Around With Al Jolson" when the artist was experiencing the dramatic elementalism of Georgian Bay, will gaily bang the painter with their windy bladders and whoop about 'the sincere passion for beauty,' 'Crudity of colour,' 'experimental,' 'comfortable' and 'interpretative' pictures.*

Tangled Garden, Elements and a host more, are but items in a big idea, the spirit of our native land. The artists hope to keep on striving to enlarge their own conception of that spirit. And they remember sometimes, 'that the best in this kind are but shadows, and the worst are no worse, if imagination amends them.'»[39]

MacDONALD –
«BOUQUETS FROM A TANGLED GARDEN»

In accusing MacDonald of throwing a pot of paint in the public's face, the critics used the same accusation that Ruskin had used against Whistler many years earlier. However, *Tangled Garden* was not a pot of paint flung wildly at the canvas; it was the result of long and careful study. Mac-Donald had been sketching flowers for years, especially since his move to Thorn-hill in 1913. Extensive preparatory studies were made in pencil and oil for *Tangled Garden,* which was painted in the garden behind his house. Despite the apparent confusion of the painting, the composition is carefully organized, with the trees and sunflowers forming a triangular framing element for the more open space in the centre. The areas of light and shade are used for the same effect, adding further coherence to the composition.

One of MacDonald's sources of inspiration may have been the tapestries he had seen in the Scandinavian show and in magazine illustrations, for he was interested in the flat, decorative treatment of space demanded by the tapestry medium.[40] Thomson had explored his idea a year earlier in his *Northern River,* and he may have had some influence on MacDonald, as the two artists had been very close.

Like the tapestries, *Tangled Garden* does not have the traditional recession in depth, but has a movement from the bottom to the top of the canvas. The flat, dark foreground area gives the appearance of being very close to the spectator. Behind this is the middle ground with its many shrubs and flowers and, higher up, the flat facade of the barn, which seems to push up against the dense foliage. The eye is forced upwards by the tall sunflowers, which unite the three areas. The central flower is bathed in the soft evening sunlight, and the ones to the right and left are in shade.

Together, they create a screen through which the rest of the composition is seen, serving the same purpose as the spruces do in Thomson's *Northern River.*

Tangled Garden was decried as a radical work because it broke from the academic type of flower paintings that were popular at the time. Charlesworth complained that "the size of the canvas is much too large for the relative importance of the subject, and the crudity of the colours, rather than the delicate tracery of all vegetation seems to have appealed to the painter."[41] MacDonald himself missed the central issue when he retorted that "every one of these pictures is sound in composition. Their colour is good, in some instances superlatively good; not one of them is too large."[42] No one at that time recognized the significance of the break this painting made with the conventional formulas, or the threat it posed to established tradition.

85 J. E. H. MacDonald *The Tangled Garden* oil on board 48″ x 60″ 1916 National Gallery of Canada

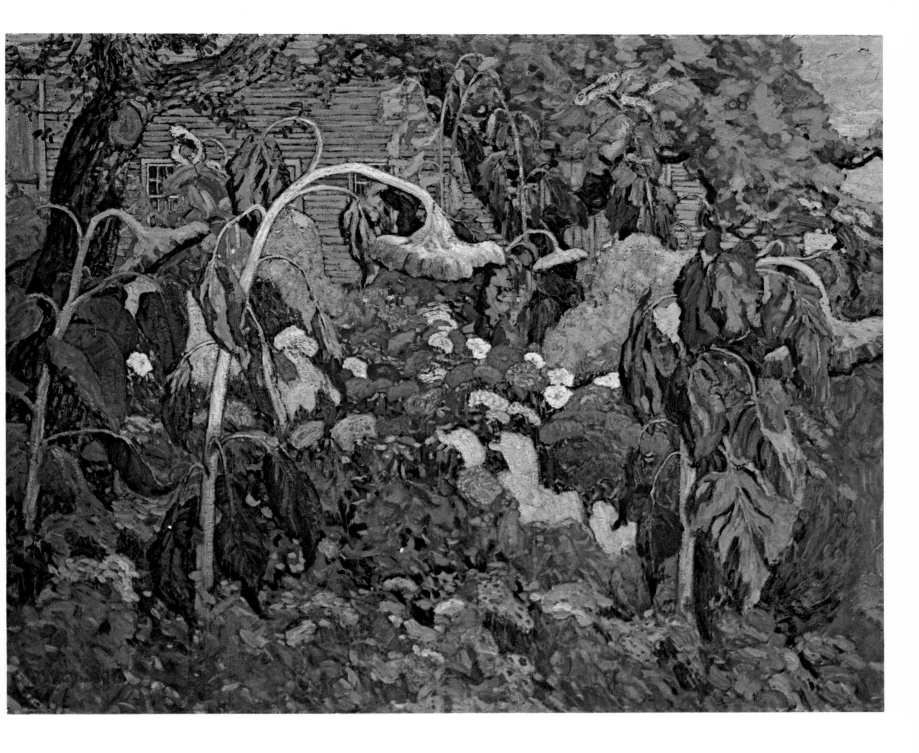

84 Detail of J. E. H. MacDonald *The Tangled Garden*

THE ELEMENTS

«*In* The Elements *the artist breaks loose again in a whirl of chaotic shapes, where the clouds are as rocks and the rocks and vegetation and humans are in one convulsive whirl that certainly suggests an agitation of these same elements.*»
Toronto Star, *March 11, 1916*

«*Mr. J.E.H. MacDonald has shown one painting that bears the title* The Elements, *which is almost post-impressionistic in its lack of realism. It represents two men, or at least it looks like two men, who have lighted a fire among the rocks on a very windy day. All the lines are grotesque, the artist having apparently laboured to secure this effect, and the colours of the various elements are challenging in the extreme. Although the picture is not realistic, it does suggest a driving gale.*»
Mail & Empire, *March 11, 1916*

The Elements was exhibited in the 1916 OSA show with *The Tangled Garden,* and was equally disturbing to the critics. It is basically a continuation of MacDonald's earlier experiments in *The Lonely North* of 1913. This is evident in the sky of *The Elements* which is based on an early 1913 sketch called *The Elements, Laurentians* (now in the McMichael Conservation Collection). The location for *The Elements* is Georgian Bay, with a view toward Jack Knife Island, north of Split Rock. The main emphasis is on the black storm clouds sweeping overhead and on the swaying pine trees. Near the centre of the composition are two figures huddling around a fire for warmth. In contrast to the vigorous movement of the upper part of the painting, the lower area of rocks and inlet is relatively calm and peaceful.

Little is known of MacDonald's activities during the year following the *OSA* show in March, 1916. He was very friendly with Thomson at the time; and of all the Group, MacDonald was probably the most deeply affected by his tragic death. In the fall of 1917 he helped to catalogue the four hundred works still in Thomson's possession, and to build the cairn for Thomson at Canoe Lake. While working on the cairn he suffered a physical collapse and possibly a stroke, which kept him bedridden for months. During his convalescence he turned to writing poetry with the encouragement of Barker Fairley, who had become a close friend of the Toronto group. After a long and gradual recovery, MacDonald was well enough by the fall of 1918 to accompany Harris and Johnston on the first boxcar trip to Algoma.

86 J. E. H. MacDonald *The Elements* oil on board 28″ x 36⅛″ 1916 Art Gallery of Ontario

While Thomson lived out his last years in Algonquin Park, and MacDonald continued to struggle in Toronto, the activities of the other artists became fragmented because of the war. The Battle of Ypres in April and May of 1915 had made it clear that there would be no early victory, and the numerous Canadian casualties awakened a call to arms at home. Jackson enlisted in June as a private in the 60th Battalion, and was sent overseas in November. Harris joined up in the summer of 1915, and taught musketry at Camp Borden. He suffered a physical collapse in 1917 after his brother was killed, and he was discharged shortly afterwards. Varley worked for Rous and Mann until he went overseas in 1918 to paint for the War Memorials. Lismer moved to Halifax in 1916 to become principal of an art school and did not take any part in the war until he joined the War Memorials in 1918.

The Canadian War Memorials was formed in 1917 to make a pictorial record of Canada's role in the war.[43] It was conceived by Sir Max Aitken, later Lord Beaverbrook, who was already in charge of the War Records. The first artists to be involved in the project were all British, including such notable painters as Paul Nash and Wyndham Lewis. Presumably, Canadian artists were not considered capable enough for the job, because none were commissioned until much later. Among the artists to go overseas for the War Memorials were Cullen, Morrice, David Milne, and Bill Beatty. The only two members of the Group who painted the front line action were Jackson and Varley; the remainder, including Lismer and Johnston, painted the home front.

It was hoped that the war paintings would boost the sagging spirits of the Canadians and produce a record for future generations. However, not everyone was in favour of the scheme, which seemed extraneous to a life and death struggle for survival. In addition to the expense involved, the army was not eager to have artists getting in the way of the serious fighting. Many people felt that the whole idea was a failure, because after the war most of the 850 works produced were stored away in a basement and completely forgotten for years to come.

JACKSON

Jackson was the only member of the Group to see action as a soldier. But he was wounded soon after he arrived at the front in June of 1916, and was sent back to England to convalesce. In 1917 he was about to be shipped out again when he received an order to report to Lord Beaverbrook in London. Beaverbrook appointed him to the staff of the Canadian War Memorials and promoted him to the rank of lieutenant. Shortly afterwards, he was sent to France to make sketches for some paintings.

What to paint was a problem. There was nothing to serve as a guide. War had gone underground. There was little to see. The old heroics, the death and glory stuff, were obsolete; no more "Thin Red Line" or "Scotland Forever." The Impressionist technique I had adopted in painting was now quite ineffective; visual impressions were not enough. I had no interest in painting the horrors of war, and I wasted a lot of canvas.[44]

Earlier battle scenes usually represented the heroics of Wolfe dying on a battlefield, Napoleon leading his troops, or a grandiose cavalry charge. The First World War changed that, because it was a different type of war with a battlefront of 400 miles. The soldiers spent long months in the trenches surrounded by nothing but rain, mud, and death. Some artists continued to paint heroic scenes with titles such as *Over the Top* or *Charge of Flowerdew's Squadron*, but they were mostly empty, rhetorical paintings of little artistic value.

Jackson did not want to paint the action and drama of the front line, and his early paintings reflect a complete reaction to the horror of war. One of his favourite works from this period is *Springtime in Picardy,* depicting a peach tree blooming in the courtyard of a smashed-up farm house. The use of bright colours, the lively brush strokes, and rhythmic forms are almost suggestive of Van Gogh and the Post-Impressionists. Despite the presence of the two soldiers and the ruined building, the mood depicted is one of a pleasant spring day.

87 A. Y. Jackson *Springtime in Picardy* oil on canvas 25⅝'' x 30½'' 1918 Art Gallery of Ontario

There are many who criticize Jackson and the other Canadian artists for ignoring the harsh realities of the war. It is true that some of them did little more than paint pretty landscapes with a few picturesque ruins, adapting their native techniques to a European setting. Despite the presence of bloodshed and suffering all around them, they showed no inclination to paint it, or to reveal that they were moved by it in any way.

But the efforts of the Canadian war artists should not be dismissed without a fair trial. Some of their paintings show another side of the war, one which is less heroic, but none the less real. One example is Jackson's *A Copse, Evening*, which reflects a later statement he made about the war:

Up the line one was conscious of so much more than visual impressions. Hell Blast Corner could look serene and colourful on a spring day and one could find colour harmonies on the Green Crassier, but these were only minor truths, which con-fused one trying to render an equivalent of something crowding on all the senses.[45]

In *A Copse, Evening*, the countryside is a mere succession of bumpy knolls, with shattered tree stumps, a few figures, and searchlights probing the dark sky. There is an eerie, phosphorescent beauty to the scene which is heightened by its intrinsic ugliness. Here is one side of the reality of war, a reality in which "it was not death they dreaded. Sometimes that was welcomed. It was the mutilation of the mind."[46]

Varley did not get to the front until late 1918, but was deeply moved by what he saw of the war. An extremely sensitive individual, he responded in a direct way to its more tragic side. With almost no previous experience in painting a finished composition, Varley produced his first large canvas entitled *For What?*. It represents a burial party preparing graves for another load of corpses, which are piled into a cart. One of the gravediggers pauses in his work and looks over at the cart. The air is filled with an aura of stillness and death. The gloomy, olive-green colouring adds to the tragic mood. It is essentially an old-fashioned picture in the narrative tradition and is readily intelligible, even without the title. Yet this unsophisticated approach is somehow perfectly appropriate and results in a powerful work where emotions, technique, and intent are in complete accord.[47]

«*I was in Ypres the other day — in Maple Copse and Sanctuary Wood — you pass places such as Piccadilly or Hell Fire Corner and you follow up a plank road and then cut off over a festering ground, walking on the tips of shell holes which are filled with dark unholy water. You pass over swamps on rotting duckboards, past bleached bones of horses with their harness still on, past isolated rude crosses sticking up from the filth and the stink of decay is flung over all. There was a lovely wood there once with a stream running thro' it but now the trees are powdered up and mingle with the soil. One or two silly maimed stumps are left, ghastly mockeries of what they were. . . .*

«*I tell you, Arthur, your wildest nightmares pale before reality. How the devil one can paint anything to express such is beyond me. The story of War is told in the thousand and one things that mingle with the earth — equipment, bits of clothing almost unrecognizable, an old boot stuck up from a mound of filth, a remnant of sock inside, and inside that — well, I slightly released the boot, it came away in my hand and the bones sifted out of the sodden rag like fine sand. Ashes to ashes, dust to dust. I find myself marvelling over the metamorphosis from chrysalis to butterfly but I never get beyond marvelling. . . .*»[48]

88 A. Y. Jackson *A Copse, Evening*
oil on canvas 34″ x 44″ 1918
National Gallery of Canada

89 F. H. Varley *For What?*
oil on canvas 58¼″ x 72¼″ c. 1918
National Gallery of Canada

Varley painted three other major works on the war. *Some Day the People Will Return* deals with the civilian side of the war. This painting of a cemetery in Belgium that has been blown up by shells makes a powerful comment on the brutality of a war that leaves nothing untouched, even the dead. But the flowers that grow up out of the ruin indicate there is hope for the future. Once again Varley's work is a restrained and clear statement of great simplicity.

German Prisoners is somewhat less effective than the other works, but still conveys the desolation of the landscape, with its shell-torn trees, and remnants of wheels and bodies. The straggling prisoners, the broken wheel, and the time of day suggest the dreary, endless nature of the war.

By the time he painted *The Sunken Road*, Varley had advanced to a point where he could use a more modern approach to the tragic theme of death found in *For What?*. The scene focuses on the dead bodies sprawled on the ground, which are all the more disturbing because of their anonymity. At the upper left is the somewhat obvious symbol of a rainbow, suggesting resurrection or rebirth. Unlike the gloomy colours in *For What?*, Varley has painted *Sunken Road* with a bright blue sky and light creamy colours for the earth, contrasting with splashes of red blood on the corpses. Despite the fresh Impressionist treatment, and the impersonality of the bodies lying in a sun filled landscape, the scene has an great emotional impact.

Until the present, there has never been any doubt that Varley witnessed this scene and painted it as he saw it. For this reason it comes as a surprise to find that the main source for the work was a photograph. The accompanying photograph repeats exactly the arrangement of the dead corpses, and there can be no doubt that Varley used it as the basis for the painting. This does not detract from his work, but demonstrates how Varley was able to go beyond the photograph to make a powerful statement about the war. As one critic said, "There is nothing here of sentiment, nothing indeed of personal passion. We find a massive objectivity, a sense of all pervading tragedy, of human will overpowered by Fate."[49]

90

91

90 F. H. Varley *Some Day the People Will Return*
oil on canvas 72" x 90" 1918
National Gallery of Canada

91 F. H. Varley *German Prisoners*
oil on canvas 50" x 72³/₈" c. 1918
National Gallery of Canada

92 Photograph of the Dead, used as a study
for *The Sunken Road* c. 1918

93 F. H. Varley *The Sunken Road* oil on canvas 52″ x 64½″ c. 1919 National Gallery of Canada

Back in Canada, other artists were working for the war effort. Some painted ships being built in the yards, and others, like MacDonald, worked on war posters. Frank Johnston was asked to contribute to the War Memorials with a painting showing the activities of the Royal Canadian Air Force at their training camp. He made many sketches from the air, and one result was the large painting called *Beamsville*. It is a dramatic view looking down from the air at the clouds and several other planes below, with the shoreline of Lake Ontario twisting its way almost vertically up the canvas. Roads and fields are arranged to provide a sharp recession towards a vanishing point at the top of the canvas, making the effect of height even more pronounced.

Lismer spent most of the war in Halifax, and after being commissioned to the War Memorials in 1918, he painted several scenes of ships in Halifax Harbour. He also executed numerous lithographs of minesweepers, submarine chasers and troop ships. His best-known work of this period is the *Olympic with Returned Soldiers*, which is a favourite mainly because of its subject matter. At first glance, paintings such as *Winter Camouflage* seem totally unrelated to the war, for the camouflaged ships can only be detected on closer view—an ingenious way of avoiding the war theme. The painting is basically a pleasant winter landscape in the old Impressionist manner, with bright pastel colours.

Jackson also painted Halifax scenes when he was sent there early in 1919 to record the troops returning home. He later painted *Entrance to Halifax Harbour,* which was bought by the Tate Gallery, after the Wembley show of 1924.

95 Arthur Lismer *Halifax Harbour — Time of War*
oil on canvas 42″ x 52″ **1916**
Dalhousie Art Museum

96 Arthur Lismer *Olympic with Returned Soldiers*
oil on canvas 48″ x 64″ **1918**
National Gallery of Canada

97 Arthur Lismer *Convoy in Bedford Basin* oil on canvas 36″ x 102″ 1918-19 National Gallery of Canada

98 Arthur Lismer *Winter Camouflage* oil on canvas 28'' x 36'' 1918 National Gallery of Canada

99 A. Y. Jackson *Entrance to Halifax Harbour* oil on canvas 25½'' x 31¾'' 1919 Tate Gallery, London

With the war over, the Toronto artists gradually reassembled into a cohesive group once again. The war had had its effect on all of them. Varley had discovered himself as an artist, and both he and Jackson received acclaim when the War Memorials were exhibited in London, New York, Toronto, and Montreal. The war also broke the earlier dominance of commercial art – as Varley said, "The Commercial taint has been stamped under, and gad, I'm gloating in the hundred and one possibilities of the medium."[50] Most important, the war had caused Canada to emerge as a nation with a new maturity and self-confidence. It had unified the country and given Canadians a sense of identity, both in their own country and in the world at large. This national spirit was to be one of the big factors leading to the formation of the Group of Seven in 1920.

BOXCAR TRIPS TO ALGOMA
A.C.R. 10557

"Could you manage to join me on a sketching trip for two weeks – from about September 20 to October 4? This is an invitation – meaning that it would be a privilege for me to take care of the material end."[51] In this way, the plans for the first boxcar trip to Algoma began to take shape. Harris, the indefatigable enthusiast and organizer, was once again undertaking a new scheme when he sent this invitation to MacDonald in the late summer of 1918.

After his discharge from the army, Harris had gone to Georgian Bay and Manitoulin Island with Dr. MacCallum in the spring of 1918.[52] From there, they took the train up to Sault Ste. Marie and then the Algoma Central to Stop 123, where they were vividly impressed by the scenery. Eager to return, Harris planned another trip and asked MacDonald to join him. A short time later he had more exciting news for MacDonald: "Well James, Me boy, down on your knees and give great gobs of thanks to Allah! Sing His praises, yell terrific halleluyalis. That they may reach even into His ears – we have a car awaiting us on the Algoma Central!!!"[53] Somehow he had managed to persuade the railroad to lend them a car, which could be left on sidings while they stopped to paint. The famous boxcar was painted a brilliant red and had the inscription A.C.R. 10557 in large black letters on the side. As MacDonald said, "That figure became our street number on the long way of the wilderness, our token association with the Company's doings."[54]

The boxcar was as colourful inside as it was outside. It had a little Christmas tree over the main door, and a moose skull hung beneath the window – over this was a spray of evergreens and the motto: *Ars Longa Vita Brevis*. The car was a virtual studio on wheels and was outfitted with bunks, tables, chairs, a stove, and shelves for books and painting materials. It also came equipped with a canoe and a three-wheel jigger for short runs up and down the tracks.

On the first trip, Harris and MacDonald were accompanied by Dr. MacCallum and Frank Johnston. In mid-September they went up to Sault Ste. Marie, then headed north right up the Algoma Central Railroad to Mile 113, where they made their first stop at Canyon. Here they spent several days sketching the dramatic scenery along the Agawa River, with its steep cliffs soaring vertically upwards for hundreds of feet. They would rise early, have breakfast, then set out for a day of exploring and sketching. Two of them would take the canoe and head up the river. The other two would take the "pede" and set off down the track, loaded down with sketching equipment. From Canyon they moved down the line to Hubert, near the falls of the Montreal River, then to Batchewana, where they painted the rapids. They witnessed the exciting change of colour as it swept over the landscape, turning from green to orange to red and finally, to the whiteness of a snow-covered landscape. At the end of September they returned to Toronto with a huge batch of sketches, exhilarated by what they had done and seen.

100 MacDonald and Johnston in Algoma

«Every day advanced the passing of the leaf, and soon our painters had to go in quest of the desirable 'spot of red.' The hills that had been crimson and scarlet with maple were changed to purplish grey. The yellow leaves were following fast. They realized one night of breaking cloud that there was a growing moon, and they looked at old star friends from the car door—the Dipper lying flat among the spruce tops, and one rare night bright Capella dimmed in a jet of Aurora. After such a night the trees could resist no longer, and they saw many a one cast off all her leaves in one desperate shower. Birch woods, that were dense yellow in the morning were open grey by night. But the wild cherry leaves still hung as though the high fifes and violins were to finish the great concert of colour. They were another of the notable little graces of the bush, daintily hung in every shade from palest yellow to deep crimson against the big blue-gold hills of the Montreal Valley.»[55]

101 J. E. H. MacDonald *Leaves in the Brook* oil on panel 8½'' x 10½'' 1919 McMichael Conservation Collection

In May of 1919, MacDonald, Harris, and Johnston held an exhibition of their Algoma paintings at the Toronto Art Gallery.[56] Altogether, the three artists had 144 works on view, including sixteen large paintings – an astonishing production over the period of a few months. A brief introduction to the show described how they had lived in the boxcar and sketched the advancing season. It mentioned that the works done in the studio were "painted as imaginative summaries of impressions made by the country on the mind of the artist."[57] In a statement that previews the first show of the Group of Seven, the artists remarked that they were interested in discovering their own country, but had been ridiculed and criticized for having no traceable connection with nature. However, many of the critics praised this show, and even Hector Charlesworth called it "a display which is at least vital and experimental."[58]

One of the works in the exhibition was MacDonald's *Wild River*, painted below the falls of the Montreal River. It is MacDonald's first Algoma canvas, and although it does not have the freedom and assurance of the later works, it is still a striking painting. It provides a link between the earlier paintings such as *Tangled Garden* and the later *Solemn Land*. Like the early ones, it has a tapestry-like surface, which MacDonald uses to give rhythm and vitality to the work. But there is an expressiveness in the brushwork of *Wild River* not found before.

Wild River had been exhibited a few weeks earlier in the spring *OSA* show, where it received strong criticism. When it was included in the first Group of Seven show one year later, it was criticized for portraying a river that ran uphill: "Mr. MacDonald has done a piece so far removed from realism, from 'photography,' from actual nature – rivers do not flow uphill, even climb over a hump – that one wonders if Canadian art will ever grow so much more radical that the *Wild River* will appear as conventional as the *Tangled Garden*."[59]

Augustus Bridle described *Wild River* in his article "Are These New Canadian Painters Crazy": "Here we have chameleon rocks and scarlet foliage, crooked spruces that suck under stones and honey-like jazz of wild water half way between a ripple and foam."[60] But his comments were intended as a compliment – not as an insult.

BARKER FAIRLEY ON MacDONALD «*J. E. H. MacDonald cannot have expected to escape criticism with his* Wild River, *but in view of his known versatility and power, the criticism might have been more intelligent or tentative. For my own part I find it difficult to reconcile the flat planes of the picture with its unrestful texture. There is strength in this uneasy tapestry with the two giant pines clamped across it but there is not that intense hold on reality that MacDonald's admirers cannot help looking for. Not, of course, the literal photographic reality that some would have, but that deeper reality of his own experience out of which the picture grew. A painter who can saturate his pictures with weather as MacDonald can, crinkling them with blown air, drenching them with moonlight, or smearing them with fierce sun, creates an impatience, which is itself a tribute to his ability, when he works on more hasty and partial lines.»[61]*

102 J. E. H. MacDonald *The Wild River* oil on canvas 53'' x 64'' 1919 The Faculty Club, University of Toronto

SECOND BOXCAR TRIP TO ALGOMA The first boxcar trip was such a success that Harris organized another one in the fall of 1919. This time Jackson took MacCallum's place, and joined Harris, MacDonald, and Johnston as the fourth member. Once again days were spent sketching and exploring the rugged Algoma landscape. Every week or so the boxcar would be moved to another siding, providing them with completely new surroundings.

103 Lawren Harris *Waterfall Algoma* oil on canvas 47″ x 54″ c. 1918 Art Gallery, Hamilton

«The nights were frosty, but in the box car, with the fire in the stove, we were snug and warm. Discussions and arguments would last until late in the night, ranging from Plato to Picasso, to Madame Blavatsky and Mary Baker Eddy. Harris, a Baptist who later became a theosophist, and MacDonald, a Presbyterian who was interested in Christian Science, inspired many of the arguments. Outside, the aurora played antics in the sky, and the murmur of the rapids or a distant waterfall blended with the silence of the night. Every few days we would have our box car moved to another siding.»[62]

104 J. E. H. MacDonald *Algoma Waterfall* oil on canvas 30″ x 35″ 1920 McMichael Conservation Collection

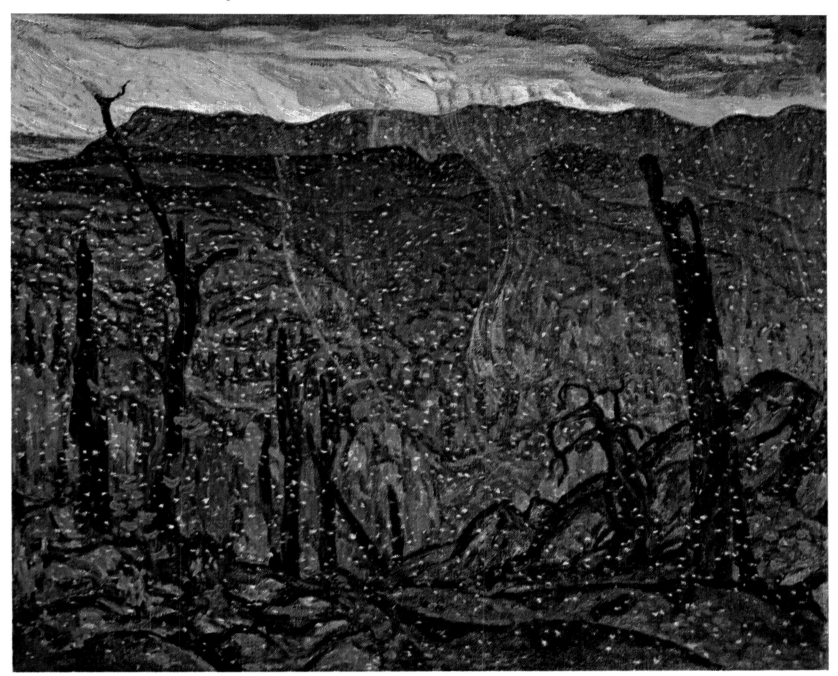

106 A. Y. Jackson *First Snow, Algoma* oil on canvas 42" x 50" 1919-1920 McMichael Conservation Collection

JACKSON – ON SKETCHING IN ALGOMA

«*Seldom was there found a subject all composed and waiting to be painted; out of a confusion of motives the vital one had to be determined upon. Sketching here demanded a quick decision in composition, an ignoring or summarizing of much of the detail, a searching-out of significant form, and a colour analysis that must never err on the side of timidity. One must know the North country intimately to appreciate the great variety of its forms. The impression of monotony that one receives from a train is soon dissipated when one gets into the bush. To fall into a formula for interpreting it is hardly possible. From sunlight in the hardwoods with bleached violet-white tree trunks against a blaze of red and orange, we wander into the denser spruce and pine woods, where the sunlight filters through–gold and silver splashes– playing with startling vividness on a birch trunk or a patch of green moss. Such a subject would change entirely every ten minutes and, unless the first impression was firmly adhered to, the sketch would end in confusion. Turning from these to the subtle differences in a frieze of pine, spruce, and cedar, or the slighter graceful forms of the birch woods, one had to change the method of approach in each case; the first demanded fulness and brilliancy of colour, the second depth and warmth, the next subtlety in design and colour; and these extreme differences we found commingled all through.*»[63]

«Since this country was on the height of land, there were dozens of lakes, many of them not on the map. For identification purposes we gave them names. The bright sparkling lakes we named after people we admired like Thomson and MacCallum; to the swampy ones, all messed up with moose tracks, we gave the names of the critics who disparaged us. It was during this trip that MacDonald made studies for October Shower Gleam *and I got the sketch that I later painted into a large canvas,* October Algoma; *both paintings were acquired by Hart House, University of Toronto.»*[64]

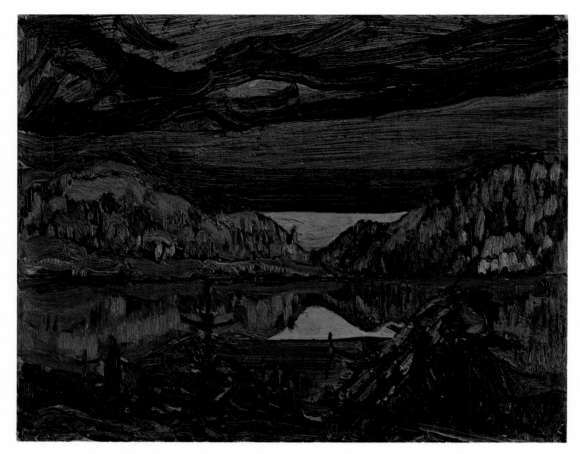

107 J. E. H. MacDonald *October Shower Gleam* (sketch)
oil on panel 8¹/₂" x 10¹/₂" 1920 McCurry Collection, Ottawa

108 A. Y. Jackson *Wartz Lake, Algoma* oil on panel 8¹/₄" x 10 7/16" 1920 Vancouver Art Gallery

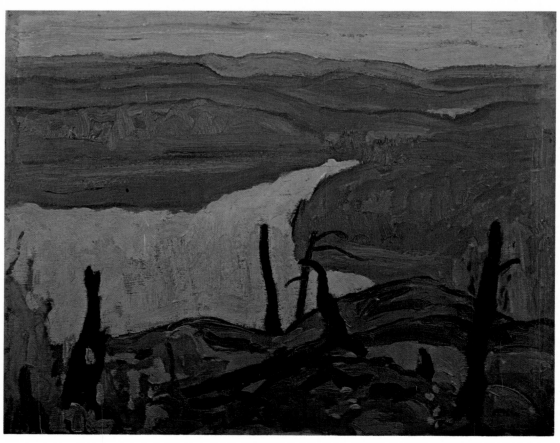

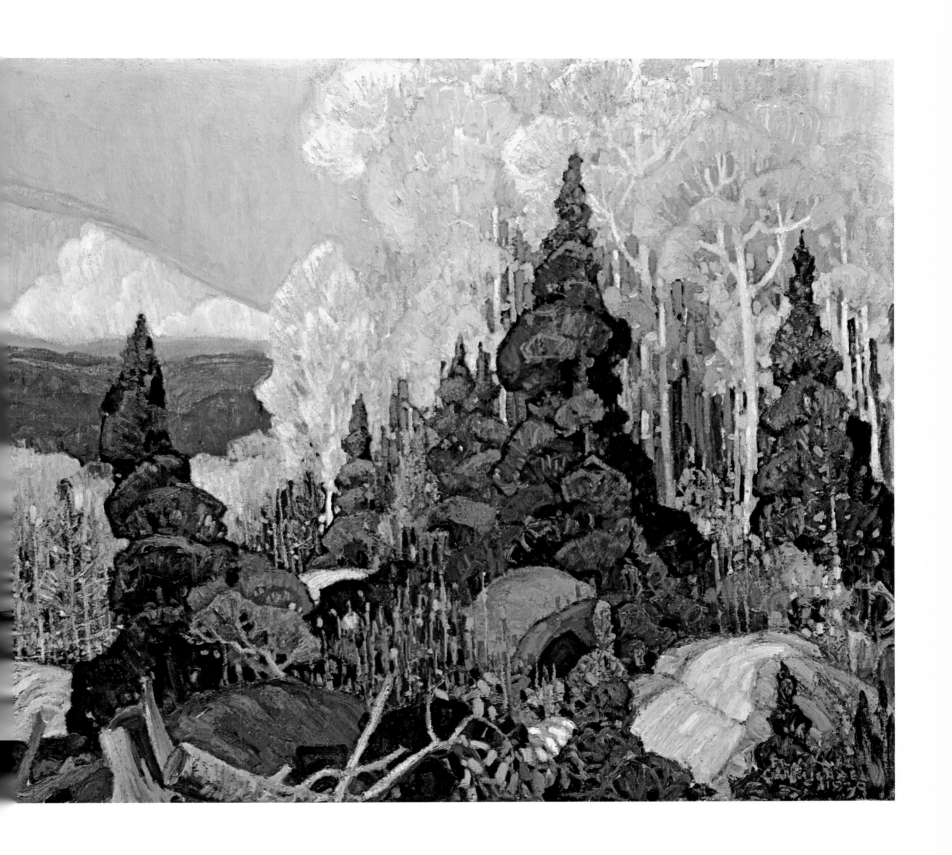

113 Frank Carmichael *Autumn Hillside* oil on canvas 30″ x 36″ 1920 Ontario Heritage Foundation, Art Gallery of Ontario

114 F. H. Varley *Self-Portrait* oil on canvas 24″ x 20″ 1919 National Gallery of Canada

Varley returned from the war matured as an artist and as an individual. He turned towards painting portraits and became the only one of the Group to free himself from a dependency on landscape. Varley was inner-directed and concerned with the world of feeling and emotions. His *Self-Portrait* of 1919 reveals his sensitive and introspective nature, as he stares directly at the spectator with a gesture partly of defiance, partly of sadness. There is not one other serious self-portrait by a member of the Group, indicating their dislike of any type of personal confrontation in their art.[65]

In 1919 Varley also painted a striking portrait of a proud peasant woman, called *Gipsy Head*. The red-orange background forms a dramatic contrast to the woman's jet-black hair and earth-coloured dress. Varley laid on the paint roughly with a palette knife and then scraped it off in several areas – a technique perfectly suited to the strongly modelled face of the sitter. There is tremendous expressive power in the portrait, which captures the gypsy's noble bearing. Despite the apparent originality of the portrait, it was not done without reference to Europe. It is very much in the tradition of the English portraitist Augustus John, whom Varley knew and greatly admired. However, Varley may even have surpassed Augustus John in this bold and simple statement.

116 F. H. Varley *Portrait of Vincent Massey*
oil on canvas 47" x 56" 1920 Hart House, University of Toronto

The work that drew the most comment in the first Group exhibition was Varley's *Portrait of Vincent Massey*. Barker Fairley, a close friend of Varley, had struggled for weeks to secure the commission against the wishes of the conservative members of the establishment, who didn't want a "modernist" like Varley to do the portrait.[66] The work was intended to commemorate Massey's role in building Hart House, which opened in 1919, and was soon to play an important role in supporting the Group of Seven.[67]

The Massey painting showed that Varley was capable of handling a portrait of a very different type from the *Self-Portrait* or *Gipsy Head.* It is one of the first official portraits not to have the stiffness and formality of those from the Victorian era. Varley has painted Massey in an informal suit, casually seated in a chair. Every effort was made to give a feeling of mood — "Mr. Varley has clearly endeavoured to carry the mood over the whole picture so that every square inch of canvas speaks and breathes with the sitter, and places itself in pictorial relation to the face and figure."[68] The cool, blue-grey background isolates the sitter from the world and heightens the distant, almost morose expression on his face.

By painting Massey, Varley established himself as a painter of Toronto's élite society. This brought him much-needed income, but he disliked painting to order, and his bohemian ways soon upset his clients, causing him to fall out of favour. Even the Massey portrait was not without its moments of conflict. At one sitting Massey arrived an hour late. Once he had taken his seat for the portrait, Varley put down his brushes and walked away saying, "You wait there. Now *I'm* going out for an hour." Another incident occurred when he painted Chester Massey. Varley became upset when Mrs. Massey attended the sessions, since "they never even offered me so much as a glass of sherry." Near the end of one sitting, a servant brought two glasses and offered them to the Masseys. When Varley was asked if he wanted a drink, he eagerly said yes. When the glass was brought, to his surprise he found it was hot water. "We always have a glass of hot water before meals," explained Mrs. Massey.[69]

«*His portrait of Vincent Massey, a masterful delineation, has a touch of the same grim fatalism softened by sympathy with the subject; a character in action naturally resilient and sunshiny, in repose sedate and studious, in Varley's treatment bordering on the morose, with a rather irrelevant note of blue and red behind the head, perhaps to balance the sharp note in the colours in the handkerchief and to offset the unoccupied grey area of the background. A remarkable example of intense emotionalism in the painter projected into the subject as an interpretation.*»[70]

PART TWO

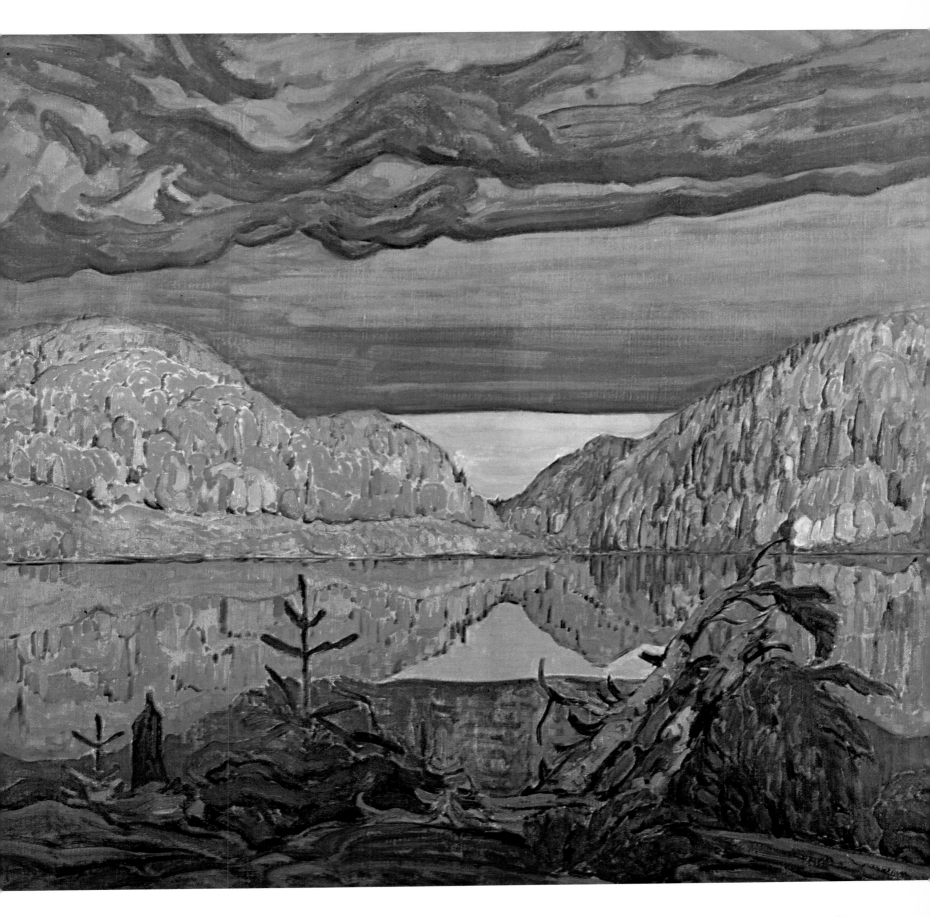

117 J. E. H. MacDonald *October Shower Gleam* oil on canvas 40'' x 48'' 1922 Hart House, University of Toronto

5

The Group of Seven Exhibitions and Nationalism

A FRIENDLY ALLIANCE FOR DEFENCE

With the war over, and everyone back in Toronto, the stage was set for the formation of the Group of Seven. Both the artists and the public had long been aware of a common group spirit. As Jackson said, "Had it not been for the war, the Group would have been formed several years earlier and it would have included Thomson."[1] Until this time they had been known simply as a group of young radicals who were trying to inject new life into the stuffy Toronto art world. They stood apart as a distinct group in all the annual *OSA* exhibitions and were always lumped together by the critics. The 1919 exhibition of Algoma works by MacDonald, Harris, and Johnston marked the first time the artists had exhibited on their own, and the idea for an enlarged group probably grew out of this show. By coming together in what MacDonald called "a friendly alliance for defence," they could hold their own exhibitions and more successfully defend themselves against their detractors.[2]

No one knows exactly when or how the Group came into existence. The decision to form the Group probably was made in February or March of 1920, while Jackson was away sketching at Penetang. When he returned to Toronto at the end of April, he noted that "the first thing I heard . . . was that the Group of Seven had been formed, and that I was a member of it."[3] It appeared that several artists had met one evening at Lawren Harris' house on Queen's Park. Discussion may have centred around the criticism they received in the 1919 Algoma show, and a suggestion made for another exhibition of their own. The problem was, what to call themselves? A title such as the "Algonquin School" or the "Algoma School" would have been too restricting, and one like the "New Canadian School" too pretentious. Since there were seven artists with the same ideas, why not call it the Group of Seven?[4]

In this way the Group came into being and made plans for its first exhibition. As Jackson later wrote, "the organization was a loose one; it had a name and a purpose but it had no officers, no by-laws and no fees."[5] They met formally only a few times each year to make plans for exhibitions and trips or to consider the addition of new members. Otherwise, they gathered informally at the club for lunch and went sketching together once or twice a year. There was a strong feeling of camaraderie, but this became less important as everyone went his separate way during the twenties. It is often forgotten that the "young revolutionaries" were by no means young at this time. When the Group was formed MacDonald was the oldest at forty-seven, and Carmichael the youngest at thirty. All the others were in their mid to late thirties.

118 Installation shot of the first Group of Seven exhibition, May 1920

The first exhibition was held at the Art Gallery of Toronto from May 7 to May 27, 1920.[6] Each artist exhibited a few large canvases and some sketches. In addition to the Seven, there were three invited contributors from Montreal: Randoph Hewton, Robert Pilot, and Albert Robinson. Many of the works in the show have already been discussed: Harris included his *Waterfall*; Jackson exhibited his *Terre Sauvage* of 1913, and Mac-Donald his *Wild River* of 1919. Varley showed his *Sunken Road*; Lismer, *Halifax Harbour–Time of War*, Johnston, *Fire-Swept, Algoma*; and Carmichael, *Autumn Hillside*.

The introduction to the catalogue was essentially an apology, stating that the artists were trying to paint Canada in a new way and to produce something vital and distinctive. They realized that this would inevitably meet with "ridicule, abuse or indifference," but they hoped that some individuals would see the necessity of having an art that interpreted the spirit of national growth. What they feared most was indifference, and in self-defence they actually invited adverse criticism.

Surprisingly, the reaction of the press to the 1920 show was almost the exact opposite of what the Group claimed it to be. A. Y. Jackson remembers that those who saw the exhibition were either amused or indignant, and that some threatened to resign from the Art Gallery. "There was plenty of adverse criticism," he recalled, "little of it intelligent."[7] Lawren Harris noted: "The painters and their works were attacked from all sides. Whole pages in the newspaper and periodicals were devoted to it."[8] Arthur Lismer, who also claimed that "the critics had a glorious holiday," said, "This was the day of pathological, culinary and waste-disposal words."[9] It seems amazing now that scarcely one word of adverse criticism can be found in the original newspaper reviews. Virtually all the Toronto papers had lavishly favourable notices and accepted the Group as long-established artists. The only suspicious-looking article was one entitled "Are These New Canadian Painters Crazy?"[10] But this was a complimentary tribute to the Group written by Augustus Bridle.

How, then, can one explain the later statements by the most respected members of the Group? Did their memories fail them or were they trying to gain more publicity by making themselves look like martyrs? The fact remains that the Group and their support-ers have carefully preserved the popular belief that they fought violent opposition from the press and the public in the early years.[11] They cultivated the image of themselves as valiant heroes overcoming the ignorant philistines.

In later years, they seemed to remember all the bad criticism and little of the good. Lismer, for example, confused the "Hot Mush School" and "Drunkard's Stomach" criticism of 1913 and 1916 with that of the first Group show.[12] Others probably recalled the more vicious criticism of the Wembley debate and after, and mistakenly associated it with the early exhibitions.

Their attitudes can be further explained by their hypersensitivity to criticism. This began with their earlier reactions to the Hot Mush School article, and was still apparent in the defensive tone of the catalogue introductions. One wonders why they took what little criticism there was so seriously, especially when most of it was unintelligent and uninformed, and written by people who knew nothing about art.

One explanation for this is that newspaper criticism formed only a small part of the overall response to their art. There were almost daily confrontations in the Arts and Letters Club between the "Artists' Table" and the "Knockers' Table," where Charles-worth and the other traditionalists sat.[13] There were also innumerable people who must have made devastating verbal attacks on the Group without ever putting it into print. This also may account for the artists' distorted picture of reactions to the first Group show.

119 Arthur Lismer *Sketch of Harris the night The Group of Seven was formed* pencil 8" x 10" Library of the Art Gallery of Ontario

«*Our first exhibition had a very poor reception. . . . Some people who saw the exhibition were amused, and some indignant. Some members threatened to resign from the Art Gallery of Toronto. . . . There was plenty of adverse criticism, little of it intelligent. A great deal of it was mere abuse, much of it from people who had not even seen the exhibition. It came not only from laymen but from artists as well, 'Products of a deranged mind,' 'art gone mad,' 'the cult of ugliness,' these were some of the terms used to describe paintings which, whatever their faults, attempt to depict the Canadian scene sincerely and honestly.*»[14]

(Jackson)

«*. . . the effect of these new paintings upon the Canadian public and press was startling. That a real art movement inspired by the country itself should be taking place in Canada was more than the critics and public could credit. The painters and their works were attacked from all sides. Whole pages in the newspapers and periodicals were devoted to it. Such a display of anger, outrage, and cheap wit had never occurred in Canada before.*»[15]

(Harris)

«*In the spring of 1920, the Group held its first exhibition at the Art Gallery of Toronto and the critics had a glorious holiday. They, the critics, were as inventive as the painters. This was the day of pathological, culinary and waste disposal words — in criticism: 'Hot Mush' —'Drunkard's Stomach.'*»[16]

(Lismer)

120 The Group of Seven seated around a table at the Arts and Letters Club.
Left to right: Varley, Jackson, Harris, Barker Fairley (non-member),
Johnston, Lismer, MacDonald (absent, Carmichael)

Seven Painters Show Some Excellent Work

Fine portraits, north country views and winter scenes are depicted.
Toronto *Star*, May 7, 1920

Seven Artists Invite Criticism

Group of local painters who are doing distinctive work. Unique exhibition.
Young men seek to interpret Canada in original manner.
Mail & Empire, May 10, 1920

Art and Artists

The work of all these artists shows the breadth and directness which characterizes
the tendency of the modern school.
Globe, May 11, 1920

Are These New Canadian Painters Crazy?

They are not decadent, but creative. They go direct to nature. Their aim in art
is greater vitality — and they have got it.
Canadian Courier, May 22, 1920

121 Arthur Lismer *Knockers' Table* pencil 18¼" x 30" 1922 McMichael Conservation Collection

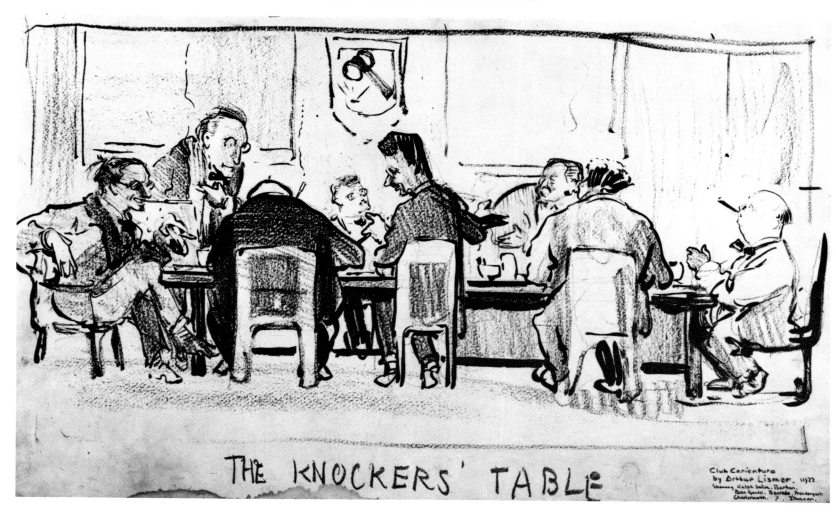

The foreword to the Group's second exhibition in May, 1921, was not as apologetic as the first. It mentioned how well the Group's touring exhibition had been received in the United States and elsewhere in Canada.[17] There was a plea for the spectator to keep an open mind when viewing the show, with the reassurance that "we have as little desire to be revolutionary as to be old-fashioned."[18] This was followed by the familiar argument that the works expressed a Canadian experience to which other Canadians should be able to relate. In concluding, the artists hoped that they would eventually be accepted as "a real civilizing factor in the national life," and not as a nuisance or a luxury.

Only the original members of the Group, minus Frank Johnston, exhibited in this show, which was seen by over 2,500 people in the twenty-four days it was open. In addition to private sales, four paintings (two by Jackson, and one each by Varley and Carmichael) were sold to the National Gallery, for a total of $1,600.[19] This was not a bad response, and the only surprising thing was the lack of any controversy.

The reaction of the press to this show was not as favourable as it had been the year before, but much of the criticism was surprisingly intelligent. One critic noted that "their work is for the most part that of young men who have not reached their zenith, but it is a true, vigorous expression of Canadian Life and Canadian art, racy of the soil, yet adhering to the great humanistic traditions of Europe."[20]

Another reviewer in the *Globe* commented that the sketches were preferable to the finished canvases, which were merely elaborations of the ideas in the smaller paintings. "Many of these smaller pictures are full of atmosphere and of poetic stimulus, and give the impression of having been painted at a moment when nature and the artist were in close, familiar touch, while the larger ones suggest an imagination running riot in a city studio far away from the sane sway of the out-of-doors."[21]

Group of Seven

FOREWORD

NEW material demands new methods and new methods fling a challenge to old conventions. It is as impossible to depict the autumn pageantry of our northern woods with a lead pencil as it is to bind our young art with the conventions and methods of other climates and other ages. The thought of to-day cannot be expressed by the language of yesterday. The Victorians seem dull and the Elizabethans frigid to a generation with its own problems. Artistic expression is a spirit, not a method, a pursuit, not a settled goal, an instinct, not a body of rules. In the midst of discovery and progress, of vast horizons and a beckoning future, Art must take to the road and risk all for the glory of a great adventure.

The third exhibition of the Group began with this brief foreword. Gone are the patient appeals to the public for understanding. The militant and defiant tone suggests that the Group was under constant attack. Their very lives seemed to be at stake as they concluded that art "must take to the road and risk all for the glory of a great adventure."[22] From this one can assume that they expected the reaction of the press to be absolutely devastating.

Group of Seven Not So Extreme

Radicals come nearer to public in latest exhibition Canadian Studies.
Interesting display of paintings on view in Art Gallery.
Mail & Empire, May 13, 1922

Salon of "Group of Seven" Reflects Canadian Impulse to Glimpse Beyond Skyline

Disregard of artistic convention and daring use of colour drawn from palette of northern forests mark showing of local artists.
Globe, May 10, 1922

Pictures of the Group of Seven Show "Art Must Take The Road"

Exhibition now on view indicates that these highwaymen have recovered from the sensation of being outlaws and are becoming legitimate outposters in art.
Toronto Star, May 20, 1922

These were the headlines that appeared in the three major Toronto papers. Augustus Bridle, who wrote the review for the Star, felt that the Group's obsession with "taking to the road" was like a quest for the "Holy Grail of Art," and he wondered where they hoped to go.[23] Bridle was unstinting in his praise of their work, but indicated that their paintings were, at this stage, beginning to look more and more alike, with the exception of Varley's work. He analysed their paintings with sensitivity and gave constructive criticism when he felt it was merited. In commenting on the Group's reaction to criticism, he concluded:

People in general are conservative. No group can hold out absolutely against that. No new art can thrive without public recognition. It cannot live just upon the hostility of traditional painters. If these men seem considerably out of order to the average eye, that is part of the penalty for being outposters. If they enjoy being out of order and snigger up their sleeves at the stupidities of the rest of us — well, of course, that is a horse of another color. And if they get the idea that all the new road work and all the adventure are done by themselves because they happen to have formed a protestant group, we should set them down as upstarts.

But I don't think that the average good sense of this group has any such arrogant conceit; otherwise I should not have bothered to write so much about the things they do.[24]

There were no more Group shows until 1925, but several events between 1922 and 1925 brought the Group even more into the public eye. The first was Charlesworth's attack on the National Gallery in the fall of 1922, and the second was the controversy over the Wembley show in 1924. Both events involved a confrontation between the National Gallery and the Royal Canadian Academy, with the Gallery taking the side of the Group of Seven. The Gallery director, Eric Brown, had been an ardent defender of the Group since his appointment in 1913, and as a result of his influence, the Gallery had been steadily acquiring paintings by the Group.[25] By 1920, it owned eighteen of their major paintings and twenty-seven works by Tom Thomson. In the first Group exhibition, the Gallery purchased three of the most expensive paintings in the show, and in 1921 and 1922 it continued to make major acquisitions.

It happened that many of these works were hanging in the National Gallery when Charlesworth visited it in 1922. Disturbed by the absence of works by the respected academicians, he wrote an article in *Saturday Night* entitled "The National Gallery a National Reproach."[26] In his usual colourful style he accused Eric Brown of favouritism toward the Group at the expense of the eminent members of the Academy. Sir Edmund Walker, chairman of the board, immediately came to the defence of Brown and the Group in a letter to the editor.[27] And Jackson and several others wrote a scathing attack on Charlesworth in the *Mail & Empire*, criticizing him for making judgements on something he knew nothing about. With all the sarcasm they could muster they suggested that:

After Mr. Charlesworth is through rearranging the National Gallery at Ottawa, might we not lend him to New York to straighten out the Metropolitan Museum? They have a lot of fake stuff by Cézanne, Rockwell Kent, Prendergast, and other experimental painters which he could shove down in the cellar for them.[28]

By far the most important incident for the Group was their participation in the Wembley show of 1924. It was this event more than any other which gave them international status and, eventually, recognition at home. The history of the Wembley show began in 1923 when Eric Brown heard that the British Empire Exhibition to be held at Wembley, just outside of London, was to have a large section devoted to the fine arts. Fearful that the selection of Canadian works would be left in the hands of the Royal Canadian Academy, he managed to have the responsibility for electing the jury handed over to the Board of Trustees of the National Gallery.[29] As a concession to the Academy, its president, G. Horne Russell, was invited to be on the jury, but he refused the invitation. A representative jury was then set up, consisting of eight jurors, all of whom were members or associate members of the Academy. Most were sympathetic to the "modernists," but only Arthur Lismer and Randolph Hewton could be considered as belonging fully to that camp. The jury selected nearly 300 works by artists from all over Canada.

When the exhibition opened at Wembley in the spring of 1924, the reaction of the British press was overwhelmingly enthusiastic, especially about the "new school of landscape painting."[30] The Tate Gallery considered several Canadian works for purchase, and eventually acquired Jackson's *Entrance to Halifax Harbour*.[31]

Wembley represented a triumph for the Group of Seven and modern art in Canada, for at last Canadian art had achieved real international acclaim. What was even more important was that the praise came from the British, for there was still a fervent admiration for the mother country, and her approval was the most that could be hoped for. The Group's account of the show suggests that it was their own personal triumph. But while the British press did single out members of the Group for praise, they were even more impressed by Morrice and Tom Thomson,[32] and the reviews gave equal space to Gagnon, Horatio Walker, and many others. One thing that the critics agreed upon, however, was that Canada was developing a national style of its own and could no longer be accused of "foreign-begotten techniques."[33]

122 Arthur Lismer Caricature of Hector Charlesworth, music and drama critic of *Saturday Night*

The real battle for acceptance took place on the home front when the irate academicians saw themselves pushed aside in favour of the young moderns. The Academy members claimed that they were not fairly represented in the show, and that the Academy should have been responsible for selecting the jury. They also considered that the moderns did not truly represent Canada, and were sure that their works, which emulated the Royal Academy, would have received even higher praise. One editorial stated that:

If the walls of the Canadian section of the British Empire Exhibition are to be covered with crude cartoons of the Canadian Wilds, devoid of perspective, atmospheric feeling and sense of texture, it is going to be a bad advertisement for this country. We should advise the Department of Immigration and Colonization to intervene to prevent such a catastrophe.[34]

To the Academy, the young "moderns" were no more than attention-seekers, who painted the most unpleasant and uncivilized parts of Canada in gaudy colours. They particularly resented the way the Group of Seven tried to impose their own viewpoint on everyone else in Canada, rejecting anything which did not conform to their outlook. The main defender of the Academy was the ultra conservative *Saturday Night*, which published editorials with titles such as "Freak Pictures at Wembley" and "Canada and her Paint Slingers." Hector Charlesworth wrote most of them, and his line of attack can be seen in his reaction to the praise given by the English press:

«Flub-dub, every word of it, but no doubt sincere flub-dub, based on the conviction that this is the pure-quill Canadian stuff: and that other types of landscape painting which present the beautiful pastoral phases of this country are false and insincere. At least that is the theory which the exponents of 'emphatic design' have tried to choke down the throats of the Canadian public. . . . This school of painting is not of the soil, but of the rocks. The sections of Canada which its votaries in their harsh, uncompromising style (which of itself is alien to the Canadian temperament) delight to depict, undoubtedly do exist. Unfortunately, one must also add; for the areas of primeval rock and jack-pine constitute Canada's gravest problem in an economic sense and the most serious barrier to her political and social unity. We cannot deny them; but they are not all of Canada, as the laymen who boost this school, as the only true, sincere and original Canadian art would have the world believe. It does not even represent the best of Canadian vision and craftsmanship in a purely technical sense.»[35]

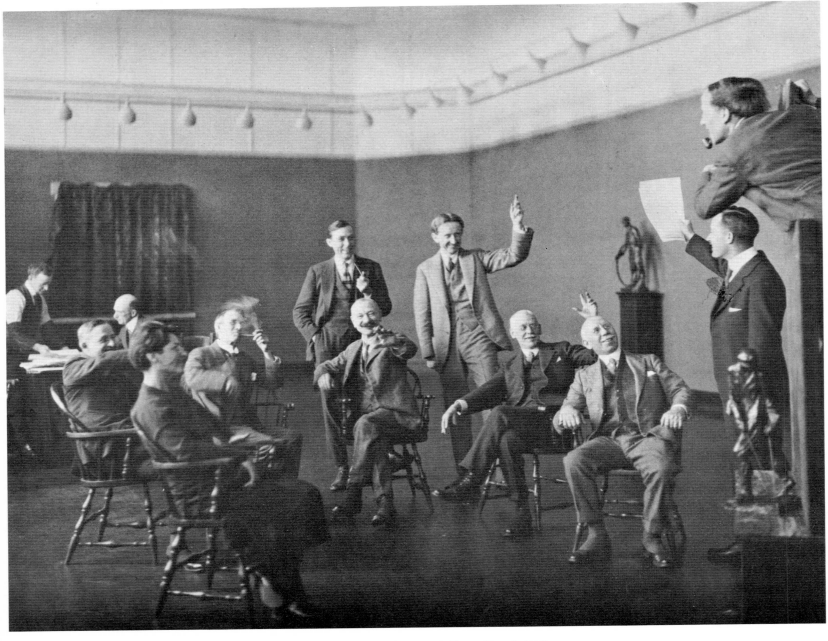

123 The Wembley Jury. Left to right: (seated) Clarence Gagnon, Florence Wyle, F. S. Challener, Horatio Walker, Franklin Brownell, Sir Wyly Grier, (standing) R. S. Hewton, Eric Brown, Arthur Lismer, Harry McCurry

The Wembley show forced artists and critics to take sides, and from this time on reactions became more polarized and more extreme. In the next two years the most violent battles in the history of the Group took place, perhaps justifying their later memories of unremitting critical abuse. When the Group held its fourth exhibition in January, 1925, the comments were no longer ones of indifference or lukewarm praise. The *Star Weekly* headed its column with the title, "School of Seven Exhibit is Riot of Impressions."[36] This review, like many others, was written in a sarcastic tone, often making it difficult to tell whether the Group was being ridiculed or praised. Harris, with his boldly simplified mountain scenes, assumed the role of scapegoat, and was accused of flinging "whole mountains in the faces of the critics."[37]

Hector Charlesworth wrote a review of the show for *Saturday Night*, entitled "The Group System in Art."[38] He had both criticism and praise for the Group. Most of his opinions were based on the premise that correct academic technique provided the necessary standard for artistic judgement. The closer a work approached this standard the more he praised it. Some of his other critical comments had a degree of truth to them, such as his annoyance at the way members of the Group "aspire to dominate pictorial expression in this country." He pointed out that "all groups or schools which adhere to fixed methods and opinions are a handicap to artistic progress."[39] The Group professed not to fall into this category, but when seen objectively it is clear that they did so more than they realized. The other of Charlesworth's criticisms was that their paintings were monotonously alike, even though they were a "veritable riot of primary colours." In concluding, he said that although most of the pictures were superficially daring, they were "essentially timid, as though each member were afraid of violating his fraternal oath."[40] Charlesworth hit a sore point with the Group, and a glance at the works in the exhibition reveals that his objections were somewhat justified.

Another type of criticism from this period–one which has often been overlooked–was the more serious writing on the Group which appeared at first in *The Rebel*, then *Canadian Forum* and the *Canadian Bookman*.[41] By far the most intelligent and perceptive of this criticism was written by Barker Fairley, a close friend and ally of the Group. Besides defending the Group and discussing their work, he had the courage to point out their failings as well as their strong points. In 1925 his article on the fourth Group show appeared in the *Canadian Forum*:

By this time there must be fully two hundred people in Toronto who are genuinely interested in them. As art goes, this verges on a popular success, and the air hummed with approval. The general opinion was that this show eclipsed its predecessors and the Group had come into its own.

For my own part, much as I enjoyed myself, I couldn't quite go so far. Perhaps there was less careless painting this time, but was there the same degree of inner adventure? How many of these fifty pictures had the extra kick in them that makes a work vital and surprising and new every time we look at it?[42]

He went on to discuss works by individual artists, giving particular praise to Lismer for his *Happy Isles* and *MacGregor Bay*. What disturbed him about the numerous mountain scenes was that the artists were trying to paint an area they did not know well: "Liberties with nature must be based on knowledge of nature; failing this it is healthier to paint pure cubism."[43] This was an apt criticism of the Group's early attempts at painting the West.

After the 1925 exhibition, the next confrontation occurred when Jackson was challenged to a debate with Wyly Grier at the Empire Club. The Toronto *Star* reported the debate with the headline, "If Cow Can Stay in Parlour, Then Why Can't Bull Moose?"[44]

Wyly Grier, who was on friendly terms with Jackson and had been a juror for the Wembley show, presented the case for the academic side; Jackson supported the "moderns" and the Group of Seven. Grier spoke first and pointed out that there had been artists prior to the Group who could be called distinctly Canadian, such as Cullen, Morrice, and Gagnon. He then expressed his concern over the idea of artists' forming themselves into a group; the unavoidable drawback was that the members all adhered to a central doctrine or dogma, with the result that they would all begin painting alike. Grier concluded by making a plea for artists to turn to figure painting, saying that this

was the area of greatest weakness in Canadian art.

His criticism had some relevance for the Group, but it was rapidly forgotten in the wake of the emotional defence given by Jackson. He started out by describing the earlier pastoral painters of Canada, who emulated European trends and showed no concern for creating a native art. Then, in a lively and aggressive manner, he attacked the collectors of the Dutch school in Montreal, who collected paintings like cigarette cards. Jackson claimed that the Group, with its Canadian pioneering spirit, had broken the dependence on European styles and had found its own way by creating an art with its origins in the land. This, he said, was appreciated by the British at Wembley, but not at home. He suggested that Canadians should encourage their own art, and he ended his talk with an honest eye to the future. "Now, a last word, because tomorrow we will all be academic. And when the last cow is taken from the drawing room and the walls are alive with red maple, yellow birch, blue lakes and sparkling snowscapes, I can hear the young modern painter up north say to his pal, 'there's the trail those old academic Johnnies, the Group of Seven, blazed.' "[45]

There were other battles to come, for in 1925 there was another exhibition at Wembley, chosen by the same jury, which once again enraged the Academy. In 1926, the academicians made a last-ditch stand to gain control over the National Gallery, when they tried to oust its director, Eric Brown. The headline in the Toronto *Star* read: "Painters Demand the Head of Art Dictator of Canada."[46] But by this time the "revolutionaries" were firmly enough entrenched to have the criticism quickly and quietly disposed of. A year later, a selection of the Wembley paintings was sent to Paris for an exhibition of contemporary Canadian art, to be held at the Musée de Jeu de Paume. It also included a retrospective collection of works by Thomson and Morrice as well as some west coast Indian art. The success of the show firmly established the modern school in Canada.

The Group continued to hold exhibitions in Toronto, which were sometimes cir-

124 Moyer *Jackson-Grier Debate*
pencil *Toronto Daily Star* February 27, 1925

culated to Montreal and elsewhere in Canada.[47] There were Group shows in 1926, 1928, and 1930, and a final one in 1931. All of them included a substantial list of invited contributors, so that the Group no longer appeared to be fighting alone for their cause. The press continued to castigate an "unrepentent" Group of Seven, but generally there was a feeling that the Group was here to stay and that it had won its battle. Some of the reviews became more sensational, presenting the reactions of truck drivers, western cowboys, and the man on the street to the Group, but these were usually too inane to be taken seriously.[48]

Other flare-ups occurred when the travelling shows hit places like Vancouver for the first time, bringing storms of protest from an uninitiated public.[49] Despite the shocked reactions of the West to the Group, there were fewer prejudices to overcome, and acceptance followed rapidly.

Another indication of the Group's acceptance was the publication in 1926 of Fred Housser's book on *A Canadian Art Movement: the Story of the Group of Seven*.[50] Still the most important source book on the Group, it presents an extremely accurate account of their formative years. As a friend of the Group and financial editor of the Toronto *Star*, Housser wrote the book from a sincere devotion to their cause and a desire to make them better understood by the public. In an objective, lucid style he traces the growth of the movement, documenting his views with excerpts from letters and newspaper reviews, as well as with some amusing anecdotes. The early years are discussed in detail, including the Scandinavian show, the role of Tom Thomson, the war years and beyond. In addition, individual paintings are analysed, and the ideas of each artist and of the Group as a whole are clearly presented. The book has its faults – an overemphasis on nationalism, a misrepresentation of the critics, and an incomplete understanding of European influences, but these are minor. Furthermore, considering Housser's background and the low level of art criticism at the time when it was written, the book is a remarkable achievement. With its publication, the Group of Seven became history.

125 Arthur Lismer
The Artist Having an Isolation Peek
charcoal pencil 11″ x 15″ c. 1931
McMichael Conservation Collection

NATIONALISM AND THE GROUP

«O Canada! Our home and native land!
True patriot love in all thy sons command.
With glowing hearts we see thee rise
The true north strong and free;
And stand on guard, O Canada
We stand on guard for thee.»[51]

The Group had been motivated by strong national feelings ever since they came together in Toronto before the First World War. Events such as the Scandinavian show had increased their enthusiasm to explore "the whole country for its expressive and creative possibilities in painting."[52] Although the war broke up their efforts, once it was over, their desire to set out on the great adventure was even stronger. Canada had emerged from the war with a new awareness of its independence and a determination to have a distinct identity. In 1919 MacDonald wrote that "the Canadian Spirit in Art is just entering on possession of its heritage. It is opening a new world, and the soul of the artist responds with the feeling that it is very good. . . . It aims to fill its landscapes with the clear Canadian sunshine and open air, following faithfully all seasons and aspects."[53]

For the Group, nationalism meant several different things. First, it represented a search for a common feeling about Canada which they could interpret in their painting. Second, it involved the creation of an art that would provide Canada with a distinct image. Above all, it meant that Canada had to have its own art if it were to be a great country.

The members of the Group were fully convinced that it was the northern landscape which made Canada unique and different from any other country. If Canada were to have an identity, it could only do so through a discovery and representation of its northland. Lawren Harris wrote that the Group came "to realize how far this country of Canada was different in character, atmosphere, moods, and spirit from Europe and the old land.... It had to be seen, lived with, and painted with complete devotion to its own character, life, and spirit, before it yielded its secrets."[54]

Thus the Group went out into the rugged and elemental landscape in order to capture Canada's "moods." Their concern was not to realistically paint the rocks, lakes, and pine trees, but rather to use them as symbols that could represent the beauty and greatness of the country.

The Group's choice of landscape, rather than people, to symbolize the greatness of Canada was a direct outgrowth of the cult of the North. They felt it was the northern environment that had shaped the vision of Canadians, and not the reverse. As Hugh Kenner commented about the Group's work, "Nobody ever appeared in those pictures, no human form except occasionally a tiny portaging figure hidden by his monstrous canoe. Nobody was needed. The Canadian Face was there right enough, rock of those rocks, bush of those bushes."[55]

The idea of using the landscape to express national feeling was not a unique discovery of the Group of Seven. American artists had gone through the same process of discovering their landscape and its possibilities for expressing national greatness. However, the Group were not interested in their work; instead they read the transcendental poets, like Whitman and Thoreau,[56] who confirmed their idea that the northern landscape mirrored the national character.

To express these ideas in their art, the Group felt it was imperative that they create a style of their own, one which would not be accused of dependence on "foreign-begotten" techniques. They agreed with Wyly Grier's famous statement of 1913 that "our art will never hold a commanding position, . . . until we are stirred by big emotions born of our landscape; braced to big, courageous efforts by our climate; and held to patient and persistent endeavour by that great pioneer spirit which animated the explorers and soldiers of early Canada."[57] They claimed to turn their backs on Europe and to respond directly to the landscape for their inspiration.

The enthusiastic response to the Wembley show proved to them that they had created an art of their own. Instead of being dismissed as imitators of European styles, they had the critics exclaiming that "there can be no question that Canada is developing a school of landscape painters that is strongly racy of the soil."[58] It seemed that the Group was succeeding in its task.

However, in terms of both technique and subject matter, it was questionable whether the Group created an art that was uniquely Canadian. Initially, they relied heavily on European techniques to provide them with the means for expressing their response to nature. Even when they denied these precedents, they were still basing their approach to nature on late nineteenth century concepts. In their escape to the untamed North and in their attempt to capture the moods of the landscape, they closely paralleled the earlier efforts of the Post-Impressionist painters in France. In the 1880's Gauguin and Van Gogh had rejected the city and searched for a primitive landscape in which they could rediscover spiritual values. They, too, had abstracted nature's elements into symbols and had unified them through colour and line to achieve an overall feeling of mood.

The Group's claim to be "painting Canada" was in many ways a mythical one, unless the Precambrian Shield is seen as all of Canada.[59] Some of the Group members, such as Casson and Carmichael, never ventured outside of Ontario during the Group years. Others painted in various parts of Canada at different times, but Jackson was the only one who made a conscious effort to paint the country from coast to coast. More than any other artist, he crossed and recrossed Canada, but he seldom felt at ease when sketching outside of the familiar territory of Quebec and Ontario, and his works showed this. He once confessed to Emily Carr that he did not like the West and found it unpaintable because it was so lush and overgrown.[60] From this point of view the Group could be considered as primarily regional in character.

Despite the many statements to the contrary, the Group was indisputably a Toronto-based movement. Nearly all of the artists lived in Toronto during the key years from 1913 until the Group disbanded. All the exhibitions opened in Toronto, and only a few were circulated across Canada. Artists from Montreal were invited to exhibit in the early Group shows, but after Wembley there was considerable friction between the two cities, aggravated all the more when Jackson called Montreal the most bigoted city in Canada.[61] The only real satellite of the Toronto Group was the National Gallery of Canada in Ottawa. It was the Gallery director, Eric Brown, who did more than anyone else to promote the Group by sending out exhibitions and by arranging lectures across the country. Canadians in the West sometimes resented the presentation of the Group as representative of all of Canada. However, over a period of time the Group came to be accepted as the founders of a national movement.

One important outcome of the Group's nationalism was their attempt to convince Canadians that they needed to have an art of their own if Canada were to be a great country. The foreword to the first Group exhibition stated that all the artists were "imbued with the idea that an Art must grow and flower in the land before the country will be a real home for its people."[62] These ideas, borrowed from the Irish nationalist writers, such as Æ (George Russell), became the main defence for the Group, as if to say "accept us because we paint Canada, and because Canada needs its own art to be great."

The Group wanted desperately to create an art tradition which would represent Canada and be uniquely Canadian. With unrelenting zeal, they fought against the apathy of Canadians who believed that there could be no such thing as a true Canadian identity – and therefore no such thing as a truly Canadian art. They succeeded in giving Canada an art that is now accepted as distinctively Canadian, and an art that has impressed itself on the Canadian consciousness so indelibly that it has almost become a cliché.

AN AMERICAN CRITIC, 1867:

«*Every nation thinks it can paint landscape better than its neighbour, but it is not every nation that goes about its task in a way peculiar to itself. No one is likely to mistake an American landscape for the landscape of any other country. It bears its nationality upon its face smilingly.*»[63]

Art Takes to the Road

«We had commenced our great adventure. We lived in a continuous blaze of enthusiasm. We were at times very serious and concerned, at other times hilarious and carefree. Above all we loved this country and loved exploring and painting it.» [1]

The catalogue for the 1922 exhibition of the Group concludes with the statement that "art must take to the road and risk all for the glory of a great adventure." [2] In the years following the formation of the Group, artists began to range across the country, sketching everywhere from Nova Scotia to the Rockies and the Arctic. Their activities as a group became more diffuse, and they began to work more independently of each other. They were almost always on the move, some went with deliberate purpose, and others, such as Varley, went in search of themselves. They usually visited several different areas in the course of a year, and each artist eventually found his own favourite sketching ground and became deeply attached to it. MacDonald produced some of his most distinctive works in Algoma, and as a result Algoma was called "MacDonald's Country." Jackson became known for his scenes of Quebec, Harris for his paintings of Lake Superior, and Lismer for Georgian Bay.

THE MARITIMES – HARRIS

In 1921 Harris visited Halifax and saw its dismal slums. The canvases he produced on that trip form a striking contrast to the earlier Toronto houses painted in gay, decorative colours. The bright reds and yellows are replaced by sombre greys and blues, and a powerful dramatic feeling enters into Harris' work for the first time.

The Halifax paintings have long been considered as a comment on social conditions in the slums. However, there is nothing in the earlier paintings to suggest that Harris' concern was with a moral message. The Toronto scenes of the Ward were criticized because they portray the ugly houses of the poor rather than the beautiful houses of the rich, not because they represent poverty and suffering. But in *Black Court, Halifax,* with its gloomy houses, the mud courtyard, and the blank faces of the slum children, Harris appears to be saying something more. This attitude seems to be supported by an excerpt from one of his poems in the book, *Contrasts,* which was published in 1922:

Are you like that?
Are you sad walking down streets,
Streets hard as steel; cold
* repellent, cruel? . . .*

Are you sad seeing people there,
Outcast from beauty,
Even afraid of beauty,
Not knowing?

Are you sad when you look down city lanes,

Lanes littered with ashes, boxes, cans,
* old rags;*
Dirty, musty, garbage-reeking lanes
Behind the soot-dripped backs of blunt
* houses,*
Sour yards and slack-sagging fences? [3]

However, when one looks more closely at the painting *Black Court, Halifax,* it becomes clear that Harris is not concerned with showing the squalid slums or the plight of the poor. On the contrary, he is motivated by the eerie beauty of the scene – the faceless people melt into the background.

There is even less possibility of calling Harris' other painting from this period, *Elevator Court, Halifax,* a work of social comment. The buildings are all neat and tidy, and there are no people to distract the viewer's attention from the stark reality of the scene. This work marks a radical change in Harris' art; here he moves from a generally flat-surface treatment to an emphasis on deep three-dimensional space. He uses space, form, and colour to create a mood of timelessness and mystery. All the main compositional lines recede in sharp perspective to a vanishing point to the right of the huge smokestack. From this point emanate the rays of the setting sun, creating dramatic contrasts of light and shade on the buildings, sky, and smokestack. The final effect inspires a romantic mood of contemplation and reverie, which verges on the surreal. [4]

126 Lawren Harris *Black Court, Halifax*
oil on canvas 38″ x 44″ 1921
National Gallery of Canada

127 Lawren Harris *Elevator Court, Halifax*
oil on canvas 38″ x 44¹/₈″ 1921
Art Gallery of Ontario

THE MARITIMES – MacDONALD

A year after Harris' visit to Nova Scotia, MacDonald made his one and only sketching trip to the east coast. He spent six weeks near Petite Rivière, Nova Scotia, absorbing the general atmosphere.

He seemed mostly interested in the people and boats, and made careful notes and measured drawings of dories and other craft, also detailed descriptions of Indian basket and canoe-making. This was a habit of his, and he had many notebooks full of conversations with local folks, their ways of making things, topography and natural history.[5]

A number of sketches were produced, but only a few were painted up when he returned to Toronto. One of the sketches, *Church by the Sea*, shows that MacDonald was moving in the direction of greater simplicity at the same time as Harris was, perhaps because the austere surroundings suggested a more disciplined treatment. He uses broad, horizontal bands of colour instead of the broken brushwork of the Algoma paintings, and the resulting flat, two-dimensional quality closely resembles the style of Gauguin and the Symbolist painters in France.

THE MARITIMES – LISMER

Lismer was a frequent visitor to the Maritimes from 1930 onwards. He had spent three years in Halifax during the war, and was attracted to the sea, the people, and the simple way of life. One of his favourite haunts in the forties was Cape Breton Island where he painted small villages, fishing gear, and the Cape Breton shoreline. *Nova Scotia Fishing Village,* which was painted on his first trip in 1930, probably represents Blue Rocks Harbour, Nova Scotia. The painting reveals Lismer's love

of found objects, from the boats and fishermen's huts to the paraphernalia of anchors, floats, and lobster traps. These objects, he felt, revealed the elemental life of the people who made them. Their bright colours and their unusual shapes particularly appealed to him. "They are the real abstract," he said, "they fall into natural positions. To re-arrange them into formal still-lifes would be to kill them. I am too fond of the things themselves to want to change them into something else."[6]

128 Arthur Lismer *Nova Scotia Fishing Village*
oil on canvas 36" x 42" 1930
National Gallery of Canada

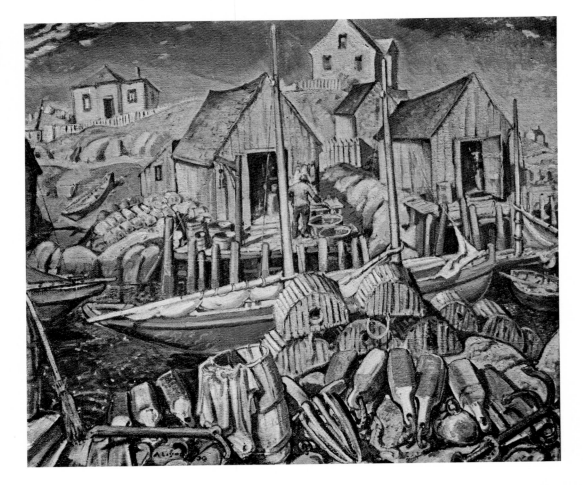

129 J. E. H. MacDonald *Church by the Sea* oil on board 4″ x 5″ 1922 Mr. & Mrs. R. MacDonald Collection, Toronto

In the spring of 1921, Jackson made the first of many visits to the south shore of the St. Lawrence. He stayed at the village of Cacouna, near Rivière du Loup, first boarding with a French-Canadian family and then moving into a small hotel in the village. After a few weeks of sketching alone, he felt the need for company, and asked Albert Robinson to join him. The arrival of Robinson caused quite a stir in the little community, and soon the two artists became legendary figures around the area.[7]

It was during this trip that Jackson made sketches for *The Winter Road, Quebec,* and Robinson for his *Return from Easter Mass* (now in the Art Gallery of Ontario). Jackson's work contains the same formalized, abstract treatment as his Algoma paintings of the same period, but here the mood is more strongly emphasized through the dark grey-mauve tonality. The sleigh tracks rise vertically up the centre of the painting, pass through a broken fence, and run over snow-covered hillocks on their way towards the village. Framed by the fence are the houses, which are simplified into triangular shapes of different colours. The curving rhythm of the foreground hillocks is repeated in the middle distance and again on the horizon, providing the centralized composition found in many of Jackson's paintings. The overall effect is an unusual blend of contradictory elements: the stillness of mood contrasts with the rhythmic curves of the hills, and the flatness of the houses contrasts with the recession through the series of planes.

A comparison between Robinson's *Melting Snow, Laurentians* and Jackson's *Early Spring, Quebec* shows similarities in the approach of the artists. In many ways, Robinson's treatment is even stronger than Jackson's with his bold use of abstract patterns and deep, rich colours. Warm yellows and oranges are vividly contrasted with cool blues and greens, while the broad, flat brush strokes give a solid, geometric structure to the painting.

Jackson and Robinson returned to the south shore in the following year and stayed at Bienville, just below Quebec. The year after that, Jackson went to Baie St. Paul, where many of the Montreal artists were working. In 1924 he wrote to MacDonald, saying, "Mr. and Mrs. Newton, Mabel May and Holgate are expecting to come here next week and with the Gagnons, Baie St. Paul will be for the time the liveliest art centre in Canada."[8]

In thirty years of visiting Quebec, the only season Jackson missed was the spring of 1925, when he was teaching at the Ontario College of Art. By the following year he was back sketching with Robinson. Every year his many friends would welcome him back, and his visits became so regular that his friends could forecast the weather by the time of his arrival. When he came late, it was considered a sure sign that spring would last a long time. In 1927 he made his first trip to Quebec with Dr. Banting, the celebrated co-discoverer of insulin. Jackson later recalled with delight the image of his friend Banting crouched behind a fence trying to sketch in the freezing weather, saying "and I thought this was a sissy game."[9] These were happy times for Jackson, and his autobiography is filled with amusing anecdotes relating to his many experiences.

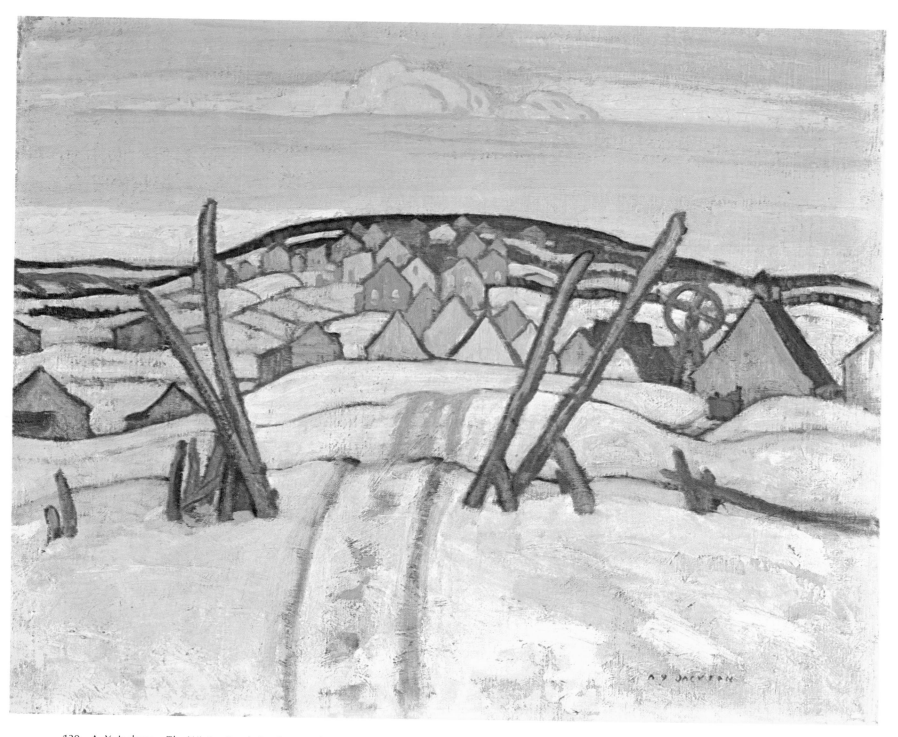

130 A. Y. Jackson *The Winter Road, Quebec* oil on canvas 21″ x 25″ 1921 Band Collection, Toronto

131 A. Y. Jackson *Early Spring, Quebec*
oil on canvas 21¼″ x 26¼″ 1923
National Gallery of Canada

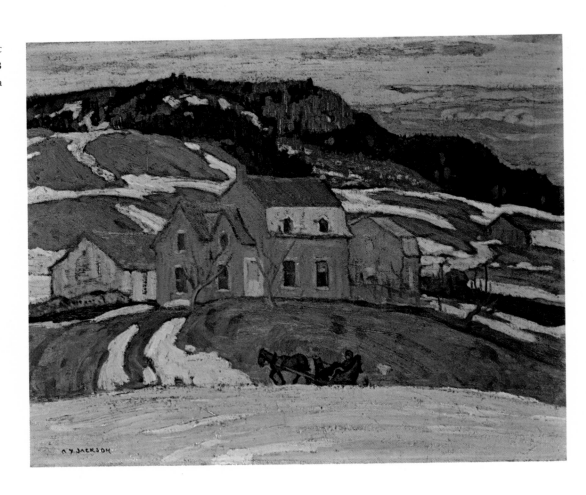

132 Albert H. Robinson *Melting Snows, Laurentians*
oil on canvas 27⅛″ x 33¼″ 1922
National Gallery of Canada

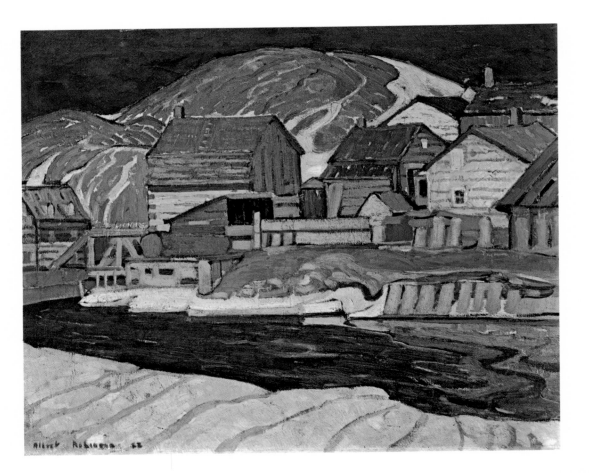

« Jackson is not a modern artist. He professes no creed or attachment to any school or 'ism. He is not a city artist, he reflects no studio introspections, no quick decisions to produce a painting in terms of any mechanical, psychological or abstract echo of something theoretic or of some social commentary. This is no reflection on the vitality and meaning of contemporary painting. It means that A. Y. Jackson is not that kind of a painter. He has an out looking eye not an in looking mind. He paints from visual contact with nature, and his selective range and summarizing technique is amazingly alert and vigorous. It comes from a prodigious experience of analysis and rejection, and of using pigment or the medium of paint as an emotional instrument itself to express the textures, the plastic forms, and environmental character of things seen. He solves most of his problems on the spot from experience, not from theory or fashion. »[10]

133 A. Y. Jackson *A Quebec Village* oil on canvas 21¼" x 26" 1921 National Gallery of Canada

Jackson produced a great number of drawings, oil sketches and canvases of Quebec in the twenties and thirties. He was at his best when painting familiar views of the rolling hills and old farm buildings in Quebec. There is a naturalness to these works which is seldom found in his paintings of other parts of Canada. As Lismer said, "Jackson's paintings offer no problem. They are easy to look at, disarming at first in their simplicity." [11] This deceptive facility belied his astute powers of observation. He was an outward-looking artist whose main concern was to record the landscape before him. He simplified, summarized, and injected his characteristic sense of rhythm into the scene.

Usually, he started with an oil sketch, in order to capture his impression of the light and colour of the setting. Then, contrary to the normal practice, he would make a drawing to set down the main details of form and structure, and to make annotations for colour. The drawing was mainly to serve as a reminder for the final work, but often it had greater freedom than the finished product. At the end of the season, Jackson took his sketchbook and panels back to Toronto, and then chose several from among them to be painted up. *Barns* (in the McMichael Conservation Collection) was the sketch for his well-known canvas in the Art Gallery of Ontario.

Jackson conveyed a wide variety of moods in his paintings, despite the similarity of subject matter. In *Barns,* the gentle curves of the hills, buildings, and sky create an undulating rhythm that is light and musical. This quality is heightened by the contrast between the warm and cool colours, which captures the effect of the setting sun on a spring afternoon. A radically different mood is found in *Grey Day, Laurentians,* where the rhythms are harsh, and the colours dark and sombre. The barns, with their irregular shapes and angular roofs, add to the threatening atmosphere.

Jackson became immensely popular, both through his works and his personality. His paintings were appreciated widely because they were direct and easy to understand. As a person, he was appreciated for much the same reasons. His friendliness and good humour put people at ease. An active and rugged individualist, he had none of the mannerisms of the city artist, and no time to worry about philosophical problems. Above all, he had a deep love of Canada and the outdoors, and was never happier than when he was out in the bush, paddling a canoe, or jumping from rock to rock along the shoreline of Georgian Bay. He put up with all kinds of hardships and discomfort in severe weather, but jokingly claimed that he was impervious to everything as long as he had some of Harris' famous Roman Meal.

Jackson's mission was to reveal Canada to Canadians, and over a period of time he assumed the role of propagandist for the Group. He travelled across Canada giving informal talks and making provocative statements for the press. He also wrote numerous articles and later published his own autobiography called *A Painter's Country.* Although he contributed immensely to our knowledge of the Group, he unwittingly propagated many of the popular misconceptions about them. Of even greater consequence, and less his own fault, was that he led people to think that all the Group shared his uncomplicated approach to art and life.

134 A. Y. Jackson *Grey Day, Laurentians*
oil on canvas 21″ x 26″ 1928 McMichael Conservation Collection

135 A. Y. Jackson *Barns* oil on panel 8¹/₂″ x 10¹/₂″ 1926 McMichael Conservation Collection

136 A. Y. Jackson *Farm at Tobin near Trois Pistoles, Quebec*
pencil 8³/₈″ x 10³/₈″ 1926 National Gallery of Canada

134

135

136

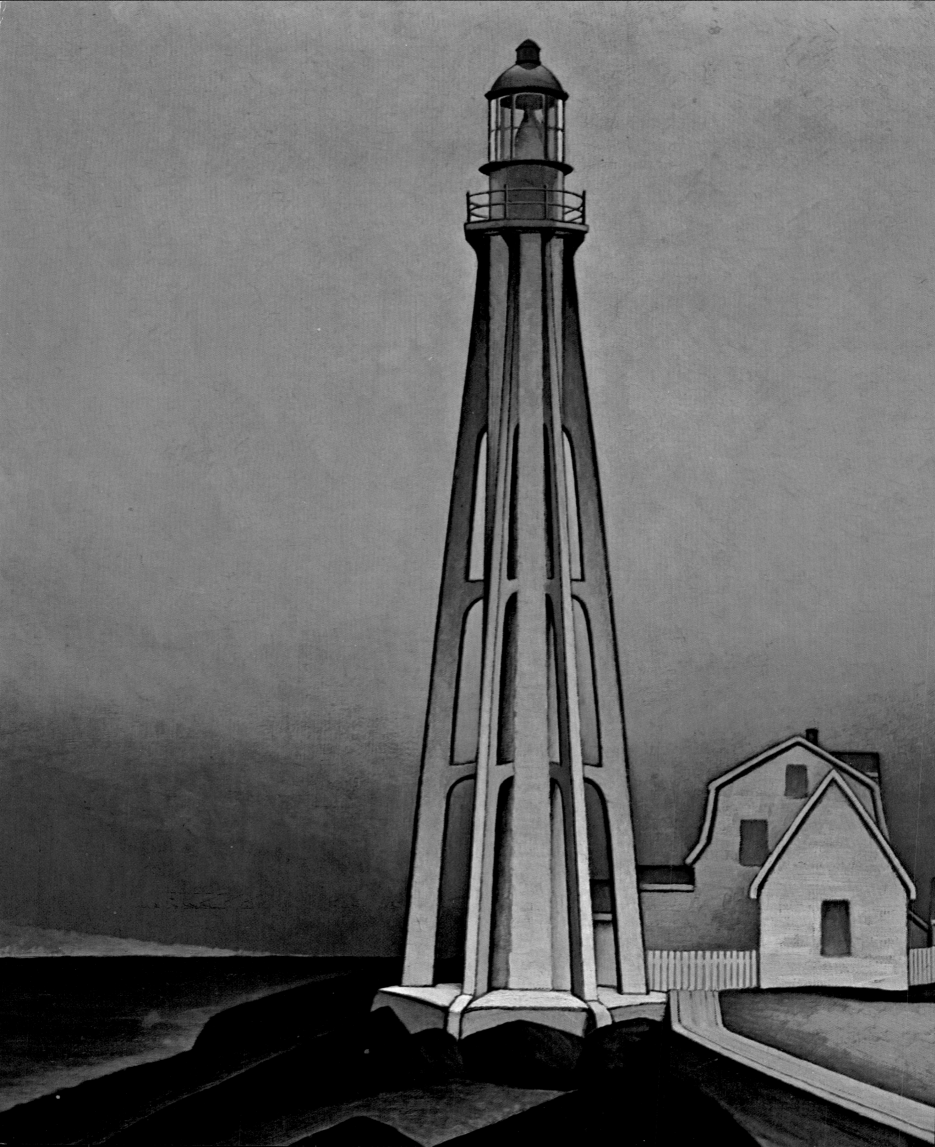

In the fall of 1929 Harris visited Quebec with Jackson, and the two artists sketched along the south shore of the St. Lawrence. Impressed by the lighthouse at Father Point near Rimouski, Harris made a study of it, which he later painted up in Toronto. His choice of theme, and his execution of it, differ dramatically from Jackson's paintings of Quebec, since at this stage Harris was attempting to express spiritual values in his art, as well as moving toward greater abstraction.

137 Lawren Harris *Lighthouse, Father Point*
oil on canvas 42″ x 50″ 1930
National Gallery of Canada

GEORGIAN BAY Georgian Bay was one of the first sketching grounds of the Group, and most of them continued to visit it from 1913 onwards. In the 1920's Jackson, Varley, and Lismer did a great deal of work in the area. They found the rugged and elemental landscape capable of infinite variety. There were peaceful lagoons, hidden bays, and thousands of islands of all shapes and sizes. Many of the islands and headlands were nothing more than bare rocks with a few weather-beaten trees clinging to them. This landscape provided a perfect setting for both the artists and their work. In this harsh terrain they could live up to their image as intrepid outdoorsmen, exploring the wild northland while braving the rigours of its climate. And here they could dramatize the elements that would bring the spirit of Canada into their art.

138 A. Y. Jackson *Night, Pine Island* oil on canvas 25¼" x 32" 1921 McCurry Collection

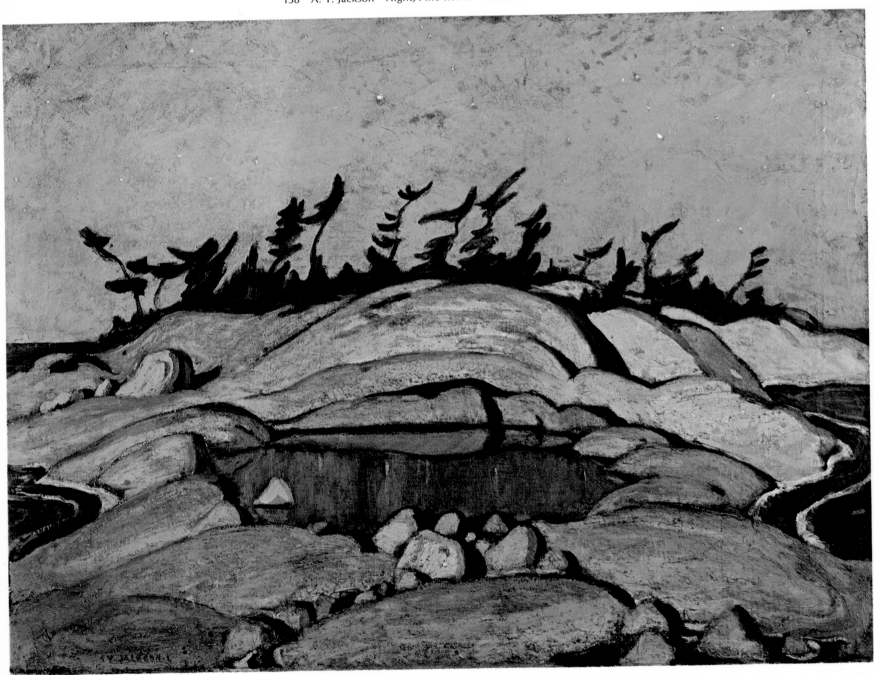

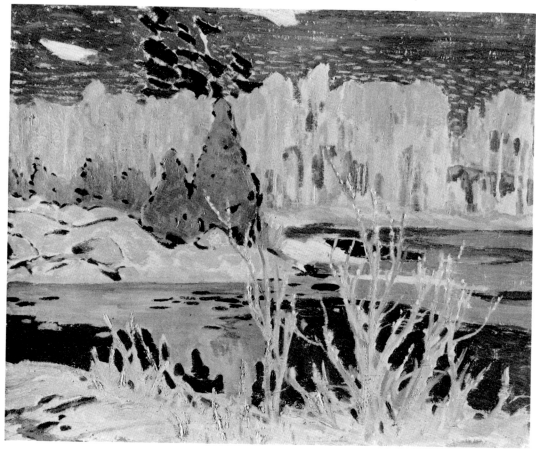

139 A. Y. Jackson *Early Spring, Georgian Bay*
oil on canvas 21¼" x 26" 1920 National Gallery of Canada

140 A. Y. Jackson *Georgian Bay, November*
oil on canvas 26" x 32" c. 1921 Hart House, University of Toronto

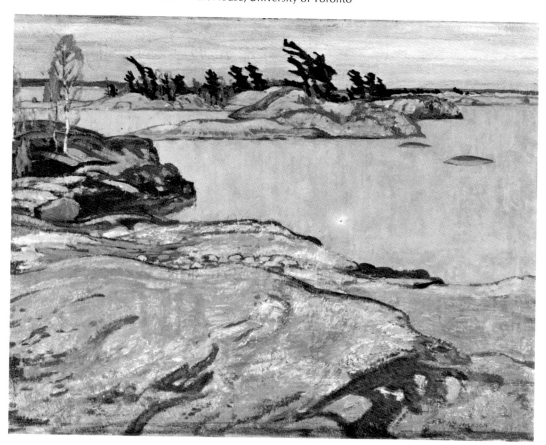

JACKSON

After the war, Jackson returned to Georgian Bay in the winter of 1920, to see what it looked like with no one around. *Early Spring, Georgian Bay* was painted after this trip and reflects his current interest in flat, decorative patterns. The cool blues are vividly contrasted with the warm oranges and dark olive-greens. Although there is a sense of recession into depth, the final effect is decorative and two-dimensional. Water, island, trees, and sky form broad, flat bands of colour which are united by the foreground shrubs and pine trees. Jackson often uses this technique, and its origin can be found in the work of the Symbolists, such as Gauguin, Emile Bernard, and Maurice Denis.[13]

Jackson was associated with Georgian Bay almost as closely as he was with Quebec, for he made innumerable trips there throughout his life. As in Quebec, his main concern was to capture the many moods of the bay, from tranquil summer nights to raging spring storms. In *March Storm, Georgian Bay,* the tormented sky conveys a threatening atmosphere which is heightened by the wind-bent pines on the horizon and the dark-green water. This painting is one in which Jackson uses sombre colours as a means of expressing mood, but he can also use line for the same purpose in a sketch such as *Windy Day, Georgian Bay.* Here cyclonic movement is created by the taut, concentrated forms of the pine tree and the stump at the centre of the composition. The lines radiate out toward a more wispy, free handling at the edges, suggesting a racy feeling of movement over the surface of the drawing.

141 A. Y. Jackson *Windy Day, Georgian Bay*
pencil 7¼″ x 11″ c. 1925 McMichael Conservation Collection

142 A. Y. Jackson *First Snow, Georgian Bay*
oil on canvas 21″ x 26″ 1920 Canada Packers Ltd. Collection

HOUSSER ON JACKSON

«*He has painted the Georgian Bay in all seasons and in almost every aspect; from its open spaces ruffled by a brisk breeze, to its inmost channels in the delicate lacery of early spring. He finds in the smoothly rounded rocks, colour, rhythm, light and shadow which he never tires of exploring. He camps on off-shore islands, hunts out silhouettes of pines and environs them with night and witchery.*»[14]

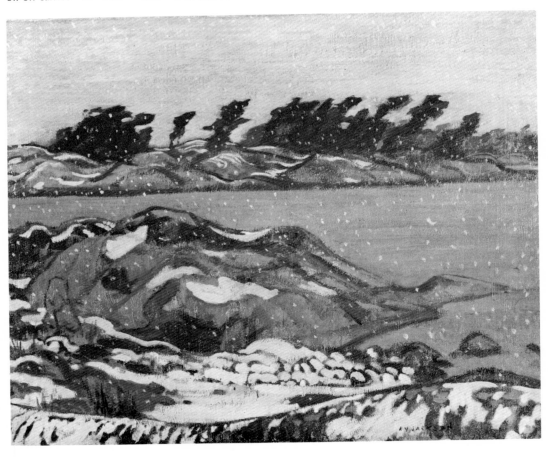

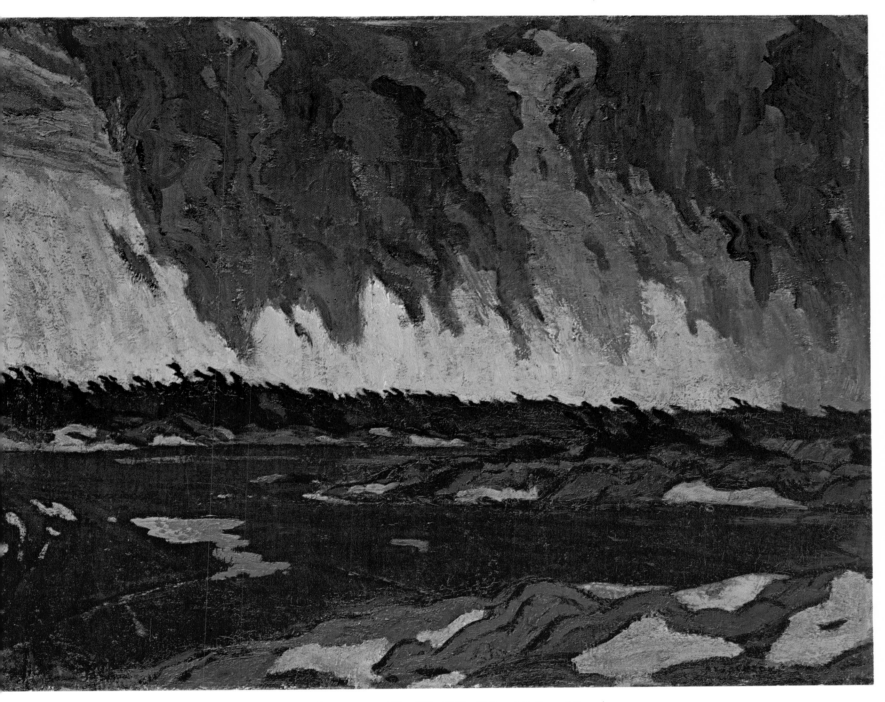

143 A. Y. Jackson *March Storm, Georgian Bay* oil on canvas 25″ x 32″ 1920 National Gallery of Canada

JACKSON ON GEORGIAN BAY

«*Every wind brought its change of colour — the North wind with everything sharply defined and the distant islands lifted above the horizon by mirage; the South wind — the blue giving way to greys and browns and the water washing over the shoals; and the West wind best of all — sparkling and full of movement. Only the East wind seemed to kill all incentive to paint, which seldom lasted.*» [15]

Lismer's fascination with Georgian Bay goes back to his first visit to Dr. Mac-Callum's cottage in September, 1913. In his early attempts at painting the bay, such as the 1913 sketch *Georgian Bay* (in the National Gallery of Canada), he experimented with the effects of sun shining through the clouds and sparkling on the water. The land masses are weakly handled, and there is no foreground element for contrast.

Three years later, when he painted *A Westerly Gale, Georgian Bay,* he had made great advances in technique. In this work, he moves from a low to a high horizon and provides a well-defined foreground of rocks and twisted pine. The gale is blowing from left to right across the canvas, and this movement is blocked by the counter-thrust of the tree in the left. All the basic elements for *September Gale* are found in this work, but none of them is developed to its full expressive power.

In 1921 Lismer painted several works that lead directly to *A September Gale.* One of these is a sketch called *Rain in the North Country,* where he captures the full force of the gale through powerful brush-work, striking colours, and expansive forms. The pine on the left is dramatically bent by the driving rain and wind, and forms a strong diagonal from lower right to upper left. When seen in relation to the slashing diagonal brush strokes from the other direction, a distinct ''X'' is formed, which provides a dynamic focus for movement. A similar device is used with even greater effectiveness in *September Gale.*

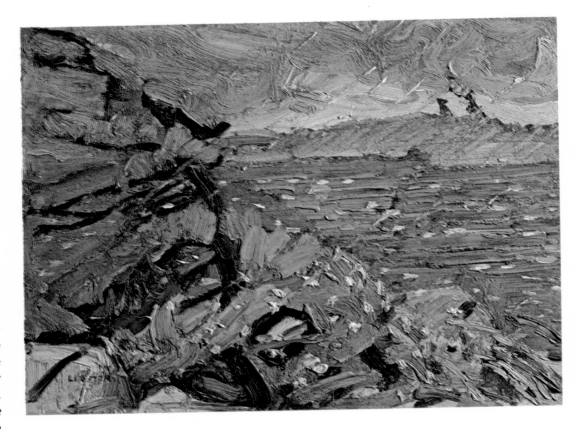

144 Arthur Lismer *Rain in the North Country*
oil on panel 8³/₄'' x 12¹/₈'' c. 1920 McMichael Conservation Collection

145 Arthur Lismer *A Westerly Gale, Georgian Bay*
oil on canvas 25¹/₂'' x 31¹/₂'' 1916 National Gallery of Canada

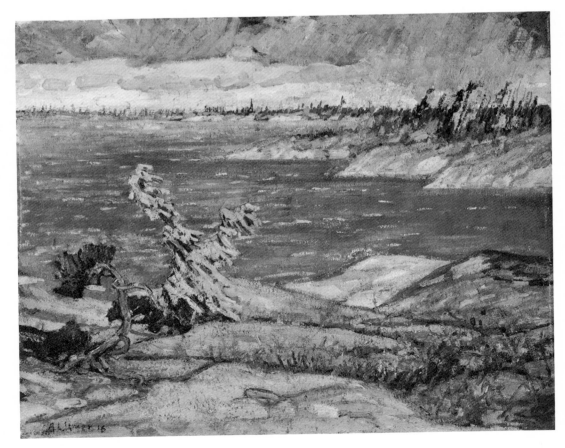

146 F. H. Varley *Stormy Weather, Georgian Bay*
oil on panel 8¹/₂″ x 10¹/₂″ c. 1920 McMichael Conservation Collection

147 F. H. Varley *Wind and Sun*
oil on board 11″ x 13⁵/₈″ c. 1920 National Gallery of Canada

Little is known of Varley's trips to Georgian Bay or of the development leading up to his famous *Stormy Weather, Georgian Bay* in the National Gallery. However, works such as *Wind and Sun* show that he had considerable difficulties in conveying the effect of strong winds and rough water. Another sketch, called *Stormy Weather, Georgian Bay* (in the McMichael Conservation Collection), is much more successful. Here he employs much the same device as Lismer, using strong diagonals to create a powerful movement from left to right across the sketch. The earthy colours and vigorous brushwork add to the impression of the storm.

In the fall of 1920 Lismer and Varley were sketching at Dr. MacCallum's cottage at Go Home Bay. Late one afternoon, they had an argument over the selection of a choice painting spot, and Varley stomped off to another corner of the island to make his sketch.[16] After they returned to Toronto they painted canvases based on these sketches. The result was Varley's *Stormy Weather, Georgian Bay* and Lismer's *September Gale*. Both works ultimately return to the epic theme of Thomson's *West Wind*, but each artist adds his individual interpretation. Together, these three paintings are among the best-known in Canadian art, and have become symbols for the North. According to Jackson they are "three of the finest paintings ever done in Canada."[17]

Varley's *Stormy Weather* is more spontaneous than Lismer's work. It is also simpler in composition, with a high viewpoint down to the pine tree and the great expanse of the bay. The free-flowing rhythm of the waves at the right is picked up in the branches of the windswept pine tree. Varley excels in the rich handling of the bay, contrasting the thickly applied paint in the area of rough water with the smoothness of the calm water beyond. In the distance, the setting sun brilliantly lights the dark clouds, as the storm passes over. It is a lyrical but forceful statement,

148 F. H. Varley *Stormy Weather, Georgian Bay* oil on canvas 52" x 64" 1920 National Gallery of Canada

During this period, Lismer devoted increasing amounts of time to teaching and art education. He was appointed vice-principal of the Ontario College of Art in 1919, and held the position for eight years, in spite of constant friction with George Reid, who was principal at that time. Lismer's characteristic enthusiasm repeatedly led him into battle with the old guard, who tried to block or ignore any changes or reforms that he attempted to institute. He was motivated by a strong sense of moral purpose and could not stand to see the waste of human potential caused by unimaginative teaching and lack of discipline.

After seemingly endless frustration, Lismer resigned from the Ontario College of Art in 1927, and became educational supervisor at the Art Gallery of Toronto for the next eleven years. It was in this post that he achieved recognition for his innovations in teaching art to children. This interest stemmed mainly from an exhibition of children's art he brought to Toronto in 1927. The Viennese educator, Franz Cizek, who had previously sent numerous travelling shows across Europe, organized the exhibition. Cizek had already made notable progress in establishing children's art as a viable art form, and Lismer was to develop his ideas even further. He believed that the purpose of child art education was not to produce artists, but to teach children to use their eyes and become aware of the beauty around them. Art should be a joyous experience, a means of self-expression and of discovering new experiences. Lismer commented on the way in which the Cizek show "captured the imagination of the public *and mine,* and started us off with a magnificent demonstration of what children could do under *guidance.*"[18] He set up his own Children's Art Centre at the Art Gallery of Toronto, which was a remarkable success, with 500 children attending the first classes.

Lismer's concern with art education applied to adults as well as children, and he pursued his purpose with almost missionary zeal. During the 1920's he lectured to many different groups in Ontario, and in 1932 he was asked to give a western lecture tour for the National Gallery of Canada. This idea came from his close friend Eric Brown, who had earlier tried to appoint Lismer as curator of Canadian art for the Gallery, but without success. A number of lectures were prepared on topics such as "The Necessity of Art," "Canadian Painting of Today," and "Art in Canada." These were presented to large audiences in towns from Winnipeg to Victoria, and supplemented by a variety of informal talks to luncheon groups, art clubs, and anyone else who cared to listen. The tour met with surprising success and introduced many westerners to modern art for the first time.

With untiring energy, Lismer crusaded for the cause of art, hoping to convince people that art and beauty had the power to transform and enlighten man's vision. He felt that Canadians were caught up in the "icy grip of acquisitiveness," and he was determined to overcome their apathy and ignorance.[19] Canada, as he saw it, could only become a civilized country by developing its own art and culture. As a young nation, it had to search for higher goals if it was ever to become a vigorous and independent nation.

Lismer was above all a fiercely independent individual, with strong opinions and sense of humour to back them up. His close friend Harris described him as "a vigorous, enormously active and perceptive person, with a wit like quicksilver."[20] Although he generally liked people, he could not tolerate pretension, laziness, or close-mindedness, and could be scathing in his attacks on anyone who exhibited these traits. Art, he felt, had the power to bring greater understanding to all men.

Art is the common denominator of union between men more than race, creed, history or personality. Art binds us together more than any other human activity in life.[21]

153 B. B. [Bertram Brooker?]
Sketch of Arthur Lismer
crayon c. 1925
McMichael Conservation Collection

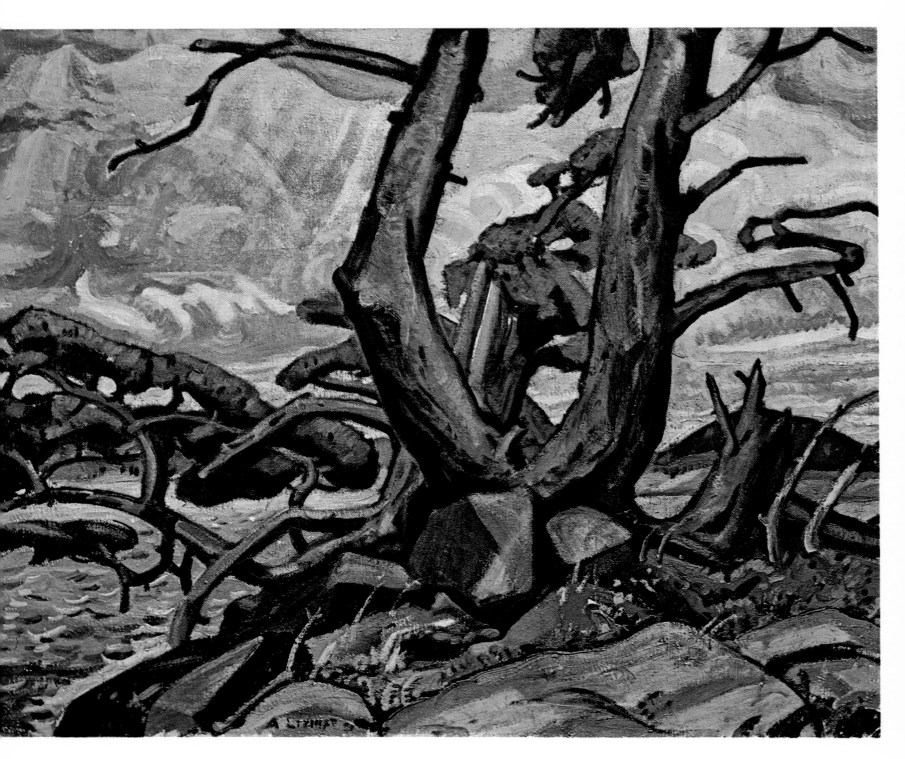

152 Arthur Lismer *Pine Wreckage, McGregor Bay* oil on canvas 32^1/$_2$″ x 42^1/$_2$″ 1929 Art Gallery of Ontario

PINE WRECKAGE, McGREGOR BAY

Lismer returned again and again to Georgian Bay during the years to come, and the changes in his style can be traced through his paintings of the bay. By the time of *Pine Wreckage, McGregor Bay,* his style has moved towards an even bolder treatment of form and colour. The foreground motif becomes the main point of interest, with greater emphasis placed on the massive rocks, the twisted trees and vegetation. The roughly applied colours are contained by the well-defined forms. It is a strong, masculine art, with little delicacy, unlike his drawings and sketches from the same period, which are more subtle and refined.

150 Arthur Lismer *Evening Silhouette*
oil on panel 12³/₄'' x 16'' 1926
McMichael Conservation Collection

151 Arthur Lismer *Pines, Georgian Bay*
brush & ink 11'' x 15'' 1933
Art Gallery of Ontario

and a remarkable achievement for some-one who did not consider himself a land-scape painter.

September Gale is a close up view of the storm in full force. Instead of a distant view of the final stages of the storm, Lismer takes us down close to the waves and presents its full impact. In contrast to Varley's broad treatment, Lismer's is tightly controlled and linear. Colours are more carefully contained within well-defined forms and boldly handled to suggest the storm's violence. Each element of the composition contributes to an overall ex-pression of dynamic energy. The fore-ground trees and grass are bent back by the wind, and the rock formations repeat the same pattern, accentuating the storm's tremendous force. The waves form a strong and deliberate rhythm, moving from right to left, which is picked up by the scattered trees on the island, sil-houetted against the turbulent sky. How-ever, it is the "V" formed by the blades of grass and the branches of the large tree that expresses the real intensity of the storm, leading the eye like an arrow to the left of the canvas. Lismer cleverly counter-acts this force with the upward twist of the tree and the angularity of the jutting rocks. The interplay of these opposing forces gives the tension needed to bring the scene alive.

149 Arthur Lismer *A September Gale, Georgian Bay* oil on canvas 48" x 64" 1921 National Gallery of Canada

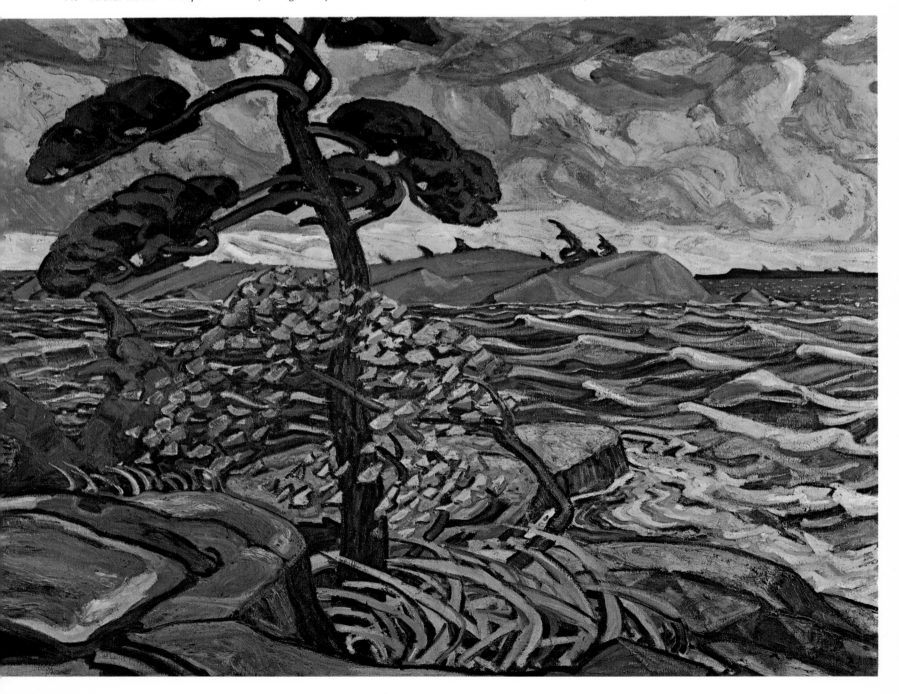

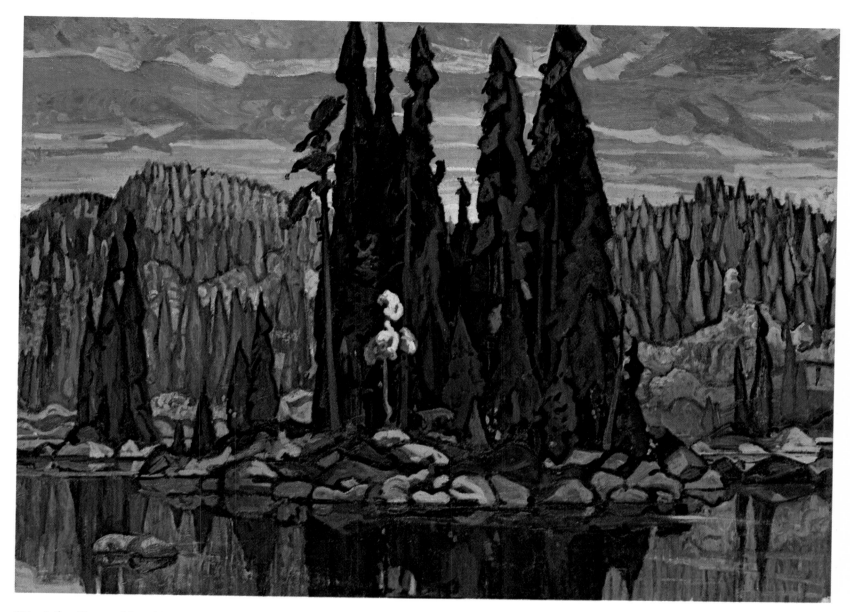

154 Arthur Lismer *Isles of Spruce* oil on canvas 47″ x 64″ 1922 Hart House, University of Toronto

The Group's first Algoma trip in 1918 was followed by successive visits each year until
1921. Harris was the only one to go on all of them. MacDonald and Johnston went on
every trip except the last one, and Jackson went on all but the first. Lismer went with
Jackson and Harris to Algoma in the fall of 1921 for a few weeks, but returned early to
begin teaching at the Ontario College of Art. In addition to the fall trips, there were also
excursions made by Jackson, Harris and Lismer in the spring of 1920 and 1921, after the
openings of the Group of Seven exhibitions.

For the first two or three years the artists used the famous boxcar, but on the later
trips they lived in log cabins or camped out.[22] By the end of the 1921 trip, they felt that
they had exhausted their subject matter and were in search of new territory to paint. It
was after this trip that Harris and Jackson went on to the north shore of Lake Superior,
which was to replace Algoma as their favourite sketching ground.

155 J. E. H. MacDonald *Algoma Forest*
oil on panel 8½″ x 10½″ 1920 McMichael Conservation Collection

156 Lawren Harris *Montreal River*
oil on panel 10½″ x 13¾″ 1920 McMichael Conservation Collection

JOHNSTON IN ALGOMA

By the time of Johnston's last trip to Algoma in 1920, he was using a more decorative approach in his work. A year earlier, Barker Fairley had commented on his "complete adjustment of technique to artistic purpose," and noted that "it will be interesting to see whether he will continue in his present vein of luxuriant decoration, or submit more patiently to the landscape before him and aim at something deeper." [23] Barker Fairley's conclusion that "his present manner attracts and fatigues at once" perceptively indicates both Johnston's greatest strength, and his greatest weakness.

Johnston was a superb craftsman, but was mainly concerned with decorative effects, which he consciously sought out. He once wrote to his wife, "The detail in this country suggests a thousand themes for decoration, and of course, the ensemble is equally as beautiful as the detail." [24]

Dark Woods is similar in compositional arrangement to MacDonald's *Algoma Forest* and Harris' *Montreal River*, which were done at the same time. But Johnston uses gouache instead of oil, producing a very different effect. The tones are more subtle and subdued, and the surface is flat and smooth, compared to the rich texture and colour of the two panels.

HARRIS ON ALGOMA

«*We worked from early morning until dark in sun, grey weather or in rain. In the evening by lamp or candlelight each showed the others his sketches. This was a time for criticism, encouragement, and discussion, for accounts of our discoveries about painting, for our thoughts about the character of the country, and our descriptions of effects in nature which differed in each section of the country. We found, for instance, that there was a wild richness and clarity of colour in the Algoma woods which made the colour in southern Ontario seem grey and subdued. We found that there were cloud formations and rhythms peculiar to different parts of the country and to different seasons of the year. We found that, at times, there were skies over the great Lake Superior which, in their singing expansiveness and sublimity, existed nowhere else in Canada*»[25]

157 Frank Johnston *The Dark Woods, Interior* gouache on masonite 22″ x 18³/₈″ c. 1921 Art Gallery of Ontario

«While the bad publicity received did not bother us, it did have an immediate consequence: Frank Johnston resigned from the Group. From the economic standpoint he had difficulty in earning a living from his painting.»[26]

In this statement A. Y. Jackson summarily dismisses Johnston from the scene and provides the traditional view of why he left the Group in 1920. However, after the opening of the first Group of Seven show, the only one Johnston exhibited in, he was not criticized, but lavishly praised by the critics. One newspaper review noted that "Mr. Johnston uses lovely colours, but most of all, his work is decorative, because of the imaginative quality it possesses."[27] Another said that he "has a prodigious fancy, a wonderful eye, and an imagination that is not often possessed by metaphysical ideas."[28] Instead of losing money because of his association with the Group, his most expensive work in the show, *Fire-Swept, Algoma,* was purchased by the National Gallery for $750.

A few months after the Group exhibition, Johnston exerted his independence by having a large one-man show of about 200 paintings at the T. Eaton Company Galleries. It was enormously successful, and Johnston became the darling of the critics, probably much to the distress and envy of the other Group members. In the fall of 1921 he left for Winnipeg, to become principal of its School of Art. His arrival there had a great impact on the Winnipeg art world.[29] When he later held a show of 320 paintings at the Art Gallery, it was the largest exhibition ever held in the city.

When Johnston returned to Toronto three years later, he was met with big headlines saying that he had resigned from the Group of Seven. In an interview with the press he explained the position:

I was never a member of the school of seven in the sense of taking a formal oath of allegiance to an art brotherhood or of subscribing to rigid doctrines. They were my friends. I shared their enthusiasm for new ideas and new methods. I used to exhibit along with them, years ago when they first decided to make a united front against criticism.[30]

Johnston claimed that he stopped exhibiting with the Group because he wanted to go his own way in exhibitions, not because of any disagreement with the Group. This is in keeping with his character, for he was a strong-willed individual and extremely ambitious. He was also determined to provide a comfortable life for himself and his family, and worked hard to achieve this. When Johnston left the Group he was treated as a traitor to the cause, who had sold himself in order to make money. Even though he had painted many powerful works of Algoma and was very much a part of the Group before 1921, he was quietly swept under the carpet. It is unfortunate that Johnston's later works did not have the same force as the early ones, so that he could have better defended himself against the Group's accusations. But in 1927 he changed his name to the more exotic title of Franz Johnston and turned more to working for department store art galleries.[31] He remained an excellent craftsman, and his work had great commercial success, but it seldom rose above a decorative and anecdotal level.

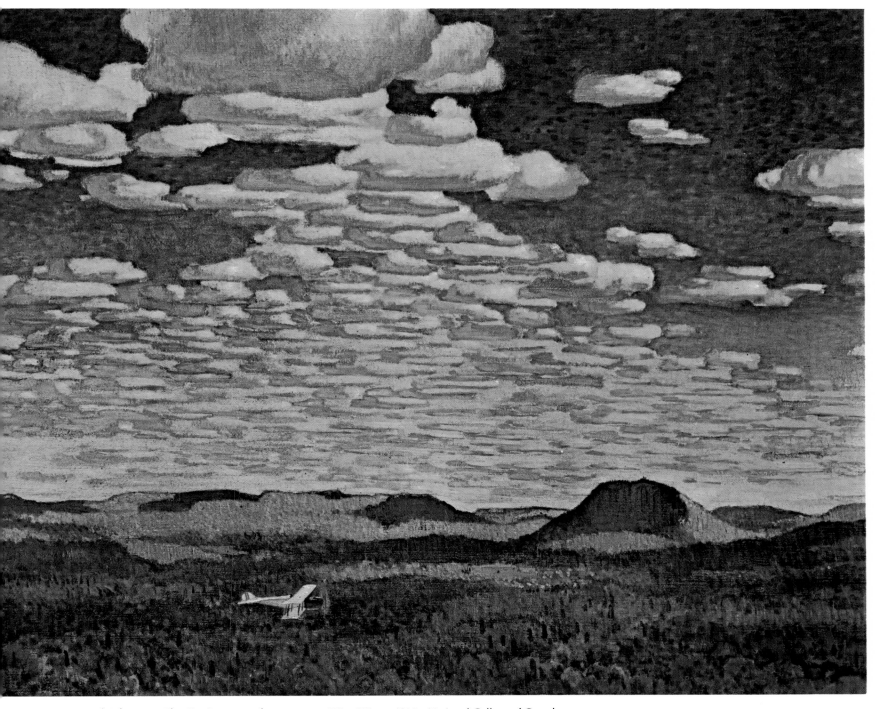

158 Frank Johnston *The Fire Ranger* oil on canvas 48″ x 60″ c. 1920 National Gallery of Canada

«*I always think of Algoma as MacDonald's country. He was a quiet unadventurous person, who could not swim, or paddle, or swing an axe, or find his way in the bush. He was awed and thrilled by the landscape of Algoma and he got the feel of it in his painting. He loved the big panorama:* Solemn Land, Mist Fantasy, Gleams on the Hills *were some of the titles of his paintings.*»[32]

MacDONALD – SOLEMN LAND

MacDonald felt a deep inner response to the Algoma landscape. Unlike his friends Jackson and Harris, who were hardy woodsmen, MacDonald had a frail and delicate constitution. He seemed to find strength in the rugged mountains, the hidden lakes, and the dramatic skies, for he was the one who made the most powerful statements when painting them. By the time of the second and third Algoma trips, his technical skills reached perfect harmony with what he was trying to express, as is seen in *Solemn Land*.

MacDonald's first studies for *Solemn Land* were made in 1919, when he was sketching on the Montreal River, but the canvas was not painted until 1921. A comparsion between one of the early sketches and a photograph of the site reveals how faithfully he reproduced the scene's topography. In the sketch, the colours are predominantly the vivid yellows of late fall and the pale blue of the tranquil sky and lake. It has all the freshness of a sketch before nature, but it is not in any sense dramatic.

The final canvas presents a striking contrast to both the sketch and the photograph. The sky is filled with dark, heavy clouds, which form an oppressive mass over the lake. The great cliff rises up to a crest and plunges into the lake, lit by the sun shining through the clouds. Beyond are the deep purple hills. The shapes of the hills and headlands have been boldly simplified, and the contours exaggerated to provide both rhythm and movement. They help to provide an impression of deep space, for the eye is led in a smooth curve from the red tree in the immediate foreground to the focal point of the cliff, on to the far mountains, and then back again via the mountains on the right.

Solemn Land was the culmination of a long and methodical development from early works such as *Lonely North* of 1913 or *The Elements* of 1916. Breaking away from the flat, decorative scenes of the early Algoma works, MacDonald created a monumental landscape of simplified forms, infused with strong colour and a definitive expression of mood. In achieving this, and in his rejection of naturalistic representation, MacDonald followed exactly the well-worn path of the European Symbolists.

Although MacDonald's concepts repeated those of earlier European artists, he was unaware of it.[33] He was directed instead by his broader philosophy and his reading of Whitman, Thoreau, and other American transcendentalists. MacDonald knew these authors well enough to give lectures on them, and they profoundly influenced his own concept of nature and art.[34] The transcendentalists believed that man could only rise above his physical self by contemplating nature. It was through nature that man reached a higher and more spiritual end, and ultimately achieved Oneness.

MacDonald tried to express this inner response to nature in his paintings and to move beyond descriptive naturalism. In a lecture on the "Relation of Poetry to Painting," given in 1929, he wrote: "A picture is not the reflection of a thing seen but a compound of feelings aroused in the artist by the things seen, resulting according to his skill in a more concentrated impression than the natural objects can give." [35]

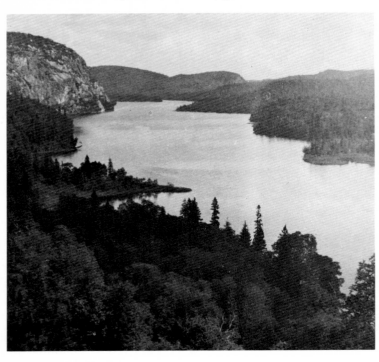

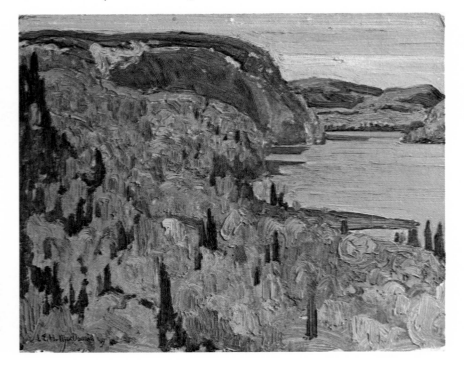

«*O to realize space!*
The plenteousness of all, that there are no bounds,
To emerge and be of the sky, of the sun
and moon and flying clouds, as one with them.»[36]
(WHITMAN)

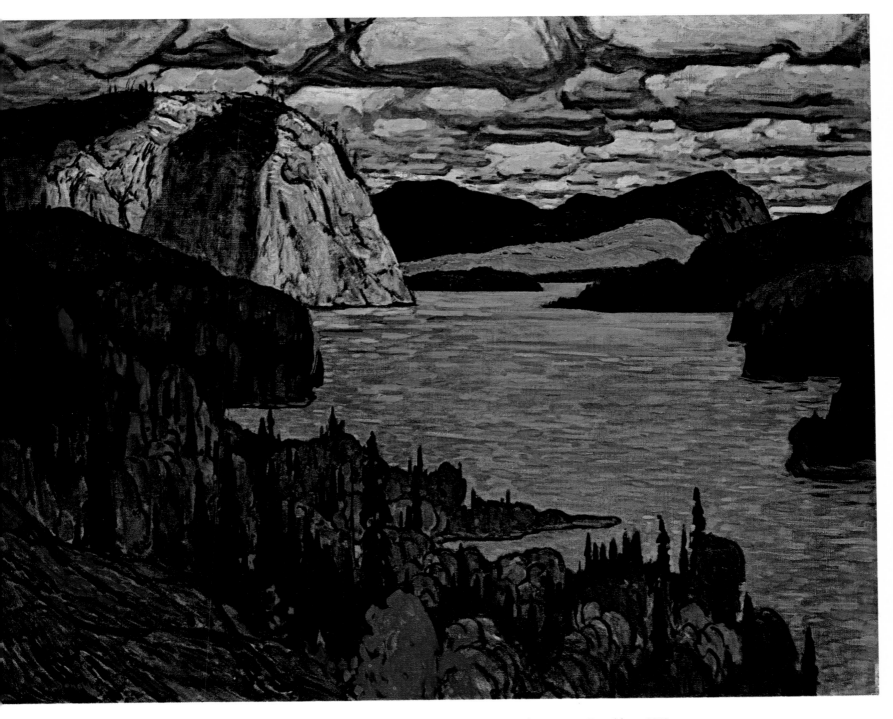

159 The site for *Solemn Land*. Photograph of the Montreal River taken under the supervision of J. E. H. MacDonald c. 1920

160 J. E. H. MacDonald *The Solemn Land* (sketch) oil on panel 8½″ x 10½″ 1919 S. C. Torno Collection, Toronto

161 J. E. H. MacDonald *The Solemn Land* oil on canvas 48″ x 60″ 1921 National Gallery of Canada

162 J. E. H. MacDonald *Rowanberries, Algoma* oil on canvas 30″ x 35″ 1922 Mr. & Mrs. W. A. Manford Collection, Toronto

The landscape of Algoma inspired in MacDonald a great variety of moods. He could turn from the vast panorama of *Forest Wilderness* to an intimate glimpse of nature in *Rowanberries* or to a poetic scene of a moonlit night, as in *The Lake, October Evening*.

Forest Wilderness is one of MacDonald's most impressive Algoma paintings, and vividly portrays the wild and rugged terrain. For many years it was called *Algoma Tapestry*, because of its rich, lush colour. His use of comma-like strokes of pure colour for the red bushes in the foreground — a feature directly borrowed from Van Gogh — is found in several other paintings from this period. However, it is naturally assimilated into MacDonald's style and does not detract from his individuality of approach.

Rowanberries returns to the restricted spaces of *Leaves in the Brook*, but with a new sense of the totality of nature. The bright red clumps of berries create a dancing rhythm in the foreground through which the flow of the brook from right to left to right can be seen. The shapes of the rocks have been simplified and are painted with a free brush, which adds to rhythmic quality. In the foreground dabs of pure red and blue are juxtaposed to show the reflection of sun and berries on the stream.

The Lake, October Evening has a richly treated foreground of red bushes and black spruce, forming a screen which sets off the lake and mountains behind. The moon casts an olive-tinted light over the scene, adding to the mood of stillness and calm.

163

163 J. E. H. MacDonald *The Lake, October Evening*
oil on canvas 21″ x 26″ 1922
Canada Packers Ltd. Collection

164

164 J. E. H. MacDonald *Forest Wilderness*
oil on canvas 48″ x 60″ 1921
McMichael Conservation Collection

Many of MacDonald's works from this period are simplified and stylized to almost pure abstraction. A superb example of this is the sketch for *Mist Fantasy*, where sky, land, water, and clouds are harmoniously blended into an overall design that has the freedom of a purely spontaneous gesture.[37] Broad horizontal bands of colour are set off by expressionistic dabs of bright red and olive, culminating in the magnificently free handling of the tree above. There is an immediacy of impact and a dynamic sense of rhythm, which make this one of MacDonald's most exciting sketches.

The finished canvas is more contrived and more consciously decorative than the sketch, but still retains the rhythm and poetry of the original statement. Colours are contained within well-defined shapes and are heavily outlined, in a manner similar to that used by the European Symbolists.[38] They had used this same technique earlier when they sought to express mood and emotion through a decorative approach to nature. But there is a universal quality to his work which ultimately makes any precedents unimportant.

165 J. E. H. MacDonald *Mist Fantasy, Sand River, Algoma* (sketch)
oil on board 8½″ x 10½″ 1920 National Gallery of Canada

In 1922, MacDonald completed the last of the Algoma paintings, ending the most productive phase of his career. A year earlier he had started teaching at the Ontario College of Art, which placed severe restrictions on his time, but brought him much-needed income. He continued to work as a commercial designer and also took on several large decoration schemes for St. Anne's Church and the Claridge Apartments.[39] In the summer months he travelled, first to Nova Scotia in 1922, then to the Rockies in 1924 and every year following until 1930.

MacDonald was greatly admired and respected by the other members of the Group. Somewhat older than the rest of them, he gave constant help and encouragement, and was looked up to as something of a saint. His efforts to show the public that Canada deserved to have its own landscape tradition and to defend the Toronto artists from their critics were untiring. He was also the first to capture a Canadian spirit in his art, and his works have had the most lasting appeal.

MacDonald has often been called the poet of the Group, but he was much more than that. Besides writing poetry himself and interpreting the ideas of Thoreau, Whitman, and others, his interests entered many different areas. According to his son, Thoreau MacDonald, he was "one of the universal souls who are interested in everything, from the music of the spheres or the brotherhood of man to planting potatoes or the making of axe handles."[40] There has been little appreciation of the astute intelligence and tremendous inner resources that lay behind the image of the dreamy poet.

166 J. E. H. MacDonald *Mist Fantasy, Sand River, Algoma* oil on canvas 21¹/₈″ x 26¹/₄″ c. 1922 Art Gallery of Ontario

In the late fall of 1921, after the last trip to Algoma, Harris and Jackson went along the north shore of Lake Superior towards Thunder Bay. The country impressed Harris so much that he returned there every autumn for the next few years with his friends. It was markedly different from the rich and tumultuous landscape of the Algoma region. Everywhere there was a feeling of open space, with sweeping ranges of smoothly rounded mountains and always the vastness of the lake and sky. Harris was deeply impressed by these skies, "which, in their singing expansiveness and sublimity, existed nowhere else in Canada."[41] If Algoma was MacDonald's country, Lake Superior now became Harris' country. He responded to the starkness and bareness of the landscape, whose bold simplicity corresponded with the direction Harris' own painting was taking.

Harris' early background provided a stimulating environment for the growth of ideas and the search for spiritual values. His grandfather and two of his uncles were distinguished ministers in the church, and his family was wealthy and sophisticated. As a youngster, he made several trips to Europe, and in his early twenties he spent several winters in Germany studying art. He had an active and exploring mind, and spent much of his time attending concerts and reading books on philosophy.

Back in Toronto, he became a close friend of MacDonald, and they usually talked more about literature than art. Through the Arts and Letters Club he met Roy Mitchell, the first director of the Hart House Theatre, who introduced him to Eastern thought and philosophy. He eagerly read the Irish nationalist poets, Yeats, Synge and Æ (George Russell), as well as the theosophists Madame Blavatsky, Ouspensky, and Spengler.[42] Although these writers seem esoteric to most readers today, they were then much in vogue in Toronto's cultural circles. Many of Harris' friends were theosophists, and all the members of the Group were aware of the basic concepts of theosophy.[43] Harris was not an intellectual in the academic sense of the word and never pretended to be; his interest in philosophy formed part of his constant search for spiritual truths and the meaning of art.

Through intense reading and discussion Harris gradually formulated his ideas about art. He was convinced that art must express spiritual values as well as portraying the visible world; the role of the artists and the function of art are to reveal the divine forces in nature.

Harris was by no means the first to show an interest in portraying the transcendental in art. Almost a century earlier the European Romantics had attempted to reveal the mysterious moving forces that they felt existed in nature. Later in the nineteenth century the Symbolists had explored the inner world of the imagination in an effort to restore spiritual values to art. Shortly before Harris began applying these ideas, two other artists, Kandinsky and Mondrian, were making their major discoveries in Europe. They were both theosophists, and both led the way to the development of non-objective art. Kandinsky, in particular, later influenced Harris with his essay *Concerning the Spiritual in Art*, published in 1912.[44]

Harris does not appear to have been aware of these developments taking place in European art; like MacDonald, he was more influenced by the literature he read, such as that of the American transcendentalists and the Irish nationalists. In 1918, Æ published his *Candle of Vision*, in which he presented his ideas on the Divine Being in nature. Like Harris, Æ felt that through a study of nature "the lover of Earth obtains his reward and little by little the veil is lifted off an inexhaustible beauty and majesty."[45]

Even more important for Harris was his involvement with theosophy, which became the guiding force in his life. The Theosophical Society, to which Harris belonged, was founded in New York by Madame Blavatsky in 1875.[46] Its main purpose was to unite Eastern religion and philosophy with that of the West, and to support the idea of universal brotherhood. Linked with this was a belief in the omnipresent spirit and the divine forces in nature. Through contemplation of these forces, one could rise above the material world and experience the ultimate Oneness. This mystical and spiritual experience gave true meaning to life.

There was a close connection between these ideas and those that Harris was trying to express in his art. He felt that the purpose of art was to reveal "the essential order, the dynamic harmony, the ultimate beauty, that we are all in search of, whether consciously or not."[47] Harris wanted to lead the spectator towards enlightenment and an inner experience of pure beauty. In this sense Harris was trying to do much more than paint the northland as he saw it, and his art cannot be fully understood unless put in this context.

167 Detail of Lawren Harris *Above Lake Superior*

Above Lake Superior is the most familiar of Harris' work of this period. Gone are the rich textures and colours of the Algoma works. Now everything is reduced to essentials. Instead of the transitory effects found in the early house paintings, there is a new sense of permanence and timelessness. Colours change from brilliant reds and greens to austere greys, blues, and creams. Forms are boldly simplified and contours sharply defined.

In *Above Lake Superior*, a prominent foreground motif sets off the massive hump of the distant mountain, and this mountain in turn partly blocks the view of the infinity of sky and water beyond. Five weather-worn stumps rise up from the snow-covered foreground and are sharply modelled by the bright sunlight. Two other trees lie horizontal to the picture plane to offset this strong vertical emphasis, and in the left foreground, additional trees lead the eye into the depth of the painting.

This strict compositional arrangement contributes to the mood of timelessness that Harris was trying to achieve. One viewer said of the painting: "It is not painting. It is sculpture."[48] This absolute clarity of form gives *Above Lake Superior* a monumental quality and links it with the age-old classical tradition in art. Harris wanted to embody the spirit of the North, to reveal its universality. By creating a symbol of the North, he hoped to go beyond the specific locale to a landscape of the human spirit. It was his hope that the painting would lead the viewer to contemplate the divine forces in nature, and ultimately to a mystical experience of Oneness.

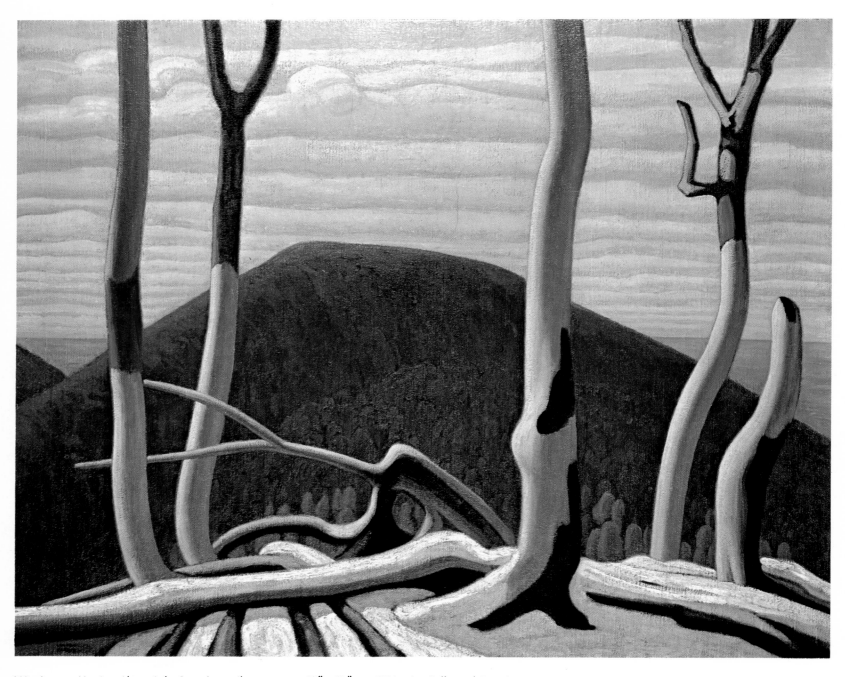

168 Lawren Harris *Above Lake Superior* oil on canvas 48″ x 60″ c. 1922 Art Gallery of Ontario

«*Every work of art which really moves us is in some degree a revelation – it changes us. Experiences, much more than instruction, are a seeing with the inner eye – finding a channel to our essential inner life, a door to our deepest understanding wherein we have the capacity for universal response.*»[49]

Jackson relates that he was somewhere in the bush with Harris when they came across the big pine stump that appears in *North Shore, Lake Superior*, later nicknamed *The Grand Trunk*.[50] In the sketch, Harris transposes the stump to a setting overlooking Lake Superior. He places it dramatically in the centre of the painting, seemingly rising up toward the golden rays of the sun which shine down from the upper left. Beyond are the shaped layers of cloud and the vast expanse of Lake Superior.

There is no doubt that the stump represents something more than just a lone stump in the wilderness. To interpret it as a phallic symbol would seem totally out of keeping with the puritanism of the Group. However, within the context of Harris' ideas on art it is not far fetched, for he strongly believed in the elemental forces in nature, including the basic sexual forces. Harris was probably unaware of the Freudian interpretation, even though it provided a perfect symbol for expressing his concept of nature.

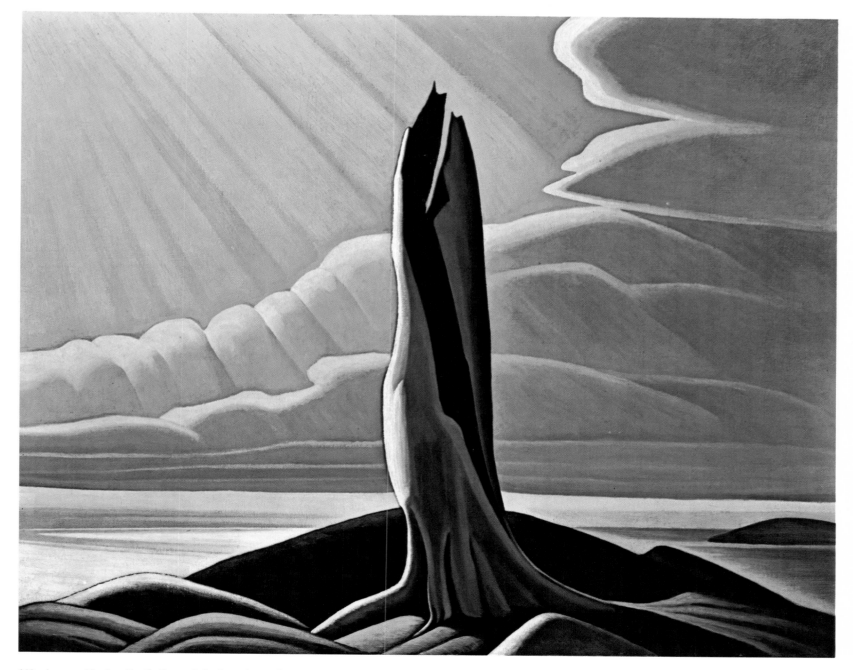

169 Lawren Harris *North Shore, Lake Superior* oil on canvas 40″ x 50″ 1926 National Gallery of Canada

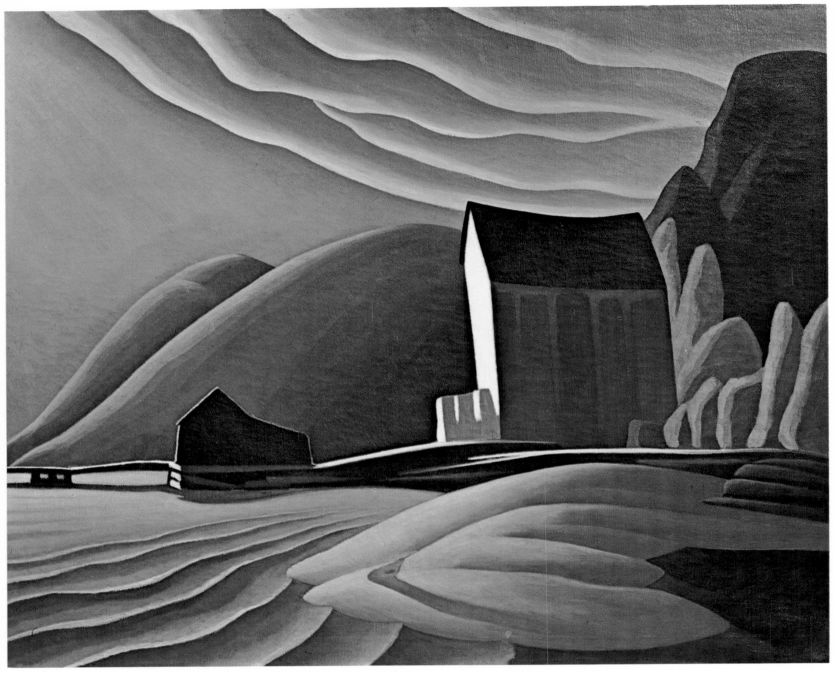

170 Lawren Harris *The Ice House, Coldwell, Lake Superior* oil on canvas 37″ x 45″ c. 1923 Art Gallery of Hamilton

«It was this country that gave Harris the motives for many of his best known canvases. There was a feeling of space, dramatic lighting, the stark forms of rocky hills and dead trees and beyond, Lake Superior, shining like burnished silver.»[51]

Harris gradually moved toward greater abstraction and a more complete expression of his philosophical views. After 1924 he no longer dated or signed his works, because he did not want them to be tied to a specific artist or time.[52] To break away from a specific place, he began numbering his works, so that they became *Lake Superior I, II, III,* and so on.

In *North of Lake Superior* and *Clouds, Lake Superior,* he leaves out the contrived foreground area found in *Above Lake Superior* and concentrates entirely on sky, clouds, water, and the effects of light and space. Clouds become abstract shapes in themselves, and the light appears to emanate from within the painting with a life of its own. Although recognizable landscape elements such as land, water, and sky are present, these have been arranged into purely abstract patterns. The landscape becomes a universal landscape of infinite space, where clouds are mystically suspended and bathed in light emanating from an all-powerful source. Light takes on a new symbolic meaning as a revelation of unity and pure spirit.

«And light has no weight,
Yet one is lifted on its flood,
Swept high,
Running up white-golden light-shafts,
As if one were as weightless as light itself —
All gold and white and light.»[53]

171 Lawren Harris *North of Lake Superior*
oil on canvas 48″ x 60″ c. 1924 London Public Library & Art Museum

172 Lawren Harris *Clouds, Lake Superior*
oil on canvas 40¼″ x 50″ 1923 The Winnipeg Art Gallery

Jackson accompanied Harris on several Lake Superior trips, and their reactions were markedly different.

The rich and almost garish colour of Jackson's *Above Lake Superior* forms a dramatic contrast to the starkness of Harris' Lake Superior paintings. It returns to the centralized composition of paintings such as *Terre Sauvage,* 1913. Like that painting, it is a more experimental type of work, and stands out from Jackson's characteristic style.

173 A. Y. Jackson *Above Lake Superior*
oil on canvas 46" x 58" 1924 McMichael Conservation Collection

174 Detail of A. Y. Jackson *Above Lake Superior*

Harris continued to make regular trips to the north shore of Lake Superior after his first visit in 1921. He returned for a week in October of 1922 with Jackson, and stayed near Coldwell. The following year he came back with Lismer, and spent a miserable month camping out in the wet and cold. In 1924 Carmichael joined him for the trip, and the year after that Harris organized the last expedition to the area, inviting Jackson, Carmichael, and Casson to accompany him. They camped in the area around Coldwell Bay and as usual met up with day after day of rain and snow. The bad weather never seemed to dampen Harris' enthusiasm, and he was always up before daylight. When Jackson growled, "What's the use of getting up, it's raining," Harris invariably replied, "It is clearing in the west." When it finally did clear three days later, Harris would say, "I told you it was clearing."[54]

This was the last time they worked together as a group, and in many ways it marks the end of a common group spirit. Following the 1924 trip, Harris became interested in painting the Rockies, and seldom went back to Lake Superior. While Jackson and Lismer returned only sporadically, Carmichael and Casson continued to make regular excursions to Coldwell, Rossport, and Jackfish, where they painted northern Ontario villages.

175 A. J. Casson *Algoma*
watercolour 17″ x 20″ 1929 McMichael Conservation Collection

176 A. Y. Jackson *North Shore, Lake Superior*
oil on canvas 25″ x 32¼″ 1926 Estate of Charles S. Band

177 Frank Carmichael *Bay of Islands* watercolour 17¹/₂″ x 21¹/₂″ 1930 Art Gallery of Ontario

178 Arthur Lismer *October on the North Shore, Lake Superior*
oil on canvas 48″ x 64″ 1927 National Gallery of Canada

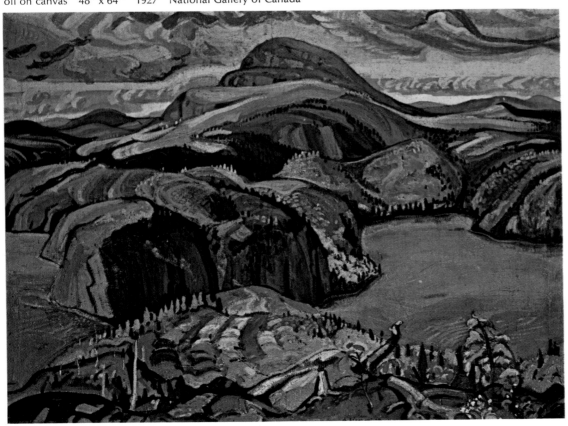

By painting small Ontario villages, Carmichael and Casson hoped to do for rural Ontario what Jackson was doing for Quebec. *Jackfish Village* and *Hillside Village* are typical works of this period. For watercolours, they are surprisingly large in size, and have almost the same depth of colour as oil painting. The artists' use of colour in these works is refreshingly rich and pure, and they handle the medium with great assurance. There is a strong emphasis on design as well as an intimate feeling for the landscape.

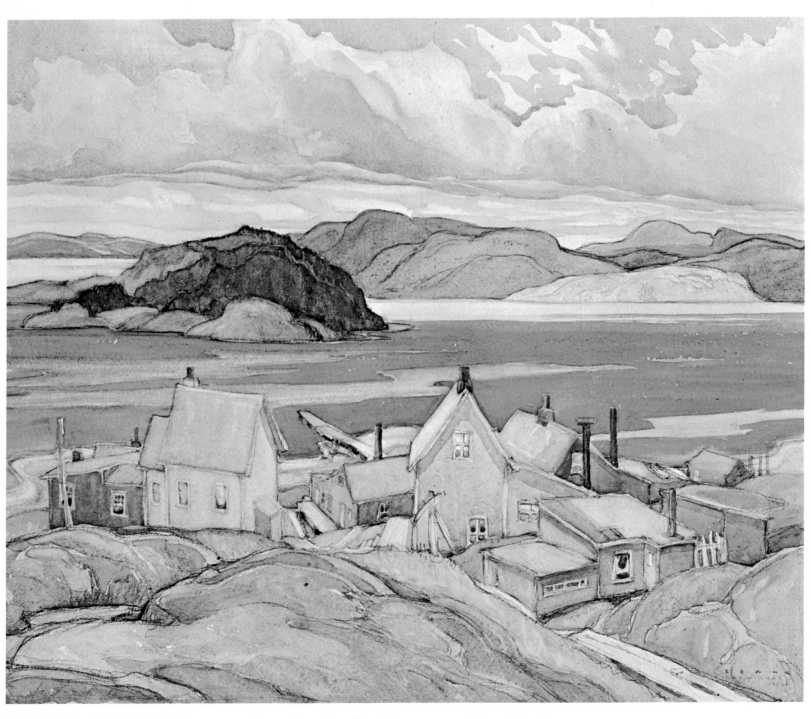

179 Frank Carmichael *Jackfish Village* watercolour and pencil 20″ x 22⅚₆″ 1926 Art Gallery of Ontario

Carmichael's way of life continued relatively unchanged through the early twenties. He worked as art director for Rous and Mann from about 1916 to 1925, with Casson as his assistant. Then he moved to the firm of Sampson Matthews, where he remained until 1932. Although his sketching trips were mostly confined to yearly vacations, he made excellent use of his time and worked with great energy and intensity. In 1920 and 1921 he sketched in the Lake Rosseau area; about 1923 or 1924 he worked at Mattawa on the Ottawa River; and in 1924 and 1925 he went on the Lake Superior trips. In the following years the La Cloche Hills along the North Channel became his favourite sketching ground. Carmichael also went north on weekends whenever possible, to sketch in the area around his family home at Orillia.

«*Southern Ontario villages have a domino-like clarity. Their slabs of plaster walls — spanking white in the sun, and their roofs of blue, black and terra cotta, allow full play for an artist's sense of pattern.*»[55]

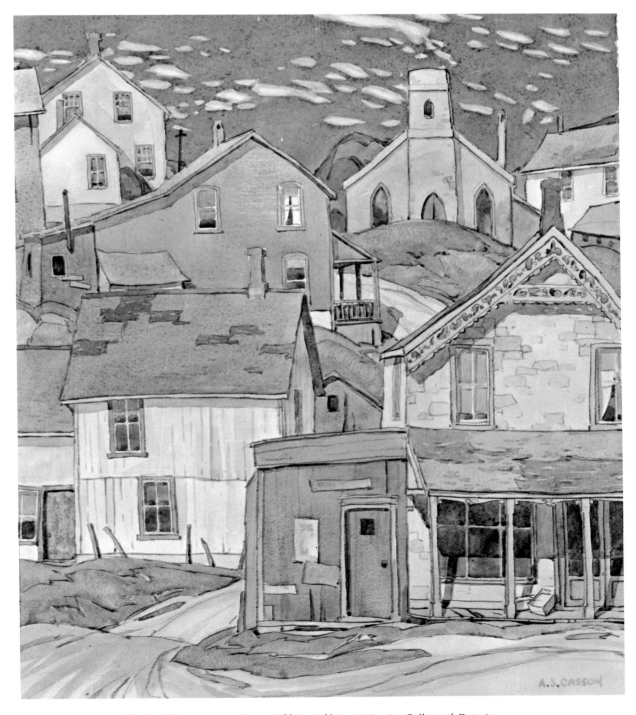

180 A. J. Casson *Hillside Village* watercolour 20½″ x 17¼″ 1927 Art Gallery of Ontario

The close friendship between Carmichael and Alfred Casson began in 1919 when Casson joined Rous and Mann at the age of twenty-one and became Carmichael's assistant. Casson was Toronto born, but had grown up in Guelph and had gone to school in Hamilton. When he returned to Toronto with his family in 1916, he saw his first works by the yet unformed Group of Seven. Eager to become a landscape painter, he went to evening classes at the Central Technical School and made sketching trips around Toronto. During the first years at Rous and Mann he learned the fundamentals of typography and graphics under Carmichael, who was a demanding and exacting teacher. Carmichael discovered Casson's interest in sketching, and soon the two artists were working together on weekends. Their friendship became firmly established during their month-long sketching trips to Lake Rosseau. Casson rapidly assimilated everything he could from Carmichael, a debt he acknowledges with pride when he says, "Anything I came to know about the organization of paint on canvas originated with him."[56] Later he had to stop painting with Carmichael in order to break away from his influence and to find his own style.

After the formation of the Group in 1920, Casson was introduced by Carmichael to the other members of the Group over lunch at the Arts and Letters Club. He soon became a regular visitor at the Artists' Table. However, it was not until the Lake Superior trip of 1925 that he was invited to go sketching with them. Early the next year, after a party at Lawren Harris' house, he and Carmichael were talking on their way home. Suddenly Carmichael asked, "How would you like to be one of the Group?" When the surprised Casson said that he would be honoured, Carmichael's reply was, with typical understatement, "Well, you are one."[57] Casson was the first new member to join the Group, and his addition again brought the number to seven, filling the vacancy caused by the resignation of Frank Johnston a few years earlier.

In the same year, Casson received another, equally important invitation, this one to join the Royal Canadian Academy. By 1926 the Wembley storm was over, and the Group was generally accepted by the public. It had also reached the stage where it needed new life and a new direction, but unfortunately little could be done to change it. The safe middle path taken by Casson can be seen in this statement from the *Mail & Empire*:

The newcomer to the Group of Seven does not experiment with modernism. He is a fine colourist with a feeling for Canadian landscape. To those who know and love the scenery of civilized Ontario, Casson speaks with eloquence. His canvases will form resting places for those visitors to the present show who cannot understand Lawren Harris and who feel nervous irritation when they look upon things that they do not understand.[58]

Casson belonged to the second generation of painters working in the Group style, and he was able to slip into their ranks without going through the same struggle and experimentation that the older painters did in their formative years.

Carmichael and Casson always remained slightly on the fringes of the Group. This was partly due to age, for Carmichael was the youngest of all the original members, and Casson was even younger. There were twenty-five years between Casson and Mac-Donald and about fifteen between Casson and the others, a fact which always made him feel somewhat overawed by the older members. Both artists worked full-time to support families, and this also set them apart from the rest of the Group, who had little sympathy for commercial artists. It was considered acceptable to be an art teacher, but there was still a stigma attached to working in the commercial field. Unlike the other Group members, they never ventured outside of Ontario on their sketching trips, and even these were limited to brief summer holidays and weekend trips.

The major contribution of Carmichael and Casson to the Group was in reviving the neglected art of watercolour painting. Both of them enjoyed working in this medium, which was perfectly suited to their approach and to their work in the commercial field. In order to improve the quality of watercolour painting, and to give it new respectability, with the help of Fred Brigden they organized the Canadian Society of Painters in Water Colour.[59] The society's first exhibition was held in 1926 and was so successful that regular shows were held for years after.

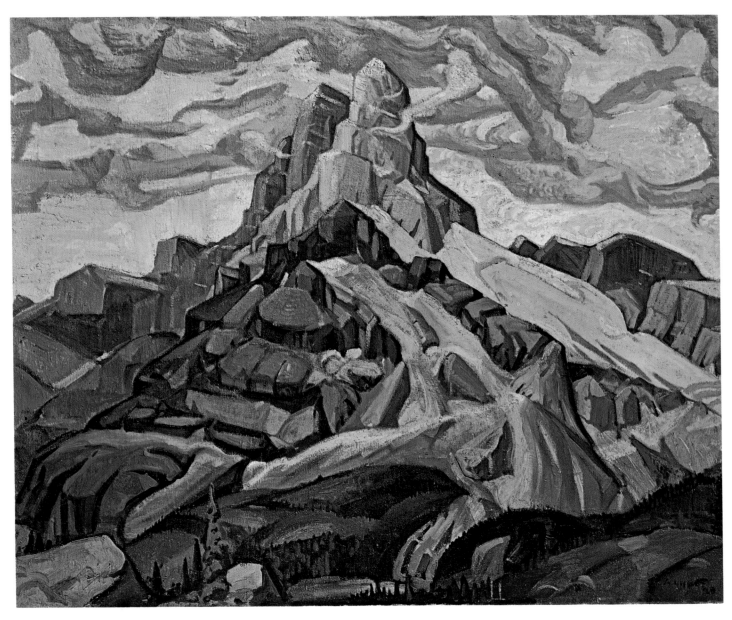

181 Arthur Lismer *Cathedral Mountain* oil on canvas 48" x 56" 1928 Montreal Museum of Fine Arts

THE ROCKIES

After several years of painting Lake Superior, the artists began moving further west. They became fascinated by the Rockies and by the difficult challenge of finding a pictorial equivalent for the vast mountain landscape. Harris made regular trips west from 1924 to 1929, and Jackson joined him on the first trip in 1924. MacDonald was enthralled by the rugged mountains, and he went to the Rockies every summer for seven consecutive years. Varley moved to the west coast in 1926, and was so moved by the terrain that he wrote back to a friend saying "British Columbia is heaven." Lismer made just one trip in 1928 when he made the sketch for *Cathedral Mountain*.

In 1924, Harris and Jackson went to Jasper Park for two months of sketching. Ten years earlier, Jackson had been to the Rockies with Bill Beatty, sketching for the Canadian Northern Railways. This time the two artists were planning to do some work for the Canadian National Railway, but nothing came of it. Finding the landscape along the railroad too tame, they headed into "the big country," to Maligne Lake and Tonquin, where they camped out near the timber line. There were the usual battles with the elements and the hardships of twenty-five-mile hikes and climbs of four or five thousand feet in a day's work. There were also the many anecdotes, such as the one about Jackson who rolled out of his tent one day and continued part way down a mountain before he knew what had happened, or tales of their friend Goodair, who was later killed by a grizzly bear.[60]

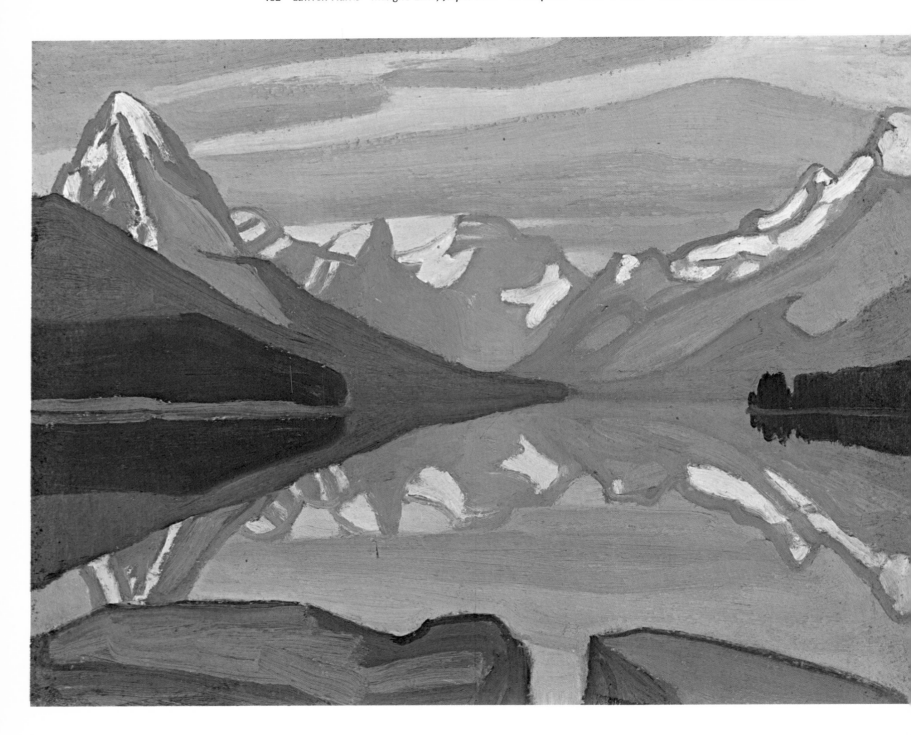

HARRIS ON THE ROCKIES «*When I first saw the mountains, travelled through them, I was most discouraged. Nowhere did they measure up to the advertising folders, or to the conception these had formed in my mind's eye. But, after I became better acquainted with the mountains, camped and tramped and lived among them, I found a power and majesty and a wealth of experience at nature's summit which no travel-folder ever expressed.*»[61]

ARTISTS IN THE MOUNTAINS – JACKSON «*We climbed a few more hundred feet over shale, and as we reached the top of the ridge the clouds suddenly lifted, the sun came out, and we looked over a country of strangely symmetrical forms; all running in long diagonal lines to sharp points – a kind of cubist's paradise, with glaciers sprawling lazily in the midst of it.*»[62]

183 Lawren Harris *Isolation Peak* oil on canvas 42″ x 50″ c. 1931 Hart House, University of Toronto

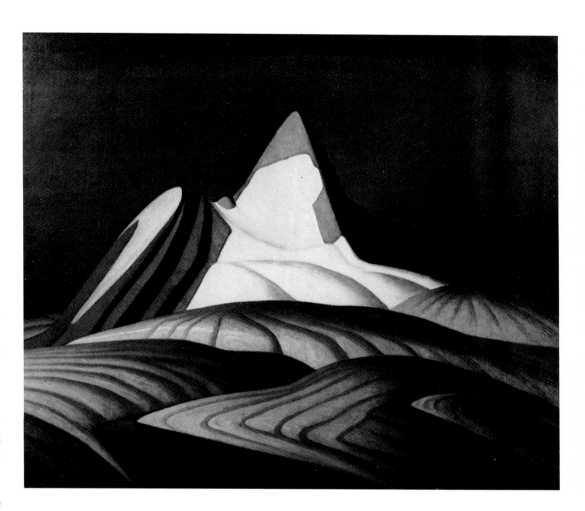

For Harris, these soaring mountains, even more than Lake Superior, came to symbolize the philosophical concepts that he was trying to express in paint. He wanted to capture his own inner response to the landscape and shape it on canvas with paint, "so that when finished it contains the experience."[63] The very size of the mountains forced him to simplify, to abstract, and to search out the underlying rhythms of the landscape.

Isolation Peak is developed from a pencil sketch of a far distant mountain. Harris telescopes in on the mountain peak and invents the undulating forms in the foreground. Shapes are simplified down to a basic pyramid for the peak, softened by a covering of snow at its base, and offset by the rock slabs to the left. The brilliant sunlight is focused on the peak itself, making it stand out dramatically from the cold, dark sky and frozen, blue-green glaciers. This is not only an unpeopled landscape, it is one which no human being could inhabit. It is "the great North and its living whiteness, its loneliness and replenishment, its resignations and release, its call and answer — its cleansing rhythms."[64]

When Harris' mountain scenes were first exhibited in the 1925 Group of Seven exhibition in Toronto, they drew a storm of protest. Pictures like *Maligne Lake* made critics accuse him of flinging whole mountains in the face of the public.

JACKSON – LETTER TO A FRIEND

«*We had our first trip. It was good fun, though I was short of wind and sore in the heels. We went to Maligne Lake with Lawren, the guide, four horses and me. I am not used to riding and walked most of the way, about twenty-five miles. We arrived at the fire-ranger's cabin and spent a couple of days with him. Then, in a big eighteen-foot canoe, we paddled down Maligne Lake fifteen miles and landed on a gravel beach where we pitched the tent. Later we looked down on our camp from two thousand feet up and several miles away. Lots of driftwood for a fire and water off the near glaciers; flowers all about us, many we had never seen before. On both sides of us, a few hundred yards away, milky glaciers came hurrying over great gravel deltas into the lake.*»[65]

184 A. Y. Jackson *Ramparts on the Tonquin* pencil 8³⁄₈″ x 10⁷⁄₈″ 1924 McMichael Conservation Collection

185 J. E. H. MacDonald *Above Lake O'Hara*
oil on panel 8¹/₂" x 10¹/₂" 1929 McMichael Conservation Collection

186 J. E. H. MacDonald *Mountains and Larch*
oil on panel 8¹/₂" x 10¹/₂" 1929 McMichael Conservation Collection

MacDonald struggled for years to solve the problem of effectively representing the mountain landscape on canvas. In his early attempts, such as *Rain in the Mountains* (in the Art Gallery of Hamilton), he tried to give the effect of scale by using a self-conscious foreground motif to set off the mountain behind, but the end result failed to convey the character of the landscape.

In the later sketches, such as *Mountains and Larch* and *Above Lake O'Hara,* both dated 1929, MacDonald comes to grip with the terrain. He does this by a lyrical and free handling of colour, form, and brush. Instead of trying to encompass the total view in his picture, he focuses on only a small segment and merely suggests the tremendous spaces beyond. Forms are boldly and abstractly brushed in, but they still convey the physical structure of the mountains with great clarity. Mood is expressed through the use of soft mauves, yellows, and greys.

Mountain Snowfall, Lake Oesa and *Goat Range, Rocky Mountains* (in the McMichael Conservation Collection) were the last two canvases MacDonald worked on before his death in 1932. In *Mountain Snowfall, Lake Oesa,* he expressed the character of the Rockies, but not by painting a whole mountain range with its vast scale and deep space. Instead, he closes in on the mountain face, rendering it in a flat, abstract design with an overall restraint in composition, colour, and form. These elements, with the gently falling snow, suggest a lyrical mood and a sense of timelessness. By saying less, MacDonald has succeeded in saying more.

187 J. E. H. MacDonald *Mountain Snowfall, Lake Oesa* oil on canvas 21″ x 26″ 1932 Estate of Charles S. Band, Toronto

Jackson went west again in 1926 with the anthropologist Marius Barbeau, who was the great authority on North American Indians and folk art.[66] Accompanying them was Edwin Holgate, a Montreal artist who later became a member of the Group. They went up the Skeena River, on the northwest coast of British Columbia, where Barbeau was studying the Indian totem poles. Jackson and Holgate sketched along the Upper Skeena between Kitwanga and Hazelton, recording the landscape and the Indian villages.

188 Emily Carr *Kispiax Village* oil on canvas 36⅛" x 50¾" 1929 Art Gallery of Ontario

189 A. Y. Jackson *Skeena River Crossing*
oil on canvas 21" x 26" 1926 McMichael Conservation Collection

Jackson did numerous drawings and oil sketches, but painted up only three canvases when he returned East. None of them was very successful, for when he was painting views of the houses and totem poles, he became absorbed in naturalistic detail and lost the feeling for the scene as a whole. When he concentrated on the countryside and attempted his characteristic rhythmic treatment, he was unable to adapt it to the vastness of the landscape. The only successful scene was an intimate view of a conventional house, surrounded by small shrubs and trees, called *Indian Home* (now in the collection of Isabel McLaughlin). Except for the mountains in the distance, this could almost be a scene in rural Quebec.

Emily Carr liked the rhythm and poetry in Jackson's works, yet she sensed that he did not really have a love for the West. "I always felt that A.Y.J. resented our West. He had spent a summer out at the coast sketching. He did not feel the West as he felt the East."[67] Jackson himself had written her earlier, saying, "Too bad, that West of yours is so overgrown, lush – unpaintable, too bad!"[68] It comes as a surprise to hear Jackson saying that a part of Canada was "unpaintable," for this was just the attitude that he vigorously attacked at every opportunity. In spite of his goal to paint all of Canada and his near-accomplishment of this objective, he still remained essentially a painter of Ontario and Quebec.

Holgate's most celebrated work of the period was his *Totem Poles, Gitsegiuklas*.[69] In this painting, Holgate cleverly uses totem poles to provide a series of planes receding into the depth of the picture. One pole is dramatically placed in the immediate foreground, setting off the two poles behind it. These poles in turn form an inner frame through which the figures, the houses, and the far distant mountains can be seen. The unusual composition, the cool colours, and the assured handling of form make this work one of Holgate's best.

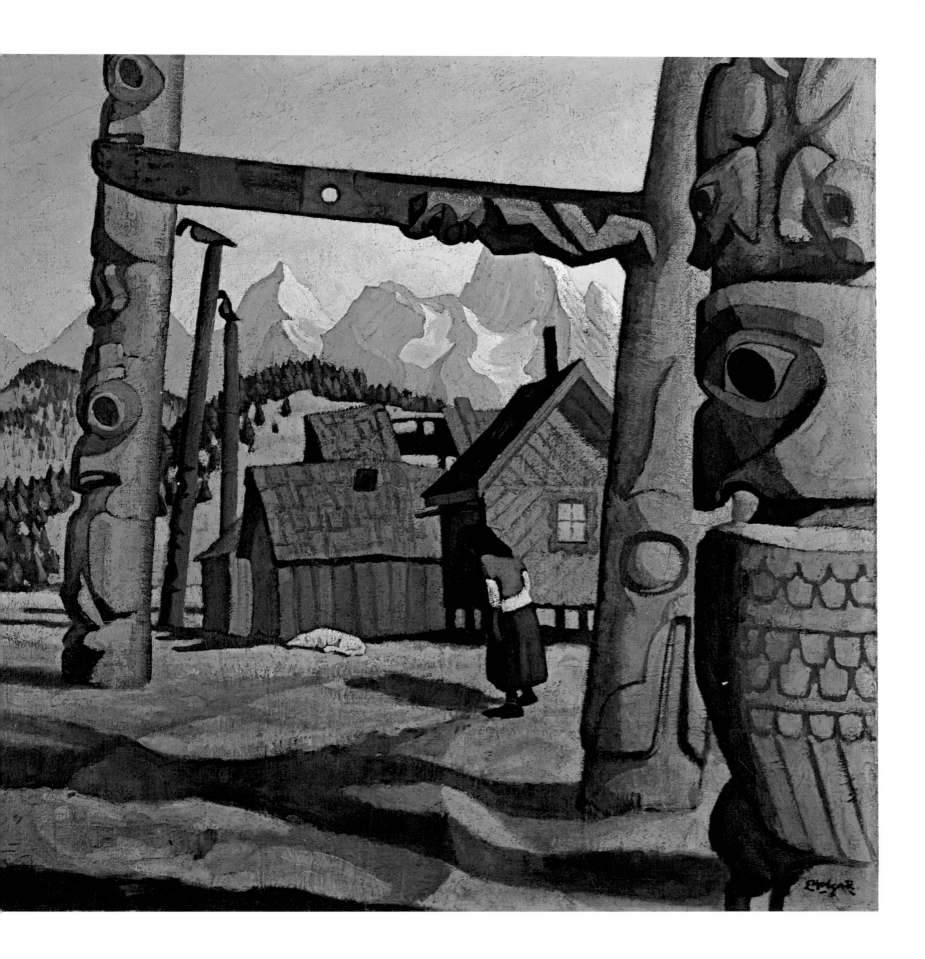

190 Edwin Holgate *Totem Poles, Gitsegiuklas* oil on canvas 32″ x 32″ 1927 National Gallery of Canada

Edwin Holgate played a relatively minor role in the history of the Group. Although born in Ontario, he was raised in Montreal, where he began his art education at an early age, studying under William Brymner. Following a number of years in Paris before and after the war, he returned permanently to Montreal in 1922, opened a studio, and began teaching wood engraving at the Ecole des Beaux Arts. He was friendly with Jackson and the Montreal artists of the Beaver Hall Group, and he often went sketching with them in Quebec. At this stage, he was considered a promising young artist, capable of competent works such as *The Cellist*, which is now in the McMichael Conservation Collection.[70]

Holgate was more of a figure painter than a landscape artist and, in this sense, previewed the activities of the Canadian Group of Painters in the 1930's. In the late twenties he did several paintings of lumberjacks and firerangers, and also made numerous woodblock prints using the same theme. His *Lumberjack* of 1926, the best known of these works, displays his rough technique with its well-defined forms and solid colours. It is technically competent and realistically painted, but lacks real power.

Holgate was one of the few Canadian artists to paint nudes, a subject usually avoided at all costs. He saw that Canadians had already accepted landscape as a genuine artistic expression and hoped to be an innovator by combining the nude with the landscape. Unfortunately the end result is not entirely successful. In *Nude in a Landscape*, the young woman reclines somewhat uncomfortably on a rocky ledge, with the lake and mountains stretching out behind her. Holgate repeats the same surface textures and soft, rounded shapes in both the figure and landscape in an attempt to integrate the two. Despite these efforts, the figure still seems completely incongruous in an outdoor setting; it remains essentially a studio nude in a studio landscape.

191 Edwin Holgate *Lumberjack (Le Bucheron)*
oil on canvas 26" x 22" 1926
Sarnia Public Library & Art Gallery, Sarnia, Ontario

192 Edwin Holgate *Nude in a Landscape*
oil on canvas 29" x 46" c. 1930
National Gallery of Canada

Holgate's trip to Skeena with Jackson in 1926 brought him closer to the Group, and in 1928 he had two works in the Group exhibition, including *Lumberjack*. His growing reputation was enhanced by his decorations for the Totem Pole Room at the Chateau Laurier Hotel in Ottawa, which he based on the sketches from his Skeena trip. In 1930 he had nine works in the Group show as an invited contributor, and the next year was asked to join as a member. However his membership was brief, for the Group disbanded soon after.

It is difficult to understand why Holgate was admitted to the ranks of the Group, when many other competent artists were not. The Group were undoubtedly aware that they were a dying movement, and they probably hoped that an outside member from Montreal would make them more truly national and give new life to their cause. However, Holgate did not save the Group from collapse, nor did he continue to develop with the same promise he had displayed in the twenties.

Until confronted with the paintings of Emily Carr, it is difficult to appreciate how "eastern" Jackson and Holgate were. Emily Carr had been up the Skeena as far back as 1907, and had also made many canvases of totem poles and Indian life. After a long series of discouragements, she stopped painting in 1913 in order to look after her boarding house and to earn a living. For the next fifteen years she took care of the "House of All Sorts," made pottery, and raised 350 Bobtail puppies.[71] Then in 1927, Eric Brown, director of the National Gallery, came to visit her. He had heard about her work from Marius Barbeau, and wanted to invite her to show fifty canvases in an exhibition of west coast Indian art at the National Gallery. When Eric Brown mentioned the Group of Seven her reply was – "Who are they?"[72] At his suggestion, she read about them in Housser's book, *A Canadian Art Movement*, and decided to go east to meet them.

This was to be one of the most important events in her life, for after meeting all of the Group she decided to resume painting. From 1927, her association with the Group, and Lawren Harris in particular, was a close one. Their influence is not only apparent in her art; her vivid impressions of her new friends are also recorded in her journals. These first-hand reactions provide one of the most revealing insights into the Group.

193 Arthur Lismer *Emily Carr Meets the Group*
pencil c. 1927
McMichael Conservation Collection

«*Thursday November 17th: Oh, God, what have I seen? Where have I been? Something has spoken to the very soul of me, wonderful, mighty, not of this world. Chords way down in my being have been touched. Dumb notes have struck chords of wonderful tone. Something has called out of somewhere. Something in me is trying to answer.*

«*It is surging through my whole being, the wonder of it all, like a great river rushing on, dark and turbulent, and rushing and irresistible, carrying me away on its wild swirl like a helpless little bundle of wreckage. Where, where? Oh, these men, this Group of Seven, what have they created?–a world stripped of earthiness, shorn of fretting details, purged, purified; a naked soul, pure and unashamed; lovely spaces filled with wonderful serenity. What language do they speak, those silent, awe-filled spaces? I do not know. Wait and listen; you shall hear by and by. I long to hear and yet I'm half afraid. I think perhaps I shall find God here, the God I've longed and hunted for and failed to find. Always he's seemed nearer out in the big spaces, sometimes almost within reach but never quite. Perhaps in this newer, wider, space-filled vision I shall find him.*

«*Jackson, Johnston, Varley, Lismer, Harris-up-up-up-up-up! Lismer and Harris stir me most. Lismer is swirling, sweeping on, but Harris is rising into serene, uplifted planes, above the swirl into holy places.*» [73]

EMILY CARR – AFTER SEEING PAINTINGS BY HARRIS

«*I have never felt anything like the power of those canvases. They seem to have called to me from some other world, sort of an answer to a great longing. As I came through the mountains I longed so to cast off my earthly body and float away through the great pure spaces between the peaks, up the quiet green ravines into the high, pure, clean air. Mr. Harris has painted those very spaces, and my spirit seems able to leave my body and roam among them. They make me so happy.*» [74]

CARR ON JACKSON

«*Monday November 14, 1927: I loved his things, particularly some snow things of Quebec and three canvases up Skeena River. I felt a little as if beaten at my own game. His Indian pictures have something mine lack – rhythm, poetry. Mine are so downright. But perhaps his haven't quite the love in them of the people and the country that mine have. How could they? He is not a Westerner and I took no liberties. I worked for history and cold fact. Next time I paint Indians I'm going off on a tangent tear. There is something bigger than fact: the underlying spirit, all it stands for, the mood, the vastness, the wildness, the Western breath of go-to-the-devil-if-you-don't-like-it, the eternal big spaceness of it. Oh the West! I'm of it and I love it.*» [75]

CARR ON LISMER

«*Wednesday, November 16, 1927: I have met the third of the 'Group of Seven,' Arthur Lismer. I don't feel as if these men are strangers. Somehow they wake an instant response in me. Lismer's last two pictures gave me a feeling of exhilaration and joy. All his works are fine, but he is going on to higher and bigger things, sweep and rhythm of the lines, stronger colours, simpler forms. …I wonder if these men feel, as I do, that there is a common chord struck between us. No, I don't believe they feel so toward a woman. I'm way behind them in drawing and in composition and rhythm and planes, but I know inside me what they're after and I feel that perhaps, given a chance, I could get it too. Ah, how I have wasted the years! But there are still a few left.*» [76]

194 Emily Carr *Indian Church*
oil on canvas 42³/₄″ x 27¹/₈″ c. 1930
Art Gallery of Ontario

In September of 1926 Varley left Toronto for Vancouver, to head the department of drawing and painting at the Vancouver School of Art. From this point onwards Varley had little to do with the Group of Seven. He exhibited in only two more Group shows, and it was almost twenty years before he returned to Toronto to live. The years prior to his departure were restless ones, with desperate financial hardships and little painting of importance. He withdrew more and more from the activities of the Group, and went on fewer sketching trips. Although he remained friendly with several of the Group, he had unpleasant conflicts with some and was vehemently disliked by others.

Once in Vancouver, he lived up to his new responsibilities and had a profound effect on art education there during the ten years he taught at the School of Art. When he first began teaching, he was faced with a rigid academic system and a strong resistance towards anything new or modern. In a letter to a friend he noted that "people treat me with their gloves on, fearing to be contaminated with evil influence."[77] However, he had the rare ability to inspire his students to tremendous creative freedom, and soon he had many supporters. Jock Macdonald arrived at the School of Art as head of design the same year Varley did, and the two artists became close friends. Jock Macdonald praised him as the "artist who laid the foundation stone of imaginative and creative painting in British Columbia."[78] And with Varley's encouragement, Macdonald broke away from a tightly linear style to a free and expressive use of colour. Both of them made regular sketching trips into the mountains of British Columbia and camped out for days at a time. In 1933 they broke away from the Vancouver school and set up the British Columbia College of Art, which survived for two years.

195 F. H. Varley *Dharana* oil on canvas 34″ x 40″ 1932 Art Gallery of Ontario

Varley considered his best work to have been done after he left Toronto, and he undoubtedly did find new inspiration on the west coast. He was deeply impressed by the mountains in a way he never was by the terrain in the East. His landscapes, such as *The Cloud, Red Mountain* took on a new freedom and individuality, as if he had been suddenly released from the confines of the Group approach. There is expressive force in the deep, rich colours; but the mood is not a reflection of the physical forces in nature – it has a calmer, more spiritual quality.

Part of this new feeling stemmed from an awakened interest in Oriental art and philosophy which he was exposed to in Vancouver. One former student remembers how Varley deluged them with Japanese prints, Persian manuscripts, as well as the works of Matisse and Puvis de Chavannes.[79] As a part of Vancouver's small artistic community, he became involved in the intense discussions on Eastern philosophy, and he undoubtedly heard the Indian poet and philosopher Rabindranath Tagore when he lectured there in 1929.

The title of *Dharana* signifies one of the higher Buddist states of meditation, where the mind is free of the body and at one with its surroundings. The painting attempts to reveal the mystical relationship between the sitter and the landscape, inspiring a mood of spiritual contemplation. Unfortunately Varley verges on sentimentality in his treatment of the figure and does not successfully relate it to the landscape.

196 F. H. Varley *The Cloud, Red Mountain, B.C.* oil on canvas 34″ x 40″ c. 1928 Art Gallery of Ontario

Varley was inspired not only by the landscape, but by his personal relationships as well. About this time he began his long association with Vera Weatherbie, an art student, whom he described as "the greatest single influence in my life."[82] Of the many portraits and figure studies of Vera dating from the early 1930's, the most striking is the portrait, *Vera*, in the Massey Collection. With great assurance, Varley conveys a mood of relaxed sensuality. The slightly tilted head and sloping shoulders, the hint of a smile on her lips, and the forthright gaze, all suggest a feeling of intimacy. Her face is an almost pure oval, and the strongly modelled features contrast with the shapelessness of the body and clothing. There is a gentle rhythmic movement from the out-swung hair, to the collar and back to the other collar, adding to the lyrical and sensual mood.

However, it is the unusual use of colour that contributes most to the character of the portrait. Green is the predominant tone, and it is used liberally for the shading of the face, the clothing, and the background. This is one of the first times Varley employed colour for symbolic purposes. Here green is intended as a spiritual colour, in conjunction with the blue. Varley's realization that different colours produced different psychological effects was in no way an original concept, for it had been popular since the Post-Impressionist generation of Gauguin and Van Gogh. It is just another example of the time lag in adapting these ideas to a Canadian situation. When some of his portraits were exhibited in 1930, the reaction of the public revealed that it was even further behind:

F. H. Varley is represented by a collection of meaningless pictures of women which are after psychic effects and are painted in sickly colours which remind one of cheap candles.[83]

197 F. H. Varley *Head of a Girl*
black chalk 9⅜" x 9" c. 1930-35
National Gallery of Canada

Although there are elements in Varley's work that can be traced back to Europe, he still must be considered as independent of any movement. He was a man of sensitivity and passion, and, true to the Romantic school, he professed to paint what he felt. Like many romantics, he worked in fits and starts, and had to be moved by a great surge of emotion in order to create.

Varley was in many ways marginal to the main current of the Group of Seven, both in his art and in his temperament. He never had the same interest in portraying Canada just because it was Canada, even though he was impressed by the landscape. Whether painting landscape or figures, he preferred to go his own way and not be restricted to a particular philosophy. As a strongly independent personality, he had little sympathy with the spirit of camaraderie that was basic to the Group. His bohemian ways and his moody temperament caused a great deal of friction with other members of the Group, who in turn presented a confusing image of him as a person. In public, he was made to appear an eager supporter of the Group, and all the personality conflicts were carefully disguised. However, in private he was often scorned as a seducer of women and a penniless alcoholic who was to be avoided when seen on the street. This conflict of images has tended to obscure the real Varley, a man with weaknesses and vices, but also a man of humanity and passion, motivated by a deeply-felt religious spirit.

VARLEY – ON PORTRAITS «*When you paint a person well you are not yourself. You empty yourself of all preconceived ideas about the subject. As you look at the sitter you see the truth emerging in the face. All people are beautiful in one way or another.*»[84]

198 F. H. Varley *Vera* oil on canvas 24" x 20" c. 1930 National Gallery of Canada (Massey Bequest)

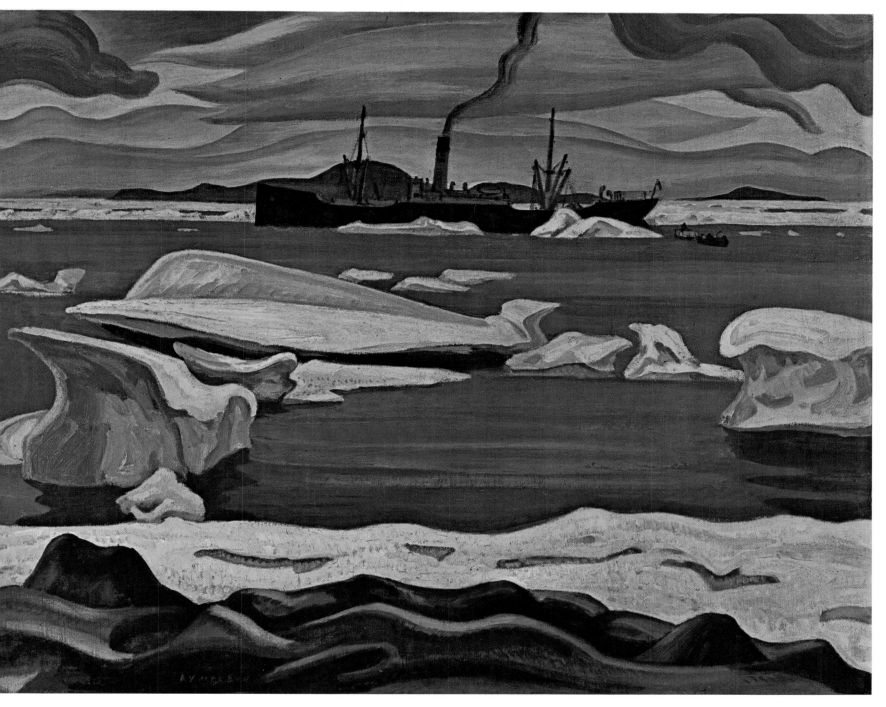

200　A. Y. Jackson　*The Beothic at Bache Post, Ellesmere Island*
oil on canvas　32″ x 40″　c. 1928
National Gallery of Canada

201　Sir Frederick Banting　*Ellesmere Island*
oil on panel　8½″ x 10½″　1927
McMichael Conservation Collection

Many of the on-the-spot oil sketches and drawings that Jackson brought back with him were successful in conveying the character of the remote and barren landscape. *The South Coast of Bylot Island,* one of his strongest drawings, was sketched as the *Beothic* sailed past the island. There is great sensitivity of line in Jackson's treatment of the bold rhythmic contours of the mountain forms. The heavy pencil-strokes used for the mountains contrast with the light, wispy clouds and the water in the foreground. It is interesting to compare the movement in this drawing with the static, frozen quality of Harris' painting, *Bylot Island,* in the National Gallery of Canada.

Upon Jackson's return from the Arctic after fifty-one days at sea, the press commented that he was "more Canadian, more virile than ever."[87] Jackson called upon Canadians to put themselves at the head of the big adventure of discovering Canada's vast northern empire. He said he never wanted to work in Europe again and would discourage art students from going there.[88] In the following year, he continued his pursuit of discovering Canada for Canadians when he made the arduous journey to the Northwest Territories with Dr. Banting and Mackintosh Bell. They went up to Great Slave Lake and visited Fort Resolution and Yellowknife, before going over to Walsh Lake. Jackson did mainly pencil drawings on the trip, since he could not make oil sketches, "as the mosquitoes got all mixed up with the paint."[89]

BANTING ON JACKSON

«*Sketching was done under considerable difficulty; cold and wind would have chilled the enthusiasm of a less ardent worker. Jackson cherishes an illusion that the finest colour is generally to be found on the most exposed spots. A restless desire to find what lies beyond the distant hills makes it hard to keep up with him. The barren wastes proved to be rich in form and colour, strange rhythms and unexpected vistas. During our all too brief and exciting scrambles ashore, he would be chuckling and laughing all day — a mood I found contagious.*»[90]

«*On the ship he would watch the changing landscape, following the wind-blown clouds, drinking in the beauty of colour of the coast formations, and studying the subtle effects of light on the moving ice.*»[91]

202 A. Y. Jackson *The South Coast of Bylot Island* (sketch)
pencil 7½" x 11" 1927 McMichael Conservation Collection

203 A. Y. Jackson *Remains of Mary on the Shore at Beechey Head* pencil 10⁷/₈'' x 7⁵/₈'' 1927
Norman Mackenzie Art Gallery, University of Saskatchewan, Regina, Saskatchewan

In 1930, Jackson was again invited to visit the Arctic, and this time he was accompanied by Lawren Harris. They left on the *Beothic* on August 1, and followed much the same route as on the previous trip. The weather was rough for most of the trip; the winds reached seventy miles an hour, and the huge waves threw the small ship about like a toothpick. They also had to contend with fog, snow, and drifting ice floes. Jackson and Harris did a large number of sketches on this trip, but were often restricted by time and space. "On many occasions we had time only to take rapid notes," Harris recalled. "These notes we worked up into sketches, crowded in our small cabin, seated on the edge of our respective bunks with only a port hole to let in the light." [92]

One of the places they went ashore was Pangnirtung, where Jackson climbed up to a high vantage point looking down over the fiord and to the snow-capped mountains beyond. The settlement below "consisted of the usual white painted wooden buildings and the colourful Eskimo igloos and tents made of skins and old sails stuck anywhere. There were husky dogs and boulders all over the place." [93] He later painted a canvas from his sketches called *Summer Pangnirtung*. By now, Jackson was more at ease with the landscape, and he created a vigorous rhythm of rounded boulders and flowing lava-like earth. The colours remained dark and earthy, but were appropriate for the setting. Despite the freedom of this work, there is still a tendency to portray picturesque subject matter, which forms a striking contrast to the dramatic simplicity of the work Harris was doing at this time.

204 A. Y. Jackson *Summer Pangnirtung*
oil on canvas 21″ x 26″ 1930
Dr. & Mrs. Max Stern Collection, Montreal

205 Lawren Harris *North Shore, Baffin Island* oil on canvas 32″ x 42″ c. 1930 Private Collection

THE *LEADER-POST* ON LAWREN HARRIS

«*In spite of their titles, the pictures of Mr. Harris do not portray a view to either Devon Island at midnight or North Shore, Baffin Island or the icebergs of Baffin Bay North. What they portray is entirely a different story. They give the painter's own conceptions of these spectacular scenes. And these conceptions are essentially abstract and philosophical. His icebergs are strange monuments with a symbol embodied in their form and their colours. They do not freeze you when you look at them, for they are not of ice, they are what Lawren Harris feels and thinks after he has contemplated them*»[94]

If Jackson did not find radical new art forms in the North, Harris responded to the Arctic in a bold new way. Harris had been moving in the direction of greater simplicity ever since his Lake Superior works. In the Arctic he found a landscape more remote than any he had seen before; often there was no land to be seen – just ice, sky, and water.

In works such as *North Shore, Baffin Island* and *Icebergs and Mountains* Harris gave a personal and expressive interpretation of the Arctic. The clouds in *North Shore, Baffin Island* soar above the mountains, whose peaks are eerily lit by the sun. Their simple and rhythmic shapes give the impression of a vast and otherworldly landscape. *Icebergs and Mountains* shows a concern for mood and an interest in the unusual shapes of the clouds and the terrain. Harris creates a feeling of tension in the centre of the painting by the use of the curve and counter-curve of mountain and sky. Colour is almost a monochromatic grey and white in the background, but is effectively separated from the blue of the icebergs and water by a horizontal strip of green.

206 Lawren Harris *Icebergs and Mountains, Greenland* oil on canvas 36" x 45" c. 1930 Art Gallery of Hamilton

The Arctic works are more important in terms of their expressive qualities than as works of semi-abstraction. At this time, Harris was concerned with expressing the spiritual in art. Four years earlier, he had written an article in which he spoke of "the great North and its living whiteness, its loneliness and replenishment, its resignations and release, its call and answer – its cleansing rhythms."[95] He continued by saying that "the top of the continent is a source of spiritual flow that will ever shed clarity into the growing race of America, and we Canadians being closest to this source seem destined to produce an art somewhat different from our Southern fellows – an art more spacious, of greater living quiet, perhaps of a more certain conviction of eternal values."[96] It was in the Arctic that Harris found what he was looking for. He imbued his works with a sense of timelessness and of monumental simplicity.

The two different approaches of Harris and Jackson show the two directions Canadian art was taking. Jackson continued to interpret Canada as the "artist topographer," suggesting that Canadians would produce a unique art by painting more and more of the landscape. Harris, on the other hand, was beginning to seek his answers in the inner world of the spirit, where there were an equal number of adventures and even more exciting areas to be explored.

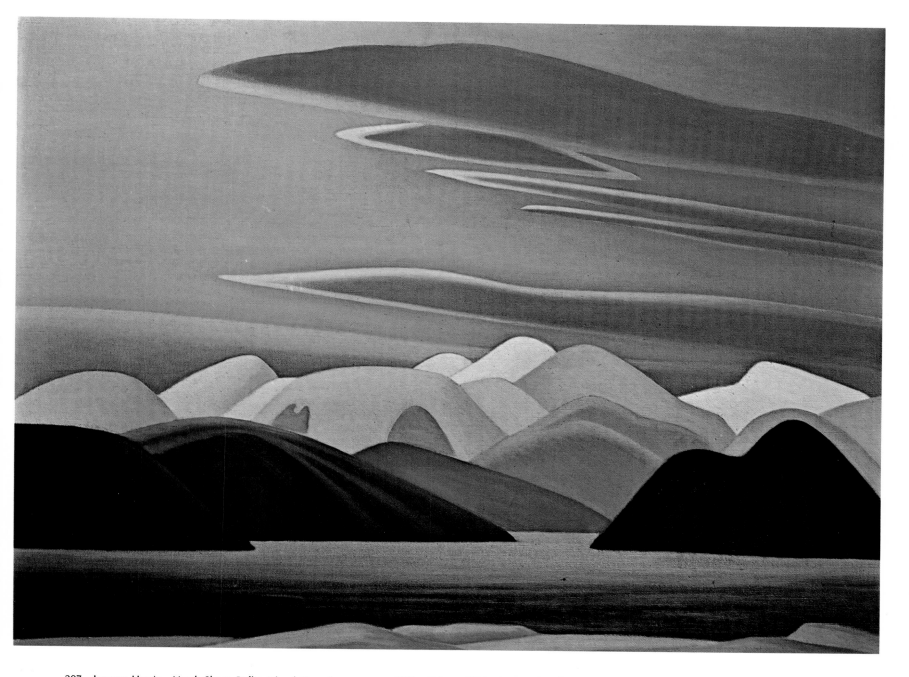

207 Lawren Harris *North Shore Baffin Island (I)* oil on canvas 32″ x 42″ c. 1930 National Gallery of Canada

One of the last parts of Canada to be painted by the Group was the Prairies. Aside from FitzGerald, Jackson was the only other member who was interested in painting it. Even he did not paint it until five years after the Group disbanded, when he went to Alberta in 1937. That year he sketched the foothills around Lethbridge and did the study for his *Blood Indian Reserve* (in the Art Gallery of Ontario). In later years, he returned many times to this area.[97]

It was FitzGerald who became known as the "Painter of the Prairies," even though he did almost no works of the flat midwestern countryside.[98] Lemoine FitzGerald was the last artist to join the Group and in many ways was the most original and individual of them all. He was born in Winnipeg in 1890, and was a contemporary of most of the other Group members. Brought up on his grandmother's farm at Snowflake, in the south of Manitoba, he left school at fourteen and worked for a wholesale druggist, a stock broker, and an engraver before becoming a full-time artist in 1912. Subsequently, he did everything, from interior decorating to scenery painting, in order to earn his living.

In late 1921, at the age of thirty-one, he left his wife and family to study at the Art Students' League in New York for the winter. This first trip from his native province was probably made at the insistence of Frank Johnston, who had arrived in Winnipeg in the fall of 1921 to become principal of the School of Art.[99]

At the end of the winter FitzGerald returned to Winnipeg and was to remain there for the rest of his life. (His only other trip outside of Canada was a visit to Mexico in 1951.) He became a teacher at the Winnipeg School of Art in 1924 and taught there for the next twenty-five years. This quiet and stable life formed a marked contrast to those of the other Group members, who spent nearly all their time on the move.

FitzGerald was known in the East mainly through the works he sent to exhibitions. In 1918, the National Gallery purchased a scene of *Late Fall, Manitoba*, and in 1925 one of his works was included in the Wembley show. The Group invited him to contribute in their last two shows in 1930, and his paintings must have made a strong impression, for they invited him to join the Group in the summer of 1932. MacDonald was still alive, and this addition brought the total number of Group members to nine.

Why was FitzGerald chosen over the thirty other invited contributors in the 1931 show? He was not an ardent artist-explorer like the other members, nor did he share in the Group spirit of camaraderie. Considering that the Group had already revealed its intention to disband and to form a larger group, it is clear that FitzGerald's inclusion was largely an honourary membership in recognition of his achievements as an artist.[100] FitzGerald never exhibited as a member of the Group of Seven, but the next year he became a founding member of the Canadian Group of Painters.

208 L. FitzGerald *Snow I*
pencil 17⅝" x 23⅝" 1950
Art Gallery of Ontario

Doc Snider's House, one of the three paintings FitzGerald exhibited in the 1931 show, clearly shows why the Group were impressed by his work. In this painting, he uses dry and delicate colours and crystal-clear light to express the frozen quality of the winter landscape. Here he succeeded in capturing the atmosphere of the Prairies without having to represent the traditional wide-open space.

He worked outdoors in the coldest of weather, and he devised some ingenious methods to protect himself from the sub-zero temperatures. When painting *Doc Snider's House*, he stayed in a little shack with a stove in it, which he pulled about on runners.[101] Although FitzGerald painted directly from nature, his works still possess a universal quality. By concentrating on the particular, he was able to find something common to all. The search for drama, movement, and rhythm, which exists in so many works by the Group, is not found in FitzGerald's paintings. Instead, there is a feeling of restraint and economy, which conveys his understanding of the landscape with great effectiveness. In his later works he achieves an even greater individuality and moves on to pure abstraction.

Like his contemporary, David Milne, FitzGerald stands apart from the Group. He worked in isolation and solitude, and was able to find enough subjects in his immediate surroundings to last him a lifetime. Since the world he painted was essentially an inner world of the imagination, he felt no need to trek across the country in search of new scenes. His subjects were simple ones and his goals were modest.

209 L. FitzGerald *Doc Snider's House* oil on canvas 29½″ x 33½″ 1931 National Gallery of Canada

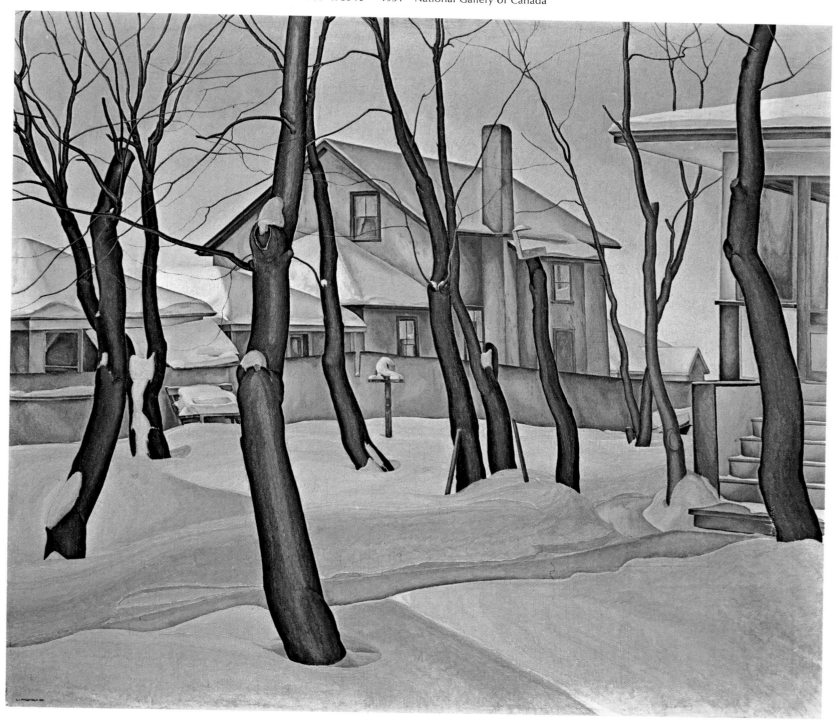

7 The Later Years

THE DECLINE OF THE GROUP OF SEVEN, BY TM [THOREAU MacDONALD]

«*The Group of Seven and their followers have always been regarded as Canadian through and through. That has been their special pride and they have never tired of praising the grandeur of the North and the Great Canadian Shield. But for Canadian patriots, lovers of our Country, their present exhibit is far from cheering. For they are ever becoming more artistic, more artificial. Without any feeling for the face of our country they tiresomely express themselves in strange and unbeautiful forms, in artificially constructed scenery without life.* »[1]

THE DISBANDING OF THE GROUP

In December, 1931, the Group of Seven held their eighth and final exhibition at the Art Gallery of Toronto. Included in the show were twenty-four invited contributors, as well as the eight Group members, which gives some idea of how diffuse they had become. After the preview of the exhibition, an announcement was made that the Group "had ceased to exist as such."[2] They explained that "a bigger association is to take its place, not a formal art society with constitution and executives, but an art group, widened to include a far reaching representation of all creative Canadian artists."[3] The disbanding of the Group had been long forthcoming, and MacDonald for one felt that it had outlived its purpose several years earlier.[4]

The Group had been in formal existence since 1920, and the artists had been painting together for seven years prior to that. This was as long a life as could be expected for any artistic group and was almost identical to the lifespan of the Impressionist movement in France. When the Group broke up, most of its members were already in their fifties, and the youngest member, A. J. Casson, was thirty-five. By 1932, the Group had become an institution and was widely accepted by most Canadians. Two years earlier Jackson had commented: "The prejudice against the Group is pretty well dying out, and there is a different attitude. Today, practically all the younger artists are working along the lines we followed."[5] The last part of his statement was all too true, and the many imitators eventually did more harm than good to the Group's reputation.

Without being aware of it, the Group had gradually begun to impose their views on art in Canada. Other artists resented their attempts to dominate the art scene, and in 1927 Gagnon wrote to Eric Brown saying,

Nothing can be done to change matters as long as the Group of Seven will fight and dictate to all the other artists in Canada, nothing will happen to make things better. The younger generation of artists seeing that they cannot enter the House of Seven because all of the Seven Rooms are occupied by the Seven Wise Men, rather than sleep on the steps will move along and build a house of their own.[6]

It seemed as if the Group had a monopoly on Canadian art, and for a while there was little recognition of the younger artists who were experimenting with new ideas of abstract and non-objective art. The Group's influence was so powerful that most artists either emulated them, while claiming individuality, or broke away from them altogether.

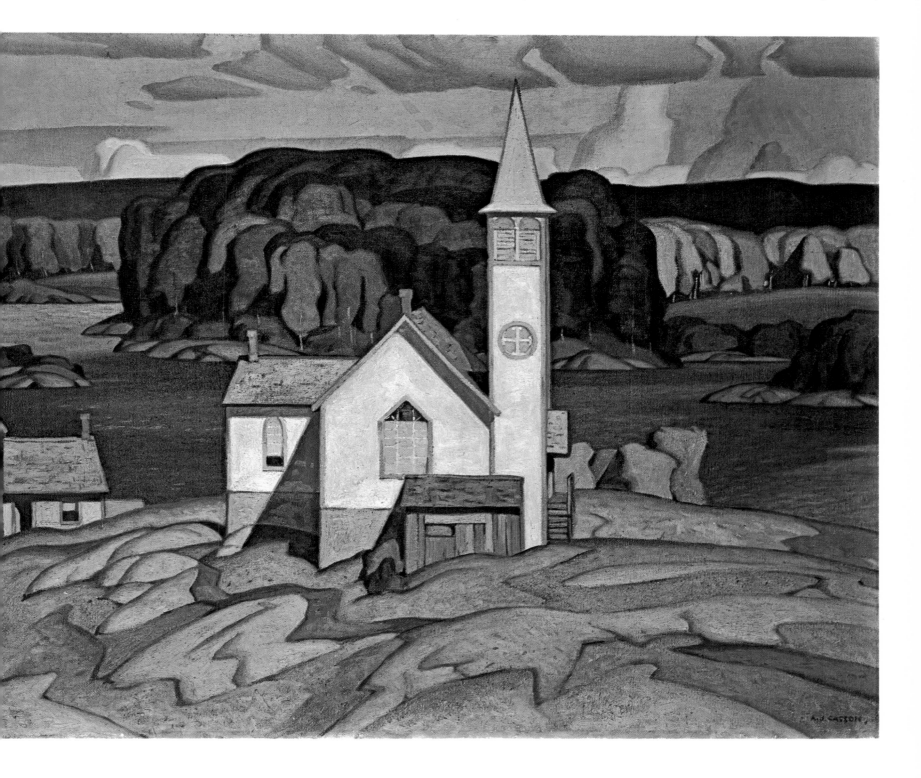

«Our artists are still out on the Loon Lake portage confronting the rocks and the black bears. The Group of Seven led them there thirty years ago.»[7]

The organization that replaced the Group was called the Canadian Group of Painters. In the foreword to its first exhibition in November, 1933, it proudly claimed to be a direct outgrowth of the Group of Seven, and noted that all of the Group were included among the twenty-eight founding members.[8] "Its policy is to encourage and foster the growth of Art in Canada, which has a national character, not necessarily of time and place, but also expressive of its philosophy, and a wide appreciation of the right of Canadian artists to find beauty and character in all things."[9]

The Canadian Group of Painters suggested that it would be different from the Group of Seven because it drew its members from all of Canada and was concerned with figure painting as well as landscape. In later years, the Group had been most commonly criticized for two things: its lack of figure painting, and its regionalism. Unfortunately, the Canadian Group's attempt to rectify these faults was an overly self-conscious one, and it failed to come to grips with the real problem. It still remained essentially Toronto- and Montreal-based, dependent on landscapes as its basic subject matter. It also proudly considered itself to be an amateur movement, and it is interesting to note that over one-third of the members were women.

While most of the older artists continued along their well-trodden paths, some of the younger ones produced interesting variations on the overworked theme of Canadian landscape. But generally they stuck to a well-established formula, without any of the searching or experimentation of the early Group works. There were competent landscapes, such as Yvonne McKague Housser's *Cobalt* or Charles Comfort's *Tadoussac*, but many were pale Group imitations, such as Anne Savage's *Spruce Swamp*. The addition of a figure or a few buildings to a landscape was not enough to keep in the vanguard of the modern movement. The artists were still clinging desperately to an outward-looking, naturalistic conception of nature – an approach which had ended in France with the Impressionists half a century earlier. John Lyman had been sensitive to the limitations of this outlook as early as 1932, when he wrote:

The real adventure takes place in the sensibility and imagination of the individual. The real trail must be blazed towards a perception of universal relations that are present in every parcel of creation, not towards the Arctic Circle.[10]

Over the years, the Canadian Group gradually lost its dependence on landscape painting, but this was not until the late forties. A few artists, such as Lawren Harris and Jock Macdonald, made the transition from landscape to abstraction, but most of them did little more than turn to a new type of subject matter. Instead of painting the rugged Precambrian Shield, they painted people. Some of them, like Bess Housser, painted people in a landscape. Others, like Prudence Heward, concentrated on the figure alone, and some turned to portraiture, like Lilias Torrance Newton.

There were many excellent painters who exhibited with the Canadian Group, including Emily Carr, David Milne, Goodridge Roberts, and Jacques de Tonnancour. The list of members and invited contributors is impressive and contains all the best-known figures in Canadian art. But none of them depended on or participated in a common "Group Spirit"; they considered the Canadian Group merely an outlet for exhibiting their works. The really significant developments taking place in Canadian art in the thirties and forties were happening outside of these art circles.

211

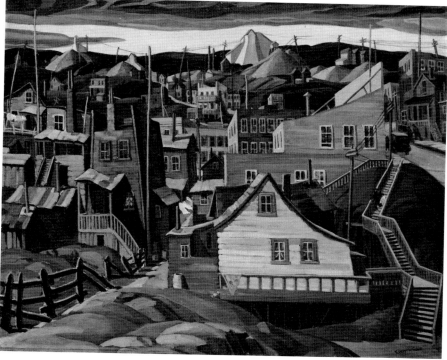

212

213

214

211 Ann Savage *Spruce Swamp*
oil on canvas 20'' x 24'' 1929
Hart House, University of Toronto

212 Yvonne McKague Housser *Cobalt*
oil on canvas 44¼'' x 54¼'' 1930
National Gallery of Canada

213 Thoreau MacDonald *Great Slave Lake*
pen & ink 9'' x 12½'' 1950
McMichael Conservation Collection

214 William P. Weston *Cheam*
oil on canvas 42'' x 48'' 1933
Hart House, University of Toronto

215 Charles Comfort *Tadoussac*
oil on canvas 30'' x 36'' 1935
National Gallery of Canada

215

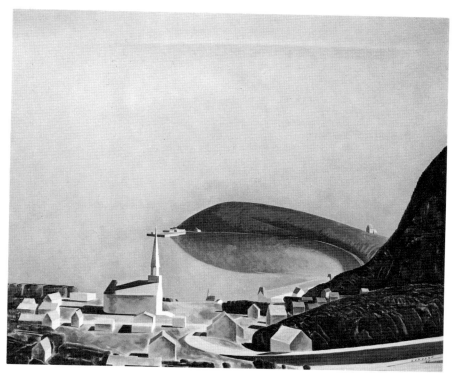

THE GROUP AFTER 1932 With the disbanding of the Group of Seven, the history of the Group as a unified art movement comes to an end. MacDonald died in November of 1932, at a time when he was on the verge of making new discoveries. (In later years his key role in the Group's development was often overlooked, partly because of the longevity of the other Group members.) Varley, who had gone west in 1926, severed almost all connection with the Group. Harris was soon to leave for the United States, and the remaining members went their separate ways. By 1932, the period of experimentation and discovery was over, and the main battles had been won. The large retrospective exhibition of 1936 was final proof of their acceptance and recognition.

In the years to come, Jackson, Lismer, Carmichael, and Casson were the artists who most consistently continued to work in the spirit and style of the Group. At their best, they produced paintings of great lyrical power, and at their worst they produced comfortably realistic landscapes according to a well-worn formula. Harris and Varley were the only two who continued to grow and to experiment as artists. Harris' concern for expressing spiritual values in art made him move towards abstraction in the thirties. Varley was briefly attracted to Cubism, Symbolist colour theory, and Oriental art, but generally he continued his independent approach. Neither artist broke any radical new ground, but they must be respected for having searched for new and meaningful ways to express themselves.

216 Arthur Lismer *When Shall We Three Meet Again?* pen and ink 6" x 8½" 1936 McMichael Conservation Collection

More than any other member of the Group, Harris continued to develop as an artist and to explore new ideas. He had always been the driving force behind the Group, from his visit to the Scandinavian show with MacDonald, to his proposal for a Studio Building devoted to Canadian art, and his organizing of the Algoma and Lake Superior trips. More than likely Harris was responsible for the initial idea for a "Group of Seven" and for its implementation. With his inexhaustible energy, he virtually swept the Group along in a wave of enthusiasm, although he never claimed credit for his efforts or his generosity.

An indication of how important Harris was to the Group is revealed by Jackson's reaction when he discovered that Harris was not coming back to Toronto in 1940. "We were bereft. While we rather prided ourselves that the Group had no leader, without Harris there would have been no Group of Seven. He provided the stimulus; it was he who encouraged us always to take the bolder course, to find new trails."[11]

While most of the Group settled into their set patterns in the late twenties, Harris was blazing new trails. In 1927 he helped bring the *International Exhibition of Modern Art* to Toronto, which opened the public's eyes for the first time to the new developments in modern art.[12] The exhibition was reviewed by Harris and Frank Johnston in the *Canadian Forum*. While Harris was receptive to the new ideas presented in the show, Johnston attacked them more viciously than any critic had ever attacked the Group.[13] At this point Harris' own art began moving slowly toward abstraction with the boldly simplified works of the Rockies and the Arctic. He became more closely associated with Bertram Brooker, who had been encouraging the Group since his arrival in Toronto in 1921.[14] Brooker was familiar with Kandinsky's theories on the spiritual in art and had started to paint pure abstractions in the twenties, which were shown at the Arts and Letters Club.

Harris was interested in Brooker's ideas, but did not abandon representational art until he went to the United States in 1934. He was invited to Dartmouth College in New Hampshire to become their artist in residence, and ended up spending four years there. By 1936 he had arrived at pure abstraction with works such as *Equations in Space*, which resembles the hard-edge school of the sixties. During the following years his paintings were almost exclusively abstract, but some of them did revert to representational images. From Dartmouth he went to Sante Fe, New Mexico, for two years, where he became a member of the Transcendental Group of Painters. It was 1940 before he returned to Canada and settled in Vancouver for the remainder of his life. *Composition #1* was the first painting he did in his new Vancouver studio.

The best way to understand Harris' abstract works is through his *Essay on Abstract Painting*, which was first published in 1949.[15] In this essay Harris clearly formulated his own theories on abstract art. He believes that the arts can embody a vast range of experiences without having to imitate anything in nature. The closest analogy to non-representational art is music: "It is becoming an art as pure as music and with the same possibilities of infinite and moving expressions and creations and with a similar depth, power and subtlety of meaning. And this new kind of painting introduces us into an inexhaustible realm of new experiences."[16] Harris stresses that the new art still represents ideas, emotions, and the world of the imagination, but without the intermediary of recognizable subject matter. With abstract and non-objective arts the interplay of colour and form evokes a direct emotional response in the spectator. By the use of these elements in their purest form, the artist can express and communicate the eternal values of truth and beauty.

Much of what Harris said had already been expressed many times before. His theories as well as his paintings were heavily dependent on the writings and work of Wassily Kandinsky, who had published his book *Concerning the Spiritual in Art* in 1912.[17] Like Harris, Kandinsky was a theosophist and had developed his ideas out of a desire to express spiritual values in art without having to resort to recognizable images. However, Kandinsky's analogies with music and his detailed discussion of colour symbolism were much more sophisticated than those of Harris. In addition to Kandinsky, Harris was

217 Lawren Harris c. 1956

probably influenced by André Breton, who published his *Manifesto of Surrealism* in 1924, and the Dutch artist Piet Mondrian, who was also a theosophist and had made the same move from representational to non-objective art.[18]

Harris' move from representation to abstraction was a logical conclusion of his earlier search for spiritual values in nature. In 1926, he had written that the artist must become one with the spirit of the North and must create living works "by using forms, colour, rhythms and moods."[19] It was an easy step from the bold simplification of the Arctic works to a use of colour, form, and light for their own intrinsic and symbolic value. In the abstractions up to 1950, his works were mainly variations on the basic geometric shapes of the triangle and the circle, with colour used for symbolic effect. After 1950, Harris developed a form of abstract expressionism, in which colour was used with greater freedom, and forms became swirling vortices or rhythmic patterns. In his last works, the remarkable intensity of light and colour best expresses Harris' spiritual search for the vision of gold and white light which is pure spirit.

The abstractions by Harris have been subject to much criticism. The staunch supporters of the Group felt that he had sold himself out to the modern movement, and they refused to take his later work seriously, even though Harris felt that it was more important than anything he had done while he was a member of the Group.[20] An indication of the unfavourable public reaction to his abstract paintings can be found in the fact that no public gallery in Canada purchased any of them until 1969.

218

A more justifiable criticism is that they were too cerebral, with the conscious mind controlling the spirit. Harris himself said that abstract art was "a creative interplay between the conscious and the unconscious, with the conscious mind making all the final decisions and in control throughout."[21] The criticism was not new, for as early as 1921, Barker Fairley commented on Harris' work, saying, "It would seem as if head, heart, and hand had worked in ignorance of one another."[22] At present it is difficult to judge whether Harris allowed himself to be dominated by his cool and precise intellect. But there are works by him from all periods that have great lyrical force, directness, and energy. In time these may counterbalance the image of him as the artist-intellectual.

Harris was often called the aristocrat and the intellectual of the Group, and his attitude and actions bore this out in every way. Like the other members, he wanted to bring art to the people, but in a manner very different from the crusading spirit of Lismer and Jackson. As Northrop Frye said, "He is a missionary who wants to make his own faith real to others."[23] Recognition finally came to Harris with two retrospective exhibitions in 1948 and 1963, but somehow it did not seem to touch him. He remained a deeply spiritual person – a man of true humility and great inner resources. But perhaps the image he would have best liked to be remembered by would have shown him walking alone over a glacier in the rarefied air of the Rocky Mountains, with his mane of pure white hair blowing in the wind.[24]

219

218 Lawren Harris *Equations in Space*
oil on canvas 30¹/₄″ x 60¹/₄″ 1936
National Gallery of Canada

219 Lawren Harris *Composition #1*
oil on canvas 62″ x 63¹/₄″ 1940
Vancouver Art Gallery

Of all the Group artists, A. Y. Jackson remained truest to the Group spirit and the Group style. In the year it disbanded, he asserted his independence by resigning from the Royal Canadian Academy, because he disagreed with its policies.[25] With the Group of Seven no longer in existence, he readily switched allegiance to the Canadian Group of Painters and continued his travels across Canada. In the decades to come he was a familiar figure in many parts of the country, suddenly turning up at an old friend's place for a few weeks' sketching, or going off in search of new territory to paint.

Every spring, Jackson made his regular visits to Quebec, and during the summer he ventured further afield, to Alberta, Great Bear Lake, the Alaska Highway, Yellowknife, or the Barren Lands in the Northwest Territories. In the late fall he returned to his familiar quarters in the Studio Building on Severn Street, where he lived until 1955. There he would paint canvases during the cold winter months, waiting for the spring so that he could set out again on his travels. These trips continued with unfailing regularity until he was in his eighties, and in 1965 he amazed everyone by going to Baffin Island and camping out at the age of eighty-three.[26]

Besides travelling and sketching, Jackson continued to make his voice heard for art in Canada. Jackson was a born diplomat, who could be at ease with anyone from the Governor General and bank presidents to bushmen and students. He would talk informally to classes of schoolchildren, men at business luncheons, or groups at art galleries. He delighted in telling and retelling the story of how the Group had overcome the domination of the Dutch school and, for the first time, had painted Canada as it really was. During the Second World War he helped to develop the silkscreen prints of contemporary Canadian paintings, which were sent overseas by the thousands. He also illustrated books, starred in a film called *Canadian Landscape*, and wrote his own autobiography.[27] Recognition, honours, and publicity were heaped on the "Dean of Canadian Painting" to a point that he found embarrassing. A retrospective exhibition was held in 1953, and over the years he received the title of c.m.g., seven l.l.d.'s and the Medal of the Order of Canada.

However, personality, travels, and physical endurance do not necessarily make a great artist. Although many of Jackson's paintings up until 1932 have great lyrical power and expressive force, the later works often lack these qualities. Jackson is an outward-looking artist and never attempted to be anything else. He remained bound to an inflexible formula, which demands that a painting be first of all a landscape, secondly that it have a foreground, middle distance, and background, and thirdly that it represent Canada and be easily recognizable. This allows little possibility for expressing a broad range of emotions, and, in fifty years of repeating this formula in a vast quantity of works, he was bound to become mannered and repetitive. Yet he remained true to himself and to his vision of Canada, and pursued his goals with tremendous energy through a long and full life. Lismer summed up his contribution better than anyone when he wrote: "Jackson has done more than any other writer or artist to bind us to our own environment, to make us vitally aware of the significance, beauty, and character of the land."[28]

220 A. Y. Jackson c. 1956

221 A. Y. Jackson *Blood Indian Reserve, Alberta*
oil on canvas 25¹⁄₈″ x 32″ 1937
Art Gallery of Ontario

222 A. Y. Jackson *Pre-Cambrian Hills*
oil on canvas 28¹⁄₈″ x 36″ 1939
Art Gallery of Ontario

223 A. Y. Jackson *Storm, Georgian Bay*
oil on panel 8¹⁄₂″ x 10¹⁄₂″ 1920
McMichael Conservation Collection

224 A. Y. Jackson *Monument Channel, Georgian Bay*
oil on panel 10 7/16″ x 13¹⁄₂″ 1953
Art Gallery of Ontario

In the years following the break-up of the Group, Lismer continued to be involved in art education. He made his celebrated lecture tour of western Canada in the spring of 1932.[29] During the summer of that same year he went to his first Education Fellowship Conference at Nice, in the south of France, where he gave a paper on "Art in a Changing World." For the first time he had a chance to exchange his ideas on art education with some of the most progressive educators in the world. The friendships he made there resulted in an invitation to the next conference in South Africa two years later. This was only a beginning, for he went back to South Africa in 1936 and spent a whole year there lecturing on methods of teaching art, and organizing a system of art education. His association with the black South Africans proved to be one of the most enriching experiences of his life, enforcing his ideas on the creative abilities of both young and old when given the necessary freedom. From South Africa, Lismer and his wife went to Australia and New Zealand, to attend another Fellowship conference before sailing back to Canada in late 1937.

The next two years were transitional ones.[30] During the winter of 1938-39, he was invited to teach at Columbia Teachers' College in New York as a visiting professor of fine arts. Although he benefited from the experience he disliked New York, and the impersonal mechanical system which seemed to infiltrate everything. The following winter was spent in Ottawa, where he had great hopes of setting up a national art program, connected with the National Gallery of Canada. This idea was the brainchild of Eric Brown, who had long been a close friend of Lismer's, and had once before tried to find a post for him at the Gallery. Unfortunately, Eric Brown died just after Lismer arrived in Ottawa, so the plans for the national program were never fully realized. The Second World War broke out the same year, making the chances for its success even slimmer. Lismer found himself frustrated by the bureaucratic civil service at every turn and became increasingly convinced that he was getting nowhere.

When he was offered the chance to become educational supervisor of the Art Association of Montreal (later the Montreal Museum of Fine Arts), he accepted eagerly. The program he set up there was very similar to the earlier one in Toronto, and it met with such great success that a separate Child Art Centre was set up in 1948. The forties provided Lismer with a long period of stability, in which he could freely indulge in his favourite activities of teaching and painting. In 1950, he was honoured by a large retrospective exhibition of 314 works, organized by the Art Gallery of Toronto and the National Gallery of Canada.

The exhibition gave ample opportunity to assess Lismer's contribution as an artist. It revealed the strength of his early works and also the unevenness of the later ones. In reviewing the show, A. Y. Jackson tactfully glossed over the later period by saying, "mostly he was a summer painter and just when the colour started to liven up he would have to pack up and go back to teaching."[31] Lismer himself often jokingly said he was nothing more than a "Sunday painter," for he realized that his devotion to teaching meant sacrificing a large part of his career as an artist.

225 Arthur Lismer c. 1956

Canadian Jungle is a good example of Lismer's later style. The technique is intentionally crude, for Lismer wanted to convey a sensation of disordered and burgeoning growth. Almost all of the canvas is covered with a mass of twisted vegetation and writhing forest undergrowth, with almost no unifying spatial organization. Forms are only vaguely defined, and discordant colours are spread over the whole canvas with little relief for the eye. Although Lismer does to some extent succeed in conveying an impression of violent, primeval growth, his execution is not on a level with his conception.

Varley continued to be plagued by bouts of depression and unrelenting financial hardships. In 1938 he left his wife and family, and went east to take up a teaching post at the Ottawa Art Association. This ended in disaster, and he later recalled that "Ottawa drove me crazy. Those civil servants, politicians and diplomats are the daftest people I know of."[32] That same year he made a trip to the Arctic on the *Nascopie* and produced some of the most impressive sketches ever done of the Arctic.[33] With the coming of the Second World War he moved to Montreal, where he remained, except for a short period in Ottawa, until his return to Toronto in 1945. These years were a time of deep despair for Varley, during which almost no work was produced or sold. It was a dismal life spent in rooming houses and taverns. Lismer recalled seeing him on the street one day in Montreal, and, to his dismay, Varley did not even recognize him.[34]

However, once he was back in Toronto, Varley resumed work, painting the later *Self-Portrait* (Hart House Collection) – a painting which reveals something of the torment and suffering he had undergone. In the same year he painted *Sea Music*, which by contrast is completely serene and peaceful in mood. This work returns to the strongly poetic flavour of the Vancouver period and paintings such as *Open Window* of 1933 (Hart House Collection). Fortunately Varley soon found patrons and supporters in Toronto, such as Charles Band and the McKay family, who helped him during the later years of his life. His retrospective exhibition in 1954 was a turning point and brought him long-overdue recognition.

227　F. H. Varley　c. 1956

230　F. H. Varley　*Kyra*
crayon　9¼" x 8⅛"　1948
Band Collection, Toronto

228　F. H. Varley　*Marie*　conte on paper　12¹⁵⁄₁₆" x 8½"　1934
Art Gallery of Ontario

229　F. H. Varley　*Eskimo Woman*　mixed media　9" x 3½"　1938
McMichael Conservation Collection

«*Green is a very spiritual colour. That is why I use it so much. When you look at the painting for a long time, other colours seem to weave their way into it, so the flesh and the dress, and the setting gradually acquire more normal colouring. Perhaps the effect is purely imaginery — but then painting is an exercise of the imagination.*»[35]

232 F. H. Varley *Nude Standing*
black chalk 10⁵/₈″ x 4³/₄″ c. 1930-35
National Gallery of Canada

231 F. H. Varley *Sea Music*
oil on canvas 28″ x 24″ c. 1945
Private Collection, Toronto

In 1932 Carmichael stopped working as a commercial artist and became head of graphic and commercial art at the Ontario College of Art. This gave him more time to paint, and he continued to produce consistently until his death in 1945. For most of his career, Carmichael's paintings leaned on the decorative side, but in later years he created some works of surprising force, such as *Light and Shadow* (1938). Undoubtedly the most underrated member of the Group, Carmichael was an elusive figure, almost forgotten behind the strong personalities of Jackson, Lismer, and the others.

Casson continued to paint southern Ontario villages, and the changes in his style can be traced through his approach to this theme. From the more decorative and richly coloured watercolours of the late twenties, he moved to a more monumental treatment of individual buildings in a landscape, exemplified by his well-known *Anglican Church at Magnetawan*. The works of the thirties were among Casson's best, with firmly controlled composition and colour, and absolute clarity of form.

From this stage Casson moved into a semi-abstract, semi-decorative period, with paintings such as the *Country Store* of 1945 (now in the Art Gallery of Ontario). Perhaps sensing the weakness and prettiness of this approach, he returned to a more dramatic treatment in the 1950's.

Carmichael and Casson were both extremely competent painters, but there is often the feeling that something is lacking in their work. Despite the technical excellence of their large canvases, they never managed to produce a *Jack Pine*, a *Solemn Land*, or a *September Gale*. What did these works have that their paintings did not? The answer to this question underlines both the strengths and the weaknesses of the Group. The paintings that have justifiably become symbols of the Group's work are those which possess a psychological force, an inner tension, and a profound symbolism. They represent more than the landscape they portray, and thus rise above purely descriptive naturalism. Paintings by Carmichael, Casson, and nearly all the Group followers lack this quality. For the most part, they are pleasant, well-painted landscapes, but without expressive power. Casson's *White Pine*, painted in 1957, illustrates this dilemma. It is well-executed, superbly designed, and dramatic in its contrasts of light and shade. It could even be said to continue the familiar theme of *West Wind* and *September Gale*, with the lonely pine bent by the wind. However, there is a mechanical quality to it; craftsmanship and design have become more important than imaginative expression.

233 A. J. Casson c. 1956

234 Frank Carmichael making a wood-engraving

198

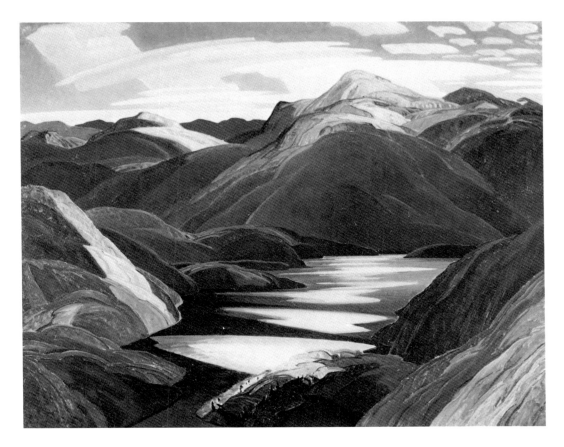

235 Frank Carmichael *Light and Shadow* oil on board 38'' x 48'' 1937 Private Collection, Toronto

236 A. J. Casson *White Pine* oil on canvas 30'' x 40'' 1957 McMichael Conservation Collection

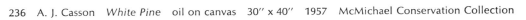

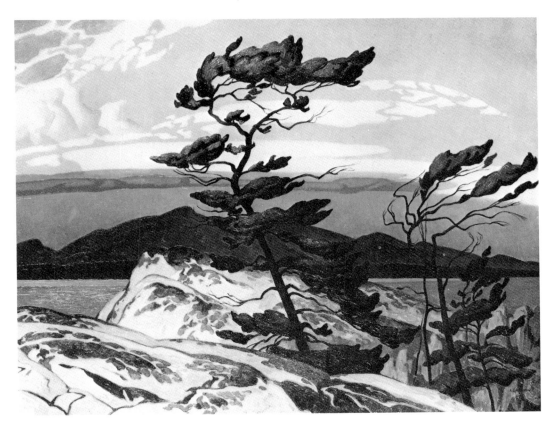

When the Group of Seven was formed in 1920, the artists hoped for recognition of their works and ideas. In the catalogue to their first exhibition they actually invited adverse criticism – but only because what they feared most was indifference. At a time when Canada was coming into its own, they felt that a major factor in the development of a strong and healthy nation was a vital and relevant art. They hoped that their works would make a significant contribution to the evolution of a truly Canadian art tradition.

Fifty years later, there is every indication that the Group attained their goals. They achieved widespread popular success and acclaim, and their works have been heralded as one of the basic symbols of Canadian culture. They have been honoured with exhibitions, degrees and medals; reproductions of their works can be found on everything from posters to postage stamps. At private exhibitions and auctions their paintings are eagerly sought after by collectors from all over Canada.

As frequently happens with popular trends, there has been a tendency to romanticize the accomplishments of the Group, which has inevitably caused many misconceptions to develop. The most common of these is the popular belief that they were violently criticized in the first Group shows. They have been cast, by friends, critics, and admirers, in the role of heroic revolutionaries, who fought against the philistines and won. However, the truth of the matter is that the reviews for these early shows were nearly all favourable, and the Group had numerous supporters from the very beginning. It is true that they received isolated adverse criticism before 1920 and a great deal of criticism in the mid-twenties, but not all of it was either unfair or unintelligent.

Another aspect of the Group's history that has often been misunderstood is their relationship to European art traditions. The Group claimed to have broken with all European movements and initiated a distinctively Canadian art. But in their reaction against the pastoral landscapes of the Dutch and Barbizon schools, they were in turn influenced by the European movements that followed these schools. Without realizing it, they incorporated elements from Impressionism, Post-Impressionism, and *Art Nouveau* into their own individual styles. However, the Group was not influenced by these schools until about thirty years after their inception – at a time when European art was already moving toward abstraction.

In their attitude towards nature the Group were also influenced by nineteenth-century ideas. They reacted against the materialism of the city and turned to nature in an attempt to find spiritual values. Abandoning the comfort of the studio, they turned to the landscape for their source of inspiration. They suffered great physical hardships in their battles with the elements, enduring storms, rain, sleet, and snow in order to capture the spirit of the country. They later told amusing anecdotes of their breaking through the ice for a morning dip, of climbing the Rocky Mountains as a preparation for producing works of art. As Jackson said, it was "husky out-of-doors stuff with much joy in the doing of it."[36] The Group were rightly admired for this attitude, but recently there has been a tendency to give them more praise for their physical accomplishments than their artistic ones.

Behind the Group's desire to paint the Canadian landscape lay the genuine conviction that it was the northern landscape that represented and expressed the country's unique character. They believed that the rocks, the lakes, and the forests were the basic symbols of the Canadian identity. It was this concept that was to capture the imagination of so many Canadians. Yet is the North the true embodiment of the Canadian dream? As Frank Underhill wrote in his article "False Hair on the Chest" (1936):

The artistic cult of the North is, as a matter of fact, pure romanticism at its worst, and bears little relation to the real life of Canada. Far from seeking inspiration among the rocks and winds, the normal Canadian dreams of living in a big city where he can make his pile quickly and enjoy such urban luxuries as are familiar to him in the advertising columns of our national magazines.[37]

It has been suggested that the Group developed a truly national school of painting, and that they painted Canada from coast to coast. However, the great majority of their works were done in Ontario, and several of the artists never ventured outside the province during the years of the Group's existence. Even Jackson, who painted Canada from coast to coast, admitted at one time that he disliked the West and found it unpaintable. In addition, all of the Group's activities were centred around Toronto, and there was little attempt made to be representative of all of Canada until later years.

Although the Group's creation of a national art has always been considered their greatest achievement it also restricted their creative expression. Rather than looking inwards for a personal vision, for the most part the artists remained committed to the external world and a well-defined subject matter. This emphasis on a particular aspect of reality – the Canadian landscape – limited the aesthetic possibilities of their expression. Only when they went beyond nationalism to express their inner emotions did their works have a universal appeal.

Nearly all of these misconceptions about the Group grew up in later years, when the Group became concerned with promoting their ideas for a Canadian art tradition. They have little bearing on their earlier period of creative activity, when their most significant artistic contributions were made.

In their formative years the Group were inspired by a spontaneous and uncomplicated feeling for the Canadian North. As Harris said, "We lived in a continuous blaze of enthusiasm. . . . Above all we loved this country and loved exploring it."[38] The artists were then united by strong convictions and a sense of camaraderie, and their actions were characterized by tremendous energy and vitality. These qualities were also reflected in their art. They were constantly experimenting with new techniques and searching for more expressive ways to convey the ruggedness of the landscape. It was during this period that they arrived at their mature styles and produced their most exciting works.

The real motivating force behind the Group was provided by MacDonald, Harris, Jackson, and Lismer. Thomson also deserves a key place in the formation of the Group, even though he died before it received its official title. His compelling personality, his devotion to the North, and his fresh and intuitive approach to art continued to have an important influence for years after his death.

The unspoken leaders of the Group were undoubtedly MacDonald and Harris. MacDonald was the first to envision a Canadian school of art that would represent the true character of Canada. Sensitive and introspective, he had the temperament of a poet and was greatly admired by the other artists. Behind his gentle exterior was great inner strength, which is also apparent in his art. Through his rich, expressive use of colour he achieved a poetic expression of mood and captured the spirit of the landscape. Harris was also deeply spiritual. With his infectious enthusiasm and his concern for an art inspired by the country, he helped to formulate many of the ideas the Group came to stand for. In contrast to his active nature, his paintings appear calm and serene, for in them he sought to reveal the inner world of the spirit with precision and clarity.

If MacDonald and Harris were the intellects and the philosophers of the Group, Jackson and Lismer were the extroverts and the spokesmen. Jackson enjoyed a good battle, whether it was an encounter with the press or a struggle with the elements of nature. But he was also a gentle and thoughtful person with countless friends all across Canada. The directness and simplicity of his outlook were reflected in both his life and work. With his characteristic flow of rhythmic forms, he sensitively portrayed the character of the Canadian landscape, and with untiring energy and devotion, he crossed and recrossed the country, painting it under every condition. Lismer had a quick wit, a sharp tongue, and a mischievous sense of humour. He was always questioning accepted traditions and was uncompromising in his fight against apathy and ignorance. As a teacher, he opened the eyes of both young and old to the world of art. His canvases had the same dynamic energy and were boldly painted in strong colours and powerful forms.

Of the remaining artists, Varley and Johnston stood somewhat apart from the Group. Varley had an independent spirit, but was close to the Group in his rebellion against authority and tradition. His compassion is reflected in the lyrical and expressive power of his landscapes and portraits. The gregarious Frank Johnston has too often been dismissed from the Group, but during the years he was associated with it, his works were both dramatic and decorative.

Carmichael and Casson, the younger members, continued the Group style and spirit for years to come. They were industrious and sincere, and their works were characterized by a superb sense of design and a straightforward approach to nature. As the last artists to join the Group shortly before it disbanded, Holgate and FitzGerald illustrated the Group's desire to be more national in character.

By the late twenties, the Group had achieved fame at Wembley, won their fight against the Academy, and found general acceptance at home. They became increasingly aware of their role as spokesmen for art in Canada, and with missionary zeal attempted to overcome public indifference and convince Canadians of the need for a national art. They fought against the idea that there could never be a Canadian art tradition and helped establish a climate of tolerance to new ideas. Through their travels, lectures, articles, and teaching, they introduced people all over Canada to the very existence of art and furthered their understanding of the artists' works and ideas. By popularizing the concept of an art founded on the Canadian landscape, they gave many Canadians a sense of national identity and enabled them to discover the beauty of their own country.

At present the Group of Seven is passing into history. The era in which their story was told by the artists and their contemporaries is over. It is now time to dispel the myths that have grown up around the artists during this period, distorting their true accomplishments. The Group's importance for future generations lies in the works they produced and in the expression of their unique vision. Although their contribution to the Canadian identity must be recognized, it should not be to the exclusion of a continuing critical evaluation. To quote Barker Fairley, "Where there is no judgement, the arts will perish."[39]

LIST OF ABBREVIATIONS

A.A.M.	Art Association of Montreal
A.G.H.	Art Gallery of Hamilton
A.G.O.	Art Gallery of Ontario, Toronto
A.G.T.	Art Gallery of Toronto
A.R.C.A.	Associate member of the Royal Canadian Academy
M.C.C.	McMichael Conservation Collection, Kleinburg, Ontario
M.M.F.A.	Montreal Museum of Fine Arts
OSA	Ontario Society of Artists
N.G.C.	National Gallery of Canada, Ottawa
R.C.A.	Royal Canadian Academy

	CONTEMPORARY EVENTS	THOMSON, THOMAS JOHN (born August 4, 1877, Claremont, Ontario, dies Algonquin Park, July 16, 1917)	MACDONALD, JAMES EDWARD HERVEY (born May 12, 1873, Durham, England; dies Toronto, November 26, 1932)	HARRIS, LAWREN STEWART (born October 23, 1885, Brantford, Ontario; dies Vancouver, January 29, 1970)
1887			APRIL emigrates to Hamilton, Ontario with family Studies at Hamilton Art School until 1888	
1888				
1889			Moves to Toronto, joins lithography company as an apprentice	
1890				
1891	Publication of first Art Students' League calendar Death of Seurat			
1892				
1893			Studies at Central Ontario School of Art and Design under Reid and Cruikshank	
1895	Maurice Cullen returns to Canada		Joins Grip Limited, design department	
1896	Laurier becomes prime minister		Visits Kentville, Nova Scotia	
1898		Works as machinist in Owen Sound for eight or nine months	Visits Rockingham, Nova Scotia	
1899		Attends business school in Chatham until 1901		
1900				Attends St. Andrew's College
1901		To Seattle, works as elevator boy, studies at brother's college	Painting near Bronte, Ontario	
1902		Works for photo-engraving firms until 1904		
1903	Gauguin dies Art Students' League publishes last calendar		Becomes member of Toronto Art Students' League, DECEMBER to England, works for Carlton Studios	At University of Toronto, for half a year
1904	Salon d'Automne, Paris, first exhibition of Fauves Milne leaves for New York		Returns and takes wife and son to England	AUTUMN arrives in Berlin, studies under Fritz Von Wille
1905	Opening of Photo Seccession Gallery in New York, Toronto Graphic Arts Club formed	Back to Toronto, works for photo-engraver		SUMMER in Canada WINTER studies in Berlin under Adolf Schlabitz and Franz Skarbina

	CONTEMPORARY EVENTS	THOMSON	MACDONALD	HARRIS
1924	André Breton, *Manifeste du Surrealisme* published SPRING Wembley Exhibition Sir Edmond Walker dies Death of Morrice in Tunis		AUGUST first trip to the Rockies	MAY Mongoose Lake with Jackson, Lismer and MacCallum Jasper Park with Jackson AUTUMN north shore of Lake Superior with Carmichael
1925	JANUARY fourth exhibition of Group of Seven at A.G.T. Second exhibition at Wembley *Drawings by the Group of Seven,* published by Rous and Mann Death of William Brymner		AUGUST to the Rockies	SUMMER sketches in Rockies AUTUMN north shore of Lake Superior with Jackson, Carmichael and Casson
1926	MAY fifth exhibition of the Group of Seven at A.G.T. First exhibition Canadian Society of Painters in Water Colour Eric Brown issues, *Press Comments on the Canadian Section of Fine Arts, British Empire Exhibition* F. B. Housser, *A Canadian Art Movement,* published	*The West Wind,* given to A.G.T.	AUGUST to the Rockies	Paints portrait of *Salem Bland* (A.G.O.) SUMMER sketches in Rockies FALL north shore of Lake Superior with Carmichael Publishes article on "Revelation of Art in Canada"
1927	APRIL exhibition of Canadian art in Paris at Musée du Jeu de Paume APRIL international exhibition of modern art at A.G.T. Exhibition of west coast Indian art at N.G.C., 50 paintings by Emily Carr Franz Cizek's show of child art at A.G.T.		Becomes head of department of graphic and commercial art at Ontario College of Art AUGUST to the Rockies	SUMMER sketches in Rockies AUTUMN Lake Superior with Lismer
1928	FEBRUARY sixth exhibition of the Group of Seven at A.G.T. Exhibition of contemporary Canadian paintings at M.M.F.A. Milne leaves United States, returns to Canada Group of Seven paintings shown in Vancouver, Calgary, Saskatoon, etc.		Acting principal of Ontario College of Art to the Rockies Visits New York for first time Designs foyer of Claridge Apartments	SUMMER sketches in Rockies FALL sketches along south shore of St. Lawrence River with Jackson

257 Tom Thomson *The West Wind* (sketch) oil on panel 8⅜" x 10½" 1916 Art Gallery of Ontario

258 J.E.H. MacDonald *Mount Goodsir, Yoho Park* oil on canvas 42" x 48" 1925 Dr. and Mrs. Max Stern, Dominion Gallery, Montreal

259 Lawren Harris *Lake Superior Painting IX* oil on canvas 40⅛" x 50¼" 1923 Mr. and Mrs. J.A. MacAulay Collection

JACKSON	LISMER	VARLEY	CARMICHAEL	OTHERS
JULY Appointed to Canadian War Memorials SEPTEMBER Sketches for War Memorials in France	DECEMBER 7 sketches of Halifax explosion (later reproduced in the *Canadian Courier*)		Elected to OSA	Johnston, *A Northern Night* purchased by N.G.C.
MARCH Works in London In France for three weeks SEPTEMBER Returns to Canada	Appointed to Canadian War Memorials	Appointed to Canadian War Memorials SEPTEMBER Sent to France at time of last offensive, paints *For What?* (N.G.C.) *German Prisoners*, (N.G.C.), etc.		Johnston paints *Beamsville* for War Memorials, first boxcar trip to Algoma with MacDonald, MacCallum and Harris in fall. FitzGerald, *Late Fall, Manitoba* purchased by N.G.C.
FEBRUARY-APRIL Halifax for Canadian War Memorials Discharged from army, returns to Toronto AUTUMN Boxcar trip with Harris, MacDonald and Johnston Elected to R.C.A.	JULY 25-30 shows 53 paintings in Halifax AUGUST moves back to Toronto to become vice-principal of Ontario College of Art (to 1927) Elected to A.R.C.A.	JULY returns to Canada Exhibits with R.C.A. for first time Paints portrait of Vincent Massey	A. J. Casson becomes his assistant at Rous and Mann Paints *Autumn Hillside*	Johnston in Algoma with Harris and MacDonald Johnston elected A.R.C.A. Casson becomes Carmichael's assistant at Rous and Mann; weekend painting trips with Carmichael
FEBRUARY-APRIL Franceville, Georgian Bay MAY Algoma with Harris, Lismer and MacCallum AUTUMN in Algoma with Harris, MacDonald, and Johnston	SPRING Algoma with Harris, Jackson, MacDonald and MacCallum With Varley and MacCallum at Georgian Bay; sketches for *September Gale* (N.G.C.)	Georgian Bay with Lismer, sketches for *Stormy Weather, Georgian Bay* (N.G.C.)		Johnston in Algoma with Harris and MacDonald Johnston, December, one man show at Eaton's College Street; *Fire-Swept, Algoma* purchased by N.G.C. Casson, July, first extended painting trip to Lake Rosseau with Carmichael; joins Arts and Letters Club. Holgate marries; returns to Paris
A Quebec Village, and *Early Spring, Georgian Bay*, bought by N.G.C. SPRING Algoma with Harris and Lismer AUTUMN Algoma with Harris and Lismer; continues to north shore of Lake Superior with Harris	SPRING Algoma with Harris and Jackson SUMMER Bon Echo, Ontario N.G.C. buys *September Gale* AUTUMN Algoma with Harris and Jackson; returns to teach at Ontario College of Art	*Stormy Weather, Georgian Bay* and *John* purchased by N.G.C.	N.G.C. buys *The Hilltop*	Casson exhibits with OSA for first time Johnston leaves Toronto, becomes principal of Winnipeg School of Art Holgate studies in Paris Fitzgerald, December, first trip outside Canada to enroll in Art Students' League in New York
LATE WINTER Bienville (near Lévis) with A. H. Robinson AUTUMN north shore of Lake Superior with Harris	Paints *Isles of Spruce* (Hart House) SUMMER Bon Echo, Ontario	NOVEMBER elected A.R.C.A.		FitzGerald returns to Canada in spring; September, first one man show at Winnipeg Art Gallery Holgate returns to Canada, settles in Montreal; teaches wood engraving at L'Ecole des Beaux Arts
Baie St. Paul, Quebec with Edwin Holgate	Georgian Bay with MacCallum North shore of Lake Superior with Harris Jury member to chose paintings for Wembley Exhibition	Works on murals for St. Anne's Church, Toronto Publication of *Newfoundland Verse* by E. J. Pratt with illustrations by Varley	Works on murals for St. Anne's Church Visits La Cloche Hills FALL trip to Ottawa Valley	Johnston holds exhibition of 356 paintings in Winnipeg Casson, *The Clearing* purchased by N.G.C. Holgate, Baie St. Paul with Jackson; paints *The Cellist* (M.C.C.)

252 A.Y. Jackson *The Freddy Channel, Georgian Bay* oil on panel 8½″ x 10⅜″ 1920 Vancouver Art Gallery

253 Arthur Lismer *A September Gale* (study) oil on canvas 20⅛″ x 24″ 1920 National Gallery of Canada

254 F.H.Varley *John* oil on canvas 24″ x 20″ 1920/21 National Gallery of Canada

255 Franklin Carmichael *Autumn Hillside* oil on canvas 30″ x 36″ 1920 Art Gallery of Ontario

256 Frank Johnston *Montreal River* tempera on paper 13¾″ x 14″ 1919 Mr. and Mrs. F. Schaeffer Collection

	CONTEMPORARY EVENTS	THOMSON	MACDONALD	HARRIS
1917	Exhibit of Society of American Artists, New York Canadian War Memorials formed under Lord Beaverbrook DECEMBER 7 Halifax explosion	JULY 8 seen for last time at Canoe Lake JULY 16 body discovered Cairn erected at Canoe Lake	Moves to York Mills Works on Thomson cairn Physical collapse Begins writing poetry seriously, meets Barker Fairley	Death of brother Physical collapse (?)
1918	SPRING Cullen, Beatty, Simpson to England for War Memorials Æ (George Russell) publishes *The Candle of Vision*	Memorial exhibition at Montreal Arts Club, Catalogue introduction by A.Y. Jackson Dr. MacCallum writes article on "Tom Thomson, Painter of the North"	SEPTEMBER first boxcar trip to Algoma with Harris, Johnston and MacCallum	MAY discharged from army with MacCallum on trip to Georgian Bay, Manitoulin Island and east end of Lake Superior
1919	Hart House opened Death of Renoir Exhibition of Algoma paintings by Harris, MacDonald and Johnston at Art Gallery of Toronto	AUGUST Mortimer Lamb writes article on Thomson in *The Studio*	Paints *The Beaver Dam* (A.G.O.) AUTUMN Algoma with Jackson, Harris and Johnston Publishes article on "The Canadian Spirit in Art"	AUTUMN in Algoma with Jackson, MacDonald and Johnston Paints *Shacks* (N.G.C.)
1920	MAY first exhibition of Group of Seven at A.G.T. Travelling exhibition of 30 works sent to the United States Borduas begins working for Ozias Leduc	Memorial exhibition at A.G.T.	SPRING Algoma with Harris, Jackson, Lismer AUTUMN Algoma with Harris, Jackson and Johnston	SPRING in Algoma with Jackson, Lismer, MacDonald and MacCallum AUTUMN in Algoma with MacDonald, Jackson and Johnston
1921	MAY second exhibition of the Group of Seven at A.G.T. Bertram Brooker arrives in Toronto Winnipeg exhibition, *Canadian Art of Today*		Paints *Solemn Land*, (N.G.C.), *Autumn in Algoma* (N.G.C.) Joins Ontario College of Art as instructor in decorative and commercial design	Visits Halifax, Nova Scotia, paints *Elevator Court, Halifax* SPRING Algoma with Jackson and Lismer AUTUMN Algoma with Jackson and Lismer; continues on to north shore of Lake Superior with Jackson
1922	MAY third exhibition of the Group of Seven at A.G.T. Works by Group exhibited in Vancouver and other Canadian cities	Montreal Museum of Fine Arts acquires *In the Northland*	Paints *Mist Fantasy* (A.G.O.) JULY trip to Nova Scotia (Petite Rivière)	Publishes *Contrasts, A Book of Verse* North shore of Lake Superior with Jackson
1923	Travelling exhibition of works by the Group of Seven to the United States		FEBRUARY art editor of *Canadian Forum* Prepared sketches for St. Anne's Church, Toronto	North shore of Lake Superior with Lismer

249 Tom Thomson *In the Northland* oil on canvas 40" x 45⅜" 1915 Montreal Museum of Fine Arts

250 J.E.H. MacDonald *The Beaver Dam* oil on canvas 32⅛" x 34⅛" 1919 Art Gallery of Ontario

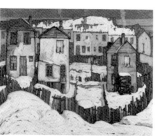

251 Lawren Harris *Shacks* oil on canvas 42" x 50¼" 1919 National Gallery of Canada

JACKSON	LISMER	VARLEY	CARMICHAEL	OTHERS
FEBRUARY arrives Montreal Exhibits at Art Association of Montreal with Hewton, sells nothing **MARCH-APRIL** at Emileville, Quebec with Hewton **MARCH** receives letter about *The Edge of the Maple Wood* from MacDonald **MAY** arrives in Toronto, meets MacDonald, Lismer and Varley at Arts and Letters Club **SUMMER** to Berlin, Ontario, and Georgian Bay **SEPTEMBER** meets MacCallum who offers studio in Toronto **OCTOBER** returns to Toronto and shares studio with Harris **NOVEMBER** paints *Terre Sauvage*, meets Thomson	**MAY** *The Clearing* purchased by the Ontario Government **SUMMER** teaches at Ontario College of Art **SEPTEMBER** first trip to MacCallum's cottage at Georgian Bay	Exhibits with *OSA* for the first time	**SEPTEMBER** to Europe Studies at Académie Royale des Beaux Arts Wins drawing medal	Johnston exhibits with OSA FitzGerald first exhibits with R.C.A.
JANUARY Moves into Studio building with Tom Thomson **FEBRUARY-APRIL** First visit to Algonquin Park **SUMMER** To Jasper Park with Beatty **AUTUMN** Algonquin Park with Thomson, Lismer, Varley Elected to A.R.C.A. **DECEMBER** To Montreal	**MAY** first trip to Algonquin Park with Thomson **OCTOBER** Canoe Lake with Thomson, Jackson and Varley Paints *Guide's Home, Algonquin* (N.G.C.)	**OCTOBER** in Algonquin Park with Thomson, Jackson and Lismer	Three months in England **FALL** returns to Toronto because of the war Shares accommodation with Thomson in Studio Building	Johnston back in Toronto, then returns to New York with help of Dr. MacCallum Holgate in Russia at outbreak of First World War
SPRING Emilleville, Quebec **JULY** Enlists in 60th Battalion Infantry, as a private **FALL** Sent overseas	**MARCH** Go Home Bay with MacCallum Moves to Thornhill (or 1916)	Visits Algonquin Park	**SEPTEMBER** marries and moves to Bolton for four months	Johnston returns to Toronto permanently
JUNE Wounded at Sanctuary Wood, convalesces in England	**MARCH** completes panels for MacCallum cottage **AUGUST** to Halifax, becomes principal of Victoria School of Art and Design	Elected to OSA	Moves to Thornhill, works for Rous and Mann	Casson moves to Toronto; begins work as a free-lance designer; studies evenings Holgate serves with the 5th Canadian Division Artillery in France (until 1919)

245 A.Y. Jackson *Mount Robson* oil on panel 8½" x 10½" 1914 McMichael Conservation Collection

246 Arthur Lismer *Smoke Lake, Algonquin Park* oil on panel 9-3/16" x 12¼" 1914 Art Gallery of Ontario

247 Franklin Carmichael *Go Home Bay* oil on panel 8½" x 10½" 1916 McMichael Conservation Collection

248 Frank Johnston *Autumn Woods, Algoma* oil on board 10½" x 13-5/16" c. 1918 Art Gallery of Ontario

JACKSON	LISMER	VARLEY	CARMICHAEL	OTHERS
JANUARY Baie St. Paul, Quebec MAY Algoma Jasper Park with Lawren Harris AUTUMN part-time instructor at Ontario College of Art *Entrance to Halifax Harbour*, purchased by Tate Gallery	MAY Algoma with Harris, Jackson and MacCallum SUMMER England	MARCH in Edmonton to paint the portrait of Chancellor Stuart of University of Alberta	FALL first trip to north shore of Lake Superior with Harris	Holgate at Baie St. Paul with Jackson, etc. Johnston returns to Toronto in October FitzGerald teaches at the Winnipeg School of Art (until 1949); Summer, Banff, Alberta
debate with Sir Wyly Grier at Empire Club Resigns from Ontario College of Art Algoma, with Harris and Lismer Quebec with Lismer and Barbeau AUTUMN north shore of Lake Superior	SPRING Algoma with Harris and Jackson SUMMER Ile d'Orléans, Baie St. Paul, and St. Hilarion Publishes article on "Canadian Art" Paints *A Quebec Village* (Kingston)	Teaches at Ontario College of Art (until 1926)	Forms Canadian Society of Painters in Water Colour with Casson and Brigden AUTUMN north shore of Lake Superior with Harris, Jackson and Casson Moves from Rous and Mann to Sampson Matthews	Casson forms Canadian Society of Painters in Water Colour with Carmichael and Brigden; Autumn, first trip to north shore of Lake Superior with Harris, Jackson and Carmichael
MARCH St. Fidèle and La Malbaie with Robinson JULY-SEPTEMBER Skeena River with Holgate and Barbeau	SUMMER Georgian Bay Publication of *A Short History of Painting,* *With a Note on Canadian Art*	Moves to Vancouver to become head of department of drawing and painting at Vancouver School of Art	Lake Superior with Harris Wins silver medal in Sesqui-Centennial Exposition	Casson becomes a member of the Group of Seven; elected A.R.C.A.; to Lake Superior with Carmichael Holgate, Skeena River with Jackson and Marius Barbeau, July-September
SPRING Bic and Tobin, Quebec with Dr. Banting JULY-SEPTEMBER to the Arctic with Banting on *Beothic* Exhibition of Arctic sketches at A.G.T.	Gaspé Peninsula Lake Superior with Harris Resigns from Ontario College of Art Appointed educational supervisor at A.G.T. (to 1936) Retains principalship of Ontario College of Art summer school			
To Quebec To Great Slave Lake, Yellowknife and Walsh Lake, with Mackintosh Bell, Banting, and C. B. Dawson *The Far North, A Book of Drawings* published by Rous and Mann	SUMMER Moraine Lake and Lake O'Hara, Rocky Mountains	Paints *The Cloud, Red Mountain* (Band Collection)	Lake Superior with Casson	

260 A.Y. Jackson *Maligne Lake,*
Morning (exhibited 53rd *OSA,*
1925) oil on canvas size not
known, destroyed Dr. Naomi
Groves

261 Arthur Lismer *Quebec*
Village oil on canvas 52¼'' x
64'' 1926 Agnes Etherington
Art Centre, Queen's University

262 F.H. Varley *Dr. Henry*
Marshall Tory oil on canvas
56'' x 48'' 1923/24 University
of Alberta, Edmonton

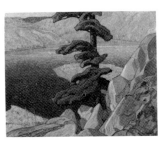

263 Franklin Carmichael *The*
Upper Ottawa near Mattawa
oil on canvas 40'' x 48'' 1924
National Gallery of Canada

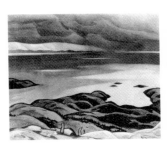

264 Alfred J. Casson *Ap-*
proaching Storm, Lake Superior
watercolour 17'' x 20'' 1929
National Gallery of Canada

	CONTEMPORARY EVENTS	THOMSON	MACDONALD	HARRIS
1929	Group of Seven paintings shown in Montreal *Yearbook of the Arts in Canada* published, ed. by B. Brooker Wall Street Crash		Becomes principal of Ontario College of Art AUGUST to the Rockies Designs mosaic decoration for Concourse Building, Adelaide Street, West Lectures on "Relation of Poetry to Painting"	
1930	APRIL seventh exhibition of the Group of Seven at A.G.T. MAY Group of Seven show in Montreal JUNE Borduas returns from France		AUGUST last trip to Rockies	AUGUST-SEPTEMBER to Arctic with Jackson Paints *Bylot Island* (N.G.C.)
1931	JANUARY, exhibition of Arctic sketches by Jackson and Harris at M.M.F.A., also in May at A.G.T. Lyman returns to Canada to live DECEMBER eighth and final exhibition of the Group of Seven at the A.G.T. Group announces intention to disband Statute of Westminster defines Dominion status		APRIL lectures on "Scandinavian Art" at A.G.T. SEPTEMBER sketching trip to McGregor Bay NOVEMBER elected to R.C.A. Suffers stroke	
1932	Picasso, *Girl Before a Mirror* APRIL incorporation of Canadian Group of Painters Group of Seven paintings shown in Vancouver Publication of *Canadian Landscape Painters* by A. H. Robson		In Barbados until April NOVEMBER 22 second stroke NOVEMBER 26 dies in Toronto Publication of *West by East and Other Poems* by MacDonald	Sketches in the Gaspé with Jackson
1933	Public Works of Art Project, later Federal Art Project, set up in United States NOVEMBER first exhibition of Canadian Group of Painters		Memorial exhibition 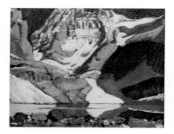 265 J.E.H. MacDonald *Lake Oesa and Mount Lefroy* oil on board 8½" x 10½" c. 1928 Mr. Jennings Young Collection	Sketches Pointe au Baril Publishes article on "Theosophy and Art" Founding member Canadian Group of Painters 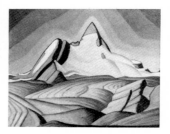 266 Lawren Harris *Isolation Peak* oil on board 11¾" x 14¾" c. 1929 Mr. S. C. Torno Collection

JACKSON	LISMER	VARLEY	CARMICHAEL	OTHERS
SPRING Quebec FALL motoring trip to Quebec with Harris	SUMMER McGregor Bay			FitzGerald, appointed principal of the Winnipeg School of Art; *Williamson's Garage* purchased by N.G.C. Holgate, does decoration for Totem Pole Room in Hotel Chateau Laurier, Ottawa
MARCH St. Fidèle, Quebec with Banting AUGUST-SEPTEMBER to the Arctic with Lawren Harris on *Beothic*	Publication of *Canadian Picture Study* SUMMER Grand Manan, New Brunswick Lunenburg and Peggy's Cove, Nova Scotia	Wins Wellingdon Arts Competition Award for *Vera* SUMMER on summer school faculty of Art Institute of Seattle SUMMER excursions to Mt Garibaldi with J. W. G. Macdonald		Johnston opens a summer school near Midland; Simpson's pays $10,000 for *Beyond the Law*, presents it to the R.C.M.P. Holgate, *Nude in a Landscape*, purchased by N.G.C.
SPRING Quebec with Banting and Hewton	SUMMER Manitou, Georgian Bay			Holgate becomes a member of Group of Seven
Les Eboulements, Quebec; Cobalt, Ontario Gaspé sketching with Harris DECEMBER resigns from R.C.A.	MARCH western lecture tour sponsored by N.G.C. SPRING conference of New Education Fellowship, Nice Travels in France, Italy, Switzerland	Paints *Dharana* (A.G.O.) Begins living weekends at Lynn Valley DECEMBER one man show at Vancouver Art Gallery	Leaves Sampson Matthews to become head of graphic commercial art at the Ontario College of Art Builds cottage in La Cloche Hills	FitzGerald becomes a member of the Group of Seven, (July)
Grace Lake, in La Cloche Hills, north shore of Lake Huron SPRING Quebec	SUMMER McGregor Bay Founding member, Canadian Group of Painters	Founds British Columbia College of Art with J. W. G. Macdonald and Harry Tauber Founding member Canadian Group of Painters.	Founding member, Canadian Group of Painters	Casson, FitzGerald, Holgate, founding members Canadian Group of Painters Holgate holds exhibition at Art Association of Montreal Casson paints *Anglican Church at Magnetawan* (N.G.C.)

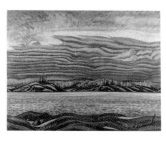

267 A.Y. Jackson *Algoma, November* oil on canvas 31⅜" x 39⅜" 1935-36 National Gallery of Canada

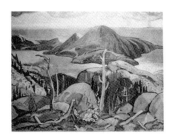

268 Arthur Lismer *Sombre Isle of Pic, Lake Superior* oil on canvas 34" x 43¼" c. 1927 Winnipeg Art Gallery

269 F.H. Varley *The Lions* oil on panel 12" x 15" 1931 McMichael Conservation Collection

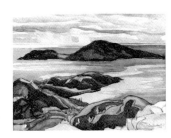

270 Franklin Carmichael *Lake Superior* watercolour on paper 9½" x 12" 1925 Mr. and Mrs. F. Schaeffer Collection.

271 Edwin Holgate *The Cellist* oil on canvas 51" x 38½" 1923 McMichael Conservation Collection

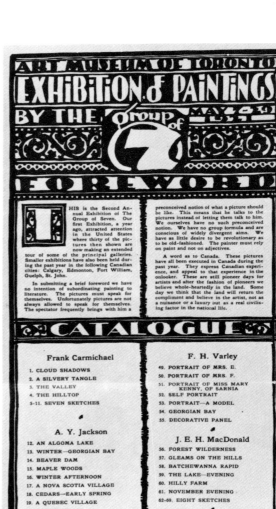

FOREWORD

THE group of seven artists whose pictures are here exhibited have for several years held a like vision concerning Art in Canada. They are all imbued with the idea that an Art must grow and flower in the land before the country will be a real home for its people.

¶ That this Art will differ from the Art of the past, and from the present day Art, of any people; superseding nothing, only adding to what has been done. Also it seems inevitable when something vital and distinctive arises it will be met—

(1) by ridicule, abuse or indifference.

(2) The so-called Art lovers, having a deeply rooted idea that Art is a matter of picture buying through the medium of the auctioneer or dealer, will refuse to recognize anything that does not come up to the commercialized, imported standard of the picture-sale room.

They prefer to enrich the salesman than accept the productions by artists native to the land, whose work is more distinctive, original and vital, and of greater value to the country.

(3) The more sophisticated will meet it with: "If you have no traditions, no background, no Art is possible." How then do traditions arise? Or they will say that anything produced will shortly die and be superseded—which is to say that nothing has been or ever will be worth the doing. They will say anything that sounds erudite, patting their own backs at the expense of Art and country.

Finally: A very small group of intelligent individuals, realizing that the greatness of a country depends upon three things: "its Words, its Deeds, and its Art." Recognizing that Art is an essential quality in human existence they will welcome and support any form of Art expression that sincerely interprets the spirit of a nation's growth.

¶ The artists here represented make no pretence of being the only ones in Canada doing significant work. But they do most emphatically hold that their work is significant and of real value to the country. They also hold with A. E. Russell, the Irish writer, "that no country can ever hope to rise beyond a vulgar mediocrity where there is not unbounded confidence in what its humanity can do." And that, "if a people do not believe they can equal or surpass the stature of any humanity which has been upon this world, then they had better emigrate and become servants to some superior people."

¶ A word as you view the pictures. The artists invite adverse criticism. Indifference is the greatest evil they have to contend with. But they do most emphatically ask you—do you read books that contain only what you already know? If not, they argue, that you should hardly want to see pictures that show you what you can already see for yourselves.

ROUS & MANN, LIMITED, TORONTO

GROUP OF 7

CATALOGUE EXHIBITION OF PAINTINGS

MAY 7th—MAY 27th 1920

PRICE: 10 CENTS

ART MUSEUM OF TORONTO

708.971 T
1920 May

CATALOGUE

1 FRANK CARMICHAEL

1.	Spring	$350
2.	Autumn Sunlight	350
3.	November	450
4.	An Autumn Landscape	450
5—8.	Sketches	each 50
7—14.	Sketches	each 35

2 LAWREN HARRIS

15.	Portrait	
16.	Portrait	
17.	Portrait	
18.	Portrait	
19.	Waterfall	$1,000
20.	Shacks	1,000
21.	Wet Day	400
22.	In the Ward	400
23.	Saturday Morning	400
24.	Falling Snow	500
25.	Decorative Landscape	600
26—29.	Sketches	not for sale

3 A. Y. JACKSON

30.	The Northland	$600
31.	Night—Georgian Bay	200
32.	A Summer Cottage	200
33.	Storm—Georgian Bay	200
34.	A Nova Scotia Village	250
35.	A Fishing Village	250
36.	Three Rock Falls	250
37.	A Storm in March	300
38.	The Freddy Channel	200
39.	Cognashene Lake	200
40.	Spring in Lievin	300
41—47.	Sketches	not for sale

4 FRANK H. JOHNSTON

48.	Canyon Algoma	$ 50
49.	Reflections—Agawa Canyon	75
50.	Frost Pattern, Below Rapids	100

FRANK H. JOHNSTON—(Continued)

51.	Near Beaver Meadow	$100
52.	Woodland Tapestry	100
53.	Rapids on the Agawa	100
54.	Falling Leaves	100
55.	Autumn Impression	100
56.	Beaver Meadow	100
57.	Fallen Tree	150
58.	Wild Cherry and Live Forever	150
59.	Algoma	150
60.	Bald Rock—Algoma	150
61.	Autumn—Algoma	150
62.	Spruce Tangle—Algoma	150
63.	Edge of the Forest	200
64.	Fire Swept—Algoma	750
65.	Beaver Haunts—Algoma	750

5 ARTHUR LISMER

66.	The River Drivers	$600
67.	Logging	600
68.	Halifax Harbor	600
69.	Spring in Nova Scotia	600
70.	Springtime on the Farm	300
71.	Winter	125
72.	The Valley	100
73.	Camouflage	100
74.	The River	125
75—81.	Sketches	each 30

6 J. E. H. MacDONALD

82.	The Tangled Garden	not for sale
83.	Pumpkins and Pump	$350
84.	A Laurentian Village	250
85.	The Wild River	not for sale
86.	The Little Fall	250
87.	A Beaver Dam	250
88.	October Afternoon—Laurentians	250
89.	Blossom Time	not for sale
90.	Pine Boughs	100
91.	Wind Clouds	50
92—96.	Sketches—Lake Simcoe	each 25
97.	Sketch—Algoma	25
98—101.	Sketches	not for sale

7 F. HORSMAN VARLEY

102.	Portrait of Mr. Vincent Massey.	
	Loaned by Mr. Massey and by courtesy of the Warden and Stewards of Hart House.	
103.	Portrait of Miss Winifred Head.	
104.	Portrait of J. E. H. MacDonald, A.R.C.A.	
105.	Character Sketch—Prof. Barker Fairley.	
106.	The Sunken Road—August 1918	
107.	The Old Barn	$300
108.	Farm—South Camp, Seaford, Eng.	150
109—114.	Sketches	

R. S. HEWTON

115.	The Barnyard	$300
116.	The White Cottage	200
117.	Pont Neuf—Paris	200

R. PILOT

118.	Noonday, Ste. Eustache	$40
119.	The Yellow Tree	40

ALBERT ROBINSON

120.	Returning to Boucherville	$500
121.	Drawing Ice	500

Frank Carmichael Lawren Harris
A. Y. Jackson Arthur Lismer
J. E. H. MacDonald F. Horsman Varley
Studio Building
Severn Street Toronto, Ontario

Frank H. Johnston
96 Kenwith Ave.
Toronto

Some of the pictures of this group may be hired, preferably by clubs and educational institutions. For further particulars apply J. E. H. MacDonald, 24 Severn St., Toronto.

INVITED EXHIBITORS:

R. S. Hewton R. Pilot Albert Robinson
Montreal Montreal Montreal

ART MUSEUM OF TORONTO
EXHIBITION OF PAINTINGS BY THE Group of 7
FOREWORD

THIS is the Second Annual Exhibition of The Group of Seven. Our first Exhibition, a year ago, attracted attention in the United States where thirty of the pictures are now making an extended tour of some of the principal galleries. Smaller exhibitions have also been held during the past year in the following Canadian cities: Calgary, Edmonton, Fort William, Guelph, St. John.

In submitting a brief foreword we have no intention of subordinating painting to literature. The pictures must speak for themselves. Unfortunately pictures are not always allowed to speak for themselves. The spectator frequently brings with him a preconceived notion of what a picture should be like. This means that he talks to the pictures instead of letting them talk to him. We ourselves have no such preconceived notion. We have no group formula and are conscious of widely divergent aims. We have as little desire to be revolutionary as to be old-fashioned. The painter must rely on paint and not on adjectives.

A word as to Canada. These pictures have all been executed in Canada during the past year. They express Canadian experience, and appeal to that experience in the onlooker. These are still pioneer days for artists and after the fashion of pioneers we believe whole-heartedly in the land. Some day we think that the land will return the compliment and believe in the artist, not as a nuisance or a luxury but as a real civilizing factor in the national life.

CATALOGUE

Frank Carmichael
1. CLOUD SHADOWS
2. A SILVERY TANGLE
3. THE VALLEY
4. THE HILLTOP
5—11. SEVEN SKETCHES

A. Y. Jackson
12. AN ALGOMA LAKE
13. WINTER—GEORGIAN BAY
14. BEAVER DAM
15. MAPLE WOODS
16. WINTER AFTERNOON
17. A NOVA SCOTIA VILLAGE
18. CEDARS—EARLY SPRING
19. A QUEBEC VILLAGE
20. MOUNTAIN ASH
21. MOONLIGHT
22. CACOUNA
23. LOWER ST. LAWRENCE —FEBRUARY
24. LOWER ST. LAWRENCE —MARCH
25. SPRING NIGHT
26. EARLY SPRING—GEORGIAN BAY
27—34. EIGHT SKETCHES

Arthur Lismer
35. A SEPTEMBER GALE —GEORGIAN BAY
36. TUGS—HALIFAX HARBOR, N.S.
37. ROCK AND WATER
38. THE PINE TREE
39. THE THREE PINES
40. THE CHANNEL—GEORGIAN BAY
41—48. EIGHT SKETCHES

F. H. Varley
49. PORTRAIT OF MRS. B.
50. PORTRAIT OF MRS. F.
51. PORTRAIT OF MISS MARY KENNY, OF SARNIA
52. SELF PORTRAIT
53. PORTRAIT—A MODEL
54. GEORGIAN BAY
55. DECORATIVE PANEL

J. E. H. MacDonald
56. FOREST WILDERNESS
57. GLEAMS ON THE HILLS
58. BATCHEWANNA RAPID
59. THE LAKE—EVENING
60. HILLY FARM
61. NOVEMBER EVENING
62—69. EIGHT SKETCHES

Lawren Harris
70. THE FRINGE OF THE CITY
71. JAZZ
72. STREET—WINTER AFTERNOON
73. HOMES
74. ISLAND—MacCALLUM LAKE
75. EVENING—ALGOMA
76. OCTOBER AFTERNOON —ALGOMA
77. END OF A LITTLE LAKE
78. BEAVER POND
79. SPRUCE
80—89. TEN SKETCHES—(Not For Sale)

Frank Carmichael,
Lawren Harris, A. Y. Jackson,
J. E. H. MacDonald,
F. H. Varley, Arthur Lismer,

STUDIO BLDG., SEVERN ST.
TORONTO

Prices on application at the desk.

ROUS & MANN, LIMITED, TORONTO

THE GROUP OF SEVEN EXHIBITION CATALOGUES

The most important documents related to the Group of Seven are the catalogues for the early exhibitions. The views of the Group are expressed in the forewords to the catalogues and in the selection of works included. As the only contemporary statement of the Group's beliefs, the forewords are essential to an understanding of their philosophy. In them the Group expressed their strong national feelings and their desire to create a distinctively Canadian art. Between the first and the third forewords there was a noticeable change of mood, from the apologetic note of the 1920 catalogue to the aggressive and confident tone of 1922 introduction. The selection of works remained independent throughout; the artists chose works that they considered to be most representative, even if they were done years earlier, as in the case of Jackson's *Terre Sauvage* (called *The Northland* in the 1920 exhibition).

Although the production of each catalogue was a joint effort, Carmichael was chiefly responsible for the design, and Harris for the forewords. The three catalogues illustrated here (and the 1925 catalogue, which is not included) were the only ones designed by the artists themselves. After 1925 the catalogues were put out by the Art Gallery of Ontario, and usually included a long list of invited contributors. There were a total of eight exhibitions: the fourth was held in 1925; the fifth in 1926; the sixth and seventh in 1928 and 1929 respectively; and the last exhibition late in 1931.

The film-clips below were taken by Mr. C. A. G. Matthews, a member of the Arts and Letters Club and a friend of the Group. They were taken in about 1930 and are the only films of the Group from that time. The artists are, from left to right: J. E. H. MacDonald, Alfred J. Casson, Arthur Lismer, Franklin Carmichael, A. Y. Jackson, and Lawren Harris.

group of
FOREWORD

NEW material demands new methods and new methods fling a challenge to old conventions. It is as impossible to depict the autumn pageantry of our northern woods with a lead pencil as it is to bind our young art with the conventions and methods of other climates and other ages. The thought of to-day cannot be expressed by the language of yesterday. The Victorians seem dull and the Elizabethans frigid to a generation with its own problems. Artistic expression is a spirit, not a method, a pursuit, not a settled goal, an instinct, not a body of rules. In the midst of discovery and progress, of vast horizons and a beckoning future, Art must take to the road and risk all for the glory of a great adventure.

group of
EXHIBITION OF PAINTINGS
MAY. 5 ~ MAY. 19 1922

ART GALLERY OF TORONTO
GRANGE ROAD

PRICE 10 CENTS

CATALOGUE

Frank Carmichael
1. LEAF PATTERN
2. THE PASSING OF AUTUMN
3. ABANDONED
4. CORUSCATION
5. FANCIFUL AUTUMN
6. MORNING
7. SAPLINGS

F. Horsman Varley
8. GYPSY BLOOD
9. CHARACTER STUDY
10. ALLEGORY
11. ROCKY SHORE

J. E. H. MacDonald
12. OCTOBER SHOWER GLEAM TELEGRAM LAKE
13. RIVER PASTURES
14. MIST FANTASY. NORTHLAND

J. E. H. McDonald—Cont'd
15. WINTER SUN
16. MOUNTAIN BROOK
17. YOUNG CANADA
18. AGAWA WATERFALL
19. DECORATION FOR CHRISTMAS MUSIC PARTY

Arthur Lismer
20. ISLANDS OF SPRUCE, ALGOMA
21. THE SOMBRE HILL, ALGOMA
22. THE RED BARN
23. THE SHEEP'S NOSE, BON ECHO
24. LITTLE SPRUCE AND MUSKEG
25. SHORE LINE, SAND LAKE, ALGOMA
26. SUNGLOW. ALGOMA
27. ROCK, LAKE AND PINE
28. RED PINE, LAKE MASINAME
29. LITTLE COVE. ALGOMA
30. SUNLIT ROCK AND REFLECTIONS

Lawren Harris
31. ABOVE LAKE SUPERIOR
32. ROCK, ALGOMA
33. MORNING SUN, MITCHELL LAKE
34. EVENING. NIPIGON COUNTRY
35. ALGOMA COUNTRY
36. GREY DAY, NORTH SHORE, LAKE SUPERIOR
37. AFTER RAIN, NORTHERN LAKE
38. MID WINTER MORNING
39. SHACKS, ALGONQUIN PARK
40. EVENING, KEMPENFELDT BAY, LAKE SIMCOE
41. EARLY SUMMER AFTERNOON, BARRIE
42. ELEVATOR COURT, HALIFAX
43. BLACK COURT. HALIFAX
44. SPRING IN THE OUTSKIRTS
45. IN THE WARD VI.

A. Y. Jackson
46. THE NORTHLAND
47. NOVEMBER, GEORGIAN BAY
48. ALGOMA HILLS
49. SHOALS AND ISLANDS
50. NORTH SHORE, LAKE SUPERIOR
51. APRIL. GEORGIAN BAY
52. HILL COUNTRY, QUEBEC
53. NOVEMBER MOONLIGHT
54. GREY DAY, TADENAC
55. SPRUCE COUNTRY
56. AUTUMN EVENING
57. FIRST SNOW
58. BARNSTON PINNACLE
59. A QUEBEC VILLAGE
60. THE VILLAGE, EARLY SPRING
61. THE SNAKE FENCE

Percy Robinson
(invited contributor)
DECORATIVE PEN DRAWINGS
to Poem "Georgian Bay"
(In the Corridor)

Frank Carmichael
Lawren Harris
A. Y. Jackson
J. E. H. MacDonald
F. H. Varley
Arthur Lismer
STUDIO BLDG., SEVERN ST. TORONTO

Prices on application at the desk

INTRODUCTION

1. Carl Berger, "The True North and Free," *Nationalism in Canada*, ed. by Peter Russell (1966), 3-26.
2. For a discussion of the period 1867-1910, see J. Russell Harper, *Painting in Canada* (1966), Part 3.
3. Harper, *Painting in Canada*, 211.
4. Ottawa, N.G.C., *Homer Watson, 1855-1936* (1963), letter to Arthur Lismer.
5. A. Y. Jackson, *A Painter's Country* (1958), 102 (page numbers refer to paperback edition, first published in 1964).
6. A. Y. Jackson, in Introduction to K. D. Pepper, *James Wilson Morrice* (1966), x.
7. "If Cow Can Stay in Parlour, Then Why Can't Bull Moose?" Toronto, *Star*, Feb. 27, 1925.

CHAPTER 2

1. William Watson, "The Art of Maurice Cullen," *Canadian Review of Music and Art*, Jan., 1943, 10.
2. Shortly before leaving, Cullen received a letter from the French critic Thiébault-Sisson, saying it would be disastrous for him to leave Paris for too long, and offering him help if he stayed. See Hamilton, A.G.H., *Maurice Cullen* (1956), Introduction.
3. J. Chauvin, *Ateliers* (1928), 112.
4. The European Impressionists attempted to capture the fleeting effects of light and colour in nature. Objects ceased to have importance as real objects in themselves, and were seen as reflected patterns of light and shade. This brought about a more two-dimensional treatment of space, as found in Monet's paintings of *Haystacks* in 1891.
5. See works by the American Impressionist John Twachtman, such as *Winter Harmony*, c. 1900, in the National Gallery of Washington.
6. Suzor-Coté had worked in Paris for nearly seventeen years prior to returning to Montreal in 1908. He was more closely associated with the French-speaking community and for this reason had less influence on developments in Toronto. However, he did exhibit in Toronto from 1910 onwards, and in 1913 an article on him appeared in the *Yearbook of Canadian Art*, published by the Arts and Letters Club in Toronto.
7. Donald Buchanan, *James Wilson Morrice* (1936), 37.
8. Jackson, *Painter's Country*, 19.
9. Hamilton, A.G.H., *Cullen*, Introduction.
10. Buchanan, *Morrice*, 36.
11. N. MacTavish, "Maurice Cullen; A Painter of Snow," *Canadian Magazine*, April, 1912, 544.
12. *Ibid.*
13. Jackson, *Painter's Country*, 19.
14. Buchanan, *Morrice*, Chapter IX.
15. Harper, *Painting in Canada*, 248.
16. Donald Buchanan, "James Wilson Morrice, Painter of Quebec and the World," *Educational Record of the Province of Quebec*, LXXX, No. 3 (1954), 164.
17. Clarence Gagnon, "Morrice as Painter," unidentified newspaper clipping, N.G.C. Archives.
18. The influence of Cullen and Morrice on the Toronto artists is difficult to assess. Their works were often seen in exhibitions, and Jackson undoubtedly spoke highly of them when he came to Toronto in 1913. Harris, MacDonald, and Lismer mention them at various times, but there is no indication of how deeply they were influenced.
19. Jackson, *Painter's Country*, 73.
20. The Beaver Hall Group, which was formed in 1921, included artists such as Edwin Holgate, Randolph Hewton, Clarence Gagnon, Mabel May, and Lilias Newton. Unfortunately, the group never firmly established itself and was disbanded a few years later.
21. "Jackson Says Montreal Most Bigoted City," Toronto, *Star*, Sept. 10, 1927.
22. *Ibid.*
23. Jackson, *Painter's Country*, 5.
24. Arthur Lismer, *Canadian Picture Study* (1930), 21.

25. Jackson, *Painter's Country*, 16.
26. Housser, *Canadian Art Movement*, 79-82. A. Y. Jackson, "J. E. H. MacDonald," *Canadian Forum*, XIII, No. 13 (1933), 136, indicates that Jackson first saw a painting by MacDonald in 1908 at a Montreal exhibition and that "sometime after he began writing to me." This probably took place in 1910, after Jackson returned from Europe. In 1913 (March 12 and April 4), Jackson also wrote to Eric Brown, suggesting he purchase works by modern Canadians. The letters are in the N.G.C. Archives.
27. See works by artists such as Elmer Schofield, E. W. Redfield, and George Bellows illustrated in *Studio* magazine between 1912 and 1913.
28. Jackson, *Painter's Country*, 27.
29. Toronto, A.G.T., *A. Y. Jackson Paintings 1902-1953* (1953) 5.
30. F. B. Housser, *A Canadian Art Movement* (1926),77.
31. *Ibid.*, 78.

CHAPTER 3

1. See W. Colgate, *Canadian Art* (1943), for a brief account of these clubs.
2. See W. Colgate, *The Toronto Art Students' League, 1886-1904* (1954).
3. Letter from J. E. H. MacDonald to F. Housser, dated Dec. 20, 1926, commenting on Housser's *A Canadian Art Movement*, which had just been published. The letter was never sent and is still in the possession of Thoreau MacDonald.
4. MacDonald, letter to Housser, Dec. 20, 1926.
5. *Ibid.*
6. *Ibid.*
7. See *Canadian Art Club 1907-11* (1911), 4. Address given by D. R. Wilkie on the occasion of the first exhibition in Feb., 1908.
8. *Ibid.*, 21. Essay on the "Canadian Art Club" by James Mavor.
9. Augustus Bridle, *The Story of the Club* (1945), 5. The Club moved to new quarters on Elm Street in 1920, where it is presently located.
10. *Ibid.*, 10.
11. Harris was listed among the "Charter Members: 1908-9" (Arts and Letters Club Library), and joined in late 1908 or early 1909. Most of the early biographical information on Harris is based on a letter written by his wife, Bess Harris, to J. Russell Harper dated July 14, 1962, in N.G.C. Archives. Not all of the dates given here are accurate. For example, Bess Harris and most other sources say that Harris returned from Europe in 1910, after visiting the Near East and Minnesota lumber camps in 1909. However, his trip to Palestine and Arabia was in January, 1908, and he probably returned home for a short period before going to Minnesota in the winter of 1908-9. By the summer of 1909, he was living in Toronto. My thanks to Charles Hill for his research on Harris' early years.
12. *Harper's Magazine*, July, 1908, 165-74; Oct., 1908, 651-60; Nov., 1908, 918-28; Dec., 1908, 198-209; Feb., 1909, 449-58; March, 1909, 516-29; April, 1909, 782-54. For illustrations of the Minnesota lumber camp, see Norman Duncan's article on "Higgen's – A Man's Christian," *Harper's Magazine*, July, 1909, 165-79.
13. See John A. B. McLeish, *September Gale* (1955), 24.
14. See Sybille Pantazzi, "Book Illustration and Design by Canadian Artists, 1890-1940," *National Gallery of Canada Bulletin*, IV, No. 1 (1966), 6-24.
15. McLeish, *September Gale*, 25.
16. Robson wrote short monographs on Thomson, MacDonald, and Jackson, as well as a longer book on *Canadian Landscape Painters*, in 1932. In writing on art his intention was to provide an "interpretative appreciation" and not a critical analysis. From this point of view, Robson's approach cannot be considered scholarly and is useful mainly for the insights into individual works.
17. Thoreau MacDonald, *The Group of Seven* (1944), 2.
18. MacDonald's father was born in Nova Scotia, and his mother was English. See E. R. Hunter, *J. E. H. MacDonald* (1940), 2.

19. Quoted by Nancy Robertson Dillow, in her unpublished manuscript on *J. E. H. MacDonald* (revised 1969), 10. I am extremely grateful to her for her permission to use information from the manuscript, which remains the most complete and authoritative study on the early years of MacDonald.
20. This date is uncertain. For Thomson's early biography, see Blodwen Davies, *A Study of Tom Thomson* (1935); and R. H. Hubbard, *Tom Thomson* (1962).
21. Letter by Leonard Rossell describing artists at Grip, in the N.G.C. Archives.
22. McLeish, *September Gale*, 16. McLeish is the most reliable source for biographical details on Lismer.
23. Letter from MacDonald to Housser, Dec. 20, 1926.
24. McLeish, *September Gale*, 29.
25. Quoted in MacKenzie Porter, "Varley," *Maclean's Magazine*, Nov. 7, 1959.
26. *Ibid.*
27. A. Lismer, "The Early Years," *F. H. Varley, Paintings 1915-1954*, Toronto, A.G.C. (1954), 4.
28. There is little written information on Johnston's early years, and I am grateful to Paul Rodrik, his son, for information concerning his father.
29. Robson, *Canadian Landscape Painters*, 146.
30. Letter by L. Rossell, on artists at Grip, in N.G.C. Archives.
31. In conversation with the author, August 19, 1969. There is almost no published information on Carmichael. See Colin S. MacDonald, *A Dictionary of Canadian Artists*, Vol. 1 (1967), 116-17.
32. See Buffalo, Albright Art Gallery, *Exhibition of Contemporary Scandinavian Art*, Jan. 4-26, 1913. Copies of this catalogue are extremely rare, and one of the few in existence is in the N.G.C. library.
33. This catalogue is still in the possession of Thoreau MacDonald, who kindly permitted me to examine it.
34. L. Harris, "The Group of Seven in Canadian History," *Canadian Historical Association Report*, June 16-19, 1948, 31. A near replica of this text was published by Rous and Mann in 1964, entitled *The Story of the Group of Seven*.
35. J. E. H. MacDonald, *Lecture on Scandinavian Art*, at the A.G.T., April 17, 1931 (typescript).
36. *Ibid.*, 2.
37. *Ibid.*
38. A. Lismer, "Canadian Art, An Informal History," on CBC *Wednesday Night*, June 14, 1950 (transcript).
39. In conversation with the author, Sept., 1969, and as related to Robert McMichael on several occasions. However, Jackson was certainly aware of the show and talked to the other Toronto artists about it.
40. See "Studio Talk," *The Studio*, LVII, No. 238 (1913), 335-336; and A. Branting, "Modern Tapestry Work in Sweden," *The Studio*, LVIII, No. 239 (1913), 102-11.
41. R. H. Hubbard, *Development of Canadian Art* (1963), 88.
42. L. Harris, "The Group of Seven." Talk delivered in the Vancouver Art Gallery, April, 1954, and broadcast from CBU, Vancouver, Sept. 15, 1954.
43. MacDonald, *Lecture on Scandinavia Art* (1931), 2.
44. Harris, "Group of Seven" (1948), 31.
45. Letter to Dr. M. J. McRuer, postmarked Oct. 17, 1912, in the M.C.C. Archives. Thomson writes: "We had a dump in the forty mile rapids which is near the end of our trip, and lost most of our stuff – we only saved 2 rolls of film out of about 14 dozen."
46. H. R. MacCallum, "Tom Thomson Painter of the North," *Canadian Magazine*, L (1918), 376.
47. Dennis Reid, *The MacCallum Bequest of paintings by Tom Thomson and other Canadian painters*, Ottawa, N.G.C. (1969). This provides an excellent and authoritative discussion on MacCallum and his contribution.
48. Excerpts of letters from Carmichael to his wife, compiled by his wife in manuscript form, in the M.C.C. Archives. The statement on MacCallum is from a letter dated Feb. 6, 1915.
49. The Eight in New York, later called the Ash Can

School, had earlier accomplished the same changes the Group of Seven was to bring about in the twenties. They rejected European standards, broke down the strength of the Academy, and consciously tried to create a distinctively American art. In the years around 1904, they were criticized as the "Apostles of Ugliness," and were attacked even more violently than the Group.
50. Bridle, *Story of the Club*, 16.
51. Harris, "Group of Seven" (1948), 36.
52. McLeish, *September Gale*, 75-76.
53. Letter from Bess Harris to J. Russell Harper, July 14, 1962, N.G.C. Archives.
54. When some of his sketches were shown at the Arts and Letters Club in Nov., 1911, Jefferys praised the exhibition in *The Lamps* (Dec., 1911), 12, saying, "For Mr. MacDonald's art is native – as native as the rocks, or the snow, or pine trees, or the lumber drives that are so largely his themes." This exhibition had a pronounced effect on the Toronto artists, and Harris in particular. Following the exhibition Dr. MacCallum and Harris persuaded MacDonald to devote all his time to painting.
55. Nancy Robertson Dillow, *MacDonald*, manuscript, Appendix E, for list of illustrations in *The Studio*, between 1900 and 1910 with an industrial theme. For a detailed discussion of *Tracks and Traffic*, see pages 26-38 of the manuscript, and Toronto, A.G.T., *MacDonald* (1965), 8-9.
56. Dorothy Hoover, *J. W. Beatty* (1948), 15-23. Beatty met Thomson in 1910, and they went on many sketching trips together.
57. There has been some debate over how much Thomson received for the painting, but Ottelyn Addison, *Tom Thomson: The Algonquin Years* (1969), 89, indicates that $250 is the amount shown in the minutes of the OSA, dated May 6, 1913.
58. See McLeish, *September Gale*, 50. Several artists recalled seeing the bills placed around the wainscoting of the room, as related to the author by Robert McMichael, March, 1970.
59. Fergus Kyle, "The Ontario Society of Artists," *Yearbook of the Arts in Canada* (1913), 186-87.
60. McLeish, *September Gale*, 32.
61. Jackson, *Painter's Country*, 28.
62. *Ibid.*, 30.
63. *Ibid.*
64. *Ibid.*, 31.
65. *Ibid.*, 56.
66. Quoted in Housser, *Canadian Art Movement*, 71.
67. Quoted in Montreal, M.M.F.A., *John Lyman* (1963), Chronology.
68. H. F. Gadsby, "The Hot Mush School," Toronto, *Star*, Dec. 12, 1913.
69. *Ibid.*
70. J. E. H. MacDonald, "The Hot Mush School, A Rebuttal," Toronto, *Star*, Dec. 20, 1913.
71. *Ibid.*
72. *Ibid.*
73. Quoted in Housser, *Canadian Art Movement*, 48.
74. Hector Charlesworth, "O.S.A.'s Exhibition, 1915," *Saturday Night*, March 20, 1915.
75. Gadsby, "The Hot Mush School."
76. Housser, *Canadian Art Movement*, 66.
77. Jackson, *Painter's Country*, 33.
78. Excerpts from Carmichael's letters to his wife, dated Feb. 1, 1915, in M.C.C. Archives.
79. Jackson, *Painter's Country*, 33.
80. See Naomi Jackson Groves, *A.Y.'s Canada* (1968), 105. Dr. Jackson noted that in 1918, A. Y. Jackson said that it was 40° below. By the 1930's he was insisting that it was 43° below, and by 1958 it had gone down to 45° below!
81. Addison, *Thomson*, 10. In 1968, the size of the park was approximately 3,000 square miles, almost double the original size.
82. Joseph Adams, *Ten Thousand Miles through Canada* (London: Methuen, 1912), quoted in Addison, *Thomson*, 11.
83. Letter from Jackson to MacDonald, postmarked Oct. 6, 1914. In possession of Thoreau MacDonald.
84. Letter from Thomson to MacCallum, dated Oct. 6, 1914, in MacCallum Correspondence, N.G.C.

Archives.
85. Letter from Lismer to Dr. MacCallum, no date, in MacCallum Correspondence, N.G.C. Archives.
86. Letter from Varley to MacCallum, no date, in MacCallum Correspondence, N.G.C. Archives.
87. Jackson, *Painter's Country*, 38.
88. A. Y. Jackson, "Arthur Lismer – His Contribution to Canadian Art," *Canadian Art*, VII, No. 3 (1950), 89.

CHAPTER 4

1. Jackson, *Painter's Country*, 38.
2. A. Y. Jackson, Introduction to *Exhibition of Paintings by the late Tom Thomson*, Montreal; The Arts Club, 1919.
3. A. Y. Jackson, "Arthur Lismer," 91.
4. "Studio Talk," *The Studio*, LVII, No. 238 (1913), 336.
5. Dennis Reid, *MacCallum Bequest*, 58-71. The close parallel between Thomson's decorative panels and European *Art Nouveau* can be seen in a comparison between *Forest Undergrowth III* (N.G.C.), and *A Decorative Painting* by Hans Christiansen in *Jugend*, 1898.
6. Bess Harris and Peter Colgrove, eds., *Lawren Harris* (1969), 45.
7. Quoted in N. Robertson Dillow, MacDonald, manuscript (1969), 77. This comment was made by MacDonald in a lecture at the Arts and Letters Club.
8. Some of Thomson's family suggested that he was refused because of trouble with his feet and that he was upset at not being able to enlist. See Addison, *Thomson*, 37.
9. Hubbard, *Thomson*, 9.
10. In conversation with the author, Sept., 1969.
11. Letter from Thomson to MacCallum, dated July 22, 1915. Also quoted in Hubbard, *Thomson*, 9.
12. Letter from Thomson to MacCallum, dated Sept. 9, 1915, N.G.C. Archives. Also quoted in Hubbard, *Thomson*, 10.
13. See Groves, *A.Y.'s Canada*, 106-107. In 1962, the shack was moved to the grounds of the McMichael Conservation Collection, where it presently stands.
14. Davies, *Thomson* (1935), 95-96.
15. *Ibid.*, 96.
16. Harris, "Group of Seven" (1948), 33.
17. Typewritten notes on Tom Thomson by Thoreau MacDonald, in M.C.C. Archives.
18. Letter from Thomson to MacCallum, Oct. 24, 1916, N.G.C. Archives. Also quoted in Hubbard, *Thomson*, 11.
19. See Davies, *Thomson* (1935), 118-119.
20. Branting, "Tapestry Work in Sweden," 109. An even closer parallel is with *Autumn's Garland* (N.G.C.).
21. See letter written by Henry Thomson for Blodwen Davies (but never sent) in M.C.C. Archives. He describes Tom Thomson's years in Seattle, stating that Tom "was continually looking over the various magazines giving the advertisements a great deal of study principally from the standpoint of decoration."
22. A. Lismer, "Tom Thomson 1877-1917, A Tribute to a Canadian Painter," *Canadian Art*, V, No. 2 (1947), 60.
23. "Power and Poetry in Art Galleries," *Mail and Empire*, March 13, 1915.
24. H. Charlesworth, "O.S.A.'s Exhibition, 1915."
25. Harold Town, "The Pathfinder," *Great Canadians, A Century of Achievement*, Canadian Centennial Library (1965), 110.
26. Lismer, "Thomson" (1947), 171-72.
27. MacCallum, "Tom Thomson," 378.
28. Letter from Jackson to Eric Brown, about 1930, in N.G.C. Archives.
29. A. Lismer, "Tom Thomson, (1877-1917), Canadian Painter," *Educational Record of the Province of Quebec*, LXXX, No. 3 (1954), 171.
30. There is some uncertainty over the exact location of these painting sites as well as the time they were painted. See Addison, *Thomson* (1969), 54-5.
31. Letter from Thomson to MacCallum, July 7, 1917, in N.G.C. Archives. Also quoted in Hubbard, *Thomson*, 13.

32. Davies, *Thomson* (1935), 123.
33. On Feb. 6, 1969, the CBC showed an hour long television special entitled "Was Tom Thomson Murdered?" See also R. P. Little, *The Tom Thomson Mystery* (1970), which deals almost exclusively with this issue. Although the coroner's verdict was accidental death by drowning, Judge Little suggests that Thomson was murdered by Martin Bletcher, with whom he had had an argument the night before. There is also reason to suspect that Thomson's body was never transferred to Owen Sound, further adding to the intrigue.
34. See Davies, *Thomson* (1935), 55.
35. There are many examples of this sentimentalized writing on Thomson; the best is probably Ray Atherton's article, "The Man in the Canoe," *Canadian Art* (1947), 57-58. Another example is Blodwen Davies' book, *A Study of Tom Thomson, The Story of a Man who Looked for Beauty and for Truth in the Wilderness* (1935). Despite the romantic approach, it is still an important book on Thomson.
36. H. Charlesworth, "Pictures That Can Be Heard," *Saturday Night*, March 18, 1916.
37. J. E. H. MacDonald, "Bouquets From a Tangled Garden," *Globe*, March 27, 1916.
38. Charlesworth, "Pictures That Can Be Heard."
39. MacDonald, "Bouquets From a Tangled Garden."
40. See N. Robertson Dillow, *MacDonald*, Manuscript, 57-66.
41. Charlesworth, "Pictures That Can Be Heard."
42. MacDonald, "Bouquets From a Tangled Garden."
43. R. F. Wodehouse, *Checklist of the War Collections*, N.G.C. (1967); and Paul Konody, "On War Memorials," *Art and War*, Canadian War Records (1919).
44. A. Y. Jackson, "Reminiscences of Army Life, 1914-1918," *Canadian Art*, XI, No. 1 (1953), 9.
45. A. Y. Jackson, "The War Memorials: A Challenge," *The Lamps*, Dec., 1919, 77.
46. "Recognition for Canadian Artists" by "T" in the London *Nation*; reproduced in *The Lamps*, Dec., 1919, 82.
47. See B. Fairley, "Canadian War Pictures," *Canadian Magazine*, LIV (1919), 3-11; and B. Fairley "F. H. Varley," *Our Living Tradition* (1959), 162-63.
48. Quoted in McLeish, *September Gale*, 67-68.
49. Quoted in Housser, *Canadian Art Movement*, 133. The statement appeared in an article by Sir Claud Philips in the *Daily Telegraph*.
50. McLeish, *September Gale*, 67-68.
51. Letters from Harris to MacCallum in M.C.C. Archives.
52. The usual date given for this trip is the fall of 1917, but Dennis Reid recently pointed out that all the sketches from this trip were spring scenes, suggesting that the trip was made in April or May of 1918.
53. Harris to MacCallum, letters in M.C.C. Archives.
54. J. E. H. MacDonald, "A.C.R. 10557," *The Lamps*, Dec., 1919, 33.
55. *Ibid.*, 37.
56. Toronto, A.G.T., *Algoma Sketches and Paintings – J. E. H. MacDonald ARCA, Lawren Harris, Frank Johnston* (May, 1919).
57. *Ibid.*
58. H. Charlesworth, "Painter-Etchers and Others," *Saturday Night*, May, 1919.
59. "Seven Artists Invite Criticism," *Mail and Empire*, May 10, 1920.
60. A. Bridle, "Are These New Canadian Painters Crazy?" *Canadian Courier*, May, 22, 1920.
61. B. Fairley, "Algonquin and Algoma," *The Rebel*, No. 6 (April, 1919), 28.
62. Jackson, *Painter's Country*, 56-57.
63. A. Y. Jackson, "Sketching in Algoma," *Canadian Forum*, March, 1921, 175.
64. Jackson, *Painter's Country*, 57.
65. Harris was the only other member of the Group to paint portraits. His known portraits are as follows: Dr. MacDonald, Salem Bland, Dr. John Robins, Eden Smith, Mrs. Leslie Wilson, Mrs. Holden, Bess Harris, Thoreau MacDonald.
66. Conversation between the author and Barker Fairley, August, 1969, recorded.

67. D. W. Buchanan, "The Hart House Collection," *Canadian Art*, V, No. 2 (1947), 63-68; J. Russell Harper, *Canadian Paintings in Hart House* (1955); J. Adamson, *The Hart House Collection of Canadian Paintings* (1969).
68. B. Fairley, "Some Canadian Painters – F. H. Varley," *Canadian Forum*, April, 1922, 596.
69. Quoted in Porter, "Varley."
70. Bridle, "Are These New Canadian Painters Crazy?"

CHAPTER 5

1. Jackson, *Painter's Country*, 63.
2. See Toronto, A.G.T., *MacDonald*, 14.
3. Jackson, *Painter's Country*, 63.
4. Harris, who was undoubtedly the prime mover in the formation of the Group, probably enjoyed the symbolic and mystical connotation of the number seven.
5. Jackson, *Painter's Country*, 63.
6. See Appendix.
7. Jackson, *Painter's Country*, 64.
8. Harris, "Group of Seven" (1948), 37.
9. Lismer, "Canadian Art, An Informal History," CBC *Wednesday Night*, June 14, 1950 (transcript).
10. In some cases authors have selected excerpts from favourable reviews in such a way as to make them appear to be attacks on the Group. Compare Housser's reporting of Bridle's statement (*A Canadian Art Movement*, 159) with the original article (*Canadian Courier*, May 22, 1920).
11. Bridle, "Are These New Canadian Painters Crazy?"
12. Lismer, "Canadian Art," CBC, June 14, 1950.
13. Jackson, *Painter's Country*, 64.
14. See McLeish, *September Gale*, 80.
15. Harris, "Group of Seven" (1948), 33.
16. Lismer, "Canadian Art," CBC, June 14, 1950.
17. After their first exhibitions, the Group made great efforts to promote their art across Canada and the United States. Travelling exhibitions were sent out to American cities in 1920-21 and 1923-24, and to Canadian cities in 1922-23. Approximately forty other small shows were sent to towns across Canada between 1920 and 1922. My thanks to Dennis Reid for this information.
18. See Appendix.
19. McLeish, *September Gale*, 72-73.
20. W. I. Grant, "The Present Intellectual Status of Canada," *Queen's Quarterly*, XXIX (1921), 85.
21. "Arts and Artists," *Globe*, May 9, 1921.
22. See Appendix.
23. Augustus Bridle, "Pictures of Group of Seven Show 'Art Must Take the Road,' " Toronto, *Star*, May 20, 1922.
24. *Ibid.*
25. Maud Brown, *Breaking Barriers, Eric Brown and the National Gallery*, 1964.
26. H. Charlesworth, "The National Gallery a National Reproach," *Saturday Night*, Dec. 9, 1922.
27. Sir Edmund Walker, "Canada's National Gallery," Letter to the Editor, *Saturday Night*, Dec. 23, 1922. Charlesworth's reply to the letter is included on the same page.
28. This letter was signed by A. Y. Jackson, R. F. Gagen, and A. H. Robson, and excerpts of it are quoted in McLeish, *September Gale*, 79, including the section quoted here. See Brown, *Breaking Barriers*, 65.
29. Brown, *Breaking Barriers*, 69-71.
30. It should be noted that Eric Brown went to great efforts to prepare the British press for the exhibition by giving out publicity material. One aspect of the reviews which has never been examined was the capability of the English critics. British art during this period was at a low level, which may have had some effect on the standard of criticism. The critics were certainly unable to situate the paintings in relation to other twentieth-century developments, but they did make comparisons with Swedish and Russian art. One of the best reviews of the exhibition was Rupert Lee's article on "Canadian Pictures at Wembley," *Canadian Forum*, IV, No. 41 (1924), 338-9.
31. The other works considered for purchase were Morrice, *Winter, Ste-Anne de Beaupré*; Thomson, *The West Wind*; Lismer, *September Gale*; and MacDonald, *Beaver Dam*.
32. See *Press Comments on the Canadian Section of Fine Arts, British Empire Exhibition*, 1924 and 1925. Compiled by the N.G.C.
33. This accusation had been made by the British Press in 1910 when the Royal Canadian Academy sent an exhibition to England. See Housser, *Canadian Art Movement*, 11.
34. "Canada's Art at Empire Fare," *Saturday Night*, Sept. 15, 1923.
35. H. Charlesworth, "Canadian Pictures at Wembley," Editorial, *Saturday Night*, May 17, 1924. Also quoted in McLeish, *September Gale*, 83-84. The other editorials in *Saturday Night* are as follows. "Freak Pictures at Wembley," Sept. 13, 1924; "Canada and her Paint Slingers," Nov. 8, 1924.
36. "School of Seven Exhibit is Riot of Impressions," *Star Weekly*, Jan. 10, 1925.
37. *Ibid.*
38. H. Charlesworth, "The Group System in Art, New Canadian 'School' as Exemplified in the Show of 'Seven,' " *Saturday Night*, Jan. 29, 1925. Charlesworth did not review any of the previous Group shows. It has been suggested that he intentionally ignored them as a means of showing his displeasure. However, there is nothing to indicate that he remained silent for this reason.
39. *Ibid.*
40. *Ibid.*
41. *The Rebel* was in circulation between 1916 and 1920, when it was superseded by the *Canadian Forum*, which is still in existence today. The *Canadian Bookman* was published from 1919 to 1939. For the role of the *Canadian Forum* in the history of the Group, see M. R. Davidson, "A New Approach to the Group of Seven," *Journal of Canadian Studies*, IV, No. 4 (1969), 9-16. This article was based on a thesis presented in partial fulfillment of the requirements for the degree of Master of Arts, Institute of Canadian Studies, Carleton University, April, 1969. I am extremely grateful to Miss Davidson for having permitted me to read her thesis. The Group also published numerous original illustrations in the *Canadian Forum*. See Joan Murray, "Graphics in the Forum," *Canadian Forum* (April-May, 1970), 42-44.
42. B. Fairley, "The Group of Seven," *Canadian Forum*, V, No. 53 (Feb., 1925), 144.
43. *Ibid.*, 146.
44. "If Cow Can Stay in Parlour, Then Why Can't Bull Moose?" Toronto *Star*, Feb. 27, 1925.
45. *Ibid.*
46. "Painters Demand The Head Of Art Dictator," Toronto, *Star*, Nov. 20, 1926.
47. See separate bibliography for *The Group of Seven*, exhibition catalogue, Ottawa, N.G.C. June, 1970, by Dennis Reid, for a comprehensive list of circulating exhibitions. The first important show in Montreal was not until 1930. After 1925, the Group ceased to produce and design their own catalogue, and the numbers of invited contributors increased sharply.
48. See James A. Cowan, "Hymie, Solly and a Pair of Truck-Drivers Take Part-Time Job as High Art Critic," *Star Weekly*, Jan. 31, 1925. See also Toronto, *Star*, April 28, 1930, for an interview with a western cowboy named "Shorty Campbell" who gives first-hand reactions to the Group.
49. The shocked response of Vancouver artists to the Group was in 1928, not 1932, as Jackson indicated in *Painter's Country*, 188. Lismer's warm reception on his 1932 lecture tour is described at length in McLeish, *September Gale*, 105-18.
50. This was also the year that Lismer published *A Short History of Painting with a Note on Canadian Art*. Both these books played a major role in spreading the ideas of the Group across Canada.
51. Words to Canada's national anthem, by Robert Stanley Weir.
52. Harris, "Group of Seven" (1948), 31.
53. J. E. H. MacDonald, "The Canadian Spirit in Art," *The Statesman*, I, No. 35 (March 22, 1919), 6-7.
54. Harris, "Group of Seven" (1948), 30.
55. H. Kenner, "The Case of the Missing Face," in *Our Sense of Identity*, ed. by M. Ross (1954), 203.
56. The association with the Transcendentalists was a close one. MacDonald and Harris in particular were conversant with the writings of Whitman, Thoreau, and Emerson. These authors propagated the same ideas of (1) art closely dependent on nature, (2) art that would be distinctively American, and (3) art that would break away from dependency on Europe. All of the Group knew and read works such as Whitman's *Leaves of Grass*. Housser (*Canadian Art Movement*) drew many parallels between the Group and the Transcendentalists.
57. E. W. Grier, "Canadian Art: A Resume," *Yearbook of Canadian Art* (1913), 246.
58. London, *Times*, 1924, quoted in McLeish, *September Gale* (1955), 82.
59. R. C. Harris, "The Myth of the Land in Canadian Nationalism," in *Nationalism in Canada*, ed. by Peter Russell, 27-46.
60. See Emily Carr, *Growing Pains* (1946), 238 (first published in paperback in 1966. All pages numbers refer to paperback edition).
61. "Jackson says Montreal Most Bigoted City," Toronto, *Star*, Sept. 10, 1927.
62. See Appendix. There were many other writers in periodicals such as *Canadian Forum* expressing a need for confidence in Canada. See Davidson, "New Approach," 10.
63. Critic describing American paintings in Paris Exposition of 1867.

CHAPTER 6

1. Harris, "Group of Seven" (1948), 32.
2. See Appendix.
3. Lawren Harris, *Contrasts* (1922), 57. Russell Harper, in his essay "1913-1921, The Development" in Ottawa, N.G.C., *Harris* (1963), 11-12, supports the view that Harris is concerned with social comment, and relates the above poem to *Black Court, Halifax*. The only work by Harris which does suggest social comment is a block print called *Glace Bay*, reproduced in the *Canadian Forum* (July, 1925), 303.
4. The similarity with works by the metaphysical painter de Chirico (c.f. *The Anguish of Departure*, c. 1913-14) is striking. There is also a superficial resemblance to the works of the American painter Georgia O'Keefe. However, there is no way of demonstrating what influence, if any, brought about this change in Harris' art.
5. Notes by Thoreau MacDonald on his father, in Hunter, *MacDonald*, 32.
6. Robert Ayre, "Arthur Lismer," *Canadian Art*, IV, No. 2 (1947), 51.
7. Jackson, *Painter's Country*, 69-83.
8. *Ibid.*, 73.
9. *Ibid.*, 75.
10. Lismer, Introduction to Toronto, A.G.T., *A. Y. Jackson*, 7.
11. Lismer, Introduction to Montreal, Dominion Gallery, *A. Y. Jackson*, (1946).
12. Charles Comfort, "Georgian Bay Legacy," *Canadian Art*, VIII, No. 3 (1951), 106.
13. MacDonald was also experimenting with these techniques at this time, and there is a possibility of a cross influence.
14. A. Y. Jackson, Foreword to Percy J. Robinson, *The Georgian Bay* (1966).
15. Housser, *Canadian Art Movement*, 166.
16. McLeish, *September Gale*, 76.
17. Quoted in Groves, *A.Y.'s Canada*, 110, from "Jackson and Casson," CBC broadcast, July 21, 1966.
18. Quoted in McLeish, *September Gale*, 125.
19. *Ibid.*, 107.
20. L. Harris, Introduction to Toronto, A.G.T., *Lismer* (1950), 10.
21. *Ibid.*, 28.
22. The chronology of these trips is uncertain. Jackson, in conversation with the author and Robert McMichael (March, 1970), states that he went on two boxcar trips, which would make a total of three

trips in the boxcar, since he missed the first one. Nancy Robertson, in her chronology of the *MacDonald Retrospective* (Toronto Art Gallery, 1965), states that the artists used the boxcar twice (1918 and 1919) and rented a cottage on Mongoose Lake in 1920. Dennis Reid, in *The Group of Seven*, exhibition catalogue (Ottawa, N.G.C., June, 1970), indicates that other trips were made in the spring of 1920 and 1921.
23. Fairley, "Algonquin and Algoma," 281.
24. Letter from Johnston to his wife, dated Oct. 6, 1919, in possession of Paul Rodrik.
25. Harris, "Group of Seven" (1948), 34.
26. Jackson, *Painter's Country*, 65.
27. "Seven Artists Invite Criticism," *Mail and Empire*, May 10, 1920.
28. "Art and Artists," *Globe*, May 11, 1920.
29. Lemoine FitzGerald was most impressed by Johnston's work and wrote a letter to him on Oct. 19, 1921, while on the train going east, saying, "I appreciate the truth that you have caught in your things and the big decorative values." (Letter in possession of Paul Rodrik.)
30. "Johnston Never Member of the Group of Seven," *Star Weekly*, Oct. 11, 1924.
31. Johnston's reason for changing his name for Frank to Franz may have been due to his interest in numerology. This was suggested by his son Lawren Johnston in an interview which appeared in a St. Catharines newspaper, N.G.C. files.
32. Jackson, *Painter's Country*, 56. This quote is misleading in the sense that Jackson gives no indication of MacDonald's prodigious knowledge of natural history, etc. See Thoreau MacDonald, Introduction to Hunter, *MacDonald*, xi.
33. MacDonald admired Van Gogh and other artists of the period and, according to Thoreau MacDonald, had reproductions of their works on his studio walls. However, he did not like "modernists" such as Cézanne.
34. MacDonald gave a lecture on Whitman at the Public Reference Library in Oct., 1926, and a lecture on *The Relation of Poetry to Painting with Special Reference to Canadian Painting*, in Oct., 1929. Thoreau MacDonald (Hunter, *MacDonald*) indicates that Burns was MacDonald's favorite poet.
35. Quoted in Toronto, A.G.T., *MacDonald*, 11.
36. Walt Whitman, *Leaves of Grass*, Comprehensive Reader's Edition, ed. by H. W. Blodgett and S. Bradley (New York: University Press, 1965), 181.
37. It is tempting to see an Oriental influence in this sketch, but unfortunately there is no documentary evidence to indicate that MacDonald was interested in Oriental art.
38. See works by Gauguin, Emile Bernard, Paul Serusier, Maurice Denis, and other artists belonging to the Pont Aven School and the Nabis. MacDonald was probably familiar with most of them through magazine illustrations and reproductions.
39. J. E. H. MacDonald, "Interior Decorations of St. Anne's Church Toronto," *Journal, Royal Architectural Institute of Canada*, Offprint, 1925; and Carol Lindsay, "A Rediscovered Gallery of Group of Seven Paintings," *Star Weekly*, Feb. 10, 1962. MacDonald also continued to make numerous book illustrations, eg. I. MacKay, *Fires of Driftwood* (1922): M. Pickthall, *The Wood Carver's Wife* (1922); A. MacMechan, *The Book of Ultima Thule* (1927); L. G. Salverson, *Lord of the Silver Dragon* (1927). See also J. E. H. MacDonald, *Bookplate Designs* (Thornhill: Woodchuck Press, 1966).
40. Quoted in Hunter, *MacDonald*, xi.
41. Harris, "Group of Seven" (1948), 34.
42. Letter from Bess Harris to Russell Harper, July 14, 1962, in N.G.C. Archives.
43. Harris and Lismer belonged to the Canadian Theosophical Society. When Theosophy went out of fashion in the thirties, both these artists underplayed any connection they had with the Society. Many others were Christian Scientists, including MacDonald, Johnston, and Carmichael.
44. Kandinsky published his *Uber das Geistige in der Kunst* in German in 1912. It was translated into English in 1914 as *The Art of Spiritual Harmony*.

45. Quoted in Ottawa, N.G.C., *Harris* (1963), 20.
46. For books on Theosophy see H. P. Blavatsky, *The Key to Theosophy* (Pasadena: Theosophical Society Press, 1946) and C. W. Leadbeater, *A Textbook of Theosophy* (Adyas, India: Theosophical Publishing House, 1914).
47. L. Harris, "Theosophy and Art," *Canadian Theosophist*, XIV, No. 5 (1933), 130.
48. Quoted in Housser, *Canadian Art Movement*, 190.
49. Quoted in Harris and Colgrove, *Harris*, 14.
50. Jackson, *Painter's Country*, 59.
51. A. Y. Jackson, Introduction to Toronto, A.G.T., *Lawren Harris, Paintings 1910-1948* (1948), 11.
52. Ottawa, N.G.C., *Harris* (1963), 32.
53. Harris, *Contrasts* (1922), 91. Excerpt of a poem entitled "Darkness and Light." Also mentioned in Dennis Reid, "Lawren Harris," *Artscanada*, XXV, No. 5 (1968), 15.
54. Jackson, *Painter's Country*, 58. For a general discussion of these trips, see Port Arthur, Ontario, *The Group of Seven and Lake Superior*, exhibition catalogue (1964). Introduction by William Harris.
55. Paul Duval, *Alfred Joseph Casson* (1951), 18.
56. Duval, *Casson*, 27.
57. Interview with A. J. Casson, recorded by the author, August, 1969.
58. "New Member is Added to Group of Seven," *Mail and Empire*, May 8, 1926.
59. See Paul Duval, *Canadian Water Colour Painting* (1954).
60. Harris, "Group of Seven" (1948), 35; and Jackson, *Painter's Country*, 106-109.
61. Quoted in Harris and Colgrove, *Harris*, 62.
62. A. Y. Jackson, "Artists in the Mountains," *Canadian Forum*, V, No. 52 (1925), 114.
63. Quoted in Harris and Colgrove, *Harris*, 76.
64. L. Harris, "Revelation of Art In Canada," *Canadian Theosophist*, VII, No. 5 (1926), 86.
65. Quoted in Housser, *Canadian Art Movement* 193-94.
66. Jackson, *Painter's Country*, 109-13.
67. Carr, *Growing Pains*, 238.
68. *Ibid.*
69. This painting was illustrated in Marius Barbeau's *The Downfall of Temlaham* (1928).
70. *The Cellist* was exhibited in the Wembley exhibition of 1924. There is little bibliographical material on Holgate. See MacDonald, *Dictionary*, II, 453-55.
71. Carr, *Growing Pains*, 233.
72. *Ibid.*, 234.
73. Emily Carr, *Hundreds and Thousands, The Journals of Emily Carr* (1966), 6-7.
74. *Ibid.*, 15-16.
75. *Ibid.*, 5.
76. *Ibid.*, 6.
77. Letter from Varley to Dr. Arnold Mason, dated Jan. 28, 1928, in the M.C.C. Archives.
78. Jock Macdonald, Introduction to Toronto A.G.T., *Varley* (1954), 7. See also, Ottawa, N.G.C., *Jock Macdonald, Retrospective Exhibition*, 1969-70, exhibition and catalogue by R. Anne Pollock and Dennis Reid.
79. From unpublished talk given by Fred Amess on Varley, mentioned in Harper, *Painting in Canada* (1966), 296.
80. Quoted in Donald Buchanan, "The Paintings and Drawings of F. H. Varley," *Canadian Art*, VII, No. 1 (1949), 3.
81. Quoted in Harper, *Painting in Canada*, 296.
82. Quoted in Porter, "Varley."
83. J. B. Salinger, "Freedom Fills Work by Group of Seven," *Mail and Empire*, April 4, 1930.
84. Quoted in Porter, "Varley."
85. "Canadian Artists Exhibit Widely," Sault Ste. Marie, *Star*, June 2, 1927. Jackson was not the first artist to paint the North. William Hind went on a sketching expedition to Labrador in 1890, and numerous other artists visited the Arctic in successive years (see Harper, *Painting in Canada*, 163-68). Another artist who had already painted the Arctic was Rockwell Kent, an American painter whom Jackson greatly admired. In April, 1934,

there was an exhibition of Kent's work at the A.G.T., and most of the Group met him at a party given by Harris. There is a strong similarity between Kent's work and that of the Group.
86. "Toronto Artist After Distinct Values in Art," Regina, Saskatchewan, *Leader Post*, July 30, 1927.
87. C. Greenaway, "Painter Says Canada Does Not Appreciate Arctic Possessions," Toronto, *Star*, Sept. 10, 1927.
88. *Ibid.*
89. Jackson, *Painter's Country*, 124.
90. F. G. Banting, Introduction to *The Far North A Book of Drawings by A. Y. Jackson* (1927).
91. *Ibid.*
92. Harris, "Group of Seven" (1948), 36.
93. Jackson, *Painter's Country*, 132.
94. J. B. Salinger, "Far North is Pictured by Two Artists," Regina, Saskatchewan, *Leader Post*, May 1, 1931.
95. Harris, "Revelation of Art in Canada," 86.
96. *Ibid.*
97. Jackson, *Painter's Country*, 146-53.
98. See article on FitzGerald by Robert Ayre, entitled "Painter of the Prairies," *Weekend*, VII, No. 12 (March 22, 1958). A broadcast "Painter of the Prairies" was made over the CBC Midwest network on Dec. 1, 1945.
99. See Chapter VI, Note 28.
100. FitzGerald was thrilled to be included in the Group, (see letter to H. O. McCurry, Director of the National Gallery of Canada, July 6, 1932). According to J. B. Salinger's article in the *Canadian Forum*, XII, No. 136 (Jan., 1932), 143, the Group "ceased to exist" as of December, 1931, which would mean that FitzGerald was never really a member of the Group. However, the Group did not officially disband at that time, and can still be considered as the Group of Seven until the first exhibition of the Canadian Group of Painters in November, 1933.
101. Ayre, "Painter of the Prairies."

CHAPTER 7

1. T. M. [Thoreau MacDonald], "Decline of the Group of Seven," *Canadian Forum*, XII, No. 136 (Jan. 1932), 144.
2. Salinger, "Group of Seven," 143.
3. *Ibid.*
4. Conversation between Thoreau MacDonald and the author, July, 1969. In 1921 Jackson had suggested the possibility of a "Canadian Group" in a letter to Eric Brown (April 24), in the N.G.C. Archives.
5. "Now Represents Spirit of Canadian Art, Group of Seven Not Separate Entity," Ottawa, *Evening Citizen*, April 24, 1930.
6. Quoted in Harper, *Painting in Canada*, 365.
7. Kenner, "The Missing Face"
8. See Toronto, A.G.T., *Catalogue of an Exhibition of Paintings by Canadian Group of Painters*, Nov. 1933. The foreword also indicated that the addition of figures and portraits would keep "art in the van of our forward stride as a nation."
9. Toronto, A.G.T., *Canadian Group* (Nov. 1933), Introduction.
10. John Lyman, "Canadian Art, Letter to the Editor," *Canadian Forum*, XII, No. 140 (May ,1932), 313-14. Some authors, such as Jackson (*Painter's Country*, 142), have suggested that the difficulties of the Canadian Group were due to the Depression and the Second World War. However, the generally low level of art in Canada during the thirties and forties cannot be blamed on these two factors alone. The United States went through the same events and still managed to produce some of the most original art of this century.
11. Jackson, *Painter's Country*, 139.
12. See Jackson, *Painter's Country*, 139-40, for contemporary reactions to the exhibition.
13. "Modern Art and Aesthetic Reactions," *Canadian Forum*, VII, No. 80 (May, 1927), 239-41;

"An Appreciation," by Lawren Harris; "An Objection," by Franz Johnston.

14. Thomas R. Lee, "Bertram Brooker, 1888-1895," *Canadian Art*, XIII, No. 3 (1956), 287-91.
15. L. Harris, "An Essay on Abstract Painting," *Journal of the Royal Architectural Society Institute of Canada*, XXVI, No. 1 (1949), 3-8. This essay was also published in *Canadian Art*, VI, No. 3 (1949), 103-107. In 1954 it appeared in a separate booklet, published by Rous and Mann Press Limited, with the title *A Disquisition on Abstract Painting*.
16. Harris, "Essay on Abstract Painting," 103.
17. See Chapter VI, note 44. There is a close parallel between Kandinsky's *Compositions* and those by Harris.
18. See Harris, "Essay on Abstract Painting," 105.
19. Harris, "Revelation of Art in Canada," 86.
20. G. C. McInnes, "Upstart Crows," *Canadian Forum*, XVI, No. 184 (May, 1936), 14-16, is an example of unfavourable reactions to Harris' later work.
21. Harris, "Essay on Abstract Painting," 104.
22. Fairley, "Lawren Harris," 278.
23. Northrop Frye, Introduction to Harris and Colgrove, *Harris*.
24. Both Harris and his wife helped to select the photographs and illustrations which appeared in the book *Lawren Harris*, edited by Bess Harris and Peter Colgrove (1969). The three photographs of him in the book show him walking across a glacier. Harris died in January, 1970, and was buried beside his wife Bess Harris at the McMichael Conservation Collection.
25. Jackson, *Painter's Country*, 142.
26. Groves, *AY's Canada*, 8.
27. For a list of books illustrated by Jackson, see *Who's Who in Ontario Art*. The film *Canadian Landscape* was made in 1941 by the Crawleys for the National Film Board. See Jackson, *Painter's Country*, 186.
28. Lismer, Introduction to Toronto, A.G.T., *Jackson*, (1953), 7.
29. McLeish, *September Gale*, 103-18.
30. *Ibid.*, 174-80.
31. Jackson, "Arthur Lismer," 89.
32. Quoted in Porter, "Varley."
33. See E. S. Carpenter, "Varley's Arctic Sketches," *Canadian Art*, XVI, No. 2 (1959), 93-100; and *Eskimo* (1959), by the same author, with paintings and sketches by Frederick Varley.
34. Porter, "Varley."
35. Quoted in Josephine Hambleton, "Frederick Horseman Varley," Kingston, *Whig Standard*, Jan. 12, 1948.
36. Jackson, "Sketching in Algoma," 175.
37. Frank Underhill, "False Hair on the Chest," *Saturday Night*, Oct. 3, 1936.
38. Harris, "Group of Seven" (1948), 32.
39. Fairley, "Varley" (1959), 169.

BIBLIOGRAPHY

GENERAL WORKS

BOOKS

Adamson, Jeremy. *The Hart House Collection of Canadian Paintings*. Toronto: University of Toronto Press, 1969.

Barbeau, Marius. *The Downfall of Temlaham*. Toronto: Macmillan Co., 1928.

Bridle, Augustus. *The Story of the Club*. Toronto: The Arts and Letters Club, 1945.

Brooker, Bertram, ed. *Yearbook of the Arts in Canada*, Vol. I, II. Toronto: Macmillan Co., 1928-9, 1936.

Brown, Eric. *Canadian Art and Artist, A Lecture*. Ottawa: The National Gallery of Canada, 1925.

Brown, Eric, and Jacob, Fred R. *A Portfolio of Canadian Art*. Toronto: Rous and Mann, 1926.

Brown, Maud. *Breaking Barriers, Eric Brown and the National Gallery*. Toronto: Society for Art Publications, 1964.

Buchanan, Donald W. *Canadian Painters From Paul Kane to the Group of Seven*. Oxford and London: Phaidon Press, 1945.

————. *The Growth of Canadian Painting*. London and Toronto: Collins, 1950.

————. *Canadian Art Club, 1907-11*. Toronto: Canadian Art Club, 1911.

Canadian Drawings by Members of The Group of Seven. Toronto: Rous and Mann, 1925.

Chauvin, Jean. *Ateliers: études sur vingt-deux peintres et sculpteurs canadiens*. Montreal: L. Carrier, 1928.

Colgate, William. *The Toronto Art Students' League, 1886-1904*. Toronto: Ryerson Press, 1954.

————. *Canadian Art: Its Origin and Development*. Toronto: Ryerson Press, 1943.

Duval, Paul. *Canadian Drawings and Prints*. Toronto: Burns and MacEachern Ltd., 1952.

————. *Canadian Watercolour Painting*. Toronto: Burns and MacEachern Ltd. 1954.

————. *Group of Seven Drawings*. Toronto: Burns and MacEachern Ltd., 1965.

Hammond, M. O. *Painting and Sculpture in Canada*. Toronto: Ryerson Press, 1930.

Harper, J. Russell. *Canadian Painting in Hart House*. Toronto: Hart House Art Committee, 1955.

————. *Painting in Canada, A History*. Toronto: University of Toronto Press, 1966.

Harris, Lawren Stewart. *The Story of the Group of Seven*. Toronto: Rous and Mann, 1964.

Holme, Charles, ed. *Art of the British Empire Overseas*. London: The Studio Ltd., 1917.

Housser, F. B. *A Canadian Art Movement, The Story of the Group of Seven*. Toronto: Macmillan Company, 1926.

Hubbard, R. H. *An Anthology of Canadian Art*. Toronto: Oxford University Press, 1959.

————. *The National Gallery of Canada*, *Catalogue of Paintings and Sculpture, Volume III: Canadian School*. Ottawa: National Gallery of Canada, 1960.

————. *The Development of Canadian Art*. Ottawa: National Gallery of Canada, 1963.

Jackson, A. Y. *A Painter's Country*. Toronto: Clarke Irwin and Co. Ltd., 1958 (first paperback edition, 1964).

Kilbourn, Elizabeth. *Great Canadian Painting, A Century of Art*. The Canadian Centennial Library. Toronto: McClelland and Stewart, 1966.

Lambert, Richard Stanton. *The Adventure of Canadian Painting*. Toronto: McClelland and Stewart, 1947.

The Lamps. Toronto: Produced and published by the Arts and Letters Club, December, 1919.

Lismer, Arthur. *A Short History of Painting, with a Note on Canadian Art*. Toronto: Andrews Bros., 1926.

————. *Canadian Picture Study*. Toronto: Art Gallery of Ontario, 1930.

McLeish, John, A. B. *September Gale, A Study of Arthur Lismer of the Group of Seven*. Toronto: J. M. Dent and Sons, 1955.

MacDonald, Colin S. *A Dictionary of Canadian Artists*. Vols. I, II, III. Ottawa: Canadian Paperbacks, 1967, 1968, not yet published.

MacDonald, Thoreau. *The Group of Seven*. Canadian Art Series. Toronto: Ryerson Press, 1944.

McInnes, Graham, C. *A Short History of Canadian Art*. Toronto: Macmillan Co., 1939.

————. *Canadian Art*. Toronto: Macmillan Co., 1950.

MacTavish, Newton. *The Fine Arts in Canada*. Toronto: Macmillan Co., 1925.

Press Comments on the Canadian Section of Fine Arts. British Empire Exhibition, 1924-1925. Ottawa: National Gallery of Canada, 1925.

Reid, Dennis. *The MacCallum Bequest, of paintings by Tom Thomson and other Canadian Painters and the Mr. & Mrs. H. R. Jackman Gift of the murals from the late Dr. MacCallum's cottage painted by some of the Group of Seven*. Ottawa: National Gallery of Canada, 1969.

————. *The Group of Seven*. Exhibition. Ottawa: National Gallery of Canada, 1970.

Robson, A. H. *Canadian Landscape Painters*. Toronto: Ryerson Press, 1932.

Ross, Malcolm, ed. *Our Sense of Identity – A Book of Canadian Essays*. Toronto: Ryerson Press, 1954.

Russell, Peter, ed. *Nationalism in Canada*. Toronto: McGraw Hill, 1966.

Yearbook of Canadian Art. Compiled by the Arts and Letters Club of Toronto. London: J. M. Dent and Sons, 1913.

ARTICLES

Abell, Walter. "Canadian Aspirations in Painting." *Culture*, III (1942), 172-182.

Alford, E. J. G. "Trends in Canadian Art." *University of Toronto Quarterly*, XIV, No. 2 (January, 1945), 168-80.

————. "The Development of Painting in Canada." *Canadian Art*, II, No. 3 (1945), 95-103.

Amaya, Mario. "Canada's Group of Seven." *Art in America*, LVIII, No. 3 (May-June, 1970), 122-25.

Anderson, Patrick. "A Poet and Painting." *Canadian Art*, IV, No. 3 (1947), 104-7.

Ayre, Robert. "The Canadian Group of Painters." *Canadian Art*, VI, No. 3 (1949), 98-102.

————. "Artist's Island." *Weekend* Picture Magazine, III, No. 41 (1953), 26-30.

Bailey, A. G. "Literature and Nationalism after Confederation." *University of Toronto Quarterly*, XXV, No. 4, (July, 1956), 409-24.

Barbeau, Charles Marius. "Backgrounds in Canadian Art." Ottawa, *Royal Society of Canada*, XXXV, 3rd Series, Sect. 11 (1941), 29-39.

Bell, M. "Toronto's Melting Pot." *Canadian Magazine*, XLI (1913), 234.

Binkley, Mildred B. "Bibliography: Canadian artists and modern art movements." *Ontario Library Review*, XIV, No. 2 (1929), 42-46.

Branting, Agnes. "Modern Tapestry-Work in Sweden." *The Studio*, LVIII, No. 240 (March, 1913), 102-11.

Bridle, Augustus. "The Drama of the Ward." *Canadian Magazine*, XXXIV (1909-10), 3-8.

————. "How the Club Came to Be." *The Lamps* (December, 1919), 7-14.

Brown, Eric. "Landscape Art in Canada." *Art of the British Empire Overseas*, Special Studio Number (1917), 3-8.

————. "The National Art Gallery of Canada at Ottawa." *The Studio*, LVIII, No. 239 (1913), 15-21.

————. "La jeune peinture canadienne." *L'Art et les Artistes*, No. 75 (March, 1927), 181-95.

————. "Canada's National Painters." *The Studio*, CIII, No. 471 (June, 1932), 311-23.

Brown, Maud. "I Remember Wembley." *Canadian Art*, XXI, No. 4 (1964), 210-13.

Buchanan, Donald W. "The Story of Canadian Art." *Canadian Geographical Journal*, XVII, No. 6 (1938), 273-294.

————. "Variations in Canadian Landscape Painting." *University of Toronto Quarterly*, X, No. 1 (October, 1940), 39-45.

————. "The Gentle and The Austere, A Comparison in Landscape Painting." *University*

of Toronto Quarterly, XI, No. 1 (October, 1941), 72-77.

——————. "Canadian Painting Finds an Appreciative Public." Culture, XII (1951), 51-55.

Carver, Humphrey. "Exhibition at the Toronto Art Gallery." The Canadian Forum, XI, No. 130 (July, 1931), 379-80.

Colgate, William. "The Toronto Art Students' League: 1886-1904." Ontario History, XIV, No. 1 (1953), no pagination.

Comfort, Charles F. "Georgian Bay Legacy." Canadian Art, VIII, No. 3 (1951), 106-109.

Davidson, Margaret R. "A New Approach to the Group of Seven." Journal of Canadian Studies, IV, No. 4 (November, 1969), 9-16.

Davies, Blodwen. "Art and Esotericism in Canada." The Canadian Theosophist, XVIII (1937), 57-58.

Dick, Stewart. "Canadian Landscape of Today." Apollo, XV, No. 90 (June, 1932), 281-83.

Fairley, Barker. "Algonquin and Algoma." The Rebel, III, No. 6 (April 6, 1919), 279-82.

——————. "Canadian War Pictures." Canadian Magazine, LIV (1919), 3-11.

——————. "At the Art Gallery, I. The Canadian Section of the War Pictures, II. The Royal Canadian Academy." The Rebel, IV, No. 3 (December, 1919), 123-27.

——————. "Artists and Authors." Canadian Forum, II, No. 15 (1921), 460-463.

——————. "The Group of Seven." Canadian Forum, V, No. 53 (February, 1925), 144-47.

——————. "The Group of Seven." (Editorial). Canadian Forum, VII, No. 77 (February, 1927), 136.

——————. "Canadian Art; Man Versus Landscape." Canadian Forum, XIX, No. 227 (December, 1939), 284-86.

——————. "What is Wrong with Canadian Art?" Canadian Art, VI, No. 1 (1948), 24-29.

——————. "Canadian Art: Man vs. Landscape." Our Sense of Identity. Edited by M. Ross (1954), 230-34.

Ford, Harriot. "The Royal Canadian Academy of Arts." Canadian Magazine (1894), 45-50.

Frye, H. N. "Canadian Watercolours." Canadian Forum, XX, No. 231 (April, 1940), 14.

——————. "The Pursuit of Form." Canadian Art, VI, No. 2 (1948), 54-57.

Gordon, M. "The Group of Seven." New Frontiers (Spring, 1953), 20-26.

Gowans, Alan. "The Canadian National Style." The Shield of Achilles: Aspects of Canada in the Victorian Age. Edited by W. I. Morton. Toronto: McClelland and Stewart, 1968, 208-19.

Grant, W. L. "The Present Intellectual Status of Canada." Queen's Quarterly, XXIX (July, 1921), 84-95.

Grier, E. Wyly. "Canadian Art: A Resumé." Yearbook of Canadian Art (1913), 241-48.

Harper, J. Russell. "From Confederation through the Wars." Canadian Art, XIX, No. 6 (1962), 420-35.

——————. "Tour d'horison de la peinture canadienne." Vie des Arts, No. 26 (1962), 28-37.

Harris, Lawren. "Revelation of Art in Canada." Canadian Theosophist, VII, No. 5 (1926), 85-88.

——————. "The Group of Seven in Canadian History." Canadian Historical Association (June, 1948), 28-38.

——————. "An Essay on Abstract Painting." Journal of the Royal Architectural Institute of Canada, 26 (1949), 3-8.

——————. "An Essay on Abstract Painting." Canadian Art, IV, No. 3 (1949), 103-107.

Hodgson, John Ivan. "Royal Academy Report on the Canadian Pictures at the Colonial and Indian Exhibition at South Kensington." Canada-Parliament Sessional papers, No. 12 (1886), 60-68.

Holmes, Robert. "Toronto Art Students' League." Canadian Magazine, IV, No. 2 (December, 1894), 171-88.

Housser, Bess. "In the Realm of Art: Impressions of the Group of Seven." Canadian Bookman, VII, No. 2 (February, 1925), 33.

Housser, F. B. "The Group of Seven Exhibition." Canadian Bookman, VIII, No. 6 (June, 1926), 176.

——————. "The Amateur Movement in Canadian Painting." Yearbook of The Arts in Canada (1928-1929), 81-90.

——————. "Walt Whitman and North American Idealism." Canadian Theosophist, XI (1930), 103-106.

——————. "The Group of Seven and its Critics." Canadian Forum, XII, No. 137 (February, 1932), 183-84.

Hubbard, R. H. "The National Movement in Canadian Painting." Group of Seven. Exhibition, Vancouver Art Gallery (1954), 13-17.

——————. "Growth in Canadian Art." The Culture of Contemporary Canada. Edited by Julian Park. Toronto & Ithaca: Cornell University Press, 1957.

Jackson, Alexander Young. "The Development of Canadian Art." Royal Society of Arts, XCVII, No. 4786 (1949), 129-143.

Jefferys, C. W. "The Toronto Exhibition of Little Pictures." Yearbook of Canadian Art (1913), 191-96.

Kenner, Hugh. "The Case of the Missing Face." Our Sense of Identity. Edited by M. Ross. (1954), 203-208.

Konody, Paul. "On War Memorials." Art and War. London: Canadian War Records, 1919.

Kyle, Fergus. "The Ontario Society of Artists." Yearbook of Canadian Art (1913), 187-90.

Lamb, Mortimer. "Studio Talk." The Studio, LXVII, No. 275 (February, 1916), 63-70.

Langton, W. A. "A Canadian Art Movement." Willison's Monthly, July, 1927, 66-69.

Lee, Rupert. "Canadian Pictures at Wembley." Canadian Forum, IV, No. 41 (February, 1924), 338-39.

——————. "Canadian Pictures at Wembley." Canadian Forum, V, No. 6 (September, 1925), 368-70.

Lyman, John. "Canadian Art." (Letter to the Editor). Canadian Forum, XII, No. 140 (May, 1932), 313-14.

MacCallum, H. R. "The Group of Seven: A Retrospect." Queen's Quarterly, May, 1933, 242-52.

MacDonald, J. E. H. "The Canadian Spirit in Art." The Statesman, I, No. 35 (1919), 6-7.

MacKay, Alice. "The Second Annual Exhibition of Canadian Art." Canadian Homes and Gardens, April, 1927, 32.

McInnes, Graham C. "Upstart Crows." Canadian Forum, XVI, No. 184 (May, 1936), 14-16.

——————. "Art and philistia; some sidelights on aesthetic taste in Montreal and Toronto, 1880-1910." University of Toronto Quarterly, VI, No. 4 (July, 1937), 516-24.

——————. "The Art of Canada." The Studio, CXIV, No. 533 (August, 1937), 55-72.

——————. "The Canadian Artist and his Country." The Geographical Magazine, XVI, No. 8 (December, 1943), 396-407.

——————. "Can Lusty Nationalism Foster Best in Art?" Saturday Night, March 3, 1945.

——————. "Canadian Group of Painters." Canadian Art, III, No. 2 (1946), 76-77.

MacTavish, Newton. "Some Canadian Painters of the Snow." The Studio, LXXV, No. 309 (December, 1918), 78-82.

Massey, Vincent. "Art and Nationality in Canada." Royal Society of Canada, XXIV, 3rd Series (1930), XLIX-LXXII.

Mellen, Peter. "Tribute to the Modest Collector." Canadian Collection, III, No. 9 (September, 1968), 20-21.

Morgan-Powell, S. "Montreal Art Association; Spring Exhibition." Yearbook of Canadian Art (1913), 231-36.

Montagnes, Ian. "The Hart House Collection of Canadian Art." Canadian Art, XX, No. 4 (1963), 218-20.

Mortimer-Lamb, H. "Canadian Artists at War." The Studio, LXV, No. 270 (October, 1915), 259-64.

Murray, Joan. "Victorian Canada." Canadian Antiques Collector, Part I, V, No. 2 (February, 1970) 10-14; Part II, V, No. 3 (March, 1970), 16-20; Part III, V, No. 4 (April, 1970), 16-20.

——————. "Graphics in the Forum, 1920-1951." Canadian Forum, April-May, 1970, 42-45.

Newton, Eric. "Canadian Art in Perspective." Canadian Art, XI, No. 3 (1954), 93-95.

Panton, L. A. C. "Seventy-Five Years of Service." Canadian Art, IV, No. 3 (1947), 100-103.

Pantazzi, Sybille. "Book Illustration and Design by Canadian Artists 1890-1940." National Gallery of Canada Bulletin, IV, No. 1 (1966), 6-24.

Richmond, Leonard. "Canadian Art at Wembley." The Studio, LXXXIX, No. 182 (1925), 16-24.

Robertson, J. K. B. "Canadian Geography and Canadian Painting." Canadian Geographical Journal, XXXVIII (1949), 262-73.

Robertson, Nancy, E. "In Search of Our Native Landscape." Canadian Art, XXII, No. 5 (1965), 38-40.

Salinger, J. B. "Comment on Art – The Group of Seven." Canadian Forum, XII, No. 136 (January, 1932), 142-43.

——————. "Geography and Art and Shore." Canadian Forum, XII, No. 144 (September, 1932), 463.

Sherwood, W. A. "A National Spirit in Art." Canadian Magazine, III (October, 1894), 498-500.

——————. "The Influence of the French School on Recent Art." Canadian Magazine, III (October, 1893), 638-41.

Suddon, Alan and Stewart, Laura. "Who's Who in Ontario Art." Ontario Library Review, November, 1964 – February, 1965.

Talberg, A. "Modern Painting in Sweden." The Studio, XXXI, No. 132 (March, 1904), 97-112.

T. M. [Thoreau MacDonald]. "The Decline of the Group of Seven." Canadian Forum, XII, No. 136 (January, 1932), 144.

Turner, E. H. "A Current General Problem" Canadian Art, XX, No. 2 (1963), 108-11.

Turner, Percy Moore. "Painting in Canada." Canadian Forum, III, No. 27 (December, 1922), 82-84.

WORKS ON INDIVIDUAL ARTISTS

BEATTY, J. W.

Hoover, Dorothy. J. W. Beatty. Canadian Artist Series. Toronto: Ryerson Press, 1948.

Toronto, Art Gallery of Toronto. Catalogue of Memorial Exhibitions of the work of Clarence Gagnon, RCA, J. W. Beatty, RCA, OSA. October-November, 1942.

CARMICHAEL, FRANKLIN

Toronto, Art Gallery of Toronto. Franklin Carmichael Memorial Exhibition. Introduction by F. S. Haines, March, 1947.

CARR, EMILY

Carr, Emily. Klee Wyck. Toronto: Oxford University Press, 1941.

——————. Growing Pains: The Autobiography of Emily Carr. Toronto: Oxford University Press, 1946.

——————. Hundred and Thousands; the Journals of Emily Carr. Toronto: Clarke, Irwin, 1966.

Dilworth, Ira and Harris, Lawren. Emily Carr, Her Paintings and Sketches. Toronto: Oxford University Press, 1945.

CASSON, A. J.

Casson, A. J. "The Possibilities of Silk Screen Reproduction." Canadian Art, VII, No. 1 (1949), 12-14.

Duval, Paul. Alfred Joseph Casson. Toronto: Ryerson Press, 1951.

"Who's Who in Ontario Art – A. J. Casson." Ontario Library Review, May, 1952.

CULLEN, MAURICE

Gour, Romain. *Maurice Cullen, un maître de l'art au Canada*. Montréal: éditions éoliennes, 1952.

Hamilton, Art Gallery of Hamilton. *Maurice Cullen, 1866-1934*. Exhibition catalogue. Introduction by Robert Pilot, 1956. Also shown at Art Gallery of Toronto, Montreal Museum of Fine Arts and National Gallery of Canada.

MacTavish, Newton. "Maurice Cullen: A Painter of the Snow." *Canadian Magazine*, April, 1912, 537-44.

Pilot, Robert. "Maurice Cullen, RCA." *Educational Record of the Province of Quebec*, LXXX, No. 3 (1954), 136-41.

Watson, W. R. *Maurice Cullen, RCA*. Toronto: Ryerson Press, 1931.

——————. "The Art of Maurice Cullen." *Canadian Review of Music and Other Arts*, January, 1943, 10.

FITZGERALD, L. L.

Ayre, Robert. "Painter of the Prairies." *Weekend Magazine*, VIII, No. 12 (March 22, 1958).

Eckhardt, Ferdinand. "The Technique of L. L. FitzGerald." *Canadian Art*, XV, No. 2 (1958), 114-19.

FitzGerald, L. "Painters of the Prairie." Broadcast on CBC *Midwest Network*, December 1, 1954 (transcript).

Harris, Lawren. "FitzGerald's Recent Work." *Canadian Art*, III, No. 1 (1945), 13.

Winnipeg, Winnipeg Art Gallery. *L. L. FitzGerald, 1890-1956, A Memorial Exhibition, 1956*. "Foreword," by Alan Jarvis; "Introduction," by Ferdinand Eckhardt, 1958. Also shown at Montreal Museum of Fine Arts, Art Gallery of Toronto, National Gallery of Canada.

Winnipeg, Winnipeg Art Gallery, *A New FitzGerald*. Exhibition catalogue, April-May, 1963.

GAGNON, CLARENCE

Gauvreau, Jean-Marie. *Clarence A. Gagnon*. Lecture at National Gallery of Canada, December, 1942 (typescript).

Ottawa, National Gallery of Canada. *Clarence A. Gagnon, 1881-1942, Memorial Exhibition*. 1942.

Robson, A. H. *Clarence A. Gagnon*. Canadian Artist Series. Toronto: Ryerson Press, 1938.

Toronto, Art Gallery of Toronto. *Catalogue of Memorial Exhibitions of the Work of Clarence Gagnon, RCA, J. W. Beatty, RCA, OSA*. October-November, 1942.

HARRIS, LAWREN

Adeney, Marcus. "Lawren Harris, An Interpretation." *Canadian Bookman*, X, No. 2 (February, 1928), 42-43.

Bell, Andrew. "Lawren Harris – A Retrospective Exhibition of His Painting 1910-1948." *Canadian Art*, VI, No. 2 (1948), 51-53.

Fairley, Barker. "Some Canadian Painters: Lawren Harris." *Canadian Forum*, I, No. 9 (June, 1921), 275-78.

Harris, Bess and Colgrove, Peter, eds. *Lawren Harris*. Toronto: Macmillan Co., 1969.

Harris, Lawren. "Heming's Black and White." *The Lamps*, October, 1911, 11.

——————. "The R.C.A. Reviewed." *The Lamps*, December, 1911, 9.

——————. "Palmer's Work." *The Lamps*, December, 1911, 12.

——————. "The Canadian Art Club." *Yearbook of Canadian Art*, 1913.

——————. *Contrasts, A Book of Verse*. Toronto: McClelland and Stewart, 1922.

——————. "Winning a Canadian Background." (book review.) *Canadian Bookman*, V, No. 2 (February, 1923), 37.

——————. "Sir Edmund Walker." *Canadian Bookman*, VI, No. 5 (May, 1924), 109.

——————. "The Philosopher's Stone." (book review). *Canadian Bookman*, VI, No. 12 (July, 1924), 163.

——————. "Artist and Audience." *Canadian Bookman*, VIII, No. 2 (December, 1925), 197-98.

——————. "Review of the Toronto Art Gallery Opening." *Canadian Bookman*, VIII, No. 2 (February, 1926), 46-47.

——————. "Revelation of Art in Canada." *Canadian Theosophist*, VII, No. 5 (1926), 85-88.

——————. "Modern Art and Aesthetic Reactions – An Appreciation." *Canadian Forum*, VII, No. 80 (May, 1927), 239-41.

——————. "Creative Art and Canada." *Yearbook of the Arts in Canada*. Edited by B. Brooker, 1928-1929.

——————. "Creative Art and Canada." Supplement to *McGill News*, Montreal (December, 1928), 6-13.

——————. "Theosophy and Art." *Canadian Theosophist*, XIV, No. 5 (1933), 129-32.

——————. "Emily Carr and Her Work." *Canadian Forum*, XXI, No. 25 (December, 1941), 277-78.

——————. "The Paintings and Drawings of Emily Carr." *Emily Carr, Her Paintings and Sketches* (1945), 20-28.

——————. "The Group of Seven in Canadian History." *The Canadian Historical Association; Report of the Annual Meeting Held at Victoria and Vancouver*, June 16-19, 1948, 28-38.

——————. "An Essay on Abstract Painting." *Canadian Art*, VI, No. 3 (1949), 103-107.

——————. "Arthur Lismer." *Arthur Lismer: Paintings, 1913-1949*. Toronto: Art Gallery of Toronto, (1950), 7-28.

——————. "Art in Canada: An Informal History, Part III by Lawren Harris." CBC *Wednesday Night*, June 21, 1950 (transcript).

——————. "The Group of Seven." Talk given at Vancouver Art Gallery, April, 1954, and broadcast from CBU, Vancouver, September 15, 1954.

——————. "The Story of the Group of Seven." *Group of Seven*. Exhibition catalogue. Vancouver: Vancouver Art Gallery, 1954.

——————. *A Disquisition on Abstract Painting*. Toronto: Rous and Mann Press, 1954.

——————. "What the Public Wants." *Canadian Art*, XII, No. 1 (1954), 9-13.

——————. *The Story of the Group of Seven*. Toronto: Rous and Mann, 1964.

Hart, William S. *Lawren Harris: Theory and Practice of Abstract Art*. Vancouver: Seymour Press, 1963.

Ottawa, National Gallery of Canada. *Lawren Harris, Retrospective Exhibition*. "Foreword," by Charles Comfort, LL.D.; "1883-1912, Introduction," by Ian McNairn; "1913-1921, The Development," by Russell Harper; "1921-1931, From Nature to Abstraction," by Paul Duval; "1932-1948, Theory and Practice of Abstract Art," by William Hart; "1940-1963, The Vancouver Period," by John Parnell, M.D. June 7-September 8, 1963. Also shown at Vancouver Art Gallery.

Reid, Dennis. "Lawren Harris." *Artscanada*, XXV, No. 5 (1968), 9-16.

Robins, John. "Lawren Harris." *Canadian Review of Music and Other Arts*, III, Nos. 3 and 4 (April, May, 1944), 13-14.

Toronto, Art Gallery of Toronto. *Lawren Harris, Paintings 1910-1948*. Exhibition catalogue. "Lawren Harris, A Biographical Sketch," by A. Y. Jackson; "The Paintings," by Sydney Key, October 16-November 14, 1948. Also circulated by the National Gallery of Canada.

HOLGATE, EDWIN

Chauvin, Jean. *Ateliers; études sur vingt-deux peintures et sculpteurs canadiens*. Montreal: L. Carrier, 1928.

Haviland, Richard H. "Canadian Art and Artists – Edwin Headly Holgate." *The Montreal Standard*, July 23, 1938.

JACKSON, A. Y.

"Adventure in Art," (Editorial on Jackson's trip to Arctic). *Canadian Forum*, VIII, No. 86 (November, 1927), 424.

Ayre, Robt. "A. Y. Jackson – The Complete Canadian." *Educational Record of the Province of Quebec*, LXXX, No. 2 (April-June, 1954), 79-84.

Banting, F. G. Introduction, *The Far North, A Book of Drawings, By A. Y. Jackson*. Toronto: Rous and Mann, 1927.

Barbeau, Charles Marius. *Kingdom of the Saguenay*. Toronto: Macmillan Co., 1936.

Buchanan, D. W. "A. Y. Jackson, the Development of Nationalism in Canadian Painting." *Canadian Geographical Journal*, June, 1946, 248-85.

Duval, P. "Canada's senior artist still has zeal of the pioneer." *Saturday Night*, August 11, 1945, 22-23.

Greenaway, C. R. "Jackson Says Montreal Most Bigoted City." Toronto, *Star*, September 10, 1927.

——————. "Painter Says Canada Does Not Appreciate Arctic Possessions." Toronto, *Star*, September 10, 1927.

Groves, Naomi Jackson. "A Profile of A. Y. Jackson," *The Beaver*, XV, No. 19 (1967), 15-19.

——————. *A.Y.'s Canada*. Toronto: Macmillan Co., 1969.

Hamilton, Art Gallery of Hamilton. *A. Y. Jackson: A Retrospective Exhibition*. Introduction by Edwin Holgate, March-April, 1960. Also shown at London Public Library and Art Museum.

Jackson, A. Y. "Art and Craft." *The Rebel*, III, No. 4 (February, 1919), 158-59.

——————. "A Volunteer." *The Rebel*, III, No. 6 (April, 1919), 256-57.

——————. "An Aesthetic Standard." *The Rebel*, IV, No. 1 (October, 1919), 43.

——————. "Dutch Art in Canada: The Last Chapter." *The Rebel*, IV, No. 2 (November, 1919), 65-66.

——————. "The War Memorials: A Challenge." *The Lamps*, December, 1919, 75-78.

——————. "Sketching in Algoma." *Canadian Forum*, I, No. 6 (March, 1921), 174-175.

——————. "A Policy for Art Galleries." *Canadian Forum*, II, No. 21 (June, 1922), 660-662.

——————. "Artist in the Mountains." *Canadian Forum*, V, No. 52 (January, 1925), 112-113.

——————. "Art in Toronto." *Canadian Forum*, VI, No. 66 (March, 1926), 180-82.

——————. "War Pictures Again." *Canadian Bookman*, VIII, No. 8 (November, 1926), 340.

——————. "Rescuing our Tottering Totems." *Maclean's Magazine*, December 19, 1927.

——————. "There's Still Snow in Quebec." *Ontario College of Art Annual*, 1929.

——————. "Modern Art No Menace." *Saturday Night*, December 17, 1932.

——————. "J. E. H. MacDonald." *Canadian Forum*, XIII, No. 148 (January, 1933), 136-38.

——————. "The Tom Thomson Film." Address by A. Y. Jackson on the occasion of the first showing in Toronto of the Tom Thomson film, *West Wind*, December, 1943. (Typescript in the Art Gallery of Ontario).

——————. "Dr. MacCallum, loyal friend of art." *Saturday Night*, December 11, 1943, 19.

——————. "Sketching on the Alaska Highway." *Canadian Art*, I, No. 3 (1944), 88-92.

——————. "Art Goes to the Armed Forces." *The Studio*, CXXIX, No. 625 (April, 1945), 120.

——————. "A Record of Total War." *Canadian Art*, III, No. 4 (1946), 150-155.

——————. "Lawren Harris, A Biographical Sketch." *Lawren Harris, Paintings, 1910-1948*. Toronto: Art Gallery of Toronto (1948), 6-12.

——————. "Talk on Canadian Art." Toronto: CBC *Wednesday Night*, June 7, 1950 (transcript).

——————. "Arthur Lismer – His Contribution to Canadian Art." *Canadian Art*, VII, No. 3 (1950), 89-90.

——————. "The Origin of the Group of Seven." *High Flight*. Edited by J. R. McIntosh, F. L. Barrett, C. E. Lewis. Toronto: Copp Clark, 1951, 106-62.

————. "Recollections on My Seventieth Birthday." *Canadian Art*, X, No. 3 (1953), 95-100.

————. "Reminiscences of Army Life." *Canadian Art*, XI, No. 1 (1953), 6-10.

————. "The Birth of the Group of Seven." *Our Sense of Identity*. Edited by M. Ross (1954), 220-230.

————. "The Group of Seven." Toronto: CBC broadcast, April, 1954 (transcript).

————. "Arthur Lismer." *Educational Record of the Province of Quebec*, LXXI (January-March, 1955), 13-15.

————. "Box Car Days in Algoma, 1919-20." *Canadian Art*, XIV, No. 4 (1957), 136-141.

————. *A Painter's Country*. Toronto: Clarke Irwin, 1958 (first paperback edition, 1964).

————. "A Portfolio of Arctic Sketches." *The Beaver*, XV, No. 19 (1967), 6-14.

Lismer, A. "A. Y. Jackson – retrospective." *Canadian Art*, III, No. 3 (1946), 169.

McInnes, G. C. "Fine Jackson show at the Women's Art Association." *Saturday Night*, January 20, 1940.

————. "A. Y. Jackson." *New World*, I, No. 2 (1940), 26.

Miller, Muriel. "A. Y. Jackson, a landscape painter of the Group of Seven." *Onward*, December, 1938, 477-78.

Montreal, Dominion Gallery. *A. Y. Jackson: Thirty Years of Painting*. Introduction by A. Lismer. April 24-May 8, 1948.

National Film Board. *Canadian Landscape*. Film on Jackson, 1941.

Pincoe, Grace (Comp.). *Alphabetical index to pictures by A. Y. Jackson, in exhibitions from 1904-1953*. Art Gallery of Ontario Library (typed manuscript).

Purdy, Alfred W. *North of Summer* (poems from Baffin Island, with oil sketches of the Arctic by A. Y. Jackson). Toronto: McClelland and Stewart, 1967.

Reid, J. "A. Y. Jackson, Landscape Painter-at-large; his Brush Interprets Canada's Vastness." *Saturday Night*, April 18, 1942.

Rivard, Adjutor. *Chez Nous (Our Old Quebec Home)*. Translated by N. H. Blake. Decorations by A. Y. Jackson. Toronto: McClelland and Stewart, 1924.

Robinson, Percy J. *The Georgian Bay*. Foreword by A. Y. Jackson. Toronto: Privately printed, 1966.

Robson, A. H. *A. Y. Jackson*. Canadian Artist Series. Toronto: Ryerson Press, 1938.

Toronto, Art Gallery of Toronto. *Catalogue of Arctic sketches by A. Y. Jackson, RCA and Lawren Harris*, 1930.

Toronto, Art Gallery of Toronto, *A. Y. Jackson, Paintings 1902-1953*. Exhibition catalogue. "A. Y. Jackson," by Arthur Lismer, October-November, 1953. Also shown at National Gallery of Canada, Montreal Museum of Fine Arts, and Winnipeg Art Gallery.

"Who's Who in Ontario Art – A. Y. Jackson." *Ontario Library Review*, August, 1954.

JEFFERYS, C. W.

Colgate, William. *C. W. Jefferys*. Toronto: Ryerson Press, 1944.

JOHNSTON, FRANK (FRANZ)

Johnston, Franz. "Modern Art and Aesthetic Reactions – An Objection." *Canadian Forum*, VII, No. 80 (May, 1927), 241-42.

"Johnston Never Member of the Group of Seven." *Star Weekly*, October 11, 1924.

"One Canadian Artist Deserts Extremist 'School of Seven.'" *Star Weekly*, October 5, 1924.

Winnipeg, Winnipeg Art Gallery. *Exhibition of Paintings and Sketches by Frank H. Johnston*, 1922.

LISMER, ARTHUR

Ayre, Robert. "Arthur Lismer." *Canadian Art*, IV, No. 2 (1947), 48-51.

Bell, Andrew. "Lismer's Painting from 1913 to 1949 in Review." *Canadian Art*, VII, No. 4 (1950), 91-3.

Graham, Jean. "Mr. Arthur Lismer, A.R.C.A."

Saturday Night, May 21, 1932.

Hunter, E. R. "Arthur Lismer." *Maritime Art*, July-August, 1943, 137-41, 168-9.

Jackson, A. Y. "Arthur Lismer – His Contribution to Canadian Art." *Canadian Art*, VII, No. 4 (1950), 89-90.

————. "Arthur Lismer." *Educational Record of the Province of Quebec*, LXXI (January-March, 1955), 13-15.

Johnston, Ken. "The Professor is a Rebel." *New Liberty*, May, 1951, 32-3, 44-52.

Lismer, A. "Graphic Art." *Yearbook of Canadian Art*, 1913.

————. "The Canadian War Memorials." *The Rebel*, IV, No. 1 (October, 1919), 40-42.

————. "Art Education and Art Appreciation." *The Rebel*, III, No. 5 (February, 1920), 208-11.

————. "Canadian Art." *Canadian Theosophist*, V, No. 12 (1925), 177-79.

————. "Art a Common Necessity." *Canadian Bookman*, VII, No. 10 (October, 1925), 159-60.

————. *A Short History of Painting with a Note on Canadian Art*. Toronto: Andrews Bros., 1926.

————. "An Appreciation." *Yearbook of the Arts in Canada*. Edited by B. Brooker. 1928-1929.

————. *Canadian Picture Study*. Toronto: Art Gallery of Toronto, 1930.

————. "The Canadian Theme in Painting." *Canadian Comment*, February, 1932.

————. "Art in the Machine Age." *Canadian Comment*, April, 1932.

————. "Art By the Wayside." *Canadian Comment*, July, 1932.

————. "Creative Art." *The New Era In Home and School*, December, 1932, 359-63.

————. "The West Wind." *McMaster Monthly*, XLIII (1934), 163-64.

————. "Education Through Art." *The New Era in Home and School*, December, 1934, 232-37.

————. "Education Through Art – The Artist Mind." *Progressive Education Association, Growth and Development: The Basis for Educational Programmes* (1936), 224-30.

————. *Education Through Art for Children and Adults at the Art Gallery of Toronto*. Toronto: Privately printed, 1936.

————. "The Place of Art in Education." *The New Education Fellowship, Educational Adaptations in a Changing Society* (1937), 155-67.

————. "Art in a Changing World." "Art and Creative Education." "Education Through Art." *Proceedings of the New Education Fellowship Conference, Modern Trends in Education*. Wellington, New Zealand, 1938.

————. "Child Art in Canada." *The Studio*, LXXIX, No. 625 (April, 1945), 118-19.

————. "Tom Thomson, 1877-1917, A Tribute to a Canadian Painter." *Canadian Art*, V, No. 2 (1947), 59-62.

————. "What is Child Art?" *Canadian Art*, V, No. 4 (1948), 178-79.

————. "Canadian Art: An Informal History Part II." Montreal: CBC *Wednesday Night*, June 14, 1950 (transcript).

————. "A. Y. Jackson." *A. Y. Jackson, Paintings, 1902-1953*. Toronto: Art Gallery of Toronto, 1953, 4-8.

————. "Tom Thomson, 1877-1917, Canadian Painter." *Educational Record of the Province of Quebec*, LXXX, No. 3 (1954), 170-75.

Lord, Barry. "Georgian Bay and the Development of the September Gale Theme in Arthur Lismer's Painting, 1912-1921." *National Gallery of Canada Bulletin*, V, No. 1-2 (1967), 28-38.

McLeish, John A. B. *September Gale, A Study of Arthur Lismer*. Toronto: J. M. Dent and Sons, 1955.

National Film Board. *Lismer*. Film on Arthur Lismer, Canadian Artists Series, 1952.

Toronto, Art Gallery of Toronto. *Arthur Lismer Paintings 1913-1949*. "Introduction," by Sydney Key, "Arthur Lismer," by L. Harris, January-February,

1950. Also shown at National Gallery of Canada, Montreal Museum of Fine Arts.

MacDONALD, J. E. H.

Buchanan, D. W. "J. E. H. MacDonald – Painter of the Forest." *Canadian Geographical Journal*, XXXIII, No. 3 (1946), 149.

Colgate, W. G. "Art from Manet to MacDonald." *Bridle and Golfer*, V, No. 6 (February, 1933), 26-27, 38.

————. "Personality of a Painter: The Life and Work of J. E. H. MacDonald in Review." *Bridle and Golfer*, XVIII, No. 6 (November-December, 1940), 14-15.

Hamilton, Art Gallery of Hamilton. *J. E. H. MacDonald 1873-1932*. Introduction by Thoreau MacDonald (March, 1957).

Hunter, Edmund Robert. *J. E. H. MacDonald: A Biography and Catalogue of His Work*. Canadian Artist Series. Toronto: Ryerson Press, 1940.

————. "J. E. H. MacDonald." *Educational Record of the Province of Quebec*, LXXX, No. 3 (July-September, 1954), 157-162.

Jackson, A. Y. "J. E. H. MacDonald." *Canadian Forum*, XIII, No. 13 (January, 1933), 136-38.

Jefferys, C. W. "MacDonald's Sketches." *The Lamps*, December, 1911, 12.

Lismer, Arthur. "Memorial Show Proves Greatness of Late J. E. H. MacDonald." *Saturday Night*, January 31, 1933.

Longstreth, T. Morris. "The Paintings of J. E. H. MacDonald." *The Studio*, CVIII, No. 496 (July, 1943), 43.

Maclure, John. "Hidden Treasures of a Shy Rebel." *Maclean's Magazine*, November 1, 1965.

MacDonald, J. E. H. "The Hot Mush School, in Rebuttal of H. F. G." Toronto, *Star*, December 20, 1913.

————. "Bouquets From A Tangled Garden." *Globe*, March 27, 1916.

————. "A Landmark of Canadian Art." *The Rebel*, II, No. 2 (November, 1917), 45-50.

————. "A Hash of Art." *The Rebel*, II, No. 3 (December, 1917), 90-93.

————. "A Whack at Dutch Art." *The Rebel*, II, No. 6 (March, 1918), 256-60.

————. "Art Crushed to Earth." *The Rebel*, No. 4 (January, 1918), 150-53.

————. "Art and Our Friend in Flanders." *The Rebel*, II, No. 5 (February, 1918), 182-86.

————. "Mentioned in Dispatches." *The Rebel*, III, No. 5 (March, 1919), 205-7.

————. "The Terrier and the China Dog." *The Rebel*, III, No. 2 (December, 1918), 55-60.

————. "The Canadian Spirit in Art." *The Statesman*, I, No. 35 (1919), 6-7.

————. "A.C.R. 10557." *The Lamps*, December, 1919, 33-39.

————. "A Happy New Year for Art." *The Rebel*, IV, No. 4 (January, 1920), 155-59.

————. "The Choir Invisible." *Canadian Forum*, III, No. 28 (January, 1923), 11-113.

————. "A Glimpse of the West." *Canadian Bookman*, VI, No. 11 (November, 1924), 229-31.

————. *Walt Whitman*. Notes for a lecture given at the Public Reference Library, October, 1926, now in the possession of Thoreau MacDonald.

————. *Relation of Poetry to Painting with Special Reference to Canadian Painting*. Notes for a lecture given on October 20, 1929, now in the library of the Art Gallery of Ontario.

————. *Scandinavian Art*. Typewritten notes for a lecture given on April 17, 1931, at the Art Gallery of Toronto. Original in the possession of Thoreau MacDonald, carbon at the Art Gallery of Ontario Library.

————. *West by East and Other Poems*. Toronto: Ryerson Press, 1933.

————. *My High Horse, A Mountain Memory*. Thornhill: Woodchuck Press, 1934.

————. *J. E. H. MacDonald – Bookplate Designs*. Thornhill: Woodchuck Press, 1966.

McInnes, Graham. "J. E. H. MacDonald, RCA."
New World, I, No. 3 (May, 1940), 26-27.
Middleton, J. E. "J. E. H. MacDonald, an Appreciation."
Supplement to *The Lamps*, December, 1932.
Montreal, Dominion Gallery. *J. E. H. MacDonald
Memorial Exhibition*. Introduction by Max Stern,
Ph.D. November 20-December 3, 1947.
Mulligan, H. A. "J. E. H. MacDonald (1873-1932)."
Canadian Comment, VI, No. 11 (November, 1937), 27.
Pierce, Lorne. *A Postscript on J. E. H. MacDonald,
1873-1932*. Toronto: Ryerson Press, 1940.
Robson, Albert Henry. *J. E. H. MacDonald*. Toronto:
Ryerson Press, 1937.
Robertson, Nancy. *J. E. H. MacDonald*. Unpublished
manuscript, revised version, 1969.
Toronto, Mellors Gallery. *A Loan Exhibition of the
Work of J. E. H. MacDonald, R.C.A.* Introduction
by B. Fairley. October 30-November 13, 1937.
Toronto, Art Gallery of Toronto. *J. E. H. MacDonald,
R.C.A., 1873-1932*. Introduction by Nancy
Robertson. November 13-December 12, 1965.
Also shown at National Gallery of Canada, 1966.

MacDONALD, THOREAU

Hunter, E. R. *Thoreau MacDonald*. Toronto: Ryerson
Press, 1942.

MORRICE, JAMES WILSON

Bath, Holburne of Menstrie Museum. *James Wilson
Morrice: 1865-1924*. "The Canadian Nomad," by
Denys Sutton; Catalogue by Dennis Reid. May 30-
June 29, 1968.
Buchanan, Donald, W. *James Wilson Morrice*.
Canadian Artist Series. Toronto: Ryerson Press,
1947.
——————. "James Wilson Morrice, Painter of
Quebec and the World." *Educational Record of the
Province of Quebec*, LXXX, No. 3 (1954), 163-69.
Gagnon, Clarence. "Morrice as a Painter."
Unidentified clipping, National Gallery of Canada
Library.
Montreal, Montreal Museum of Fine Art. *J. W.
Morrice, 1865-1924*. Introduction by W. R.
Johnston. 1965.
Pepper, Kathleen Daly *James Wilson Morrice*.
Preface by A. Y. Jackson. Toronto and Vancouver:
Clarke Irwin, 1966.

REID, GEORGE

Miner, Muriel Miller. *G. A. Reid, Canadian Artist*.
Toronto: Ryerson Press, 1946.

ROBINSON, ALBERT H.

Hamilton, Art Gallery of Hamilton. *Albert H.
Robinson, Retrospective Exhibition*. Introduction by
Robert Pilot, 1955.
Lee, Thomas, R. *Albert H. Robinson The Painter's
Painter*. Montreal: Private printing, 1956.

SUZOR-CÔTÉ, M. A. de FOY

Gour, Romain. *Suzor-Coté: artiste multiforme*.
Montreal: Editions éoliennes, 1950.
Jouvancourt, Hugues de. *Suzor-Coté*. (Edition of 200).
Montreal: Editions la Fregate, 1967.

THOMSON, TOM

Addison, Ottelyn, in collaboration with Elizabeth
Harwood. *Tom Thomson, The Algonquin Years*.
Foreword by A. Y. Jackson, Drawings and an
Appendix by Thoreau MacDonald. Toronto:
Ryerson Press, 1969.
Atherton, Ray. "The Man in a Canoe." *Canadian
Art*, V, No. 2 (1947), 57-58
Colgate, William, ed. *Two Letters of Tom Thomson,
1915 and 1916*. Weston, Ontario: The Old Rectory
Press, 1946. Also published in *Saturday Night*,
November 9, 1946.
Davies, Blodwen. *Paddle and Palette; The Story of Tom
Thomson*. Notes on the pictures by Arthur Lismer.
Toronto: Ryerson Press, 1930.
——————. *A Study of Tom Thomson, The Story
of a Man who Looked For Beauty and For Truth in
the Wilderness*. Toronto: Discuss Press, 1935.
——————. "Art and Esotericism in Canada."
Canadian Theosophist, XVIII (1937), 57-58.
——————. *Tom Thomson, The Story of a Man who
Looked For Beauty and For Truth in the Wilderness*.
Revised Memorial Edition, with Foreword by
A. Y. Jackson, Sketches by Arthur Lismer.
Vancouver: Mitchell Press, 1967.
Fairley, Barker, [B.F.]. "Tom Thomson and Others."
The Rebel, III, No. 6 (March, 1920), 244-48.
Frank, Marion. "Reminiscences of Tom Thomson."
New Frontiers, V, No. 1 (Spring, 1956), 22-24.
Hubbard, R. H. *Tom Thomson*. Society for Art
Publications. Toronto: McClelland and Stewart
Ltd., 1962.
Jackson, A. Y. "The Tom Thomson Film." Address
by A. Y. Jackson on the occasion of the first showing
in Toronto of the Tom Thomson film, *West Wind*,
December, 1943 (Typescript in the Art Gallery of
Ontario Library).
Lamb, H. Mortimer. "Studio-talk: Tom Thomson."
The Studio, LXXVII, No. 317 (August, 1919),
119-126.
Lismer, A. "The West Wind." *McMaster Monthly*,
XLIII (1934), 163-64.
——————. "Tom Thomson, 1877-1917, A
Tribute to a Canadian Painter." *Canadian Art*, V,
No. 2 (1947), 59-62.
——————. "Tom Thomson." *Educational Record
of the Province of Quebec*, XXX, No. 3 (July-
September, 1954), 170-75.
Little, R. P. "Some Recollections of Tom Thomson
and Canoe Lake." *Culture*, XVI (1955), 200-208.
Little, William T. *The Tom Thomson Mystery*.
Toronto: McGraw Hill, 1970.
MacCallum, J. M. "Tom Thomson: Painter of the
North." *Canadian Magazine*, L (1918), 375-385.
MacDonald, J. E. H. "A Landmark of Canadian Art."
The Rebel, II, No. 2 (November, 1917), 45-50.
Montreal, The Arts Club. *Catalogue of an Exhibition
of Paintings by the Late Tom Thomson*. Foreword by
A. Y. Jackson, March, 1919.
National Film Board. *West Wind*. Film on Tom
Thomson, 1944.
Pringle, Gertrude. "Tom Thomson, The Man.
Painter of the Wilds Was a Very Unique
Individuality." *Saturday Night*, April 10, 1926.
Robson, Albert H. *Tom Thomson, Painter of our North
Country, 1877-1917*. Canadian Artist Series. Toronto:
Ryerson Press, 1937.
Saunders, Audrey. *Algonquin Story, The Story of Tom
Thomson*. Toronto: Department of Lands and
Forests, 1948.
Toronto, Art Gallery of Toronto. *A Memorial
Exhibition of Paintings by Tom Thomson*, February
13-19, 1920.
Toronto, Mellors Gallery. *Tom Thomson: Painter of
the North. Loan Exhibition of Works by T. Thomson*.
Introduction by J. M. MacCallum. 1937.
Town, Harold. "The Pathfinder." *Great Canadians*.
Canadian Centennial Library. Toronto: McClelland
and Stewart Ltd., 1965.
"Was Tom Thomson Murdered." CBC *Television
broadcast*, February 6, 1969.
Windsor, Willistead Art Gallery. *Tom Thomson,
1877-1917*, October-November, 1957.

VARLEY, F. H.

Buchanan, D. W. "Paintings and Drawings of F. H.
Varley." *Canadian Art*, VII, No. 1 (1949), 2-5.
Carpenter, E. S. "Varley's Arctic Sketches."
Canadian Art, XVI, No. 2 (1959), 93-100.
——————. *Eskimo*. Sketches and paintings by
Frederick Varley. Toronto: University of Toronto
Press, 1959.
Duval, Paul. "Vigorous Veteran of Canadian Art –
Frederick Horseman Varley." *Saturday Night*,
December 16, 1944.
Elliot, George. "F. H. Varley's - Fifty Years of His
Art." *Canadian Art*, XII, No. 1 (1954), 2-8.
Fairley, Barker. "Some Canadian Painters: 'F. H.
Varley.'" *Canadian Forum*, II, No. 19 (April, 1922),
594-596.
——————. "F. H. Varley." *Our Living Tradition*.
Edited by Robert L. McDougall. Toronto:
University of Toronto Press, 1959, 151-69.
Hambleton, Josephine. "Frederick Horseman Varley."
Kingston, Ontario, *Whig Standard*, January 12, 1948.
National Film Board. *Varley*. Film on Frederick
Varley. Canadian Artists Series, 1952.
Pincoe, Grace (Comp.) Unpublished, I. *Alphabetical
Classified Index and Pictures Exhibited*, II.
Chronological Index to Pictures Exhibited. Compiled
in preparation for *Varley Retrospective*, 1954.
Typescript Art Gallery of Ontario Library.
Porter, McKenzie. "Varley." *Maclean's Magazine*,
November 7, 1959.
"T." "Recognition for Canadian Artists." First
published in the London *Nation*; reprinted in *The
Lamps*, December, 1919, 81-82.
Toronto, Art Gallery of Toronto. *F. H. Varley,
Paintings 1915-1954*. "The Early Years," Arthur
Lismer; "The War Records," by A. Y. Jackson;
"The Twenties," by Arthur Lismer; "Vancouver,"
by J. W. G. Macdonald; "Toronto, The Later
Years," by Charles S. Band; "An Approach to
Varley," by R. H. Hubbard. October-November,
1954. Also shown at National Gallery of Canada,
Montreal Museum of Fine Arts, and sent on
western tour.
Varley, F. H. Untitled article in *The Paintbox*,
Vancouver School of Decorative and Applied Arts,
(1928), 12.
"Who's Who in Ontario Art – Frederick Horseman
Varley." *Ontario Library Review*, August, 1962.
Windsor, Willistead Art Gallery. *F. H. Varley
Retrospective*, 1964.

NEWSPAPER ARTICLES (in chronological order)

"New Talent at the Art Exhibition." *Globe*, March 9,
1912.
"Growth of Canadian Art Revealed by O.S.A.
Exhibit." *Mail & Empire*, March 9, 1912.
"The O.S.A. Exhibition." Editorial. *Saturday Night*,
March 16, 1912.
P. O'D. [Peter O'Donovan]. "A Big Show of Little
Pictures." *Saturday Night*, March 8, 1913.
"Post-Impressionists Shock Local Art Lovers at the
Spring Exhibition." Montreal, *The Witness*, March
26, 1913.
Morgan-Powell, S. "Review of the Spring Exhibition."
Montreal, *Star*, March 29, 1913.
"Fine Paintings Placed on View." *Mail & Empire*,
April 5, 1913.
"Ontario Society of Artists." *Globe*, April 15, 1913.
Gadsby, H. F. "The Hot Mush School." Toronto,
Star, December 12, 1913.
MacDonald, J. E. H. "The Hot Mush School in
Rebuttal of H. F. G." Toronto, *Star*, December 20,
1913.
Sibley, C. L. "Greatest Show of Canadian Paintings."
Globe, December 20, 1913.
"The Little Picture Show." Editorial. *Saturday Night*,
February 14, 1914.
"Strength and Beauty in the New Pictures." Toronto,
Star, March 14, 1914.
Charlesworth, H. "Ontario Society of Artists Annual
Exhibition." *Saturday Night*, March 21, 1914.
"Power and Poetry in Art Galleries." *Mail & Empire*,
March 13, 1915.
"Color and Originality at the O.S.A. Exhibition."
Globe, March 13, 1915.
Charlesworth, H. "O.S.A.'s Exhibition, 1915."
Saturday Night, March 20, 1915.
"Some Pictures at the Art Gallery." Toronto, *Star*,
March 11, 1916.
"Extremes Meet at O.S.A. Show." *Globe*, March 11,
1916.
"Ontario Artists do Daring Work." *Mail & Empire*,
March 11, 1916.
"The New Schools of Art." Toronto, *Star*, March 16,
1916.

Charlesworth, H. "Pictures That Can be Heard." *Saturday Night*, March 18, 1916.

MacDonald, J. E. H. "Bouquet From a Tangled Garden." *Globe*, March 27, 1916.

"Ontario Artists do Vigorous Work." *Mail & Empire*, March 10, 1917.

Charlesworth, H. "Good Pictures at the O.S.A. Exhibition." *Saturday Night*, March 24, 1917.

Bridle, Augustus. "Canadian Artists to the Front." *Canadian Courier*, February 16, 1918.

"Younger Artists Come to the Front." Toronto, *Star*, March 8, 1919.

"Picture Gallery is a Riot of Color." *Mail & Empire*, March 10, 1919.

"Etchings Predominate at Art Exhibition." Toronto, *Star*, May 3, 1919.

Charlesworth, H. "Painters-Etchers and Others." *Saturday Night*, May 17, 1919.

"Some Aphorisms of the Artists of the Algonquin School." Belleville, Ontario, *Intelligence*, September 27, 1919.

Charlesworth, H. "Reflections." *Saturday Night*, December 13, 1919.

M.L.F. "Seven Painters Show Some Excellent Work." Toronto, *Star*, May 7, 1920.

"Seven Artists Invite Criticism." *Mail & Empire*, May 10, 1920.

"Art and Artists." *Globe*, May 11, 1920.

Wrenshall, H. E. "Art Notes." *Sunday World*, May 21, 1920.

Bridle, Augustus. "Are These New-Canadian Painters Crazy?" *Canadian Courier*, May 22, 1920.

"The Canadian Algonquin School." *Mail & Empire*, February 21, 1920.

"Unusual Art Cult Breaks Loose Again." Toronto, *Star*, May 9, 1921.

"Art and Artists." *Globe*, May 9, 1921.

Charlesworth, H. "Impressions of the Royal Canadian Academy." *Saturday Night*, November 26, 1921.

The Observer. "The Group of Seven and the Canadian Soul." Toronto, *Star*, January 31, 1922.

M.O.H. [M. O. Hammond]. "Retrospective Exhibition of Ontario Artists." *Globe*, February 13, 1922.

Jacob, Fred. "How Canadian Art Got its Real Start." Toronto, *Star*, April 9, 1922.

"The Group of Seven." *Mail & Empire*, May 6, 1922.

M.O.H. [M. O. Hammond]. "Salon of Group of Seven Reflects Canadian Impulse to Glimpse Beyond Skyline." *Globe*, May 10, 1922.

"Group of Seven Not So Extreme." *Mail & Empire*, May 13, 1922.

Bridle, Augustus. "Picture of the Group of Seven Show, 'Art Must Take the Road.'" Toronto, *Star*, May 20, 1922.

"Candid Critic Talks of Art." *Globe*, November 9, 1922.

Charlesworth, H. "The National Gallery a National Reproach." *Saturday Night*, December 9, 1922.

Walker, B. E. and Charlesworth. "Canada's National Gallery, A Letter From Sir Edmund Walker and a Reply by Mr. Charlesworth." *Saturday Night*, December 23, 1922.

Charlesworth, H. "And Still They Come! Aftermath of a Recent Article on the National Gallery." *Saturday Night*, December 30, 1922.

MacBeth, Madge. "The National Gallery of Art." *Saturday Night*, January 14, 1922.

Russell, G. H. "Art at the British Empire Exhibition, An Open Letter to Sir Edmund Walker." *Saturday Night*, September 15, 1923.

"Canada's Art at Empire Fare." Editorial. *Saturday Night*, September 22, 1923.

Walker, E. "Open Letter to G. Horne Russell." *Saturday Night*, September 22, 1923.

"Sir Edmund Walker's Letters re the British Empire Exhibition." *Saturday Night*, September 22, 1923.

Charlesworth, H. "An Unofficial Display of Canadian Pictures." *Saturday Night*, September 29, 1923.

Brigden, E. H.; Grier, E. Wyly; Haines, Fred, S.; Jackson, A. Y.; Jefferys, C. W.; MacDonald, J. E. H.; Palmer, H. S. "An Appeal to Painters." Letter to the Editor. *Saturday Night*, October 6, 1923.

Watson, Homer. "Canadian Art at British Empire Exhibition." Letter to the Editor. *Saturday Night*, October 6, 1923.

"Group of Seven Triumphs." *Telegram*, November 30, 1923.

Charlesworth, H. "Royal Canadian Academy." *Saturday Night*, December 1, 1923.

"Canada Has Given Birth To a New and National Art." *Star Weekly*, January 26, 1924.

[Charlesworth, H.]. "Canadian Pictures at Wembley." Editorial. *Saturday Night*, May 17, 1924.

[Charlesworth, H.]. "Freak Pictures at Wembley." Editorial. *Saturday Night*, September 13, 1924.

"Johnston Never Member of the Group of Seven." *Star Weekly*, October 11, 1924.

Charlesworth, H. "Canadian Painting for the Tate Gallery." *Saturday Night*, November 1, 1924.

[Charlesworth, H.]. "Canada and Her Paint Slingers." Editorial. *Saturday Night*, November 8, 1924.

"'School of Seven' Exhibit is Riot of Impressions." *Star Weekly*, January 10, 1925.

"Back to Intelligibility, Group of Seven Show." *Telegram*, January 12, 1925.

"Artists in the Wilds." *Globe*, January 17, 1925.

Charlesworth, H. "The Group System in Art, New Canadian 'School' as Exemplified in the Show of 'Seven.'" *Saturday Night*, January 24, 1925.

The Observer. "And That True North." Toronto, *Star*, January 31, 1925.

Cowan, James, A. "Hymie, Solly and a Pair of Truck-Drivers Take Part-Time Job as High Art Critics," *Star Weekly*, January 31, 1925.

"Must Study Figure to Develop Art – Grier." Toronto, *Star*, February 20, 1925.

"Canadian Painters Lead in Originality." Toronto, *Star*, February 23, 1925.

"Rival School's of Art Stoutly Championed." *Mail & Empire*, February 27, 1925.

"Art from the Rostrum." *Globe*, February 27, 1925.

"Artists Give Views at Club's Art Debate." Toronto, *Star*, February 27, 1925.

"Advice to Group of Seven – 'Paint the Paintless Barn.'" *Telegram*, February 27, 1925.

"If Cow Can Stay in Parlour, Then Why Can't Bull Moose?" Toronto, *Star*, February 27, 1925.

"Cult of Ugliness on Trial in England." Editorial. *Saturday Night*, June 20, 1925.

"Disdainful of Prettiness, New Art Aims at Sublimity." Toronto, *Star*, May 6, 1926.

Bridle, Augustus. "Group of Seven Betray No Signs of Repentance." *Star Weekly*, May 8, 1926.

"New Member is Added to Group of Seven." *Mail & Empire*, May 8, 1926.

Charlesworth, H. "Toronto and Montreal Painters Wild Work at the Cross-Roads By Group of Seven – A French Canada Exhibition." *Saturday Night*, May 22, 1926.

Reade, R. C. "They Have Taken Photography and Wrung its Neck." *Star Weekly*, May 22, 1926.

"Painters Demand the Head of Art Director." Toronto, *Star*, November 20, 1926.

"New Volume Vigorously Champ Champions Group of Seven." Review of *A Canadian Art Movement*, by F. B. Housser. Toronto, *Star*, December 11, 1926.

Denison, Merrill. "Story of an Art Movement." Review of *A Canadian Art Movement* by F. B. Housser. *Globe*, December 18, 1926.

"British Artist Lands Canada's Group of Seven." Toronto, *Star*, December 18, 1926.

Morgan-Powell, S. "Art in Canada; Plea for Group of Seven; Ex-Parte Arguments." Review of *A Canadian Art Movement* by F. B. Housser. Montreal, *Daily Star*, December 31, 1926.

"Seven Group Again Lead Ghost Dance of Palette." Toronto, *Star*, February 18, 1927.

Jacob, Fred. "In the Art Galleries." *Mail & Empire*, February 18, 1927.

"Canadian Artists Exhibit Widely." Sault Ste. Marie, *Star*, June 2, 1927.

"Toronto Artist After Distinct Values in Art." Regina, Saskatchewan, *Leader Post*, July 30, 1927.

"Pictures Good and Bad." *Mail & Empire*, September 9, 1927.

Greenaway, C. R. "Painter Says Canada Does Not Appreciate Arctic Possessions." Toronto, *Star*, September 10, 1927.

—————. "Jackson Says Montreal Most Bigoted City." Toronto, *Star*, September 10, 1927.

Bridle, Augustus. "Group of Seven Display Their Annual Symbolisms." Toronto, *Star*, February 8, 1928.

Harris, Norman. "Group of Seven Exhibit." *Telegram*, February 11, 1928.

"Junk Clutters Art Gallery Walls, While Real Paintings Are Hidden in Cellar." *Telegram*, February 18, 1928.

"Skies Prove Big Mystery, Mountains Ice Cream Cones." Toronto, *Star*, February 27, 1928.

"National Gallery Pleads 'Not Guilty' to Charge." *Telegram*, September 22, 1928.

Denison, Merrill. "No More Pyrotechnics at Painting Exhibitions." Toronto, *Star*, December 22, 1928.

"Group of Seven Stupid is Artist's Criticism." Toronto, *Star*, February 1, 1930.

Salinger, J. B. "Freedom Fills Work By Group of Seven." *Mail & Empire*, April 4, 1930.

Harris, Frank Mann. "Seven Group Makes Whoopee in Gloom of Rain and Sleet." Toronto, *Star*, April 7, 1930.

"Now Represents Spirit of Canadian Art, Group of Seven Not Separate Entity." Ottawa, *Evening Citizen*, April 24, 1930.

"No Praise For Group of Seven." Letter to the Editor signed: It is to Laugh. *Telegram*, April 26, 1930.

Kean, A. D. "Cowboy Sees Gallery, Acquires Art Taste. 'Shorty' Campbell Finds Out All About Group of Seven." Toronto, *Star*, April 28, 1930.

"Need Not Look to Europe for Art Expression." Reply to critic of Group of Seven, by Blodwen Davies. *Telegram*, May 10, 1930.

Hum, Ho. "The Plaint of the Philistine, The Group of Seven." *The Passing Show*, Montreal, September, 1930, 24-25, 42.

"British Art Expert Praises School of 7." Toronto, *Star*, March 21, 1931.

Salinger, Jehannie, B. "Far North Is Pictured By Two Artists." Regina, Saskatchewan, *Leader Post*, May 1, 1931.

Hairston, R. H. "Canadian Paintings Win Lovers of Art in New York City." *Globe*, March 21, 1932.

"Lismer in Vancouver Lauds Group of Seven." Toronto, *Star*, May 7, 1932.

Bouchette, Bob. "In Defence of the Group of Seven." *Mail & Empire*, July 7, 1932.

Lampman, Archibald. "Group of Seven 'Jazz Band of Art' Says John Russell." *Telegram*, September 26, 1932.

Phillips, W. J. "Art and Artists." (contains Group's statement). Winnipeg, *Tribune*, February 25, 1933.

Underhill, Frank. "False Hair on the Chest." *Saturday Night*, October 3, 1936.

Lindsay, Carol, "A Rediscovered Gallery of Group of Seven Paintings." *Star Weekly*, February 10, 1962.

CATALOGUES

For a comprehensive list of catalogues consult Dennis Reid's Bibliography to *The Group of Seven* Ottawa, National Gallery of Canada, 1970.

CREDITS

Every reasonable effort has been made to ascertain the ownership of illustrations used. Information would be welcomed that would enable the publisher to rectify any error.

Illustrations are listed by number. Principal sources and photographers are credited under these abbreviations:

ABBREVIATIONS

Galleries
A.G.H. —Art Gallery of Hamilton, Hamilton, Ontario
A.G.O. —Art Gallery of Ontario, Toronto, Ontario
H.H. —Hart House, University of Toronto, Toronto, Ontario
M.C.C. —McMichael Conservation Collection, Kleinburg, Ontario
M.M.F.A.—Montreal Museum of Fine Arts, Montreal, Quebec
N.G.C. —National Gallery of Canada, Ottawa, Ontario
V.A.G. —Vancouver Art Gallery, Vancouver, British Columbia

Photographers
AK —A. Kilbertus, Montreal, Quebec
HT —Hugh Thompson, Sherman Laws Limited, Toronto, Ontario
JE —John Evans Photography Limited, Ottawa, Ontario
WB—William Bros. Vancouver, British Columbia

1. M.C.C.; M.C.C.
2. N.G.C.
3. N.G.C.
4. N.G.C.
5. N.G.C.
6. N.G.C.
7. A.G.H.; HT
8. N.G.C.
9. N.G.C.
10. M.M.F.A.
11. N.G.C.
12. M.M.F.A.
13. Mrs. O. B. Thornton; AK
14. Mr. David R. Morrice; AK
15. N.G.C.; JE
16. A.G.O.: HT
17. N.G.C.; JE
18. A.G.O.
19. N.G.C.
20. N.G.C.
21. N.G.C.
22. Mr. Thoreau MacDonald
23. Ontario Archives
24. Ontario Archives; artscanada
25. N.G.C.
26. M.C.C.; John Glover
27. N.G.C.
28. N.G.C.
29. Paul Rodrik; John Glover
30. The Carmichael Estate
31. Studio International, London, England
34. Studio International, London, England
36. N.G.C.
37. A.G.O.
38. N.G.C.
39. The Arts and Letters Club, Toronto; HT
40. A.G.O.; HT
41. Mrs. David R. Stratford; WB
42. N.G.C.
43. N.G.C.
44. The Department of the Prime Minister; HT
45. N.G.C.
46. HT
47. N.G.C.
48/49. N.G.C.; JE
50. Reprinted with permission *Toronto Daily Star*
51. Mr. Charles McFaddin
52. N.G.C.
53. Bud Calligan; artscanada
54. N.G.C.; JE
55. N.G.C.
56. N.G.C.
57. N.G.C.
58. N.G.C.
59. Mrs.W. Howard Wert; AK
60. N.G.C.
61. N.G.C.
62. M.C.C.; HT
63. Mr. Max Merkur; HT
64. N.G.C.; JE
65. N.G.C.; JE

66. N.G.C.
67/68. N.G.C.; JE
69. N.G.C.; JE
70. A.G.O.; HT
71. M.C.C.; M.C.C.
72. Allan Gibbons; JE
73. N.G.C.
74. N.G.C.
75. M.C.C.; HT
76. N.G.C.
77. V.A.G.; WB
78. HT
79. A.G.O.; HT
80/81. N.G.C.; JE
82. Mr. Thoreau MacDonald
83. N.G.C.
84/85. N.G.C.; JE
86. A.G.O.; HT
87. A.G.O.; HT
88. N.G.C. (War Collections)
89. N.G.C.
90. N.G.C. (War Collections)
91. N.G.C. (War Collections)
92. From Canadian War Museum publication *Canada and the First World War* by John Swettenham (Ryerson Press, Toronto, 1969) reproduced by courtesy of the Public Archives of Canada.
93. N.G.C.; JE
94. N.G.C. (War Collections); JE
95. Dalhousie Art Gallery, Halifax; Wamboldt-Waterfield Photography Ltd. Halifax, Nova Scotia
96. N.G.C. (War Collections)
97. N.G.C. (War Collections)
98. N.G.C.; JE
99. Tate Gallery, London, England
100. Mr. Thoreau MacDonald
101. M.C.C.; HT
102. Faculty Club, University of Toronto; HT
103. A.G.H.; HT
104. M.C.C. (McLaughlin Collection); HT
105. M.C.C.; HT
107. Mrs. H. O. McCurry; JE
108. V.A.G.; WB
109. N.G.C.; JE
110. A.G.O.; Charlie King
111. Mr. Max Merkur; HT
112. M.C.C.; HT
113. Ontario Heritage Foundation, A.G.O.; HT.
114. N.G.C.
115. N.G.C.
116. H.H.
117. H.H.
118. M.C.C.; Ron Vickers
119. A.G.O.
120. Ron Vickers
121. N.G.C.
122. N.G.C.
123. N.G.C.; W. Hands
124. Reprinted with permission *Toronto Daily Star*
125. M.C.C.

126. N.G.C.; JE
127. A.G.O.
128. N.G.C.
129. Mr. R. MacDonald; HT
130. Mrs. C. S. Band; HT
131. N.G.C.; JE
132. N.G.C.; JE
133. N.G.C.; JE
134. M.C.C.; HT
135. M.C.C.; HT
136. N.G.C.
137. N.G.C.
138. Mrs.H.O.McCurry; N.G.C.Library
139. N.G.C.
140. H.H.
141. M.C.C.
142. Canada Packers Ltd.
143. N.G.C.; JE
144. M.C.C.; HT
145. N.G.C.
146. N.G.C.
147. N.G.C.
148. M.C.C.; HT
149. N.G.C.
150. M.C.C.; HT
151. A.G.O.
152. A.G.O.; HT
153. M.C.C.
154. H.H.
155. M.C.C.; HT
156. M.C.C.; HT
157. A.G.O.; HT
158. A.G.O.; HT
159. M.C.C.
160. Mr. S. C. Torno; HT
161. N.G.C.; HT
162. Mr. W. Alan Manford; HT
163. Mr. Michael M. Stewart; HT
164. M.C.C. (McLaughlin Collection); HT
165. N.G.C.
166. A.G.O.; HT
167/168. A.G.O.; HT
169. N.G.C.
170. A.G.H.; HT
171. London Public Library & Art Museum, London, Ontario
172. Winnipeg Art Gallery; Brigdens of Winnipeg Ltd.
173/174. M.C.C.; HT
175. M.C.C.; HT
176. Mrs. C. S. Band; HT
177. A.G.O.; HT
178. N.G.C.; JE
179. A.G.O.; HT
180. A.G.O.; HT
181. M.M.F.A.; Charlie King
182. Mr. S. C. Torno; HT
183. H.H.
184. N.G.C.; HT
185. Mr. C. A. G. Matthews; HT
186. M.C.C.; HT
187. Mrs. C. S. Band
188. A.G.O.
189. N.G.C.
190. N.G.C.
191. Sarnia Public Library & Art Gallery, Sarnia, Ontario; Grant Hill, Sarnia, Ontario
192. N.G.C.
193. N.G.C.
194. A.G.O.; HT
195. A.G.O.; HT
196. A.G.O.; HT
197. N.G.C.
198. N.G.C. (Massey Bequest); HT
199. M.C.C.
200. N.G.C.; JE
201. M.C.C.
202. M.C.C.
203. Norman Mackenzie Art Gallery, University of Saskatchewan; Nat Hrynuk
204. Dr. Max Stern

205. HT
206. A.G.H.; HT
207. N.G.C.; JE
208. A.G.O.
209. N.G.C.; JE
210. N.G.C.; JE
211. H.H.
212. N.G.C.
213. Mr. Thoreau MacDonald
214. H.H.
215. N.G.C.
216. M.C.C.
217. M.C.C.; Robert McMichael
218. N.G.C.; JE
219. V.A.G.
220. M.C.C.; Robert McMichael
221. A.G.O.
222. A.G.O.
223. M.C.C.
224. A.G.O.
225. M.C.C.; Robert McMichael
226. M.C.C.; HT
227. M.C.C.; Robert McMichael
228. A.G.O.
229. M.C.C.
230. Mrs. C. S. Band; HT
231. HT
232. N.G.C.
233. M.C.C.; Robert McMichael
234. The Carmichael Estate
235. HT
236. M.C.C.
237. N.G.C.
238. Mr. Jennings Young; Ron Vickers
239. L. S. H. Holdings Ltd.
240. N.G.C.
241. N.G.C.
242. N.G.C.
243. N.G.C.
244. N.G.C.
245. M.C.C.; HT
246. A.G.O.
247. M.C.C.
248. A.G.O.
249. M.M.F.A.
250. A.G.O.
251. N.G.C.
252. V.A.G.
253. N.G.C.
254. N.G.C.
255. A.G.O.
256. Mr. and Mrs. F. Schaeffer; Ron Vickers
257. A.G.O.
258. Dr. Max Stern; Brigdens
259. Mr. and Mrs. J. A. MacAulay; N.G.C.
260. Dr. Naomi Jackson Groves; N.G.C. Previously reproduced in Dennis Reid, *The Group of Seven*, exhibition catalogue, Ottawa: National Gallery of Canada, 1970. Text in Naomi Groves, *A.Y.'s Canada*, Clarke Irwin, 1968.
261. Mr. Walter Klinkhoff
262. University of Alberta; N.G.C.
263. N.G.C.
264. N.G.C.
265. Mr. Jennings Young; Ron Vickers
266. Mr. S. C. Torno; Ron Vickers
267. N.G.C.
268. Winnipeg Art Gallery
269. M.C.C.
270. Mr. and Mrs. F. Schaeffer; Ron Vickers
271. M.C.C.

APPENDIX

Exhibition catalogues courtesy of the Art Gallery of Ontario; film strips courtesy of Mr. C. A. G. Matthews.

The Group of Seven
Design Concept by Frank Newfeld
Design by Frank Newfeld and David John Shaw
Composed by Mono Lino Typesetting Company Limited
in Janson and Optima type
Printed in Canada by Rolph-Clark-Stone Limited
Bound by John Deyell Limited